Anna Klumpke

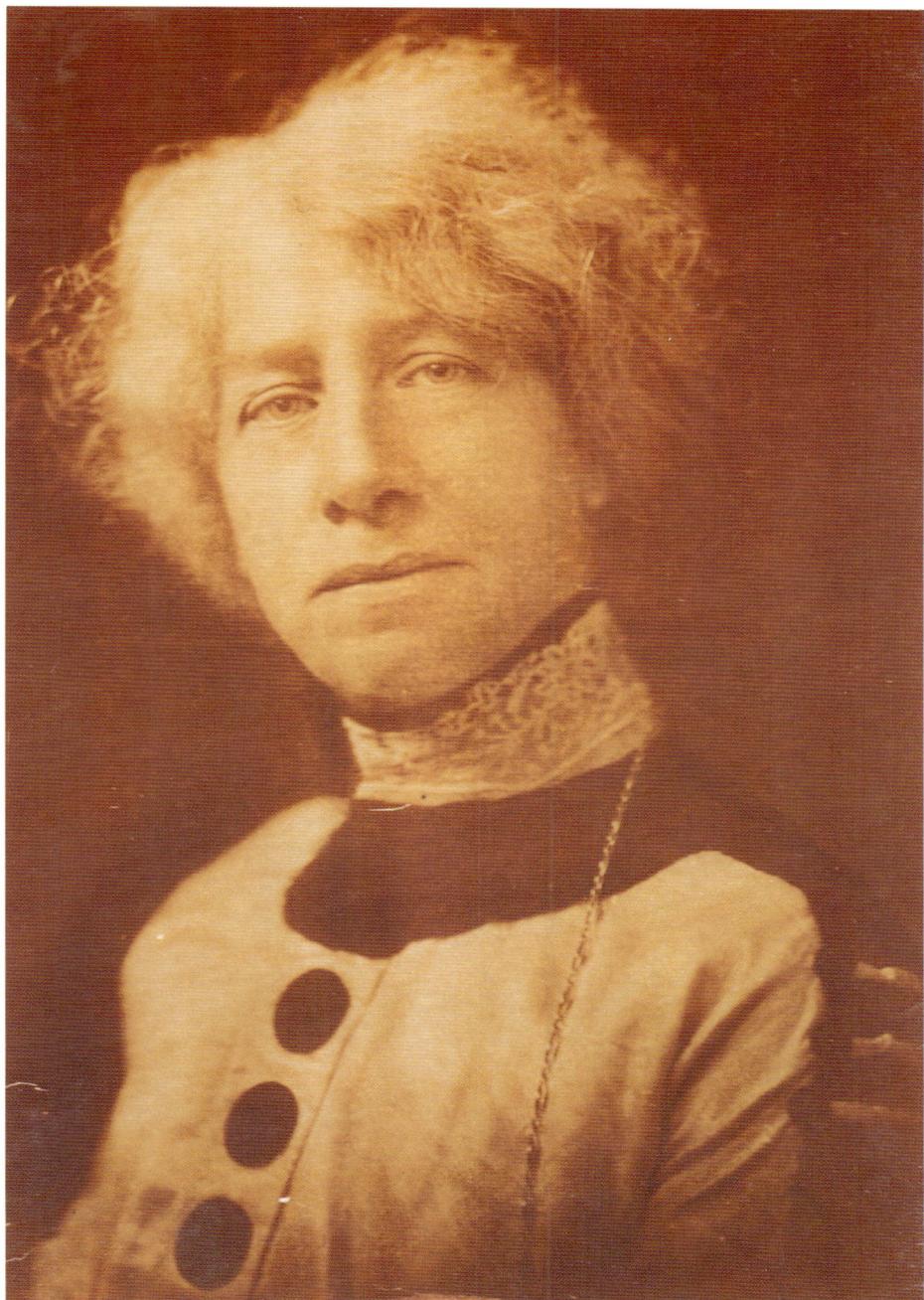

Anna Klumpke

A Turn-of-the-Century
Painter and Her World

Britta C. Dwyer

646313

Northeastern University Press

Boston

Northeastern University Press

The frontspiece, a photograph of Anna E. Klumpke, ca. 1890s, is from a
private collection.

Library of Congress Cataloging-in-Publication Data
Dwyer, Britta C., 1935–
Anna Klumpke : a turn-of-the-century painter and her world /
Britta C. Dwyer.
p. cm.
Includes bibliographical references and index.
ISBN 1-55553-386-8 (cl : alk. paper)
1. Klumpke, Anna, 1856–1942. 2. Painters—United States—
Biography. I. Title
ND237.K57D88 1999
759.13—dc21
[B] 99-13060

Designed by Janis Owens

Composed in Janson by PageMasters & Company, Boston, Massachusetts. Printed and
bound by Maple Press, York, Pennsylvania. The paper is Sebago Antique, an acid-free
sheet.

MANUFACTURED IN THE UNITED STATES OF AMERICA
03 02 01 00 99 5 4 3 2 1

TO
My Daughter, Karin

If the artist, in our inherited conception, is an outsider, he is also a rebel. . . . The very word *artist* connotes personal independence won, perhaps at high cost but nevertheless won, against all the repressive forces of society. And, though we may sometimes credit the [artist] with more emancipation than he in fact enjoys, in most cases our instincts are right.

Richard D. Altick
Lives and Letters
1969

It may not be possible to resolve the contradictions within which the artist works, but it is possible to clarify them.

Carol Duncan
The Aesthetics of Power
1993

Contents

[Part Three: Matters of Choice]

Illustrations

THE PLATES *Following page 80*

Acknowledgments

My interest in Anna Klumpke arose from the extensive coverage given her in the newspapers of late nineteenth-century Pittsburgh. As I continued my doctoral research on local women artists, she increasingly entered my thoughts. Why, I began asking myself, did this painter attract so much attention? Impressed by her Metropolitan portrait of Rosa Bonheur, I decided to meet with Doreen Bolger, then curator of American Paintings and Sculpture and manager of the Henry R. Luce Center for the Study of American Art at the Metropolitan Museum, New York. I thank her here for encouraging me in that early, probing period to study further this "fascinating character."

Writing a biography is a subjective, personal, and often lonely pursuit. But many people have contributed to what was also for me a rich and vital experience. First of all, I cannot adequately express my appreciation to the Sorrel-Dejerine family for allowing me access to the archival material at the Château de Rosa Bonheur, By/Thomery, France, in December 1991. I am grateful for permission to use documents and to reproduce art material. This book would never have been written without their generous cooperation.

I am privileged to have met the grandniece of Anna Klumpke, Catherine Mueller, and her husband, Harold, at their home in California, and to have shared in her recollections of the painter and other members of the Klumpke family.

For sharing with me the trials and triumphs of research, in a freezing cold attic above the Atelier de Rosa Bonheur, I owe my assistant and daughter, Karin, unlimited thanks. For her insight and intelligence, but also for her insistence on clarity (in sections that had to be reworked), I give her my love. During December 1991, our work was greatly facilitated and made enjoyable by Jeanine Curie and Nicole Bachoux. For useful information on Franco-American topics in general, I thank Véronique Wiesenger. I am grateful to the Archives nationales de Paris, the Musée d'Orsay, and the Centre Georges Pompidou. For arranging a special tour of works by Bonheur and Klumpke at the Musée nationale du Château de Fontainebleau, I am indebted to Madame Samoyault-Verlet and Madame E. Dauxerre. I thank Roger Bretonnet for trying to find "traces" of Klumpke and her contemporaries in Moret-sur-Loing. For valuable contacts, and above all kindness, in Paris I thank Nicole Fouché, "Ingénieur," Ecole des Hautes études en sciences sociales.

I gratefully acknowledge those who assisted me at various educational and cultural institutions, either of their own volition or in response to my request for information. I mention with thanks Lois Marie Fink, former curator of research at the National Museum of American Art (NMAA), especially for leading me through my first tentative outline for a book on Klumpke; Carolyn Carr, deputy director at the National Portrait Gallery (NPG), who shared with me material from her own research on Sara Hallowell; Arthur Breton, Archives of American Art, Washington, D.C.; at the Musée Rodin, Paris, Alain Beausire, Chargé des Archives, and Antoinette Romain, Conservateur en chef des sculptures. Special gratitude goes to Lillian Miller, the Smithsonian's historian of American culture and scholar of the Peale family of painters; sadly, she is not alive today to see this book completed. For introducing me to the study of American patronage, but especially for her insightful comments, kindness, and support, I remain sincerely grateful. Others to whom I am indebted include Mary Jo Aagerstoun for her valuable study of Anna Klumpke (M.A. thesis, George Washington University, 1994), Coit Liles, Russell Trust Association, New Haven, Connecticut, in particular for obtaining permission for me to view Klumpke's portrait of George Douglas Miller at the Skull and Bones society and for inviting me (and my Yale husband) to the "old Miller retreat" on Deer Island (Alexandria Bay, N.Y.); Erica Hirschler, Museum of Fine Arts Boston (Boston, Mass.); Jean Berry, Margaret Clapp Library Archives at Wellesley College (Wellesley, Mass.); Sandra Grindlay, Har-

vard University Portrait Collection (Cambridge, Mass.); Susan Wegner, Bowdoin College Museum of Art (Brunswick, Maine); Scott Marsh, Alan Mason Chesney Medical Archives of The Johns Hopkins Medical Institutions (Baltimore, Md.); Jean Morrow, the Spaulding Library at the New England Conservatory (Boston, Mass.); Mary Beth Looney, Brenau University Art Gallery (Gainesville, Ga.); Nancy Chodorow, University of California (Berkeley) for a discussion "on campus" in December 1992, sharing ideas on psychoanalytic theories, and especially on our common interest in mother-daughter relationships; and, finally, Lillian Faderman, California State University (Fresno). For encouraging me, during her 1993 visit to Pittsburgh, in the difficult process of conceptualizing a "romantic friendship" I am sincerely grateful.

The following institutions and organizations have all been resources for my work: in Germany, Stadtarchiv, Göttingen; in Washington, the National Gallery of Art, the National Museum of American Art, the National Portrait Gallery, the National Museum of Women in the Arts, and the General Federation of Women's Clubs; in Boston, the Fine Arts and Newspaper Collection departments at the Boston Public Library, the Massachusetts Historical Society, the New England Historic Genealogical Society, and the Suffolk Probate Office, for information on wills and inventories; in Cambridge, Massachusetts, the Henry Wadsworth Longfellow National Historic Site, the Arthur and Elizabeth Schlesinger Library at Radcliffe College, and the Harvard University Archives; in Albany, New York, the Albany Institute of History and Art; in New York City, the Metropolitan Museum of Art; in Northampton, Massachusetts, the Sophia Smith Collection at Smith College; in Worcester, Massachusetts, the American Antiquarian Society, the Worcester Art Museum, and the Worcester Historical Museum; in Center Sandwich, New Hampshire, the Sandwich Historical Society; in Philadelphia, the Pennsylvania Academy of the Fine Arts and the Pennsylvania Historical Society; in California, the California State Library in Sacramento, the San Francisco Public Library, the Bancroft Library of the University of California at Berkeley, and the Alice Phelan Sullivan Library and the Society of California Pioneers, San Francisco; in Spartanburg, South Carolina, Converse College; in Chicago, the University of Chicago Library; and, last but by no means least, in Pittsburgh, the archives of the Carnegie Museum of Art, the Historical Society of Western Pennsylvania, the Hillman and Henry Clay Frick Fine Arts Libraries, the University of Pittsburgh,

and the many accommodating persons in the Pennsylvania Room at the Carnegie Library, Oakland—where I first came across my subject.

A travel grant from the Smithsonian Institution in 1991 made it possible for me to do research at the library archives of the National Gallery of Art in Washington, and to receive intellectual stimulation from other Smithsonian fellows and visiting scholars at the NMAA. I also thank the National Endowment for the Humanities for a travel grant that enabled me to undertake research in Boston in 1994.

I am particularly indebted to the art historians who have influenced my thinking. Barbara Novak taught me, a quattrocento enthusiast and recent immigrant, that there was "art" and "culture" even in America. For inadvertently helping me to adjust to a life in the New World I remain personally in her debt. Elizabeth Johns taught me to contextualize. Her high standards of scholarship were a constant model and reminder in my own research and writing. For whatever shortcomings that may remain in this book I am entirely accountable.

A personal expression of gratitude goes to my all-time favorite guru, David Wilkins, at the University of Pittsburgh. He read several versions of the manuscript, and, above all, he always found time to listen and talk when the task of interpreting and writing seemed especially difficult. For all of this, I am thankful beyond measure.

Among the many other persons who helped in some way are, most notably, members of the Coolidge family, especially Roger Sherman Coolidge, Mary Lincoln, and Joseph Randolph Coolidge IV (his hospitality "at home" in New Hampshire was much appreciated). I also am indebted to Elting Morison for inviting me to the Morison homestead to discuss and photograph his collection of portraits by Anna Klumpke.

For her advice and encouragement regarding my biographical project I am especially grateful to Edith B. Gelles, author of *Portia: The World of Abigail Adams*. For sharing with me her work on Lucy Lee-Robbins, I thank Brandon Brame Fortune, NPG; for insightful and inspirational guidance, I thank Tamar Garb at the University College, London. I am also indebted to several women in Cambridge, England, for sharing with me ideas on their work in feminist studies during my visit there in 1994. I am particularly grateful to Hilary Rose, who reminded me of J. B. Priestley's counsel to authors: "Writing necessarily requires that you put your bum on your seat."

I am indebted as well to the persons who took the time to read parts of the manuscript and to offer encouragement and invaluable comments: Paula Kane, Mary Anne Ferguson, and Jean Carr. Members of the Department of History of Art and Architecture, University of Pittsburgh, especially Ray Anne Lockard and Marcia Grodsky in the library, were unfailingly helpful; Linda Hicks, Gail Brobst, and Matthew Roper also deserve thanks. For valuable computing assistance, I thank the University of Pittsburgh Systems Analysts Jeannette Koren and Janie Pegher. For putting up with all my admonitions for "special care" in the photographic processing of my illustrations, I thank Judy Basl at the Photo Depot, Leetsdale, Pennsylvania.

Gretchen van Slyke, University of Vermont, my cyberspace companion par excellence, has my personal appreciation for her careful reading of several versions of the manuscript, her editorial suggestions, and her constant support during the final stages of writing the book. *Je te remercie pour tous tes nombreux encouragements.* More recently, I have reason to thank Sally Redhead, Anne Bayne, and Glenys Nixon for their transatlantic messages of support. I also thank Elizabeth Thomas for stepping in at the time of my husband's terminal illness and giving me precious editing time. For helping me beyond the call of duty, I am deeply grateful. Katherine Wilkins deserves thanks for careful proofreading. All of these people provided important information, assistance, and encouragement at crucial times. My gratitude goes also to John Weingartner of Northeastern University Press, who, on the basis of a chapter and an outline, supported my vision that this project could become a book. I also thank my sons Lars and Nils for their interest, and above all for not ever asking me when my book would be finished.

More than anyone else, I thank my late husband Jack Dwyer. For an unashamedly blissful companionship, I give him my eternal love.

Introduction

This book examines a woman artist in the cross-cultural contexts of her era, late nineteenth-century America and France. Because in her life Anna Elizabeth Klumpke (1856–1942) addressed many of the issues faced by educated women of the time, her biography can serve as a case study in fin-de-siècle culture.

My approach is at once traditional and novel. First of all, in writing the story of a woman's intellectual and artistic aspirations I have looked beyond the conventional biographical approach by including thematic chapters that address women's patronage and female relationships. Furthermore, in keeping with my intent to write the story of a professional woman's personal choices, I have tried to understand the relationship of Klumpke with her companion, the artist Rosa Bonheur, as a meaningful and romantic partnership between two creative women.

The book brings together a wide spectrum of methodologies. As an art historian I bring my own priorities to the construction of the narrative. I emphasize the art and the analysis of paintings. I also consider the conditions surrounding the training of an artist and seek out relationships of artistic production and prevailing systems of patronage.

As a feminist historian I use gender as a category for historical analysis. I ask a set of critical questions about a woman's professional and intellectual aspirations and the role of art as a means of their expression. Adopting multiple perspectives, I try to make women visible as active participants in fin-de-siècle society.

Moreover, as an explorer in the history of homosexuality, I use national differences as an agenda of inquiry to consider Klumpke's relationship with Bonheur. In particular I question some late nineteenth-century attitudes toward same-sex love and "homosexuality" in America and in France.

Uniting the chapters of this book is a sustained dialogue with a set of fundamental themes: women and careers and women and choices. In the telling confrontation of these concepts lies a story that is vital to understanding the place of a woman artist against the background of her time.

The book is divided into three parts and concludes with a retrospective. In Part One, Family Matters, I draw mainly upon secondary sources, addressing the circumstances that shaped Klumpke's formative years as a member of a remarkable, career-oriented family. In Part Two, Art Matters, I examine primary documents and visual material (i.e., exhibition catalogues, newspaper reviews, and paintings) to place Klumpke within the context of her contemporaries in Paris and Boston. I discuss the conservative and academic style that she adopted as a painter. Acknowledging that most artistic innovations have been brought about by men, I argue that Klumpke could not afford, either financially or artistically, the luxury of dismissing traditional standards.

Regrettably, there are several absences here. Because Klumpke was first and foremost a portraitist, and portraits, in contrast to other genres, are often hung in private homes, it has proved difficult to trace many of her works. As a result of these lacunae, I cannot discuss Klumpke's stylistic development to my satisfaction. Instead, I concentrate on the idea of a portrait as a record of a commission. The focus is upon female patronage, a rapidly growing but still underdeveloped area within art history. In addition to artistic support by women through direct financial patronage, I also explore the question of promotional endorsement. My aim is to document the artist's American female patronage during the 1890s, on the one hand, and to understand the subtle interplay during World War I between patronage and philanthropy, on the other.

Also, there is a semantic problem: the lack of symmetry between notions of patronage and matronage. "Patronage" traditionally denotes the support or influence an artist or institution receives from a benefactor or master—patron. "Matronage" refers to the domestic responsibilities of a mother who presides over children, or a matron who maintains order in a public institution by virtue of her dignified maturity of age or social distinction.[1] Because the English language does not provide an easy way to

name women who encourage, support, assist, and influence art and artists, I continue, despite reservations, to use the traditional words "patron" and "patronage." Note, however, that their meaning arises out of a patriarchal system and does not reflect the female side of the terms.

In Part Three, Matters of Choice, I have adopted two strands of inquiry: the biographical and the thematic. The first of the two chapters uses the dialogue in Klumpke's text *Rosa Bonheur, sa vie, son oeuvre* (1908) as an interpretive guide. My intention is to offer evidence—where it is sorely needed—of a "union" between two women. (Because of the narrative structure of Chapter 7, "The Portrait as an Encounter," I have inserted page references from Klumpke's book in my text rather than citing them in endnotes.)

These remarks would be incomplete without some clarification about the biographical text per se.[2] In assuming the task of interpreting Bonheur's life, Klumpke accepted her role as eventual narrator of her companion's life story. Bonheur, however, died before she had a chance to give Klumpke a full account of her experiences, leaving Klumpke to bear the ultimate authority for the narrative. As a result, the text breaks down distinctions between biography and autobiography, in that both Bonheur and Klumpke tell their own stories. That work is divided into three parts: Klumpke's account of how she came to know and love Bonheur; Bonheur's story of her life, as compiled by Klumpke; and Klumpke's narration of Bonheur's final days and death. The tone is consciously reverential, privileging the subject of *la grande artiste*. Yet, there are passages in which Klumpke takes up the autobiographical "I," allowing her to move from silence to self-narrative: a "self" that is tangential to the central drama of the story to be sure, yet also an "I" that remains autonomous and self-identified. Although Bonheur's "voice" remains dominant, the narrative should also be viewed as one in which the relationship of biographer to subject is both symbiotic and separate.

The second chapter in Matters of Choice addresses the topic of female friendship. Exploratory in nature, first it reviews briefly, and cross-culturally, some late nineteenth-century attitudes about relationships between women. Then it attempts to reconstruct the circumstances of a specific event and the choice of one woman to live with another woman.

An explanation needs to be added here. Because this chapter addresses questions that are pertinent to our culture today, I am writing in the first person plural; the idea is not to convince or expect the reader to

accept my interpretation, but merely to try to give my study a present-day perspective.

Finally, a few comments on the archival documents at the Château de Rosa Bonheur, By/Thomery, France, need to be added. In 1934, Klumpke decided to return to her native country, leaving her home to a French niece. Though it may seem that she left a treasure trove for posterity to discover, the appearance of so much fresh material is a mixed blessing for the historian. There are plenty of "holes" to contend with, forcing one to guess at the criteria by which the American artist decided what material to save. More to the point, the self-conscious and unconscious motivations in the selection process must be considered in order to learn to read the obscured patterns. This analysis should arguably begin with objects related to art and art making, such as portfolios of drawings, notes from her days as a student at the Académie Julian, glass plates of her photographic work (which she used as an aide-mémoire), shelves of sketches, and finished Salon paintings. Klumpke's reason for storing these objects may be quite obvious. Like many an artist, she had become personally attached to these mementos of her life and was unwilling to part with them.

Assessing the textual material is more complicated. In general, the documents make up the material for a scrapbook, giving useful information about professional events through newspaper reviews, photographs and brochures of exhibitions, and lists of awards. The collection of letters, however, is unusual in that received messages are rare. Most of the correspondence consists of copies of Klumpke's own letters; they are bound into six volumes, spanning the years from 1906 to 1933. The pages are copied using the old-fashioned and time-consuming hand-press and wet-ink process. The majority of the letters document her continued activities in matters of art, her dealings with artistic affiliations in Paris, the United States, and England, and especially her continued relationship with her American patrons, recording her appeals for funds in connection with her wartime relief work.

Were these six volumes of letters bound and indexed with an eye to posterity? Were Klumpke's personal records consciously designed to enhance the impression later generations would have of her? Were they meant as a vehicle for self-promotion and self-justification? Unanswered questions abound. Yet, after carefully reading and studying the "remains

in the attic," I have concluded that at the end of a long career Klumpke was trying to shape her own story and legend.

First, and quite simply, like all artists Klumpke wanted the material—paintings, photographs, reviews—to serve as a future record of a person's artistic journey. This, I think, is a convincing motive on a pragmatic level. Certainly few artists, men or women, could boast of a fifty-year record as a Salon exhibitor. But her role as a painter was more than the sum of her professional accomplishments. What is needed is to seek to understand the meaning of her artistic enterprise in a subjective way. With all artists, past and present, Klumpke shared a quest for self-definition and emancipation. Indeed, the very word "artist" connotes personal independence won—perhaps at a high cost, but nevertheless won—against all the repressive forces of society.[3] For having achieved this goal of autonomy, I believe, Klumpke sought recognition and ultimately also remembrance.

As an interpreter of her unspoken aspiration, I recognize the subjective nature of biography. I am aware of the problems involved with reconstructing and giving meaning to another woman's life.[4] Like every historian, I have had to make hard decisions about selecting and including events and analyzing motives and causes. In the course of "uncovering" Klumpke's life, I have tried to understand how she *both* overcame social constraints *and* reinforced the dominance of male authority in the art world. To use such an approach signals an understanding that an individual does not exist as a predetermined, fixed, or secure identity, but as an identity that is in flux, changing continuously as a result of the dynamic interaction between self and society. In writing this book, I seek to illuminate the undetermined circumstances and opportunities presented to Klumpke at given times in her life. I intend to show how her professional and private journey reflects the full range of the complexities of fin-de-siècle culture. Klumpke addressed what were the most controversial issues of the age for women. Many of these have not become any less pressing with the passing of time.

Part One

Family Matters

Chapter One

The San Francisco Background

Compared with her four attractive younger sisters, Anna Elizabeth Klumpke was short and small. Handicapped from early childhood, she had a slight but apparently not ungraceful lameness that compelled her to use a cane. Her wavy chestnut hair was neatly tied up in a knot. Later in life she would crop it, allowing her hair to frame her face freely. Behind the appearance, however, was a woman who knew her mind. Her broad features—a high forehead, a pointed chin, full lips, and a prominent nose—gave her an air of strength (Frontispiece). A mien that exuded determination and willpower gave further evidence of a strong personality.

Exhibiting an early maturity in family matters, Anna became the natural mediator for her divorced mother and her sisters in moments of crisis. For example, on March 4, 1881, after a long and painful silence of ten years, she took it upon herself to write to her estranged father.[1] Her fifteen-page letter in German presented two requests: that he acknowledge his daughters' outstanding educational accomplishments, and that he provide the girls' mother with funds so that they could continue studying in Paris to become self-sufficient career women. Speaking for her sisters and their goals, Anna declared, "Here is the place to learn, there in America to earn gold."

Explaining their situation, Anna pointed out: "Mother's decision to move here has proven extremely beneficial to all of us. But there will be a time soon when we will be out of money. Help us, dear father, so that when we return to San Francisco in a couple of years, you can be proud of

3

us, and you can say also 'I have contributed so that my children can earn their bread.'"

These words draw attention to one of the most salient issues in the last decades of the nineteenth century. This is more than a plea to a father. It is a letter about women and about their right to education. The successive achievements of her gifted sisters serve in part as a benchmark by which to measure Klumpke's own professional ambitions.

As a matter of chronology, let me move from fin-de-siècle, cosmopolitan Paris, with its educational opportunities for women, to the place of Klumpke's birth on October 28, 1856: the frontier settlement of San Francisco. The oldest daughter among seven children, Anna was born to pioneering stock. Her father, John Gerald Klumpke (1825–1916), was a Roman Catholic from Ankum, near Hanover. A cobbler by training, after emigrating to the United States he decided to "go west" to provide boots for the miners of the California gold rush.[2] He took out American citizenship in 1853, while still engaged as a boot- and shoemaker; he later turned to the more lucrative real estate business in San Francisco. His success in business would later earn him a place in the book of Territorial Pioneers of California.

Anna's mother, Dorothea Mathilda Tolle (1835/36–1922), a Protestant, was born in either Göttingen, Germany, or Hoboken, New Jersey, where her father was a baker. She had been drawn westward while in her midteens by a little bag of gold dust that her married sister Augusta had sent her. Leaving her parents (she would never see her mother again), she set sail on the long and dangerous journey to California. Having crossed the Isthmus of Panama by mule, she arrived at her destination early in 1850 by sea. In San Francisco, then an embryonic city flanked by Telegraph and Russian Hills, she was met by her sister and her brother-in-law Adolphus Platt (Plate), a German immigrant gunsmith. A handsome woman with jet-black hair, large, dark brown eyes, and a waist reportedly so small that two hands could encircle it, Dorothea was twenty years old when she married John Gerald Klumpke in 1855.[3] Though their religious denominations differed, their shared German background, language, and customs were invaluable commonalities in the rough, polyglot frontier settlement of the mid-1850s.[4] In the coming years, while Anna's father occupied himself with his expanding business her mother busied herself with the family and domestic affairs.

The first major disruption in Anna's life was the accident that was to leave her lame. When she was about two years old, she fell from a chair and dislocated her right knee. "As the surgical skills in San Francisco at that time left much to be desired," Klumpke remarks, she was "from then on obliged to use a crutch."[5]

Anna was too young to recall the event. She does remember, however, that it was about then that her mother bought her a doll, explaining that its name, Rosa Bonheur, meant a "happy hour" and also "Rosa Happiness."[6] The doll, as well as prints of her acclaimed 1853 painting *The Horse Fair*, had made Bonheur's name a household word, and San Francisco was not behind the times in its enthusiasm for the famous French animal painter.[7] While critics throughout the United States were joining in the artist's extraordinary reception, claiming that "[b]y birth, Rosa Bonheur [belongs] to France; by genius, to the world," for the young Anna the doll, dressed after the fashion seen in an 1857 portrait of the artist by Edouard-Louis Dubufe, was a nursery treasure brought alive by stories from her mother about a great and unusual woman.[8]

In the fall of 1865, when Anna was nine years old, she was taken abroad for orthopedic treatment. Traveling with her mother were Anna's sisters, Augusta (aged six), Dorothea (four), and Mathilda (two). Since the transcontinental railroad had not yet been completed, they probably sailed from San Francisco to the Isthmus of Panama, crossed to the Atlantic side, and sailed on to New York, from where they departed for Europe.

On the recommendation of the family physician, Dr. Scharlach, Anna's mother continued on to Berlin to consult Dr. Langenbeck. She found accommodations for her three younger children, and then took Anna to the renowned specialist. During the following months the child "remained in an orthopedic establishment where the muscles of her lame limb were treated by the extension method."[9] Anna's condition did not improve, and Dr. Langenbeck finally advised her mother to seek advice from specialists in Switzerland. Again, there was no cure, and Anna's mother had to resign herself to the fact that not even the best physicians in Europe could help her firstborn daughter to walk and live without a crutch.

Anna was eleven years old when she and her family returned to San Francisco. They had been away almost two years. Her father, now well-off from his real estate dealings, bought a "choice piece of land in the warm belt of San Francisco" on Valencia Street and built a large house set among fruit trees and flowering shrubs. Anna and her sisters entered a

nearby school and began to learn to speak English. (Even so, German remained their primary language well into adulthood.)

In addition to the excellent teaching at the Valencia School (in the early 1900s renamed the Horace Mann School), there was Mrs. Ada Clark's institute on Market Street. It was a dancing school, or, as Dorothea wrote, "a school where we were taught good manners in how to behave when in company."[10] Anna probably did not attend the dancing lessons, described by her sister as special events "with sounds of castagnettes and melodies from the violin master Mr. Gavotti." Staying at home, she tended to occupy herself by drawing, a favorite pastime, while her mother embroidered, knitted, or stitched a carpet.[11] Dorothea worked creatively with the needle and had an excellent eye for color. Anna and her sisters would later proudly mention the prize their mother had won at an exhibition for her carpet with the design of a lion. Time for these pursuits remained limited, however, especially after the birth in 1869 of Anna's twin brothers, John Wilhelm and John Gerald (the latter did not survive). Julia, known as Lulu, was born two years later on August 12, 1871.

The second significant disruption in Anna's life occurred with the separation of her parents shortly after the birth of Julia. The exact circumstances remain unknown, though religious differences were said to have been involved. Klumpke explains that the difficulty of reconciling "various religious beliefs" was exacerbated by her father's Roman Catholic stepsister, who had been living with the Klumpkes since their return from Europe and "who insisted on imposing her religious belief upon the children."[12]

In the late 1860s, as the situation became increasingly intolerable, Anna's mother decided to seek legal advice. On April 15, 1872, Judge R. F. Morrison heard Dorothea Klumpke's case at the court of the Fourth Judicial District in the City and County of San Francisco. She was granted a divorce; the entire care, custody, and control of the children; and one-half of her husband's possessions.

The breakup was a wrenching experience for all members of the Klumpke family. For Dorothea, it was also a lesson that was to guide the rest of her parenting life. With typical determination, she decided to return with the children to her native roots in Germany. She knew of family members in Göttingen whom she could consult for places to live and schools for the children to attend. Foremost in her mind was providing each with "something solid and reliable of which no misfortune could rob

them."[13] With her six children, she again sailed for Europe, relying upon a helping hand from her oldest daughter. Anna was then in her midteens.

The relationship that had developed between mother and oldest daughter deserves exploring. Although theories in "mothering psychoanalysis" do not pretend to explain the dynamic nature of an individual or of a person's relational autonomy, they nonetheless offer a framework around which to structure ideas about mother-daughter relationships.[14] It is useful to take the childhood injury as being central in Anna's life. Clearly, the experience prolonged her dependence upon her mother, thereby complicating the expected development of individuation. Yet, having had the good fortune of "optimal mothering" in the symbiotic phase of her infancy, she had internalized an image of her primary parent that was constant and ongoing.[15] How long the close attachment to her mother remained the basis of Anna's sense of self, and exactly when her sense of separateness allowed her to "let go," cannot be determined. What can be suggested, however, is that the injury prolonged the relationship with her mother in a positive way, strengthening the bond, until she gradually grew to be able to take care of herself. From this perspective, it is possible to understand not only her role as her mother's foremost companion as they left America for Germany but, more important, her later position as a responsible coguardian of her younger siblings as she composed her letter to her father in 1881.

It is to this letter that I now return. Writing from Paris in her parental German, she ventured to surmise: "It is now ten years since we have heard from one another . . . [;] you will surely in your lonely hours have wondered what your children are up to and will no doubt have asked yourself whether your daughters have spent their time wisely and learnt a useful trade. That is why, dear Father, I shall try to give you a detailed description of our experiences."

Anna told him about the first three years in a German boarding school in Kannstadt, where she and Augusta received instruction in the classics, religious studies, French, and Latin. With a curriculum firmly rooted in German literature, Anna studied the great poets Schiller and Goethe. In addition to piano lessons, she mentioned classes in drawing and design, though, she explained, she wished she had been able to work more seriously at developing her artistic skills. When she had completed her studies, Anna wrote, she and Augusta went to Switzerland to join their mother, who had settled in a small village where the cost of living was

more affordable. With Augusta continuing her education in a French school in Lausanne, Anna "stayed at home with mother and the 'little ones' [Wilhelm and Julia], living in the most frugal and modest manner."

Reminding her father about her accident, she said, "[Y]ou do remember that I had to use crutches in San Francisco." She went on to say: "At this time Mama consulted a famous orthopedic surgeon in Lausanne, sparing no expense in procuring a 'brace' which enabled me to walk without crutches. In the beginning, it was very difficult . . . , but it was after all to my advantage to persevere. How happy I felt as I was able to walk without crutches." Describing the new freedom and mobility she had gained, she wrote, "Now it is so much easier, as I have got rid of the brace and only need a cane."[16]

Perhaps as a result of this positive change in her life, Anna decided to do what many artists do: go to Italy and learn to paint. "How gladly," she confessed to her father,

> I would have stayed there a few years but I felt and knew that Mama had to divide her income into five parts: four for us older ones, and one part for herself and the little ones. As we grew older from year to year, the family expenses also increased. Knowing that Mama deprived herself of the essentials so that she could send me the money for my expenses in Italy, I decided to return to Lausanne.

The short visit to Italy had, however, given Anna fresh perspectives. With new-won confidence in her artistic skills, the nineteen-year-old mustered up the courage to market her works, painting flowers (Alp roses and the like) for a demanding clientele of visiting tourists. "What I earned with my painting amounted to 100–150 francs [ca. 20–30 dollars]; it was little and yet it was enough to cover the cost for a few painting lessons."

She explained that the family had moved to Paris four and a half years ago in order for Augusta to pursue her medical studies and also because the city was well known for its varied and excellent educational opportunities. Of her own experiences, she recalled: "I myself visited the museums to copy paintings, wishing dearly to take painting lessons though aware that the necessary funds were not available. You cannot imagine how happy I felt when Aunt Augusta [Tolle] was kind enough to buy one of my pictures enabling me, with some additional money from Mama, to

attend classes at an art academy."[17] For reasons that remain unknown, she did not tell her father that it was her copy of Bonheur's painting *Ploughing at Nivernais* (1849) that had enabled her to begin to study art.

Having provided John Gerald Klumpke with a detailed account of his daughters' accomplishments, Anna now turned to the financial problem that had prompted her to write in the first place. Emphasizing that they had all learned to live frugally in order to make ends meet, she told her father that "everything went wrong" when her mother discovered that her agent in San Francisco had mismanaged his trust, leaving his former wife with a monthly income of sixty-four dollars.[18] "With barely enough to cover the cost of food, how is a mother with six children to live [on this allowance]?" Though her mother had begun to rent out rooms, the income from this "Home for young ladies" was hardly sufficient to cover her numerous expenses. Finally, she explained, "As mother has always been very reticent as to the cause of her alienation, your children have grown up with only the proper feelings towards their father, to whom we feel we have a right to look for some help in life's struggle and some protection against its adverse winds." Pleading for love and recognition, she concluded her letter with the firm note "Tue es" (Do it).

Though these words from a nineteenth-century daughter to her father may seem somewhat forceful, they came from a woman who was confident in speaking for her family. Like her own parents, she had learned to face obstacles and was determined to overcome difficult situations; she, too, was a pioneer about to define a new situation for herself. Though the precise nature of the subsequent financial arrangements between her parents remains uncertain, Anna's intervention proved successful. The Klumpke sisters' bold journey toward new horizons is the subject of Chapter 2.

Chapter Two

Sisters Mounting the Ladder of Science and Art

Apart from the mother-daughter relationship, sisterhood is the primary bonding metaphor among women, Edith Gelles observes in her thoughtful analysis of the world of Abigail Adams.[1] In discussing it as a blood relation, in contrast to the modern concept of sisterhood among women friends, she explains its function as a mode of important mutual assistance. As Gelles argues, the concept implies a condition of equality and reciprocity in spirit, where the intimacy of the bond affords experiences that few other relationships permit. This circumscribed world of women's values fosters the growth of equality, trust, caring, and identity. These qualities, she is quick to add, remain ideals, perhaps masking a meaner reality, but they also establish goals that conform to the best utopian visions.

For Anna, Augusta, Dorothea, Mathilda, and Julia, too, sisterhood functioned as a mode of important mutual assistance; they shared strong emotional and intellectual ties. Bonded around a supportive and ambitious mother, they were united in a quest that was both enterprising and optimistic. As Anna later recalled, they were "sisters mounting the ladder of science."[2]

To convey an understanding of what it was like to break conventions and conceptions that were embedded in age-old notions about women and their personal and professional choices, I tell the story of Anna's artistic emergence in the context of her unique family. As miniature biographies intimately connected with that of the central figure, the stories of her sisters provide evidence of the standards set by these Klumpke

women. They also record, on a small scale to be sure, the process of change involving women, culture, and educational rights.

Appropriately, the narrative begins with Augusta, whose education had been the primary reason for the move from Switzerland to Paris.[3] An account of the aspiring physician's first meeting with the dean of the medical faculty at the Sorbonne, Alfred Vulpian, provides a sobering picture of the sexual barriers that confronted women trying to enter medicine at the time. He was seated under a large picture of Hippocrates, Augusta recalls, addressing her and her mother in an affable and courteous manner. Yet, as she correctly sensed, behind this polished welcome there was a fierce opponent. Objecting to women in medicine, Vulpian explained, "I firmly believe that a woman's role is to create a home, to sacrifice herself to her husband and children, and if she is left alone, to devote her life to her children."[4] Then, pointing to the difficulties that might arise when women were placed in the same lecture halls as men, he asked her if she fully understood the atmosphere in which she would have to work. He explained that the male medical students were fiercely jealous of their privileges and that she would be studying with young men who were difficult to control, ardent, and at times turbulent and violent.[5] Vulpian proposed alternative careers in pharmacy or biology. Augusta remained firm in the face of his resistance and stated that her specific aim was to enter medical school. Given Augusta's persistence, Vulpian relented and decided to admit her and another woman, Blanche Edwards, a French national whose father was an English physician living in France.[6] Relieved and no doubt excited, Augusta began her pre-medical studies at the Sorbonne. Included in her weekly schedule were the clinical lectures on Sunday at the Salpêtrière hospital by the world-renowned neurologist Jean-Martin Charcot. Attending these events was almost obligatory for medical students, but others were also welcome, and Anna often accompanied her younger sister.

Under the circumstances, it was not easy for Augusta to prove that "science has no sex." As the dean had anticipated there were hurdles to surmount, the atmosphere at the daily anatomy and dissection classes being especially hostile. Vulpian had ordered her never to enter the amphitheater alone, always to be there well before class, and to enter the room following closely behind her professor. In the beginning, Augusta recalls, she put up with the students' shouts and invective, but then one day she decided to get out of "the bear's den." Entering the amphitheater without

professorial escort, she found a place and began her work. Her courage paid off. Showing the other students that she did not need protection, that she was determined to remain in the classroom despite their protests, she made her point clearly and resolutely. From that day on silence was restored, and the men tolerated her presence without any more "profane noises." By 1882 Augusta had completed her premed studies, receiving the highest ranking from her professors: *extrêmement satisfait*. A double celebration was called for in 1882, since Augusta's success coincided with Anna's debut at the Salon after merely one year's formal training, an achievement whose importance cannot be exaggerated.

To Augusta, it soon became clear that the difficulties she faced during her first years at the medical school meant little next to the opposition she met as she began to compete for the internship positions that marked the summit of French clinical education. A formal request from her and Edwards, citing the regulation that externs could apply after two years of limited hospital service, was summarily denied in 1884.[7] This soon led to a battle royal that riveted the attention of the medical and political circles of Paris. One hostile reporter, addressing Augusta in particular, proclaimed, "If they want to abuse [our hospitality] they can go to America, the country of eccentrics and humbug, which they would never have to leave."[8] Fortunately, however, supportive male voices were heard as well, including that of the physiologist Paul Bert. Holding that it was now too late to raise the old objections about women's abilities, Bert said that they were already studying medicine and that "many of the arguments had been proved wanting. Professional liberty carries with it the freedom to be educated, and it is this . . . that the women students are asking for."[9] Bert's intervention was crucial. On February 2, 1885, the city council of Paris mandated that women be allowed to compete for internships at the city's hospitals. Augusta had won a medical and political victory.

The paths of success crossed again that year in the Klumpke family. A few months after Augusta's great coup, Anna was awarded honorable mention at the Salon for a portrait of Augusta (unlocated), which she had been working on during 1884. How this historic moment was celebrated with champagne at the Académie Julian belongs to Anna's story.

Resistance from the medical community continued, however, making it extremely difficult for Augusta to satisfy the demands of her opponents. One examination had to be cancelled because some faculty members refused to read her paper. When she was finally allowed to take it, she re-

ceived twenty-nine out of thirty marks. The jury then stipulated that she must pass the oral examination with a score as high as that on her written test, "or else she would flunk." But as her daughter Yvonne, who also entered the field of neurology, later noted, her mother was not a woman who would be discouraged. Passing the rigorous written and oral examinations with distinction, Augusta became the first woman to win the coveted appointment as intern.[10] By 1887 Augusta had won not only the grudging respect of her male colleagues but also the admiration of Vulpian himself for her medical aptitude and outstanding performance.

However, there were lingering doubts in the public mind about how to contend with these forays by women into what had been male domains.[11] An article about Augusta by a young contemporary correspondent is revealing. He described the new intern as blonde and blue-eyed, with an intelligent look, a pale complexion, and a striking countenance. "Her dress," he added, "appeared to be severely simple in every way, a gray skirt, a white apron, and a high-necked jacket of gray material." He concluded by noting that "[h]er walk was a bit mannish, but, her voice was soft. In her hair a small ribbon was worn like a tiny jewel."[12] In the end, it was this perception of her femininity—a soft voice, a tiny jewel—that seemed to allay the reporter's ambivalence about Augusta's transgressions. Yet, how did she see herself?

An interview in 1887 with a reporter from *Le Figaro* provides a different picture of Augusta. Asked for her reaction to life in the hospital, she replied: "Don't speak of me; I only demand one thing, to be forgotten now. I am situated here and you see me in the middle of my work. I am striving to gain experience. These studies please me. Medicine captivates me. I wish to devote myself entirely to it. Much has been said as to how hard I have studied. I hope I will be considered worthy of credit in years to come and my name be forgotten."[13] Unassuming as these remarks may sound, Augusta could also promote herself. In a letter to her father, stating the hope that he would help her with the expenses incurred in setting up a practice in Paris, she points out: "No doubt you have heard that as a faithful student and successful practitioner I have already done great honor to my parents as well as to myself. I am what they call here 'a distinguished personality'. I have a brilliant medical and scientific career before me. As interne of the hospitals and Laureate of the Academy of Paris, I have obtained the highest honors a lady physician ever received in Europe, or will receive for some time."[14] Although not a feminist in the political sense, Dr.

Klumpke was distinctly aware of her unique contributions to women's educational prospects and deservedly proud of them.

Augusta left her mark in medicine. She published her research on injuries to the brachial plexus in a paper that attracted the attention of the medical field and gave rise to the term "Klumpke paralysis," still in use today.[15] In 1888 she married Jules Dejerine, a neurologist also trained under Vulpian. Subsequently, she concentrated upon laboratory work.[16] Augusta and her husband collaborated on a classic study of the anatomy of the central nervous system, working in the laboratories at the Bicêtre and (later) Salpêtrière hospitals. Striving always for collegial relations with male physicians, she earned the respect of the faculty and students. Although she still met resistance and opposition on occasion, Augusta had helped "to change minds," to alter public opinion about women in medicine.[17]

Dorothea (1861–1942), five years Anna's junior, followed closely in Augusta's footsteps in pursuit of a professional career. Drawn to the "science of the stars" since childhood, she would watch the sky at night with a small telescope, a gift she had received from "some German professor" in San Francisco.[18] Having graduated from the lycée in Paris (and not satisfied with the idea of a teaching career, which would have been the natural course to follow), she decided to go to the Sorbonne to register for a degree in the department of mathematics. Her request was viewed with skepticism. No woman had ever entered the department before, and her professors doubted the seriousness of her resolve. Undeterred by such a setback—and, like Augusta, impervious to conventional expectations—Dorothea persevered and was finally granted permission to register. Again like Augusta, she worked diligently and fulfilled her course requirements to graduate from the Sorbonne in 1886 as the first woman with a bachelor of science degree in mathematics. Refusing to conform to dominant patriarchal assumptions, Dorothea too had shown that women were capable fellow students in a field traditionally reserved to men.

Without role models, Dorothea did not initially know how a degree in mathematics would enable her to pursue an independent career. Indeed, she is the first to admit that she did not start out with any thoughts of becoming an astronomer. Content to begin work as an assistant gathering data and providing photographic star charts, she joined the staff at the Paris Observatory.[19] In 1887 she used her talents as a linguist to translate papers presented at an international conference at the observatory that

examined the role of photography. As a result of this congress the idea was born to create a photographic atlas of the stars, the *Carte de Ciel* program. A special bureau was established, and Klumpke applied to be its director. Her superiors, taken aback by her intrepidity, consulted the observatory statutes. They found that no woman had ever applied for an administrative position, but they had to admit that there was no rule against it. Impressed by the forthright attitude and scholarly qualifications of this young American woman, the directors offered her the position of head of the new bureau. In the following years at the Paris Observatory, she supervised the activities of her assistants by day and worked with telescopes and noted astronomers by night.[20]

Once again, Anna captured one of her sisters on canvas, aiming to put her in the public eye. Exhibited at the 1890 Salon, the large portrait (47$^{1}/_{2}$ × 33$^{1}/_{2}$") depicts Dorothea seated in a chair close to the spectator (Private Collection). Her large eyes, full eyebrows, straight nose, and rounded lips reveal an attractive young woman. Her hands rest on a closed book in her lap, the corners of which seem worn by handling. The only other accessory in the portrait is a large globe, placed close to her right hand as it clasps the book. Sketchy brushstrokes suggest rather than define what are probably stellar constellations. Dorothea's head is turned toward the viewer with a fixed gaze. It demands attention and, as Anna no doubt also intended, celebration.

Three years later, on December 14, 1893, Dorothea was again at the Sorbonne, this time standing before a gathering of professors and several hundred spectators. The treatise she had defended on Saturn's rings had won her a doctorate in mathematics that day. "Your thesis," one of the examining professors said during the award ceremony, "is the first which a woman has presented and successfully defended with our faculty. You worthily open the way [to other women of your generation]."[21] The *New York Times* carried a front-page article headlined "An American Woman's Triumph." But perhaps Dorothea's most spectacular accomplishment involved a balloon ride in November 1899. The idea was to carry an astronomer above the autumn fog to observe one of the last great sky shows of the nineteenth century, the Leonid meteor shower.[22] The seven-hour flight was a scientific disappointment, but it was a great milestone for women in science, since the astronomer aboard the balloon was Dorothea Klumpke. At thirty-eight, she had become the first woman to make astronomical observations above Earth's surface.[23]

While Augusta and Dorothea were mounting the ladder of science, Anna's two youngest sisters, Mathilda (1863–1894) and Julia (1871–1961), found an outlet for their creativity in the realm of music. A gifted pianist, Mathilda attended the Paris Conservatoire, where she studied with the most eminent professors of the time. Theodore Stanton, the son of the noted feminist Elizabeth Cady Stanton and a personal friend of Anna's, provides a telling picture of what it must have been like to study there. Impressed by the standards of "this school of high virtuosity," he observed that "[t]o keep one's place is almost as difficult as to get admitted to the school, for it is absolutely necessary, under penalty of expulsion, to pass the periodic examinations. . . . The professors, of course, look with most favor on pupils endowed with a talent for execution and capable of shining at these [public competitions]."[24] Mathilda seems to have been one of them; she excelled, "winning a second prize in a competition with students from all over the world."[25] Just how Anna commemorated her musical sister in the 1886 Salon portrait cannot be known, since the work no longer exists.

Anna's youngest sister, Julia (commonly called Lulu), also turned to music, making a career as a violinist and a composer.[26] Accompanying Anna in the early 1890s to Boston, she studied at the New England Conservatory, which, according to Richard Dana, a board member, was more thorough "than many of the best conservatories on the other side" of the Atlantic.[27] Gifted and ambitious, she gained her diploma in 1895 and continued her training with Eugène Ysaÿe in Brussels and Nadia Boulanger in Fontainebleau, France.[28] Julia later settled in the United States, where she was offered a tenured position as professor of music and theory at Converse College in Spartanburg, South Carolina, a women's school noted for its excellent music department.[29]

Julia's gifts stood at the heart of the Klumpke family life. Her daily practicing became an important part of their evenings together in Paris, and later wherever Klumpkes happened to gather. Like her sisters Augusta, Mathilda, and Dorothea, Julia would be commemorated on canvas. The full-size vertical portrait shows her dressed in a long white gown, her violin resting on the floor (Private Collection). Perhaps the most attractive of the Klumpke sisters, Julia stands tall and slim, her reddish hair framing a round face. Her eyes are bright and lively. Her pose is confident and her gaze at the viewer is direct. With no distracting details, the overall composition is imposing in its simplicity.

Although this story highlights the Klumpke sisters, mention must nonetheless be made of their only brother, Wilhelm (1869–1917). He was, to use his own words, "always more for a trade than for books." Writing to his father in his late teens, he explained that his mother "had me educated in the mechanical trade I aimed for and had my education pursued as far as I desired to go."[30] Expressing a wish to return to his native country, he added, "In America I would certainly have more advantages in my trade than here in Paris and I am sure that your good advice and your influence will help me along." He later moved back to Paris and turned his interest in cars to profit. With a postcard advertising his automobile for hire, Wilhelm set the precedent for the rent-a-car business that would boom in years to come. Mothered by his sister Anna, he remained a devoted son and adored brother.

Anna's experiences as an artist both illuminate the Klumpkes' story and reveal it in more detail. To prove that art, woman, and career could be compatible ideas, she enrolled in what was then the most progressive and popular institution in Paris, the Académie Julian.[31] Its purpose was proclaimed in its brochure: to prepare the artists for the Ecole des Beaux-Arts (EBA), exhibition at the Salon, or both.[32] As the former remained closed to women until 1896, their instruction at the Académie was bound to feel the impact. The inequities besetting female artists began at the source of the professional institution, the teaching studios. Although instructors visited the men's classes twice a week, they came to the women's studios just once a week, even though fees for them were double the amount charged men.[33] From the start, then, women who enrolled at the Académie Julian were aware of a double standard in art training.

Fundamental was instruction in how to draw the human figure—the alpha and omega of a nineteenth-century art education. Securing the services of such archetypal academic artists as Tony Robert-Fleury, Jules Lefebvre, and William-Adolphe Bouguereau, Rodolphe Julian, known as the *patron*, controlled the establishment. Equally popular among his male and female students, Julian was both loved and respected. Writing to her hometown newspaper in Pittsburgh, Ida Smith reported:

> Monsieur Julian is one of the kindest, gentlest men in the
> world. He criticizes the drawing as if he really wishes to help
> one. His voice is low and sweet and his accent is Provençal and

very musical. His face is friendly as well as handsome and he makes each new student feel a great hope that she may really become what she wishes. It is small wonder if we all feel a real affection for this quiet, white-haired man, who has built up the finest school for women in the world, and who watches every detail of this school with the tenderest care.[34]

The *patron*'s comments to one student, jotted down by Klumpke in her notebook while she was translating for a fellow artist, are revealing of his critical approach. Praising the student for her improvements, he said:

She could make something very good of this . . . [;] tell her to show me a serpentine line that is graceful and elegant. It is necessary that the waistband marry the body. . . . A fine arm, ah, all these little muscles! this movement of the fingers. A painter's delight!! as for the drawing of the skirt, she has lost herself in details—look at all these pleats!!!!—tell her that I abhor this—instead of making pleats in the dress she should show me the pleats in the figure [so] that one feels the movement of the legs . . . that there is a body underneath.

The *massière* (head student in the class) was generally responsible for translating his remarks; in this case, and perhaps in others, it fell upon the bilingual Klumpke to translate for her colleagues and friends.

Two of Klumpke's exercises, a female nude (Fig. 1) and a male study (Fig. 2), are fine examples of her work as a student at the Académie Julian. More of her many handwritten notes attest to her perseverance at "getting it right" or, as the *maître* would have put it, drawing the figure "true to nature." One entry jotted down after a session reads, "Always draw the human body in supple and undulating lines, never in wiry and definite lines," and "copy the figure with . . . firmness, draw both sides at once, not one after the other . . . look for the anatomy [and] accentuate the bones. Dwell on essential lines and proportions . . . note the values of shadow in relation to the background."[35]

Aesthetic aside, there were also other ways of "viewing" the models, as Ida Smith points out:

Everybody is so kind to the models. They always speak politely to them and seem really considerate. At some of the schools it is not so. I always feel sorry for the models, anyhow. I think we ought to honor them, for without them we could learn nothing; and coming from a city [Pittsburgh] without professional models, teaches one to value them. One day the model fainted. Somebody noticed her paleness and called for Leontine [the female concierge]. That capable person came none too soon, for the poor model could not get down from her platform without help. In a minute she was insensible. The secretary hung out of the window of her balcony, as usual,—then came rushing down. The students flew around like a lot of brownies [elves]. A bed was made out of coats and wraps and the model stretched out. These strange French people gave her ether. The effect didn't seem good, for she revived and fainted again three times. But it was good to see how kind everyone was, until a doctor arrived and sent them all out.[36]

In addition to the art instruction at the atelier in the rue de Berri, Julian also gave counsel and criticism twice a week in his studio. Klumpke recalls that he was

a tall man, broadly built, a rather impressive figure. Seating himself comfortably on a small stool with an air of leisure, he would begin [to criticize] while we listened with the attention given to an oracle. Copy naively and truthfully, he would say. Show the masters that my confidence in you is one well-founded. Prepare yourselves to compete favorably with my men students. There is no reason why you should not succeed, as did Louise Meyer, Virgie Lebrun [*sic*], or even Rosa Bonheur.[37]

Although most instructors at the academy stressed draftsmanship as the sine qua non, Bouguereau was the master of them all. A student described the atmosphere in the classroom when he entered:

Everything is confusion. Then suddenly there is a hush. A scout at the door with both hands raised, and popping eyes, comes flying in: "Il

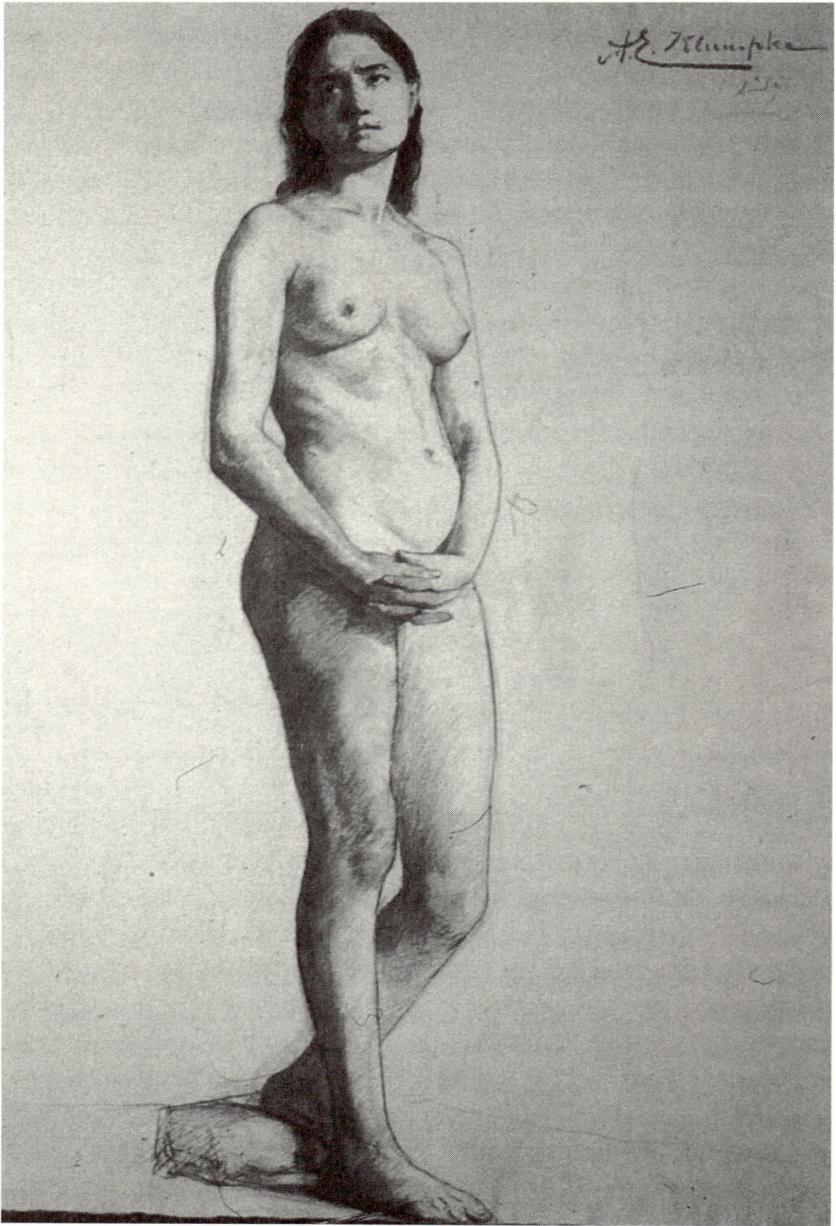

Figure 1. Anna E. Klumpke, Female Nude, *early 1880s, pencil on paper, 24 × 18¹/₂".*
Thomery—Château de By—Musée de l'Atelier de Rosa Bonheur.

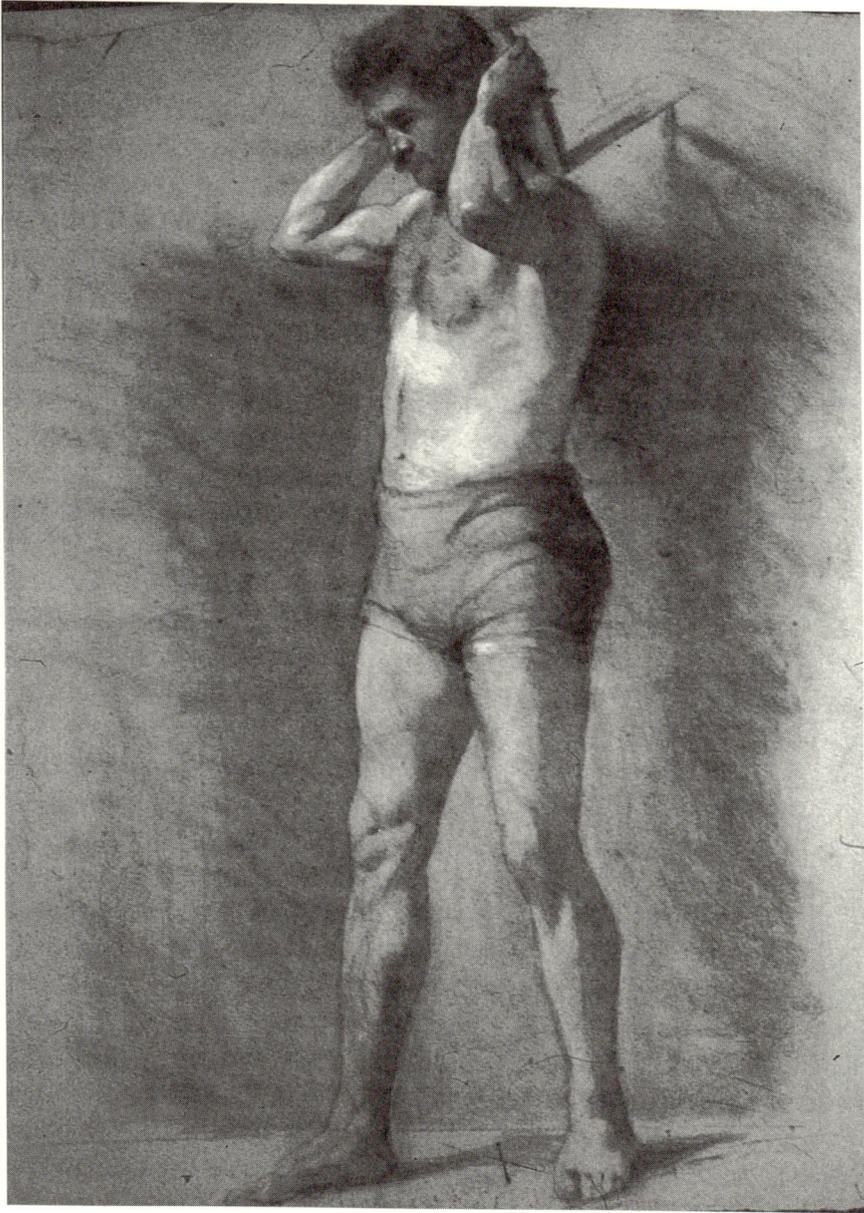

Figure 2. *Anna E. Klumpke*, Male Model, *early 1880s, pencil on paper, 24 × 18¹/₂".*
Thomery—Château de By—Musée de l'Atelier de Rosa Bonheur.

vient!" The model leaps to the platform, the students hurry to their places. A hush falls over everything and the great little man comes in smiling and bowing, escorted by the Massière. . . . Monsieur Bouguereau is very kind, but, oh! how much he knows! As he passes down the ranks, behind him are left withered women. Frequently tears follow his going. But nobody would be bold enough to weep before him. The worst thing he ever does is to say with a shrug, "That is very pretty" and pass on without further criticism. Then that maiden had better go back to [drawing from] casts. But if he shows you a thousand faults and picks your work all to pieces, then you need not care very much; all is well. Some of the students turn pale when he comes and some hide their work; and yet he is never hateful. He never seems to despise anyone. The reason we are so very much afraid, is because he knows how to draw. There is no doubt of that, and when he tells you the drawing is wrong, it is.[38]

To be sure, not all women held the training at the Académie Julian in such high regard. The American painter Cecilia Beaux (1855–1942), joining the women's class several years after Klumpke in 1888, loved Paris but was not impressed by the academy. She thought that most of her instructors' criticisms were only general, and in fact quite subjective. She added, "Until I went . . . to Charles Lazar, no word of theory ever was spoken to me by any of the masters who criticized me at the Julien [*sic*] *cours*."[39] But Beaux gave an important clue to understanding the attraction of Paris in describing her first encounter with her master, Tony Robert-Fleury. She recalled: "As I observed him from behind my easel, I felt that I had touched for the first time the confines of that which made France and Paris a place of pilgrimage. Into the room with him came something, not perhaps a quality of his own, but of what he had come from and lived in."[40] To see one's own works through the master's "un-American burning eyes," to use Beaux's words, was an almost mystical experience shared by most of the pupils. Spoken words of criticism were irrelevant.

In spite of the emphasis upon the *académie* (drawing rather than painting the figure), the masters were quite willing to let the students experiment. A report in *Le Figaro* in 1887, commenting on the schooling at the Académie, captures the general climate of freedom maintained by the in-

structors. "For some time," it noted, "the Julian atelier has taken on a modernist and even impressionist tinge, which worries calm and conservative people."[41] Klumpke, who was recognized by her masters as having a good eye for color, recalls being told that she could do as she liked. Although availing herself of the possibility of using different techniques, she remained essentially faithful to the academic armature, only adding a more spontaneous (albeit controlled) Impressionist style in her later Salon portraits.

Klumpke's compatriot Ellen Day Hale captures the ambivalent artistic mood of the early 1880s, when the Impressionists were still struggling to gain acceptance and recognition in Paris. Studying with Klumpke at the Académie Julian, which she enjoyed very much and thought just the place for her, she describes her visit to an exhibition of Impressionist painters in a letter to her family in New England.

> It has the oddest effect on you as you enter it. Next to no values and a great deal of blue and green being the predominant features at first, purple also is a very favorite color. It all makes you feel rather sick the first minute, but on looking at the pictures separately you find that you like a great many of them. There were some effects of snow and thaw and some skies and seas which were very well worth seeing, indeed especially those by a man named Monet (not Manet, he's different) but most of the brethren drew the figure in the most evil manner you can possibly imagine and painted it disgustingly as if they were little boys and girls. A very striking exception to this bad drawing is Mademoiselle Berthe Morisot's work which is strong and frank though sketchy. . . . Her color is charming, her values delicate but sufficiently forcible and she understands drawing the figure and everything else very well.[42]

Hale's disparaging comments exemplify the tendency of most women (and men) to shun departures from tradition and to adhere to the authoritative prescriptions of the day.

If, indeed, an almost obsessive need to perfect the *académie* is seen as the pinnacle of artistic training, the place of portrait painting in the curriculum becomes at once less profound and more complex. To be sure, whereas a grand narrative with figures remained first and foremost an

aesthetic creation, a portrait represented in the final analysis a finished simulacrum of the real. For this reason the *concours de portrait* was listed last in the curriculum, preceded by competitive examinations in drawing, composition, *esquisse* (the sketch), and painting.

Of the five areas of study, only the portrait competition was open to all students of both sexes. In general, the women distinguished themselves in this area, and one of them took the prize almost every year.[43] That women excelled in the *concours de portrait* is perhaps easy to understand: They were allocated more classes in this subject than their male colleagues, many of whom were preparing for the stiff EBA examinations that stressed composition and multiple-figure subjects. Though inadvertently given an area in which to excel, woman were ultimately held to lower standards of performance. Not only was their creative output circumscribed and determined by their gender but, at a crucial time in their education, they were denied competition with men, against whom they would have to compete throughout their careers.

Just when Klumpke began to focus upon portrait painting is not easy to say. She received her first commissions in 1882, probably as a result of her recognition at the Salon with the oil painting *Une Excentrique* (unlocated).[44] The popularity of the genre was certainly an important factor she would have taken into consideration. Portraits continued to attract the attention of critics, artists, and the public. Providing a fairly dependable entry into the Salon, they also paved the way for future commissions.[45] When considering her options and choosing her specialty, Klumpke would undoubtedly have thought through the economics of portraiture carefully: such paintings were a good way to earn a living. In this respect she made the portrait class at the Académie work in her interest.

Because of the awards system at the ateliers, competition was keen and the drive for honors kept the tension high. Describing the atmosphere shortly before a competition, Klumpke writes about her encounter with Marie Bashkirtseff during an exercise that included painting a man wearing his hat.

> My own attempt . . . was to present him in profile, and as I was about
> completing this work one morning, Marie Bashkirtseff, who sat in front
> of me, turned and abruptly accosted me with, "Klumpke, have you fin-
> ished? Perhaps you expect to get the medal?" "Why not? Like you, I

am working toward that aim." "If you get it," [Bashkirtseff] returned, "I shall pay [for] the refreshments. But I do not worry—this time I shall receive the medal."[46]

In her *Memoirs* Klumpke mentions her surprise at winning the award (jointly with Madeleine Delsarte), noting also that Bashkirtseff was absent at the traditional offerings of "cakes and punch" that the winner was expected to provide.

There were also moments of genuine relaxation, however. In 1885, some "Julianites" were acclaimed for their triumphs at the Salon. In celebration of her award of honorable mention for the portrait of Augusta, the artist recalls,

> M. Julian was gratified by the recognition . . . and with true French chivalry he celebrated the occasion by giving a *fête* for his class, who were welcomed to a flower-decked table, lavishly provided with a fascinating array of decorated cakes in colors rivaling the rainbow, fruits exquisitely served, and sparkling champagne. . . . Lifting his glass he said, "Mes demoiselles, the honor you have done my Academy I deeply appreciate. I congratulate you heartily. But do not sleep upon your laurels. Continue to work diligently . . . [;] that which is great in character . . . will lead you on to a *chef d'oeuvre*."[47]

An article reporting on the day of the awards at the Salon describes the more ceremonial atmosphere in the Grand Salon at the Palais de l'Industrie. Listing notable pictures and the names of visitors, it stated with solemnity:

> The Salon is over. Every one wishes that he had gone there oftener and had come to know it better. People came in by two and threes in plain morning dress, . . . their gay pink invitations in their hands, . . . exchanging greetings and congratulations. . . . Here and there among the spectators was a gentleman in evening dress, a fact which told the initiated that he was to receive a medal. . . . Great was the excitement as the jury entered, and celebrities and professors were pointed out . . . [including] M. Bouguereau, who has the medal of honor this year. His

frank, kindly face, and cordial manners delighted his pupils as they watched him from afar . . . [;] behind [him] is M. Tony Robert Fleury, one of the wisest and most excellent of the Paris professors, and the youngest . . . of the old school of academical draughtsmen. . . . After all the medals for painting had been given the long list of honorable mentions was read. [There is] a fair proportion of American names, including Alexander Harrison, Walter Gay, Julius Stewart and Edwin Weeks. Miss Anna Klumpke is, I think, the second American woman who has received an honorable mention, and the honor is deserved. The reading of her name was the occasion of hearty applause.[48]

From his seat in this crowd of dignitaries, the same reviewer observed an aspect of nervousness and restraint, but one of great happiness, too. Although Klumpke's personal experiences are not documented, this description of the painters about to receive their medals probably also applied to her.

Unfortunately, the work that gained her honorable mention is now unlocated. It is thus not possible to tell to what extent Klumpke challenged the conventional female iconography of elegance and grace to stress instead the independent spirit of her sister Augusta. Commenting on the emergence of *la nouvelle femme* and the shift in portraying women, the art critic Camille Mauclair would later make the following remarks and implicit charge to painters:

A man's portrait was a psychological document subject to analysis and moral evaluation . . . but a beautiful woman's face was an unknown terrain where there were no traces and byways. . . . She was purely physical. . . . A feminine portrait was hence always a decorative work . . . a stylized landscape of which the woman's body, invisible and central, was the driving force and the prisoner of the whole ensemble. Yet a new concept of woman's portraits has begun to emerge. Her decorative and non-conscious aspects will probably fade. A new woman is being elaborated, a pensive and active being to which a new form of painting will have to correspond. . . . A woman's portrait will cease to be a *tableau*, and will become an intimate, analytical, and ideational document.[49]

In view of this changing concept of the new woman, the disappearance of Klumpke's prized portrait of Augusta is especially unfortunate.

The mother of these children has long been waiting in the wings, and it is now time to bring her to center stage. Reflecting the thoughts of those who had heard and read about the Klumpke sisters, one contemporary observer remarked, "To enhance the skill of such well-endowed daughters, must there not be a facilitator of the first order?" Or, to put it another way, who was "their sympathizer and inspirer?"[50] The following discussion considers the qualities and characteristics that informed the mother's legacy and lessons. More specifically, it brings to the foreground some of the questions that she found it urgent to address as a single parent raising five daughters and a son.

In the 1880s, the elder Dorothea Klumpke was in her early fifties, a pioneering California woman who during the previous ten years had upheld heavy responsibilities as her children's primary caregiver. Although her family in Germany had initially provided moral support and advice, with time and distance she seems to have increasingly relied upon herself. During these years, it was probably courage and determination more than any other characteristic that informed her life and guided the decisions she made for herself and her children. With pragmatic fortitude, she learned to shoulder her weighty task. An intelligent, articulate, well-read, and informed woman, she inevitably came to view life more soberly than did women in traditional families.

To what extent her religious faith gave her support and strength cannot be ascertained. Like most Americans in Paris, she was a member of the American Church of the Holy Trinity, where she attended Sunday worship and celebrated the sacraments of marriage and baptism. Favoring a kind of service whose climax was usually the Word spoken from the pulpit, worship there was informal and stressed ethical teaching according to general principles. Dorothea Klumpke, a Lutheran by birth, may have viewed herself at this stage in life as a liberal Protestant. She knew from her religious upbringing that much of the message about the proper way of living one's life was accessible in the preached Word and in the Bible. She also knew that the purpose of life was to do one's duty, and to be steady, somewhat stern, and moralistic.[51] Although the facts cannot be determined, it may be that a source of Dorothea's strength was her liberal religion, which explained a person's existence in this way.[52] Perhaps, as

well, Dorothea Klumpke depended upon duty as the medium of her child-rearing practice because that is how she herself had been raised.

Even though she may have seen herself as a teacher, responsible for the spiritual health of her children, as well as for their physical well-being, Dorothea was first and foremost a product of her personal history and experience. As a single parent raising five daughters and a son, her responsibilities were enormous, and no small part of her motivation was her personal need to see that they would enjoy security in their lives as adults. She was demanding in her standards; with true matriarchal exactitude she expected them to work diligently, reminding them that the word "can't" did not exist in the dictionary.[53]

Growing up in the Klumpke family was, it is clear, an extraordinary experience. With no man in authority during most of the youngsters' formative years, it was the mother who guided each child to reach her or his highest level of ability. Though engaged in various occupations during the day—at the Académie Julian, at the school of medicine, at the observatory, or at the nearby lycée—the children gathered in the evening around a large table. Anna recalls: "Mother [was] seated in the bright light of a lamp with her sewing, while her children would take turns to read aloud. Our favorite books on these evenings were historical works on France and on our own country, but we dipped into poetry and romance also, and the fascinating pages of Jules Verne."[54] Whereas reading from the works of Goethe and Zola is predictable enough in a cultured household, the fascination with Jules Verne's (1828–1905) popular science-fiction adventures of the 1870s is intriguing and prophetic in view of the younger Dorothea's later pioneering balloon expedition.[55]

The picture rendered by Klumpke in her *Memoirs* is one of female connectedness around learning. It is also, to be sure, idealized, masking the tension and anxiety that accompanied the educational struggles and commitments in which they were engaged. Yet, recalling the precious times around her mother's hearth, Augusta explained: "She was everything we children could have asked for. It is she who deserves all the merit; she was an admirable mother, a noble soul. No sacrifice was too much."[56]

Anna and her sisters would later find such "sacrifice" anathema to their professional pursuits. Sacrifice as it was experienced by the elder Dorothea Klumpke, however, meant fulfilling her responsibility as a parent. It meant work and economy, even at personal cost. Her destiny defined her values and affected how she identified herself as woman and mother. Having no

options outside her position in the family, she experienced no conflict. She accepted and supported her daughters' heroic struggles, and, when extolled in the press for being a facilitator of the first order, she knew the strength that connectedness within the family gave her.

The bond between Dorothea Klumpke and her children is confirmed in manifold ways. Letters written later when they were separated are full of admiration, love, and respect. Hers are those of a devoted mother: plain, direct, long, and filled with concern for the well-being of her children. She cared, but seldom gave advice. In a letter to "My dear Anna," then in Boston, she conveys the family news from Paris: "Dorothea looks miserable, Augusta has a bad cold, Lulu is working hard to meet all the calls she expects this winter in society parties. Augusta has been very kind to her, introducing her . . . to one of the most brilliant salons of Paris." Focusing upon the youngest in the family, she continues to share with Anna her concern for Julia and her music, "her quality of tone . . . her good ear, . . . but also her lack of assuredness, an intonation that was not quite mature."[57] Devoid of sentiment, the letters were, like the presentation of her self, straightforward and direct. Perhaps words from the only man in the family, Wilhelm, capture the essence of this mother's legacy and lesson to her children. In a letter to his father, the nineteen-year-old observes, "Mother has always been very good and very devoted to all her children; she has made of her daughters women who by their intelligence and their talents can earn their living."[58] He was right. She nurtured the interests of each individual child and encouraged each to achieve her or his highest potential. In addition to providing them with the firm base of a home, she believed in their ambitions, supported them throughout their trials, and shared in their successes. The strong sense of self-worth that her daughters gained under her care was invaluable in their future careers as independent women.

For their various accomplishments and contributions to France, the Klumpke sisters were together awarded no less than five medals of the Legion of Honor.[59] Augusta was the first to distinguish herself, receiving the order of Chevalier in 1913 and the order of Officier in 1921. Anna became a Chevalier in 1924 and an Officier in 1936. Dorothea gained her Chevalier in 1934. Though their mother, who died in May 1922, was not there to experience these extraordinary triumphs, she undoubtedly was in their grateful minds.

The portrait Anna painted of her mother in 1889 provides a sense of this remarkable woman (Plate 1). In this life-size picture, Dorothea

Klumpke is seated in a chair close to the picture plane with her head slightly tilted. She looks fixedly at the viewer with an alert expression. Wearing a formal black satin dress, she is holding a book in her lap and a pair of reading glasses in her right hand. A strong studio light with a focus upon the head creates a "halo" that reinforces the visual images while also giving the sitter an almost iconic presence.[60]

The critics and art lovers visiting the Salon in 1889 praised Klumpke's *Portrait of My Mother* for its technical expertise and excellence as a character study. The eminent French art critic Albert Wolff lauded Klumpke, "especially her technique of light which is the stumbling block of so many painters. As to her style it is broad and sure of itself. Miss Klumpke has a brilliant future before her and will, if she persists, become a great artist."[61] There was also acclaim from George William Sheldon, an American art critic. Selecting her as one of the most successful American women painters in Paris, he awarded Klumpke a place in his annals of American art history. (The other painter referred to by Sheldon was Elizabeth Gardner Bouguereau.)[62]

A large illustration in the handsome volume published for the 1889 Salon attests to Klumpke's artistic recognition (Fig. 3). It shows the painter in a spacious studio apartment. She is seated on a couch at the far end of a large room playing the dulcimer. With light entering from the window on her right and a glass ceiling above, she is reading her music from a stand. Turkish carpets, shelves filled with books, draped curtains, plants, and paintings on the wall suggest the habitat of a learned and cultured person and, more important, the home of a permanent resident painter. Signed "Melle A. Klumpke," copies of the photograph may have been presented to clients and critics whom Klumpke met formally and informally in the art world.

Other, related reasons made 1889 an important year for Klumpke. This year the accolades did not end with the closing of the Salon, but continued with the celebration of the centenary of the French Revolution. The great Universal Exhibition, the most visible reminder of which is the once controversial Eiffel Tower, brought more visitors to the city than ever before. To impress the world with their nation's cultural superiority, the French included a formidable display of contemporary art as well as a retrospective exhibition of a century of the country's painting.[63] After those by French artists, the greatest number of paintings on view were by Americans. This exhibition proved significant for many painters from the

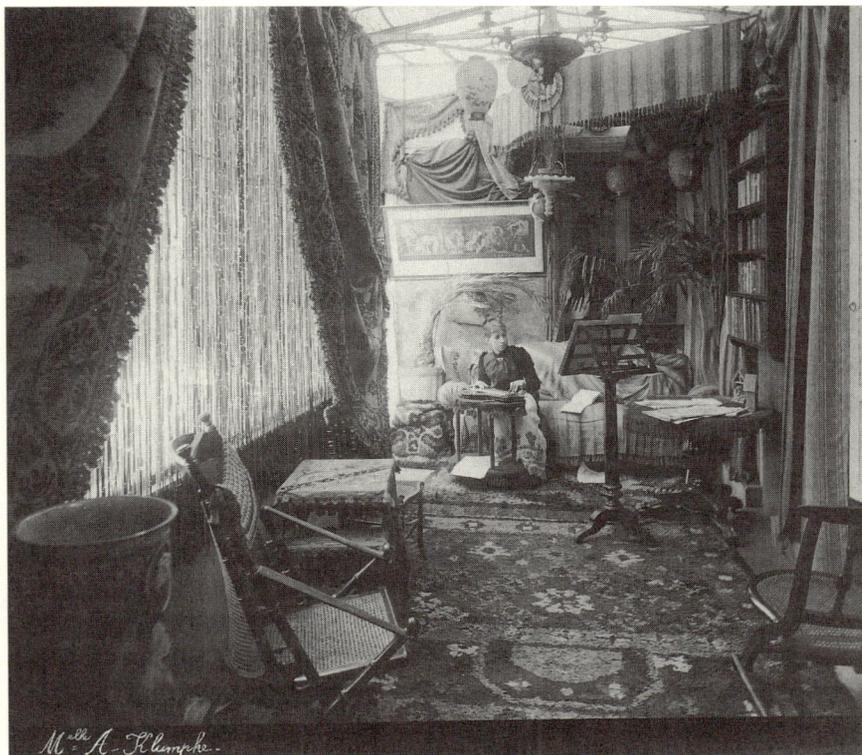

Figure 3. Photograph of Anna E. Klumpke in her Paris studio apartment, 1889. Thomery—Château de By—Musée de l'Atelier de Rosa Bonheur.

United States, who received medals and won appreciation in the context of the international marketplace. Anna Klumpke figured among those listed in this prestigious group: she had won, for her work *Une Merveilleuse* (unlocated), a bronze medal, equivalent to an honorable-mention prize at the Salon.

Remembering the occasion, she remarks: "The day that I received my third-class medal at the Exposition Universelle of 1889, my mother, delighted at my success, declared with firm conviction that it was for me the first rung on the ladder of fame. With such a horoscope, how could I but feel complete contentment and happiness: on this day I decided to marry Art."[64] Klumpke was thirty-three years old. In proclaiming her decision— to marry Art—she selected and began to shape her vision of that supreme challenge.

Part Two

Art Matters

Chapter Three

Negotiating the Salon

"In order to sell, it is first of all necessary to have acquired a certain notoriety, and this can only be achieved by showing what one has done. Painters are not rich; they have to live. How will they live if they do not earn money?" argued Jean-Léon Gérôme.[1] His contemporary Benjamin Constant similarly believed that the Salon was an aid not only to glory but to survival: "The Salon is our only means of publicity, through it we acquire honor, glory, money. For many of us it provides our livelihood."[2] Success at the Salon, Klumpke had realized, was the route to recognition. It was determined by the selection committee, the preference of such powerful critics as Albert Wolff, public response, and the officially awarded medals and honors. For all ambitious artists, native and foreign, male and female, the Salon ordinarily was where reputations were made, contacts established, and the ground laid for future transactions.

Aside from the necessity that all artists felt for a Salon to protect their interests, sense needs to be made of how the largest and historically most important exhibition forum responded to artists who were women. For the past century the Salon had been a government responsibility. In part because of considerable dissatisfaction with its gargantuan size (seven thousand works of art in 1880), the organization of the Salon was given over in 1881 to the Société des Artistes Français,[3] a process officially completed the next year. One of the results of the administrative changes was halving the number of women admitted.[4] An idea of the effect of this step can be gained by comparing the number of American women involved

with the total number of American exhibitors.⁵ Whereas women constituted 35 percent of the total in 1880, their participation had dropped to
18 percent the following year. The proportion remained the same in
1882, the year of Klumpke's debut at the Salon. In subsequent years
American women's participation at the Salon rose to 25 percent, representing the largest female group of any nation.

The most significant feature of the new Salon was the makeup of its
jury. Consisting of artists who had been voted for by all previous exhibitors, it included members who either taught or ran their own ateliers.
Among them were Tony Robert-Fleury, William-Adolphe Bouguereau,
and Jules Lefebvre. The experiences of some of Klumpke's contemporaries at the Académie Julian reveal some of the conflicts and contradictions that existed between the established structure of tuition, progress,
and success and the commercial concerns of her instructors.

Writing in her journal, Marie Bashkirtseff recognized the value of her
master's advice and professional help, but she also sensed that he was lavishly promoting her not only for her own sake but also for the glory that
her success might bring the Académie. It seemed clear to her that Julian
did not just develop in his students those qualities of technique and style
that would earn them the favor of academic Salon juries; he also represented "the right-thinking majority."⁶ Although he admitted to her that
the poor jurors who saw six hundred works pass before them in a day
could hardly do justice to the enormous responsibility they had taken on,
adding that works twenty times worse than hers would be at the Salon, he
also reminded her that "you have this going for you, which is important,
. . . I have Lefebvre, Laurens, and Bonnat who are absolutely my friends."⁷
Clearly for Bashkirtseff, Julian was both a perfect instructor and a powerful person who was quite open about the contacts that he hoped would
help him as well as her.

The painter Ida Smith of Pittsburgh concurred with Bashkirtseff; the
support of an influential artist was crucial for students' development.
Voicing her concern for the teachers' biased ambitions, she remarks,
"Our only trouble now is that our masters, Monsieur Lefebvre and Tony
Robert-Fleury, are not on the Committee as a M. Bouguereau is chair and
his pupils have a great advantage."⁸ Klumpke's compatriot Ellen Day Hale
summed up the ambivalence that she and her colleagues felt. Writing to
her parents in Boston, she explains: "I know the *patron* occasionally tells
lies, but I don't think . . . that his interest in me and my future is an in-

verted one. He seems to be very desirous to keep hold of me and make me a credit to him." She concludes, "Julian who likes money is very glad of his women's classes which pay him twice as much as the men's and every clever scholar he has is of course an excellent card."[9] For her and her colleagues, gaining Julian's approval was both effective and useful.

Like any enormous competitive enterprise with important benefits for winners, the processes of acceptance and awards at the Salons involved favoritism. As jury members, the artist-teachers tended to promote their own names by getting their students admitted to the Salon. Running their ateliers as businesses, the administrators had nothing to lose by promoting their female students. Furthermore, since they received twice as much in income and gave only half as much of their time for criticism, there was from an entrepreneurial point of view little reason for the masters not to encourage the best female students to enter the Salon. Indeed, because there was no solution to the problem of trying to deal in a fair manner with the thousands of works submitted each year, it was extremely important to have the support of a jury member, the more influential the better.[10]

The woman painter's position within Salon history is therefore complex. Though a number of women aspiring to careers in the arts had been going to Paris ever since the 1860s, Elizabeth Gardner (1837–1905) is generally credited with having opened the doors for her female colleagues.[11] Establishing herself in the city in 1864, she trained in private studios to make her debut at the 1868 Salon. Influenced by the academic style of her teacher William-Adolphe Bouguereau (they became engaged in 1879 and were married in 1896), she became a Salon regular and a medal winner. Elizabeth Gardner Bouguereau was a talented woman who knew she wanted success in the main arena of the male art establishment of her day. In an oft-quoted remark, she frankly revealed, "I would rather be known as the best imitator of Bouguereau than be nobody."[12] Although her comment had much to do with her loyalty to him, it also suggests her esteem for the French academic painting standards that she had set as her goal to meet.

Mary Cassatt (1844–1926), seven years Gardner's junior, arrived in Paris in 1866. Struggling with rejections from the Salon jury, she eventually joined the Impressionists in 1874. Not only did she then abandon the Salon-oriented concerns of her American compatriots but she stopped looking to Americans to support her portrait practice.[13] Cassatt thus removed herself from the American scene in Paris. Gardner, in contrast,

remained in the limelight with her elegant "at home" receptions and her appearances at the Salon.

The women following in Gardner's footsteps belong to the second generation of women expatriates. The best-known of them are Cecilia Beaux, Lilla Cabot Perry, Ellen Day Hale, Elizabeth Nourse, and Lucy Lee-Robbins. Born in the 1850s and 1860s and thus of Klumpke's generation, they all at one time attended the Académie Julian, making their entry into the Salon a few years after her first show in 1882.[14] Whereas Beaux, Perry, and Hale returned to America after a few years in Paris, Nourse and Lee-Robbins established their careers in France. Like Klumpke, these two women achieved remarkable successes as Salon exhibitors. Also like Klumpke, they depended on jury procedures that mitigated women's chances of being recognized.

The Parisian experience of Elizabeth Nourse (1859–1938) begins in 1887.[15] Born in Cincinnati, and trained at the Cincinnati School of Design, she established herself with her sister Louise, an indispensable assistant throughout her life, in an atelier at 74, rue Notre-Dames-des-Champs.[16] She was then twenty-eight years old.

Nourse spent the fall at the Académie Julian and was stimulated by her first exposure to an international group of women. She made her debut at the Salon in 1888. The following year she worked independently, receiving private criticism from Emile Carolus-Duran and spending much time traveling in Europe, painting peasants in their domestic settings.[17] Identifying herself as a pupil of her new teacher, she entered two genre works in the Salon of 1889. When there was a split in 1890 between the Société des Artistes Français (SAF), which had assumed control of the Salon in 1881, and a new organization of which Carolus-Duran was a member, the Société National des Beaux-Arts (SNBA), she aligned herself with the latter.[18] To what extent the schism resulted from squabbles among the followers of the conservative artists Ernest Meissonier and Bouguereau, or resulted from political or artistic controversies, is difficult to say.[19] As to the practice of showing at either of the two Salons—the new one on the Champ-de-Mars or the original exhibition on the Champs Elysées—most Americans tended to follow the example of their masters.[20] Thus, students of Meissonier and Carolus-Duran went over to the new group, and pupils of Bouguereau continued to show at the exhibitions of the SAF. As time passed, however, some Americans began to show at both Salons. Klumpke, however, remained at the SAF, which represented the tradi-

tional standard of artistic merit. With an almost ten-year record of support from her masters on the jury, she sided with the group who would best guarantee her continued visibility and approval at the Salon.[21] Nourse, on the other hand, left the SAF to show her works from then on at the SNBA. She was elected *associée* of the newer group in 1895, *sociétaire* in 1901 in the category of drawing, and *sociétaire* in 1904 in the category of oil painting, titles that gave her a privileged position as exhibitor and the right to serve as a jury member.[22]

A final accolade came in 1910, when her large work *Closed Shutters* was purchased by the French Ministry of Arts for the state's collection of contemporary art in the Luxembourg Museum. It was painted the previous year while the Nourses were spending five weeks in Alsace at the château of the marquise de Roy, a change of scene that appears to have stimulated her imagination.[23] Showing a woman (apparently her sister) at a window, it includes the "emblems of gender" typical of intimate parlor scenes— vases with flowers, for example, and a female reflection in a mirror.[24] In essence, the acquisition of a work of art by the French government marked official approval of an artist. And, as in the case of its purchase of Klumpke's painting *Le Retour de la Promenade* (Musée des Vans, Les Vans, France), such acquisitions were generally followed by favorable publicity, signaling national and international public acclaim.[25]

Aside from having acquired "a certain notoriety," to use Gérôme's words, Nourse had also achieved financial independence, supporting herself and her sister Louise by selling works to patrons in the United States. After a number of shows in America in the early 1890s, particularly in her hometown of Cincinnati and in Washington, D.C., she came to rely increasingly upon support from a large network of women friends, who admired her work, publicized it, and bought it.

The genre paintings that Nourse, and Klumpke, produced for the Salon can be understood in part by examining the way these artists negotiated the institutional setup of the art world. Images of rural life poured into the Salon during the latter 1800s. Indeed, French peasants of the nineteenth century became the most popular of all subjects for native and American Salon painters. Pictorial concepts ranged from anecdotal narratives and social commentary on the plight of the poor to Elizabeth Gardner's idealized portrayals of peasant women and children. Like most of their American male colleagues, women painters from the United States did not concern themselves with the social and political values for

which the Barbizon painters stood; they, instead, based their works loosely on French sources, favoring a conservative style.

Conditioned by Barbizon sentiment, Nourse was attracted to the subject matter and style of Jean-François Millet (1814–1875). Going to the village of Barbizon, she made a sketch of the cottage in which the artist had lived and worked. She also sought out the woman who had been Millet's model for *The Angelus* (1855–57) and made a fine character study of her, *La mère Adèle* (Barbizon, 1888). She even bought the cloak the woman had worn when she posed for Millet, as well as a spinning wheel.[26] An interest in Millet's model also appears in Klumpke's work. The artist "hunted her up" and was pleased to find that she was willing to pose for her.[27] Klumpke made several sketches, which culminated in a large painting, *Old Recollections: The Old Woman at the Well* (unlocated).

The reevaluation of Millet going on at the time could not have failed to influence the choice of work by Nourse or Klumpke. In addition to a large retrospective in 1887 and a reassessment of his achievements in the context of nineteenth-century French art at the 1889 Universal Exposition, Millet's reputation was transformed most tangibly in the saleroom, where *The Angelus* was purchased for $160,000.[28] As with the carefully promoted activity around a major sale at Sotheby's or Christie's today, so high a price was hard for the public in general, and artists in particular, to ignore. To paint Adèle, Millet's model, meant in a very strong sense for Nourse and Klumpke to share with her the name of a great master.

Aside from drawing inspiration from paintings by Millet, their works were influenced by contemporary realist artists as diverse as Jules Breton, Julien Dupré, and Jules Bastien-Lepage. Emphasizing the sculptural treatment of forms, Nourse, for instance, often placed her figures close to the picture plane in traditional balanced compositions. Klumpke's painting *The Peasant Woman* (1890; unlocated) reveals the indebtedness she shared with Nourse to Jules Breton. The picture, which was illustrated in *L'art français* following an exhibition at the Union de Femmes Peintres et Sculpteurs, displays her adeptness at handling the figure in bold forms to give it a monumental presence (Fig. 4). Based on a direct study of a seated woman, Klumpke's interpretation combines the portrayal of a human being with that of a specific type, the ubiquitous Salon peasant woman. *Catinou Knitting* (Plate 2), also by Klumpke, is another composition that pays obvious homage to Breton, especially to his painting *Turkey Tender* (1864)

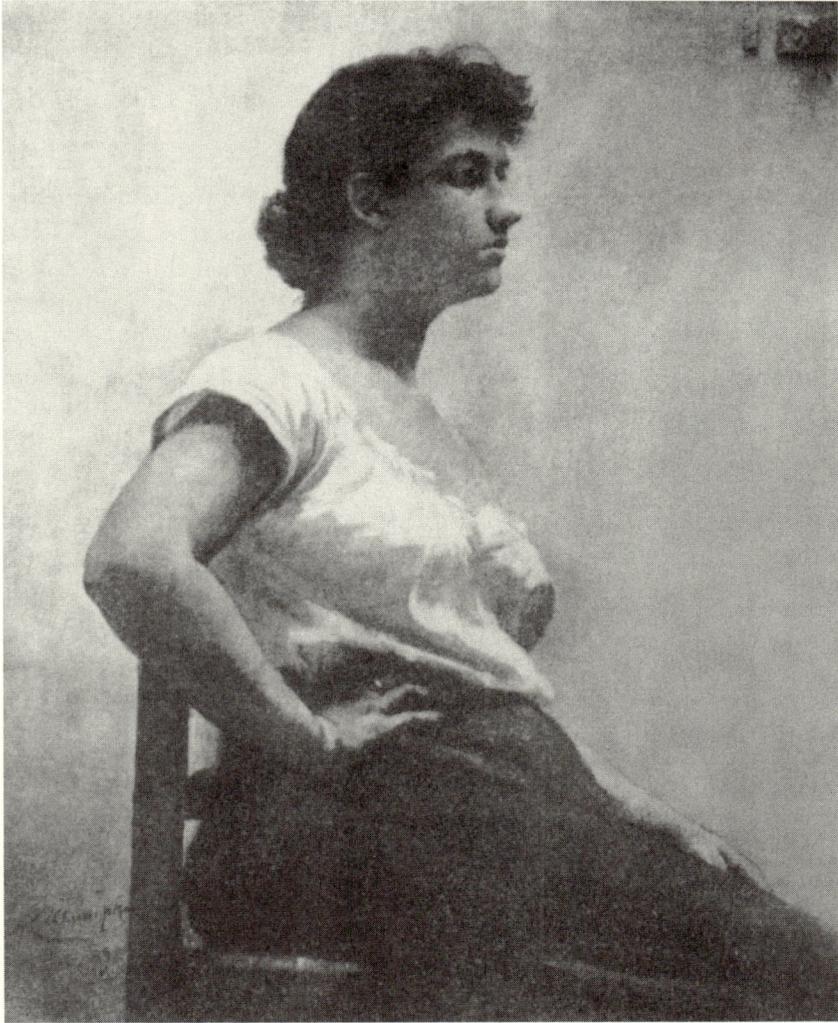

Figure 4. Anna E. Klumpke, Peasant Woman, *illustration for* L'Art français, *March 22, 1890.*

in the pose of the young peasant woman and the treatment of the pictorial space. It was shown at the 1887 Salon.[29]

Although the subject of women of the peasantry engaged the attention of many Americans at the time, for Nourse the preoccupation with women and children—caring for children and working at chores within the household—was almost an obsession. In interpreting Nourse's

mother-child paintings, there is, to today's viewer, no immediate way of telling whether an early work like *La Mère* (1888) or a later painting like *Toilette du bébé, le soir* (1900) was created by a woman or a man. Both depict a woman holding a young child in her lap; the former is a large canvas, painted in rich, dark colors, with an academic finish, whereas the latter shows a preference for a brighter palette, with pigment applied in broad strokes. That Nourse drew exclusively from the traditional iconography of women's culture in the private sphere (mother, children, domestic scenes) may have helped over time to shape her public identity as a woman. As has been argued, "the practice of painting is itself *a site for the inscription of sexual difference.*"[30] By positioning her work in "spaces of femininity," her artistic orbit as a woman appears circumscribed. Furthermore, a lifelong preoccupation with *maternité* images may also have helped to construct in viewers' minds a painter-subject relationship that was feminine, thus linking her paintings to a larger feminine visual culture. Seen in the light of historical knowledge, Nourse's imagery can be said to be both inside and outside the male tradition; it exists within two traditions simultaneously, an "undercurrent" of the mainstream.[31]

How an artist like Lucy Lee-Robbins (1865–1943), who focused upon the subject of the nude figure, is positioned in relation to her choice of subject is especially complicated.[32] An expatriate with an almost forty-year record as a Salon exhibitor, Lee-Robbins was the only child of well-to-do parents from New York who moved to France shortly after she was born. In the early 1880s, she was living in Paris with her single mother, her father having returned to America. She began her studies with Jean-Jacques Henner and Carolus-Duran at about this time. In 1888, she had established herself in a comfortable studio at 84, rue d'Assas. Lee-Robbins was the first woman to be elected *associée* of the "new" Salon of the SNBA, and the first American woman to have a painting acquired by the French government. An allegorical work, *The Three Fates*, was purchased for the permanent collection of the Luxembourg Museum in 1891. Lee-Robbins was thirty years old when she married a fellow artist, Hendrik-George van Rinkhuyzen. Making use of her ample financial resources, she maintained a separate studio throughout her married life. She never returned to the United States.

Best-known today through a portrait painted by Carolus-Duran of his nineteen-year-old "star" pupil, Lee-Robbins distinguished herself at the Salon as an accomplished painter of the female nude. Among her male

compatriots, the subject was taken on most notably by Alexander Harrison. In his work *In Arcadia* (Salon 1886) a group of women display their nudity in a wooded scene. As in *Les Nymphes* (Salon 1899) by Julius Stewart, the piece depicts models obviously painted in the studio, who unaccountably walk in nature without their clothes. Female nudes by American male painters were, however, unusual. For a woman, the subject was an even rarer choice.

Discarding any reference to classical or literary sources, Lee-Robbins's contemporary women appear mostly in interior settings—at the window, near the fire, or at a dressing table. The technique and the pose of the model are similar to those employed by her teacher Carolus-Duran. Displaying the artist's "mastery" of the female nude, the works seem to have been created for the voyeuristic pleasure of a male audience. Upon closer examination, however, some of her nude studies reveal a subtle contrast with works by male artists.[33] In, for instance, the painting *Tristesse* (1893), described in *L'Art français* as "une grande figure nue d'une mélancolie pénétrante," the female nude seems to be presented in a "more straightforward" way as "a simple unqualified study." In other words, even though the image of the sensual woman that is being constructed follows the culturally endorsed representation of female nudes, Lee-Robbins's oeuvre includes images of female nudes painted in a manner that revealed her models' sexuality and sensuality without condescension.

Klumpke's rendition of this subject, *The Breeze*, is a large canvas depicting a single female figure with gossamer drapery clinging to her body (Plate 3).[34] With a distant, melancholic look, the model languidly leans against the branches of a tree bearing fall foliage. Although Impressionistic brushstrokes and a lightened palette reveal Klumpke's adaptation of the more modern modes of painting, the modeling of the figure follows the traditional academic style, emphasizing lines and contours.

Klumpke's painting of this quasi-nude figure is an ambitious work clearly intended for Salon exposure. An effect of casual spontaneity belies the deliberation the artist put into the picture. In addition to a photograph of a woman (probably one of her sisters) in a similar pose, which she used as an aide-mémoire in composing this image, the artist made numerous life-size sketches and drawings. In preparing her large canvas, she also sought the counsel of Lefebvre, who encouraged her project and thought her sketches were "interesting and artistic."[35]

Since it is a unique subject in her oeuvre, painted at a later stage in her career, it is useful to consider this work and its place in the continued debate on the subject as primary Salon material. A special publication entitled *Le Nu aux Salons*, with an essay by the art critic Georges Normandy, is especially revealing. In this volume, generously illustrated with academically drawn single figures of nymphs, bathers, and women in various alluring poses, Normandy reviewed the shows at the Salons of the SAF, the SNBA, and the Salon des artistes indépendants.[36] In judging the works at the SNBA and at the Salon des indépendants, he complained about the style and technique on display and considered the shows in general to be *faibles*. Asserting the importance of the SAF exhibition, he wrote that the Salon "conserve pour le nu sa superiorité sur toutes les autres expositions et par le nombre des envois et par leur qualité."[37] Though Klumpke painted *La Brise* a couple of years before Normandy's article of 1912, her picture of a female nude partook of this kind of general competitive criticism. By choosing the nude as an image for Salon entry, Lee-Robbins and Klumpke aligned themselves with what was called *le grand art*, the great style of figure painting, with its idealized forms and academic classicism. As female artists within the Salon system, they absorbed the existing conventions of representation. They enacted the language available to them and mimicked the dominant structure.[38]

Aside from the issue of women's artistic production within the cultural hegemony of the Salon, there is also an ahistorical issue to explore: female nudes as a space for female viewing. Carol Ockman, in her quest for analysis and explanation of the experiences of pleasure and the need to naturalize power structures, has published a study concerning Ingres's eroticized bodies that is useful in this context.[39] Drawing upon theories of spectatorship and writings by Michel Foucault, Luce Irigaray, and Julia Kristeva, among others, about questions of binary oppositions and notions of abjection, Ockman addresses the discourse surrounding Ingres's work to explore possibilities of a space for the pleasure of the female spectator. Challenging long-held and unquestioned assumptions about Ingres's paintings, she contends that the thinking in terms of dichotomies, to which so much of his oeuvre seems to lend itself so obviously, must be questioned and subverted. Dislodging any notion of settled gender identities in her analysis of Ingres's style, Ockman, for instance, discusses the sensual properties of *The Grande Odalisque* (1814), commissioned by Napoleon's sister, and suggests that it was one of many examples of sen-

sual classicism that gave pleasure to women patrons in Consulate and Empire France. The concept of female agency, be it in viewing or owning, can of course never be totally outside the dominant structure: no "text" is fully independent from the political structures of a male-dominated society. Yet, by questioning the whole issue of reception and of changing perceptions of Ingres's work, Ockman provides an innovative perspective that makes it possible to look with a different "understanding of pleasure and distaste" at the sensual figures painted by this master and, by extension, at female nudes painted by women, past and present.[40]

Even though this interpretive strategy for reading new meaning into nude images of women is theoretically attractive, the account of the woman-art problem in fin-de-siècle Paris must ultimately be assimilated to the historically grounded Salon tradition. Insofar as entry into this sacred institution depended upon a group of men who functioned as powerful arbiters of recognition, Nourse negotiated the Salon by producing peasant scenes, Lee-Robbins by painting nudes. Klumpke, a renegade at the Salon, maintained her position in the institutional fabric of the art world by painting mainly portraits. An important aspect of this area of her expertise, as has been shown, included portraits of her sisters and mother.[41] Creating arresting works, some of which were groundbreaking in their interpretation of *la nouvelle femme* (e.g., the portrait of the astronomer Dorothea), Klumpke worked within the male tradition to find a place in the mainstream of competitive Paris. She is not known to have worked with any agent, but she took measures to advertise her Salon status in a number of subtle ways. Drawing upon her exhibition record, Klumpke, like other painters of the time, included the names of noted male instructors and the credentials she had received at the Salon to promote her identity as an acknowledged artist. It worked, because these honors were invariably quoted in the press and read by the public. To further highlight her Salon connection she had official postcards of her entries printed, some in black and white and others in color. Sending them to relatives, friends, and potential clients, she helped to spread her own reputation.[42] A Salon artist par excellence, Klumpke sought, like all serious artists, money as well as honor.

Chapter Four

Networking among Americans

It is true that painters relied upon the visibility and validation they received in the context of the Salon. Yet, to be considered fully accomplished artists, they ultimately depended on opportunities that lay outside this institution. The threat of vanishing from the art scene was very real for both men and women, and only a few managed to make the leap from being promising students to working as established professionals.[1] Moreover, even as barriers against women students in art academies fell, barriers against women as professionals lingered on. In order to work in the real world, women needed to depend upon contacts and a fair amount of good luck. The affinity of these two factors is exemplified in Klumpke's experiences with a noted art critic, a famous painter, and her childhood role model, Rosa Bonheur.

Klumpke's acquaintance with the *New York Tribune* reporter Theodore Stanton may have had a professional origin, perhaps a good review of a painting. Resident in Paris since his marriage to a French woman in 1881, he was also the editor of *The Woman Question in Europe*,[2] a book based on reports he had collected from a number of prominent European feminists who were acquainted with his mother's National American Woman Suffrage Association. (He himself was the author of the report on France, where he had personal knowledge of the laws governing marriage and the status of women.) Klumpke notes that she was invited to visit him at his wife's family home in the south of France. Having already planned to

travel to Italy to study the Old Masters on the advice of Tony Robert-Fleury, she accepted Stanton's invitation.

Klumpke explains that while staying with the Stantons she was asked to paint the portrait of their young daughter Lisette and also one of Elizabeth Cady Stanton, who was then visiting her son. No doubt honored, she accepted and began work, intending to finish later in Paris. In this life-size painting, Stanton is presented in half-length, seated in a chair close to the picture plane (Plate 4). She is dressed formally for the occasion in a shiny black dress with lace trim; a pin and bow around her neck are her only ornaments. Her whitish-gray hair, tightly curled, frames her round face. Both her hands are visible, and she has laid her glasses in her lap. In the background on her left is a table on which lies a bound volume and two journals.[3] The name "Stanton" appears on the book's spine, and the year "1888" is sketchily added to the spine of one of the journals. The date may refer to the celebration in Washington, D.C., of the fortieth anniversary of the Seneca Falls convention, where Stanton had given "a brilliant display of her feminist ideas and her unsurpassed oratorical skills."[4] To achieve a forceful portrait, Klumpke focused her attention upon the head. She used a dark, neutral background with few surrounding accessories to distract the viewer. The face is unmistakably that of a particular human being, presented without flattering idealization. A firm nose, curves around the lips, and the crease of a rounded chin cast heavy shadows on the sitter. Two preliminary drawings by Klumpke show the sitter's heavyset figure with bulges around her waist. (Stanton was as self-conscious about her weight as she was proud of her thick hair.) Using artistic license, Klumpke has made her sitter look trimmer in the finished portrait than she really was. She has also highlighted the head and her sitter's coiffed hair, drawing upon this baroque device to reinforce the visual image.

A comparison of her work with a portrait by Léon Bonnat (1833–1922) reveals Klumpke's stylistic influences. A leading portrait painter in Paris from the late 1850s to 1882, when he closed his private atelier, Bonnat chose natural poses, avoided distracting backgrounds, and concentrated on physiognomic details. Popular for his realistic character studies, he was sought after by an international clientele.[5] Like Bonnat, Klumpke knew the value of straightforward presentation, conveying with striking realism an indelible image of her sitter.

Klumpke's documented interaction with Stanton is limited but reveal-ing. Recalling her experiences as she posed for the portrait, the pioneer feminist wrote about the many pleasant hours they spent together, dis-cussing art, the early struggle for recognition, and the American artists' good places in the Salon.[6] Although she commiserated with the numerous artists who were not accepted by the Salon jury or whose work was "skyed" (that is, hung close to the ceiling), she praised the women who were "awakening to the necessity of self-support."[7] Indeed, returning to her beloved Paris after an absence of nearly fifty years, she was struck by the fact that, in the interval, several women had been admitted to places of honor.

In a later account of her social life, Stanton mentioned her regular Wednesday afternoons "at home," adding that she also attended receptions, one of them at the Elysée Palace, where she was introduced to Prime Min-ister Jules Ferry. She remembered their conversation on the role of women, which concluded, "I am sorry to confess it, but it is only too true, our French women are far behind their sisters in America."[8] She probably agreed with him. Whether her discussions with Klumpke touched upon Augusta's and Dorothea's emancipatory endeavors is not known.

In 1889, Klumpke sent the portrait of Stanton to the two major annual shows in the United States, the National Academy of Design (NAD) in New York and the Pennsylvania Academy of the Fine Arts (PAFA) in Philadelphia. It was priced at three hundred dollars, a figure that com-pared favorably with what was asked for portraits by male artists.

The portrait, which was sent to a number of subsequent exhibits, re-mained in Klumpke's possession. In a letter to Stanton's daughter, Harriot Stanton Blatch, in 1916 she wrote that "with the danger of invasion by the Huns I hurriedly cut off from the stretcher several of my valuable por-traits, among these your Mother's, made a roll of them and hid them in a safe place."[9] Whether Blatch later purchased the portrait from Klumpke or received it as a gift is not known. In 1924, on behalf of the National American Woman Suffrage Association, Washington, D.C., she donated the portrait of her mother to the Smithsonian Institution's National Por-trait Gallery. Klumpke does not seem to have been informed about this transaction. Inviting Blatch and her two daughters to By several years later, she asked whether the portrait was still in her possession or had been donated to a woman's club.[10] It is not known if the two women met to clarify the matter.

In addition to the valuable relationship with the Stantons, Klumpke could also act as a kind of American ambassador in art. Like earlier painters from the United States, such as Elizabeth Gardner, she began to suggest painters to American visitors who were interested in purchasing works of art.[11] Writing about one such person who had asked her to select some pictures, she remarked that the "choice included an Emile Breton, one by Tony Robert-Fleury, and one by Félix de Vuillefroy, an animal painter."[12] Explaining the circumstances that developed out of this transaction, she recalls that de Vuillefroy invited her to pass a month at his home, the Château de Thury, on the Oise River. Klumpke was welcomed with cordial French grace by his wife; she was especially pleased to be asked by the painter to accompany him on his sketching tours. "It was the first time," she points out, "that I have seen a great artist engaged in . . . actual technical work."[13] Learning by seeing how the artist mixed paints and observing his method of putting touches of color on his canvas provided invaluable lessons, because the technique of painting was seldom demonstrated by her instructors at the Académie Julien.

Recognizing his guest's enthusiasm and talent, de Vuillefroy advised her to find an interesting subject for a work to submit to the next Salon. Klumpke

> was not long in discovering one that seemed to me to offer a picturesque interest. Returning from a sketching tour . . . , paint-box in hand, I came upon the laundry house belonging to the Château, where a group of peasant women stood around a large tub, blithe and busy with their work, and then and there, on the instant, I made a sketch of the homely scene. Monsieur de Vuillefroy liked the composition and advised me to develop it into a large picture.[14]

Klumpke's six-foot-tall painting *In the Wash House* (Plate 5) is clearly intended for Salon exposure. As in the Stanton portrait, the artist's smooth application of brushstroke, her limited palette, and her somber colors epitomize the formula espoused by the masters at the Académie. Klumpke has organized the positions and movements of the figures around the washtub in a classically arranged, closed format. A vertical composition is divided in the middle by the window frame, placing two figures on each side of the dividing line. The profiles and semi-erect figures of two women on the

right are balanced by two women bent over the tub, one of whom is turning toward the viewer.

To capture instantaneous impressions—the gestures, postures, and facial expressions of the women—Klumpke, like numerous painters of the time, used photographs as an aide-mémoire. Two different compositions, found in a portfolio in her former studio, reveal her experimental approaches as she proceeded from rough drawing to finished canvas. One sketch, freely drawn on squared paper ($19^3/_4 \times 22^1/_2$"), shows two women standing on the left; they are pulling a large sheet from a pool of water in the foreground. The line is sketchy and jerky, and the composition is clearly off-center, with architectural lines filling the right side of the paper. On another sheet of paper (filled with exercises of hands and heads, and a preliminary pose for her portrait of Dorothea), Klumpke has inserted a small rectangular image framed by horizontal and vertical lines at the top of the paper. Drawn in ink on transfer paper, this small insert matches the size of the glass negatives she used at that time. It depicts four women—exactly as in the finished painting's centered composition— around a tub, with the window in the background. It seems that Klumpke set aside her original asymmetrical composition and decided to use the one in her photograph, enlarging the exercise and making other drawings in red pencil on paper to fill in areas of light and shade.

It was, of course, common for painters of the nineteenth century to make use of the camera. Academically trained artists such as P. A. J. Dagnan-Bouveret relied heavily on photographs, regarding them as preliminary studies, much like the first stage in the preparation of an academic painting.[15] Artists also made use of several photos to create a composite image on the canvas.[16] That so few glass plates are extant, however, makes it difficult to ascertain whether a given painter sometimes also employed a single photographed image as a primary source for a painting. It is possible that the glass negatives were deliberately destroyed or hidden in order to preserve the theory of originality. Perhaps, like her male colleagues, she did not publicize the use of photographs, hoping that she would not be found out. Whether Klumpke discussed her technique with her masters at the Académie is not known.

With a number of carefully worked-out sketches, she continued her work in her Paris studio. In March she sent the finished painting *In the Wash House* to the Salon, where it was accepted and well received. It caught the eye of Sara Tyson Hallowell, the representative for the

Chicago exposition, who had the picture sent to the city's World's Columbian Exposition that year.[17] The following fall, the painting was exhibited at the PAFA, where it was selected as one of the best figure paintings of the year, and Klumpke became the first woman to win the group's coveted Temple Gold Medal.[18] Appropriately, she now added the name of Félix de Vuillefroy to her list of accredited masters. Moreover, her encounter with Hallowell developed into a lifelong relationship. A later chapter will touch on their experiences during World War I as neighbors on the outskirts of Paris.

Close involvement with an art critic, an art instructor, and art collectors as an American woman at home in Paris could also include acting as a translator. It was in this role that Klumpke made the acquaintance of her childhood idol and role model, Rosa Bonheur. She was sought out by John Arbuckle, an American horse dealer, to act as his interpreter.[19] The president of a horse-breeding company in Wyoming, Arbuckle had been raising the Percherons depicted in Bonheur's painting *The Horse Fair* (1853). As a gesture of appreciation to the artist who had allowed "her name to be associated with the [Post Percheron] Company as a guarantee of its integrity," he arranged for one of his American-bred horses to be sent to France. Bonheur never acknowledged its arrival.[20] To find out what had transpired, in 1887 he asked Klumpke to accompany him on a visit to Bonheur and act as an interpreter. Their first attempt was not a success. Upon arrival at By, they were met by a woman who told them brusquely that Rosa Bonheur and Nathalie Micas were in Nice. Disappointed, they went back to Paris. Two years later, when Arbuckle returned to France, he again asked Klumpke to serve as his interpreter. This time she decided to prepare their visit more carefully. Uncertain how to proceed, she consulted Rosa Bonheur's sister, Jetta Peyrol-Bonheur, who worked at the Union des Femmes Peintres et Sculpteurs, of which Klumpke was a member. She received a cordial letter of reply, advising her to write to Bonheur well in advance of their visit. Peyrol-Bonheur also reminded Klumpke that her sister was "in deep sorrow" and "very sad," having recently lost her companion of thirty years. Klumpke notes that "[t]his led to an exchange of letters with the artist herself and as soon as Bonheur learned that it was Mr. Arbuckle who was so eager to meet her, she invited him and his interpreter to lunch with her in the Château de By."[21] On October 5, 1889, Klumpke and Arbuckle left Paris for the meeting. As Klumpke describes the experience,

The moment that the coachman who drove us was ready to get down from his seat to ring the door, the iron gate was opened with the clatter of two bells. On the flight of steps before the house appeared a person short in height, dressed in pants and a peasant blouse, carrying a black and white dog. . . . It was Rosa Bonheur.[22]

Klumpke went on to give her first impressions of *la grande artiste*, writing that she was surprised at Bonheur's small stature, but not by the clothes she wore. She had known for a long time about Bonheur's preference for wearing "male clothes." She noticed that this façade did not in any way diminish the feminine aspects of Bonheur's outfit, an elegantly decorated jacket with fancy buttons and embroidery and a pair of fine black-velvet trousers. The overall impression, Klumpke noted, was one of "great distinction."

Recording the events of that day, she recalls that after a most delicate meal, Bonheur turned to her and said that she wanted to apologize to Mr. Arbuckle for not having written to him. The horse he had sent had been so wild that she had not been able to use him as a model. Only the other day, Bonheur explained, the cowboys of Buffalo Bill had come with their lassoes to take the horse away.[23] Bonheur then invited them to see her studio and her latest work, saying that she was eager to have the comments of an artist. Klumpke, flattered, looked at her in surprise. "But yes, I do know of your talent," Bonheur replied.

I have seen your fine portrait [the portrait of her mother in the Salon earlier that spring], and I also know of your two sisters. All three of you prove that a woman is not less talented than a man, that she can have as much talent as him and even sometimes more.

Continuing her praise, she added:

[A]nd I admire the American ideas and those that concern the education of women, because you have not, as we have, the silly prejudice that young girls are exclusively destined to marry. I am totally shocked at the obstacles that lie in their path in Europe. If I on my part was for-

tunate to break away from these, I owe it to the talent with which providence has endowed me.[24]

Making their way up the steps to the studio, Klumpke noted a certain air of formality as Bonheur took a small key from her pocket and exclaimed, "Enter into my sanctuary!" Except for a huge unfinished painting of wild horses covering one wall of the room, Klumpke, looking around the studio, was surprised that it was not filled with studies and other paintings. Her host seemed to have sensed this, saying that if she found these walls poorly furnished with paintings it was the fault of Klumpke's compatriots. "They besiege my dealers, who remove the canvases before they are barely finished." Turning to her huge sketch of wild horses, *La Foulaison*, Bonheur remarked that she had been working on this canvas for a long time, hoping it would be her chef d'oeuvre, but since the death of her friend she was losing courage.

In parting, Arbuckle promised to send Bonheur photographs depicting the life of American cowboys, and she in turn promised to send him studies of her horses. On the return journey to Paris, Arbuckle confided to Klumpke that he was surprised at the warm welcome Bonheur had extended to them. Perhaps, he said, her kindness had arisen from the embarrassing situation she had created by not thanking him for the gift of a horse—however wild and unruly it may have been. On the other hand, perhaps Bonheur in October 1889 was simply able and willing to emerge from her mourning and welcome the presence of company. In any case, as a result of this meeting Klumpke continued her role as intermediary between Arbuckle and the French painter. She noted that "Almost unconsciously, my relationship with Rosa Bonheur became more and more cordial."

Although associations among Americans led to unique encounters in surprisingly unexpected ways, gaining recognition in the art world ultimately depended upon more traditional means: painting portraits of influential persons. This is manifest in the commission Klumpke received from the Bostonian Mary Hill Coolidge. Remembering their first meeting in the summer of 1890 in Barbizon, Klumpke notes that she "had been working on a sketch for a while when I saw a young American mother and child in a picturesque pose and light, and asked her permission to make a sketch." A newcomer to Paris, Coolidge agreed, perhaps pleased to talk to

a compatriot. She had arrived that June with her husband, Joseph Randolph, Jr., who wished to study architecture at the Ecole des Beaux-Arts, and their two young children.[25] After a brief stay in Paris, they were now living in the tranquil village of Barbizon. The child Klumpke refers to is their son, Joseph Randolph III, born December 13, 1886.[26]

When Klumpke had finished her sketch, she gave it to her new American friend, who showed it to her husband. The Coolidges liked it and agreed to ask Klumpke to finish it as a large portrait. To facilitate the sitting schedule, they invited her to stay with them in Barbizon until October 12, when they returned to their apartment at 2, rue St. Sulpice and Klumpke went back to her studio at 90, rue d'Assas. She continued to work on the canvas, had it framed, and submitted it to the Salon jury in February 1891. In the early spring, she received the coveted statement of acceptance. She attended the *vernissage* at the Palais de l'Industrie,[27] a day prior to the public opening on May 1, perhaps to add some final touches to the canvas but more probably to determine what position on the wall she had received from the hanging committee. On this occasion the jury members had voted for a good place, and Klumpke was pleased.

Entitled *Maternal Instruction*, the painting depicts Mary seated with a book in her lap; her young son, Joe, stands nestled close to his mother (Plate 6). Placed in the center of the canvas in a simplified pyramidical composition, the two white-clad figures are firmly modeled. Surrounding them are shrubs and flowers drenched with the bright light of an afternoon sun. The light palette in the painting demonstrates the artist's adaptation of the Impressionistic style. Broad strokes and the summary treatment of clothing and background show a painter in command of her craft.

Painting this portrait, Klumpke remarks, "led to my being invited to go to Boston, where several orders for portraits awaited me." With surprise, she adds that "all this [was] due to the favorable reception of my portrait of Mrs. Randolph Coolidge."[28]

Before Klumpke's departure for the States, Bonheur invited her once more to By, extending also an invitation to her mother. Convivial and dressed in her fine velvet gown to impress the new guest, Bonheur gave them a most friendly welcome. Serving them a fine *déjeuner*, which she shared with her favorite lapdog, Gamine, she talked about her work and showed them "her sanctuary." Bonheur also engaged in a serious conversation with Anna's mother. Praising her for her accomplishments as a sin-

gle parent, she said, "You Americans are recognized masters not only for bringing up your horses but especially your children. You know how to go about it. [You] serve as a model to our French mothers and [can] show them the unexpected result of such a liberal and intelligent regime."[29] Then, asking Anna to send her a photograph of herself, she presented her with a drawing and a large steel engraving. Bonheur said, "These are for you. I have dedicated them to you. I want you to take them with you to Boston as a reminder of your friend in France. . . . I wish you all success in your work over there. Do not forget me and let me hear from you."[30] In a final request, she asked Klumpke to send her sagebrush and weeds from the Western plains, which she wanted in order to represent faithfully the setting for her large picture of wild horses. "Sagebrush surely did not grow on Boston Common, nor was it so easily procured as the French artist seemed to imagine," Klumpke later wrote.[31] Yet she was mindful of Bonheur's wish as she sailed for the United States in the fall of 1891.

Chapter Five

The Lay of the Land: Boston in the 1890s

Boston could not offer the heady cosmopolitan atmosphere of Paris, yet as a cultural center of the New World it prided itself on being the literary and educational capital of the United States. Referred to as "the Athens of America" and identified as the birthplace of the Brahmin intellectual elite, Boston saw itself as being both traditional and progressive.[1] It took for granted that the best and earliest painters in America had belonged to Boston and perceived itself as a champion of modern French painting. As an emerging modern metropolis, Boston had by the 1880s tripled its area through annexation and landfill; like Haussmann's Paris, it became a city "in all respects better than before." Indeed, the newly developed area was judged to have given Boston "its West End, its fashionable quarter," comparable to London's; it was thought to have made possible Boston's transformation into a great city that might astonish visitors into thinking of St. Petersburg or Paris.

Aside from the commitment to music,[2] inspired by Vienna, the musical capital of the day, Bostonians liked to think of themselves as art lovers. William Morris Hunt (1824–1879) was their aesthetic guide: "What he said just as much as what he painted inspired a devotion to art."[3] His thorough knowledge of French art, in particular the new manner of the Barbizon painters, determined the character of the city's artistic sensibility. Yet, while art appreciation at the end of the century was distinctly marked by a Francophile bias, the actual "making of art" remained traditionally centered around the painting of portraits. Observing them in great num-

bers on a visit to Boston, the French critic S. C. de Soissons frankly thought that the city was "overflowing with this kind of art. In every house, in every family, you can see many portraits. . . . In every great gallery, in every exhibition, there are portraits almost without number."[4] Even though the popular appeal of portraits was not unique to Boston, reflecting also the preferences of the Parisian bourgeoisie, for example, the Bostonians' commitment to patronage had ensured that portraiture and, above all, its public exhibition were now prominent features of the art scene. As such, it made up a justifiable element of de Soissons's totalizing vision.

To talk about a glut of portraits is inevitably to raise questions about their makers. Who were some of the artists in Boston in the 1890s? Working in a city together with hundreds of other portraitists meant competing for attention from a few critics and a small number of other persons who constituted the informed audience.[5] How did this critical mass of "validators" treat the painter and his or her work? More specifically, what are some of the factors that helped a painter "to become visible, stay visible, or become more visible to those with a voice in the public sphere"?[6] In trying to answer these questions, this chapter explores the city's art scene in the context of a Parisian painter and her work.

Klumpke reached Boston in the fall of 1891. Returning to her native country after an absence of twenty years, she settled in a studio apartment at 132 Boylston Street in the center of the city.[7] With paintings she had brought from Paris, she made her entrée into the public arena in January 1892 with an exhibit at the prestigious St. Botolph Club, located nearby at 85 Boylston Street.

Though there existed in Boston at the time a proliferation of social organizations, the St. Botolph Club represented a unique blend of Brahmin gentility and liberal thinking.[8] Proclaiming itself an exclusively male organization, the club's declared purpose was to promote "social intercourse among authors and artists, and other gentlemen connected with or interested in literature and art." As "proper Bostonians," the Botolphians typically were well-bred sons of good Protestant families, Harvard educated, and prominent in the professional establishment. Yet, founded perhaps quite deliberately as an "improvement" over other clubs in the city, the St. Botolph club was novel in a number of ways. First, it promised a more substantial commitment to the arts than any other club at the time. In contrast

to the annual or biannual shows held by other art institutions in the city, the club offered up to eight a year. A sampling of art-related topics presented during the 1890s testifies to the breadth of the members' interests: Impressionism (discussed by the painter Frederick Vinton in 1891), Oriental art, the art of photography, and architectural decoration. Although the club was criticized for consistently poor sales at its exhibitions, it provided an ambiance where persons interested in the arts could enjoy congenial company and, if they desired, aesthetic experiences. Another unique aspect of the St. Botolph Club was its support of women artists. Aside from the group shows of the mid-1880s, which included works by Klumpke's contemporary Ellen Day Hale as well as paintings by Amanda Brewster, Helen Knowlton, and Dora Wheeler, an individual show was organized for Sarah Wyman Whitman in 1889.[9] As the wife of a club member, Henry Whitman, her personal connection undoubtedly helped to open doors. But if nepotism was to some extent responsible for this first show, artistic integrity was not necessarily compromised: Whitman was a talented landscape, portrait, and still-life painter. This show led to other individual exhibits, such as the one installed for Elizabeth Strong in 1890;[10] it featured thirty-eight animal paintings, most of which were on loan.

Having set a precedent with a number of solo shows by women, the St. Botolph Club opened its 1892 season with a comprehensive exhibit of Anna Klumpke's works. Consisting of thirty-eight oils and pastels, the display included both large Salon works and small sketches. Assembled in a private room, Klumpke's paintings were hung for aesthetic appreciation and intimate discourse. Even though the club's stated purpose involved "social intercourse" rather than marketing paintings, Klumpke succeeded in selling six of her works and also received several orders for portraits. A show at the St. Botolph Club, it seems, could satisfy the needs and wishes both of the spectator-members and of the artist-exhibitors.

A closer look at *The Dream* (Emile Zola) reveals the type of paintings the Botolphians saw at Klumpke's first show in the United States (Plate 7). Inspired by Zola's latest novel, *Le Rêve*, this large canvas, signed A. E. Klumpke, Paris 1891, depicts two young women viewed against the light of an open window.[11] Seated on opposite sides of a long trestle table, they are embroidering the cross of an altar cloth. Though they look like sisters, they are in fact mother and daughter. While Hubertine, at the window, bends forward, absorbed in her task, the sixteen-year-old Angelique is in reverie. She is gazing out toward the mass of a Gothic cathedral.

"Beautiful as a star," to use Zola's words, she is dreaming of marrying a handsome, rich prince. The outline of her soft profile is silhouetted against a dark brown interior; her blonde hair, wispy around the forehead, is drawn up in a knot on the crown of her head. She wears a pale blue dress and a matching apron, with a gauzy white shawl across her shoulders. The walls are grayish white, bare except for a small crucifix; the floor tiles are old and worn. The margins of an open book, a copy of *The Golden Legend*, by Jacques de Voragine, draw the viewer's attention to the lower left of the canvas.[12] Near the book, a large wicker basket with reels of gold cord and bobbins of silk suggests the family embroidery business. A smooth surface, a limited palette of ochres and golds with fleshy tones, and a firm modeling of the figures reveal the painter's academic training. Reminiscent of Vermeer's images of women at a window, Klumpke's picture seems bathed in a light that is both natural and symbolic.

In addition to other Salon pictures, the printed brochure listed several portraits, including that of Elizabeth Cady Stanton and Mary Hill Coolidge. The portrait of the artist's mother attracted special attention. According to one visitor, the figure, with its firmly modeled forms, could "hardly be too highly commended."[13] Remarks of this kind reveal the extent to which Léon Bonnat's realist style had permeated the prevailing critical discourse. Painterly brushstrokes and eccentric compositions tended to disappoint the Bostonians, as was manifested in the reviews of John Singer Sargent's shows at the St. Botolph Club in 1888 and 1890.[14] For the majority of conservative New Englanders, portraits had to be conventional, stressing photographic verisimilitude and simplicity of form—the style favored by Klumpke.

It is fitting to view her first show in Boston against S. C. de Soissons's account of the city's portraitists.[15] Listing approximately a dozen of the many hundreds then practicing the art of portrait painting, he lauded the achievement of Frederick Vinton, noting that it was extensive and of great value. Although de Soissons complained about the monotony of the stiff poses, which he thought interfered with the truthfulness of the portraits, Vinton's work contained individuality and distinctiveness. Singling him out as a portraitist of men especially, de Soissons praised him for his realist and forthright style, which, like Klumpke, Vinton had "adopted" from Bonnat.

Of the four women portraitists de Soissons discussed, he was careful with his praise for Sarah Whitman, who, he said, possessed "some talent."

He recognized her teacher William Morris Hunt's influence in her works, but thought that she did not have power enough to reach his level. He preferred the "originality" of Adelaide Cole Chase, "her natural, full-of-movement poses, brilliancy of coloring and great boldness of brush." Young, with her formal training still in the future, Chase seemed to de Soissons a promising artist.[16]

According to the French critic, the most successful portrait painter was Robert Gordon Hardie. He complimented him for his refined, brilliant paintings of ladies, as well as his "very strong portraits of bankers and rich people." He especially admired Hardie "for always looking for something new." Whether this would be for the better was, according to de Soissons, impossible to say, but he hoped that it would be, "for the sake of American art."

Though many painters specialized in portraits of children, de Soissons singled out Robert W. Vonnoh as the most accomplished, judging his works to be "artistic in the highest degree." The French critic shunned the children's portraits by Phoebe Jenks, however. He considered their pinkish faces crude in coloring, and he could not bear the combination of stiff draperies with conventional and awkward poses: "They are puppets set up against the invariable curtain as a background." Although conceding that there was "some sweetness in the expression of these charming little beings," he thought of this as an "outcome" of Jenks's femininity.

De Soissons concluded his survey with Edmund C. Tarbell and Frank W. Benson.[17] Categorizing them as genre painters rather than portraitists, he nonetheless believed that the men had also achieved a certain success in their portraits. He added, however, with a sense of despair that the portraits were "painted entirely in the old style. Why, why do they not try to introduce atmospheric effects in their portraits?" In sum, "the great trouble is that the majority of portrait painters work in the old way, on the principles of old times, and that is the reason why we see so little 'go,' if we may use this common but expressive word."[18] Making due allowance for the more restricted range of critical language in use at the time, perhaps his complaint about "so little 'go'" reflected his bias toward an Impressionist style; this, however, was not yet comme il faut in Boston.

As a matter of fact, de Soissons had scant appreciation for American portraitists in general, stating frankly that "few are of real artistic value."

Yet, for all his prejudices and ambivalent statements, he served the painters well. Regardless of the aesthetic practices that were being espoused, his comments mediated a discourse and created an art context that helped to make the artist visible or more visible at a given time.

With wider reference to women and the practice of art in Boston in the last decades of the nineteenth century, issues of visibility and validation become problematic. As numerous contemporaries observed, Boston was known for its unusual number of women artists.[19] The earliest and largest single group were the students of William Morris Hunt, the Bostonians' aesthetic leader.[20] Disregarding the formal academic training of the day, which was based on the study of the nude, he instead taught his students to draw freely with the easy brushwork of the Barbizon painters and to devote themselves to the study of nature. An innovative teacher in several respects, he took their professional aspirations seriously, apparently making no concessions to contemporary theories about the fragility of the female psyche.[21] Hunt taught, however, only from 1868 to 1871, after which he gave the direction of his class to his student Helen Knowlton (1832–1918).[22]

Several of the Hunt-Knowlton women painters spent time in Paris studying art. In addition to copying the Old Masters at the Louvre and the Luxembourg Museum, they attended classes at one of the many private academies. Occasionally, some women even succeeded in entering works in the Salon before returning to Boston.[23] While the academic training shared by the women abroad strengthened their drawing and technique, few if any developed a truly professional style.[24] In pointing out the problems in the mentoring system that Hunt established, it has been argued that however well-intentioned Knowlton's initiative may have been it nonetheless helped to feminize the school.[25] The students trained with women, painted with women, and most often exhibited with women, all of which positioned them and their work within the distinctive idiom of separate spheres. Despite the obvious talent and promise of many of these women artists, they remained members of what was essentially a Boston school, and hence were by extension stigmatized as regional painters.

The informal training that the first generation of Boston's women artists received is in marked contrast to the academic programs that became available later in the century. The most important of the new educational centers was the Museum School. Summarizing the women's

accomplishments in 1896, Boston's leading art critic, William Morris Downes, remarked:

> A word should be devoted to the women painters. Every year we see more and more of these sisters of the brush and palette coming forwards as doughty competitors to the men, and nowhere do they threaten more serious rivalry than in Boston, where such artists as Sarah C. Sears, Frances C. Houston, Sarah W. Whitman, Susan H. Bradley, Marcia Oakes Woodbury, Lilla Cabot Perry, Alice M. Curties, and Laura C. Hills need only be mentioned to show that the democracy of art regards neither sex nor "previous condition of servitude."[26]

To what extent this second generation of Boston women figured as "doughty competitors," collaborators, or both is a question beyond the scope of this book. More important here is to recognize the 1890s as a transitional decade in Boston's history of women artists, one that saw them grow from a "coterie of women" centered on Hunt and Knowlton to a critical mass of professional painters in the twentieth century.

The sheer number of women who sought affirmation as artists in formal and informal settings confirms the compelling and complex nature of their quest. By sending their works to public and private galleries, art associations, and other institutions, they sought to contribute to and participate in the mainstream of the city's cultural life. As exhibitors they had the opportunity to become visible in a public context. Yet, their experience as career women was also shaped by the traditional practices of exclusion. Barred from membership and thus active participation in artistic organizations like the St. Botolph Club and the equally prestigious Boston Art Club, the Boston women, along with Klumpke, were institutionally marginalized in their work as professional painters.

Although a position outside the frame of the dominant discourses is important in determining a common experience, Klumpke managed to sustain an identity as a woman artist that made her different in important ways. Besides her seniority in relation to the women at the Museum School, Klumpke was set apart by her credentials. There was no woman in the Boston art community in the early 1890s whose educational record could compare with Klumpke's extensive academic art training;

moreover, no other woman artist could boast of a ten-year record as a Salon exhibitor.

Important as it is to establish Klumpke's identity as a well-trained, experienced professional, it is just as important to examine how her work was evaluated in Boston. Though professional art critics had yet to appear on the scene, educated observers and reporters nonetheless had the power to authorize points of view and, more important, enable the artist to become visible in a competitive arena.

Some observations about the first generation of women artists may serve to put the situation in context. Although these women met with considerable approval, a mixed response from critical observers was typical. On the one hand, their works were praised as vigorous, fresh, and sincere in feeling. On the other, they were judged deficient in technique and lacking in refinement.[27] The women's alleged lack of finish and weak draftsmanship may reflect the debate that had developed in the late 1880s on the validity of Hunt's informal teaching methods. Since men wrote the bulk of nineteenth-century criticism, perhaps such comments also reflected their authors' preconceived views about the value of these women's work.

It is illuminating in this context to mention briefly the problem of gender in art criticism. By exposing the power of language, Sarah Burns has convincingly shown how contemporary discourses on sexuality and power encoded gender difference and hierarchy into the reception of works by Cecilia Beaux and John Singer Sargent.[28] She argues that even though the boldness of Beaux's technique prompted some to describe it as virile or masculine, those signs were almost always offset by some perceived softening feminine traits. The linguistically and socially constructed qualities of womanly softness were no match for Sargent's manly firmness of intellect.[29] Next to his bold images, hers were described as intimate and delightfully alive, a stance that stressed her craftsmanship rather than her artistic talent. In view of this interpretation, it is possible that writers helped to shape thoughts and mold attitudes along similar lines when discussing the Boston women.

The question of what standards a woman critic was to adopt remains. Though Burns does not address the issue, her argument on gendered criticism provides a useful stepping-stone. In the rhetoric of art criticism of the late 1800s, the basis of the encoding system, Burns claims, was an authoritative mix of the masculine and the feminine that only male artists

could attain. If Thomas Wilmer Dewing, for instance, appropriated the feminine in his soft, tonalist works, this did not compromise the force of masculine expression. Instead, it exemplified a masterful synthesis, a dovetailing of the masculine and the feminine. Within the frame of a dominant discourse that asserted and exalted the "natural" superiority of men's intellectual and creative powers, no one, including women critics, questioned the association of boldness and strength with masculinity. In other words, the socially constructed qualities of manly firmness and intellect became the single standard and determined how women critics judged women painters. Several articles signed "Greta" in the *Art Amateur* support this argument. The critic's interpretation of Ellen Day Hale's stunning self-portrait of 1885, *Lady with a Fan*, is especially revealing.[30] Finding the picture "refreshingly unconventional and lifelike," the reporter noted that Hale "displays a man's strength in the treatment and handling of her subjects—a massiveness and breadth of effect attained through sound training and native wit and courage." Endorsing the idea that inspiration, boldness, and strength were typically male qualities, Greta bolstered gender difference linguistically in her evaluation of a woman's work. As Burns notes, the notion of creative power was very much a one-way street: male artists had the best of both genders.

This raises the question of how a talented, thoroughly professional artist like Klumpke managed to gain notice from the largely male critical community. Beginning with the 1892 show at the St. Botolph Club, the reviews seem to have quickly acquired a distinctive pattern. Whether they appeared in well-established daily papers, in weekly publications, or even in syndicated columns outside Boston, they invariably paid tribute to her Parisian credentials. Typically, a reviewer would praise her skill and technique. Although some reporters certainly described shows in a merely perfunctory manner, only listing names and sitters, several sought to be discriminating. For example, one critic in 1892 praised Klumpke for her "fine perception of people and of things." He went on to say, however, that "[i]n spite of her exceptional talent as a painter"—and there were, according to him, few women painters living who were more talented in this respect—the works lacked romance and dramatic feeling. The painting *The Dream* (Emile Zola), for instance, had "only the superficial character of an illustration done in cold blood." Indeed, one could "not quite forget the model who dreams at so much per hour."[31] In this critic's judgment, Klumpke's work lacked sympathy and seemed to be an exhibition of only

her craftsmanship. As there was no Salon competition by which to measure excellence in Boston, the writer there felt confident in faulting a work like *The Dream* (Emile Zola), which the demanding jury in Paris had accepted the previous year.

Voicing their opinions in the pages of the local newspapers, reporters continued to enhance Klumpke's visibility as a painter. A report on the 1894 Chase Gallery exhibit *Portraits and Pictures* in the prestigious *Boston Sunday Herald* discussed some of the sitters, stressing the expressive animation, natural poses, and individualized features.[32] Although no less a promoter of her fine work, another reviewer of the same show struck a more controversial note. Selecting "the important full-length and life-size *Portrait of Miss D*" (unlocated), the writer gave the artist credit for having succeeded in indicating the extremely difficult "act of coming down-stairs—not at all an easy subject for the artist to undertake."[33] Even though he found the painting "distinctly praiseworthy in conception," the reporter criticized the formal elements of color and composition and thought that the work left "something to be desired." The majority of reporters, however, voiced support for the traditional-realistic values of Klumpke's portraits. In fact, one of them had been "pronounced by Paris art critics as in Sir Joshua Reynolds's best style"; it was further reported that James McNeill Whistler "had asked to have it sent over there" to London.[34] A reference to a comparison with the great Reynolds may indeed represent one form of gendered criticism; yet, the words seem an honest attestation of excellence rather than a polite compliment couched in linguistic ambiguity.

The overall impression left by a survey of the art-critical reviews might be summarized as follows. First, in contrast to the fairly short reports on shows by Boston women, many of the review articles about Klumpke compared favorably in length with the coverage that Boston's male artists received. Second, instead of the cursory descriptions of the works that were customary at the time, the reviewers tried to point out issues in order to explain the goals of the artist. Interested in the expressive content of a picture and its technical execution, they praised Klumpke when she exhibited these qualities and faulted her when she fell short of their expectations. In other words, even as she was accorded the status of a remarkable painter of portraits and genre scenes, Klumpke was also judged according to a more rigid—and by extension fairer—system of criticism than was customary for her Boston colleagues.

In their role as bearers of authority, these editors, critics, and other persons helped a woman artist to become and remain visible. A report in the *Boston Daily Advertiser*, perhaps by a woman, must have played an especially important part in Klumpke's quest to become even more visible.[35] Describing a visit to the painter's apartment and studio, the long article gave Bostonians "A Glimpse of Miss Klumpke among Her Artistic Bric-à-Brac."

> Her home is just what an artist's home should be. It is at the top of one of the old Beacon St. houses, 82, converted into business rooms. Up the three flights of stairs you climb until you find yourself in a strange place quite unsuggestive of anything Bostonian and conventional. . . . From the four tall, narrow windows of the drawing-room, one looks over the public gardens as on an enchanted land, whether it be summer or winter. Within a bright fire burns in the old-fashioned open grate. Odd chairs, carved or cushioned, quaint, graceful tables, book cases well filled, and two bewitching old spinning wheels are scattered in artistic groupings over the Japanese matting that covers the floor and intensifies the soft coloring of the many rugs. . . . One corner contains a divan screened by Turkish draperies and made comfortable by numerous pillows covered with Oriental rugs and embroideries. . . . In the studio there is even more informality than in the other rooms. Battered old brass pans and copper kettles of Moorish and Breton origin lie close to queer bits of pottery and modern books.[36]

With an eye on the displayed works, the visitor added:

> Studies abound in the room. . . . The walls of delicate blue are nearly covered by fine paintings, and on an easel stands a superb portrait of a mother and child, most picturesque and beautiful in arrangement and painted with a masterly touch. . . . On [other] easels are canvases on which Miss Klumpke is now at work.

In constructing an artist's identity, a studio thick with atmosphere had become inseparable from the image of the flourishing, cosmopolitan

painter in urban America.[37] Working as a powerful advertising mechanism, the studio was the novel and attractive "packaging" that the artist devised to lure customers. A noteworthy case was the studio of William Merritt Chase, at 51 West Tenth Street in New York. Like Chase's colleague and illustrator, John Moran, who guided the *Art Journal* reader through the artfully assembled habitat, Klumpke's visitor provided free publicity and helped construct the image of the well-traveled, highly cultivated artist in a tasteful studio interior. Even though Klumpke's studio did not pretend to be a salesroom in disguise, as Chase's exotic studio was, the description of her interior decoration with its "stuffs and bric-à-brac," constituted fine publicity. With this kind of promotion in the newspapers, the painter gained an identity associated with a cosmopolitan art atmosphere that stood her in good stead.

Klumpke's popularity, in part a result of this kind of visibility in the press, is manifest in the number of commissions she received. In a letter to her father in San Francisco she wrote, "I will have earned 5,000 dollars at the end of this year, of course I have various expenses but still I think this is very well for the first year, all through my painting."[38] The sum of $5,000 was equivalent to the yearly salary of a professor at Harvard University. It represented the income from about seventeen portraits, each selling for approximately $300.

Before discussing the group of Bostonians who supported the painter with commissions, one more comment needs to be added about this city and the art of the early 1890s. Klumpke arrived at a time when the public and the critics tended to favor the French-inspired style that she represented. As the decade progressed, taste in Boston became more adventurous and progressive. Two women artists, Cecilia Beaux and Lilla Cabot Perry, would challenge Klumpke's special status in the city with their solo exhibitions at the St. Botolph Club later in the decade. Although most of Klumpke's success grew out of her French training and her cosmopolitanism, that success also sprang in part from a happy accident of timing.

Chapter Six

A Circle of Friends: Variations on the Theme of Patronage

Visiting the United States late in the nineteenth century, a French traveler observed:

> If Massachusetts and Boston in particular are justly proud of the men they have produced, they are not less proud for having seen born a group of women who would be difficult to find anywhere else. "Comment les nommer toutes?"[1]

The favorable impression that Boston women made on this visitor from Paris was characteristic. According to Mrs. Ednah D. Cheney, a writer and reform worker who contributed a chapter on this topic in the *Memorial History of Boston*, there was indeed a type of "Boston Woman" whose attributes were clear and recognizable.[2] Arguing that her contemporaries were both traditional and progressive, Cheney sketched a portrait of the educated Boston woman as a transmitter of refined culture and a model for reform and change. She declared that such women were "aristocratic by tradition," "liberalized by education," and "democratic in [their] work." By referring to them as aristocratic, Cheney was not speaking of a hereditary caste, but of a known and visible part of the Boston elite who possessed wealth, talent, and respectability and who seemed liberal for their acquired learning and cultivation and democratic for their spirit of civic obligation. Stressing their charitable and reform

activities, Cheney recognized their important contributions to society and referred to their various involvements as part of "an onward career."

In developing her essay, Cheney made this important qualification: "[Some] Boston women are still more remarkable for their virtues in single life." She believed that a Boston woman (like the widowed Mrs. Cheney herself) could earn her living "by labor of any kind if she be honest [and] intelligent, . . . without losing the respect . . . of the most refined and respected."[3] Addressing one of the liveliest topics of the last third of the century, Cheney concluded: "Surely never before to women were nobler opportunities open than those which the near future promises."[4]

A closer look at the women who supported Klumpke in her career as an artist reveals significant parallels with Cheney's woman. On the one hand, there is the aristocratic, privileged Bostonian, who commissioned portraits or bought her paintings; on the other, there is the single woman Lilian Whiting, earning her own living, perhaps even Klumpke's promoter in the anonymous 1893 article in the *Boston Daily Advertiser*. Their respective activities in the public sphere are both abundant and revealing. For the former, these centered on work in educational reform or charitable organizations; for the latter, they involved a busy schedule in journalism.

The application of a gender-specific perspective to the artist's clientele needs to be clarified, however. It should be evident that Klumpke did not paint portraits of women exclusively. Her American works include several male sitters and children of both sexes. (See Appendix.) Yet, as is clear from the exhibition data, the majority of her portraits depict women. Noting this, the press wrote about the artist's special talent in capturing their individuality. One reviewer pointed out, "She has perhaps painted more portraits of an exclusive set of women in Boston—where she now is—than any American girl who ever won name and fame abroad."[5] In part because of such press comments, Klumpke gained a reputation as a painter of women's portraits.

This narrative on patronage begins with Mary Hill Coolidge, Klumpke's friend in Paris.[6] Providing the portraitist with prospective clients even before her arrival in Boston in the fall of 1891, she gave Klumpke ready entrée into the city's Brahmin society. The artist herself observed: "Her kind recommendations have made me a whole circle of *précieuses relations*. I rather quickly received enough portrait commissions to keep me busy for years."[7] Not surprisingly perhaps, members of the

Hill and Coolidge families, living on fashionable Beacon Hill, were included in this first group of sitters mentioned by Klumpke.

In addition to a shared sociocultural position, these and subsequent patrons were, predictably, Protestant. The Unitarianism that most of them had inherited from generations of New Englanders lay at the heart of a tradition founded on intellectual learning and integrity. Moreover, supporting the arts was part and parcel of a well-off Bostonian's intellectual identity. For some, this may have been a matter of enlarging an already sizeable art collection; for others, commissioning a portrait may have involved more personal motives. In both cases, however, commissioning and collecting art was a creative activity with significant aesthetic and social dimensions, which included varied commitments outside the domestic sphere.

These characteristics are typical of the clients in nearby Cambridge who supported Klumpke. Centered around the Longfellow family at the Craigie House on Brattle Street, most of these patrons were connected to Harvard University by family ties. Foremost among them are Alice Mary Longfellow and Lilian Horsford, two ambitious women who sought to make a Harvard education available for women.

The oldest daughter of Henry Wadsworth Longfellow, Alice (1850–1928) was raised by a devoted widowed father "who believed entirely in self-reliance."[8] Growing up with an understanding that she was free to shape her own course, she recalls: "In truth my father was very reserved with his children. In spite of his sympathy and understanding he preferred to instill certain fundamental principles by habit in the example of his own life and then . . . in any uncertainty always said, 'You must decide that for yourself.'"[9]

Alice was in her early twenties when she decided to make educational reform her most important public involvement.[10] With Anna Eliot Ticknor she was a founding member of the Society to Encourage Studies at Home (SESH), a program of private lessons for women conducted through monthly correspondence.[11] Out of this project grew the Woman's Educational Association (WEA). Unlike the SESH, with its methods based on home study, the WEA was progressive, demanding collegiate instruction for women comparable to that offered to men at Harvard.

Lilian Horsford (1847–1927) joined Longfellow in her activities at the WEA. The daughter of a chemistry professor at Harvard, she had always

had an ardent desire for further and broader education; she explained that, since Harvard College was the chief source of what she had always wanted, it was only natural that she made education prominent in her life's work.[12]

Working together as members of the Harvard Examination Board, Longfellow and Horsford were instrumental in founding the program known as the Harvard Annex. It was designed to offer women the equivalent of a Harvard curriculum, with visiting Harvard professors as instructors. More ambitious than most other programs available to women, it was fraught with structural problems, which were compounded by a lack of information and clarity regarding the standards and purposes of the new women's colleges and of collegiate coeducation. A decision in 1879 to make Elizabeth Cary Agassiz a member of the newly formed executive committee marked an important turning point in the struggle for educational rights. Before long she was made head of the project. A childhood friend of the Harvard president Charles William Eliot, Agassiz "never *seemed* brilliant, though she could quietly hold her own with anybody anywhere."[13] Agassiz's ideal of education, like her personal conduct, was an exceptional blending of the conservative and the progressive. Bound by the prevailing concept that independent careers and marriage were incompatible, Agassiz did not advocate careers for all women, but she did advocate superior education for all women—both those who would work outside the home and those who would devote their lives to domestic responsibilities. In keeping with this double-sided attitude toward women's educational reform and womanly behavior, she did not want to create another women's college, but to open the opportunities of Harvard, with full academic equality to her own sex.

Trusting the judgment of their new leader, Longfellow and Horsford allowed Agassiz to confer with Eliot on matters of consequence and deferred to her conclusions. As members of the executive committee, they agreed "to work noiselessly without taking sides," heeding Agassiz's advice that "[w]hen a thing seems to be running not quite smoothly, it is generally the best thing to let it alone [until] every one will realize the need of a change."[14] Such seems to have been the case in 1894, when Radcliffe College became a degree-granting institution for women.[15] Speaking for Longfellow and Horsford at the opening ceremony, Agassiz reconfirmed their approach, saying, "I do not believe in an aggressive

policy. I believe in making [the Harvard men] our allies. . . . Patience and silence after all seem best."[16]

By upholding gentility and contemporary standards of femininity, the Cambridge women disguised their progressive demands.[17] Not accustomed to speaking formally in mixed groups or to receiving public acknowledgment of their work, they had been raised to be "unobtrusive." Their mode of operation was compromise and mediation rather than confrontation and attack, even when they believed very strongly in their cause. The Unitarian tenets of self-help and self-respect that so strongly imbued the ideology of these women may well explain their determination and devotion. But, whatever the case, there can be no doubt that they did get things done "noiselessly" and "without taking sides."

Longfellow's and Horsford's contacts with Klumpke date from the final years of debate and deliberation in Cambridge about women's educational rights. Indeed, these discussions were going on at the same time as parallel battles for women's rights in Paris, perhaps giving rise to an exchange of ideas on this complicated and controversial topic. Exactly what prompted Horsford to commission a portrait and Longfellow to purchase two pastels (*Veux-tu faire dodo* and *Elles font dodo*) can only be guessed at.[18] What is clear is that by loaning their works to local exhibitions and to national shows such as the 1893 World's Columbian Exposition in Chicago, the Cambridge women helped to promote Klumpke's work. Already leaders in educational reform, they concurrently assumed the role of patrons, an important aspect of their private and public interests.

Aside from contacts with such educational pioneers as Longfellow and Horsford, Klumpke's circle also included women who were among the first to pursue a "career"—to use Cheney's word—in volunteerism. The benevolent work of Cornelia Adeline Granger Winthrop (d. 1903) and Mary Lothrop Peabody (d. 1911) in general, but especially in connection with the founding of the Convalescent Home for Children at Wellesley Hills, is most notable in this context. These novice administrators were faced with soliciting, managing, and disbursing funds,[19] as well as "paying personal visits" to the children, bringing in provisions like clothing and house linens, and raising funds for endowed "memorial beds."[20] With no institutional support or financial aid from the Children's Hospital in Boston, the scope and scale of their unpaid service work was enormous.

The difficulties and problems Winthrop and Peabody faced as administrators and fund-raisers would later fall upon Klumpke's shoulders in

her relief work in France during the Great War. In the 1890s, however, when she was seeking to establish herself as a painter in Boston, artistic concerns dictated her position vis-à-vis these women. Painting a pastel portrait of Winthrop (unlocated) and selling her French genre painting *Old Woman at Carcassone* (unlocated) to Peabody, Klumpke benefitted from the financial rewards of employment and from the opportunity to show her creative powers at public exhibitions.[21]

As a result of increasing recognition and approval of her work, Klumpke's social life was enriched by many personal friendships.[22] Patrons invited her to their homes, some for extended periods to facilitate the sitting schedule for a portrait, others for social and recreational occasions. That the support of the painter went beyond mere professional matters is manifest in numerous letters Klumpke later wrote to her friends in Boston. In one, for instance, she said, "You and your family have always been so cordial towards me and I shall never forget those delightful weeks spent in your family and that of Mrs. Dana [Alice Longfellow's sister]."[23]

The social interaction during the Boston years was, however, not one-sided. Klumpke reciprocated with evening parties, gathering a "galaxy of the choice spirits of Boston and Cambridge . . . artists, poets, musicians, men and women of letters, [in short] a most interesting assembly of friends."[24] Aside from these intellectual "salons," she also scheduled weekly receptions, opening her studio for private and public viewing.

Included in Klumpke's circle of friends were also a number of people residing in such outlying towns as Worcester, Wellesley, and Whitinsville. The most notable of these was Sarah E. Whitin (1836–1917).[25] A childless, relatively young widow, she had ample opportunity to develop her independence of spirit. Ambitious and energetic, Whitin served with unassuming diligence on village committees, entertained local clubs, and lent moral and financial support to fund drives for charities.

In addition to taking a keen interest in community welfare, Whitin was also a trustee on the board of Wellesley College from 1896 to 1917.[26] Her decision to establish an observatory equipped with a telescope may not seem as historically significant as the work of Longfellow and Horsford. Yet Whitin's commitment was as serious and dedicated as theirs was.

To give structure and coherence to the narrative of Whitin's work as benefactress, it is useful to connect her ambitions with those of Sarah Frances Whiting, the first professor of physics and astronomy at Wellesley

College. In her account of the circumstances around their meeting and subsequent work together, Whiting explained, "By an unpremeditated combination of events, which we are wrongly apt to call chance, Mrs J. C. Whitin, a recently elected trustee of the college, became interested to purchase a telescope, which had been used by the writer when teaching astronomy in Brooklyn and which was offered for sale."[27] Whitin bought the telescope and donated money for a building to house it.[28] Expressing her interest in this new venture, Whitin wrote, "My desires grew by the information they fed on, and I desired to do what I did do correctly, and I always liked the correct thing to look well!"[29]

As part of her need to do things correctly, Whitin delved into technical questions ranging from installing equipment to landscaping.[30] Consulting with astronomers, among them Professor Edward C. Pickering of Harvard College, she wondered "who could find out the true meridian so that the instrument [could] be properly placed"; concerned about the proximity of the observatory to the railroad tracks, she hoped it would not be "affected by the jar or smoke from the [railroad] cars."[31] Whitin employed the best-qualified horticulturist to plant appropriate trees and shrubs; when the building was nearing completion, she supervised the finishing details. She asked the architect to order two oxidized-iron ash barrels for the cellar, recommended that they have ribs down the sides to protect them, and drew a picture so there could be no mistake about the matter.[32] Reflecting her faith in Professor Whiting and her students, she made certain that everything was easily manageable by women alone. As the project was coming to an end, one trustee remarked, "Never has a person taken greater interest in every detail of a building—and rarely has one lived near enough to make such frequent visits."[33]

The dedication of the Whitin Observatory took place in Houghton Memorial Chapel. A number of leading astronomers attended, including Professor Edward Pickering from Harvard and David P. Todd, director of the observatory at Amherst College.[34] They were joined on the platform by President Hazard of Wellesley, Whiting, and her colleague Ellen Hayes, professor of mathematics and chemistry at the college.

Strategies for fostering women's place in astronomy were subtly yet clearly taken up at the ceremony by the Wellesley professors. In the inaugural address, Pickering traced the history of this branch of science. Todd spoke of his special investigations of solar eclipses. Whereas these speeches emphasized past standards or personal accomplishments, the

dedicatory addresses by the women professors looked to the future. At stake, for them, was the question of professionalism. To make their point, they read letters from three women in other countries who had done "creditable work in astronomy."[35] Lady Huggins was mentioned as the wife of a distinguished astronomer. Agnes Clerke of London was cited as the author of a history of astronomy. The last of the letters was signed by Dorothea Klumpke. Introducing her as an American woman who was now working in the Paris Observatory, President Hazard stressed the attention that her research on the rings of Saturn had attracted. The emphasis upon Dorothea Klumpke's prestige was deliberate; it was intended to encourage a future generation of women astronomers to pursue a career in science based on original research. Rather than see women turn to teaching, or charting the stars and documenting photographs for their male colleagues, the Wellesley professors, and Whiting in particular, hoped that they would prove themselves equal to men, as Dorothea Klumpke had done at the Paris Observatory.

The Wellesley instructors' active encouragement of their women students can be understood to some extent by thinking about it in the context of the changing scene in the science of astronomy.[36] A small field until the 1880s, it was growing rapidly as the science of photographic astrophysics was being introduced. In 1881, Edward Pickering of the Harvard Observatory had become the first astrophysicist to attain a position in this new field. In contrast to the direct observations of traditional astronomy, astrophysics required a sizeable number of assistants to record, document, and classify the photographic plates that the larger telescopes were generating. Pickering's adoption of this more advanced technology of cameras and spectroscopes had great implications for women in science, since it required maintaining a large labor force. But if Pickering aided progress by greatly expanding women's employment in astronomy, he was not so far ahead of his time that he promoted them to "men's work."[37] Most female assistants remained at the same level for decades, and thus had no alternative but to make a career of a job that should have been just a stepping-stone to more challenging and prestigious roles. A comment made by Williamina P. Fleming (a Scottish immigrant, divorcée, and mother, who remained in her own position for three decades) sums up the situation most tellingly. Impatient with the tedious working conditions and low salary, she remarked: "I feel almost on the verge of breaking down. There is a great pressure of work cer-

tainly, but why throw so much of it on me, and pay me in such small proportion to the others, who come and go, and take things easy."[38] Although there were, of course, many other arguments that restricted women's place in the sciences, it is clear that sex stereotyping in astronomy made the very word "professional" in some contexts a synonym for an all-male, and hence high-status, organization.[39]

Though most aspiring female astronomers were indeed forced into marginal positions, there were nonetheless a number of women who established themselves as contributing members of the scientific community. Their accomplishments in the last decade of the nineteenth century mark a turning point in the history of women astronomers, making these forerunners the first generation of public achievers in a fast-growing field of science.[40] Perhaps without really meaning to, Sarah Whitin had provided a way to highlight the status and activity of women astronomers during a critical phase of their entry into the profession.

Whether Whitin commissioned Klumpke for a portrait to commemorate her donation of the telescope and observatory remains unknown. Although no finished painting has been found, a preliminary sketch of the donor hangs today, appropriately, in the library of Wellesley Observatory. In this small canvas ($10^1/_2 \times 14$"), Whitin is depicted in an almost frontal view with her head slightly turned left. The brushstroke is scumbled and the background is unidentified. She is wearing a formal dress whose broad, white, flimsy collar falls over her shoulders and chest. Her graying hair, pulled tightly away from her face, is held in place with a decorative band at the top of her head. Holding a book in her hands, Whitin seems to have been caught in the act of reading. An unassuming sketch for today's viewer, it represented at the time of its execution the likeness of an ambitious and important benefactress.

Klumpke's friend Lilian Whiting represents another example of Ednah Cheney's "remarkable Boston woman." Though she was born and raised outside New England, both her parents, Lorenzo Dow Whiting and Lucretia Calistia Clement Whiting, were of New England descent.[41] (Her father's ancestors included the Reverend William Whiting, the first Unitarian minister in Concord, Massachusetts, and her mother was a descendant of the seventeenth-century Puritan Cotton Mather.) The only daughter and oldest of the three children, she was educated by private tutors and her parents in a home abounding in books. Of her early years in Illinois, Whiting noted, "I do not remember learning to read, I was sim-

ply steeped in the literary atmosphere of our quiet country home."[42] At an early age she turned toward writing as a career. Gaining experience as an editor first at a local paper in Tiskilwa, Illinois, and later at the *Cincinnati Commercial*, she finally decided to enter the competitive arena of Boston. Establishing herself at the Brunswick Hotel on Copley Square, an address she kept for the rest of her life, she found employment at the *Boston Traveller* as an art critic at ten dollars a week; in 1885, she became literary editor and writer of the column "Le Beau Monde," which covered a wide range of topics.[43] Her first local assignment was to interview her childhood idol Kate Field, an actress, author, and lecturer; they subsequently formed an intimate relationship. In the 1890s, Whiting moved on to become editor in chief of the *Boston Budget*, a weekly home journal for which she wrote editorials and book and art reviews.[44]

Like most editors, Whiting saw the paper under her control not only as a means to make a living but also as a way of proclaiming her views, beliefs, and political ideas. As a literary critic, she kept her readers abreast of the popular novels of the day. She reviewed, for example, Paul Bourget's "psychological fiction," *Cosmopolis*, discussed the latest novels by Henry James, and gave her impressions of Henrik Ibsen's new drama *Hedda Gabler*, which she found "intensely psychological" but not as gripping as his *Doll's House*. Whiting was especially impressed by Charlotte Perkins Stetson's (later Gilman) story "The Yellow Wall-paper," writing that the terrible dénouement had not been equalled in American literature since the stories of Poe.[45] As a writer of the newspaper's "Fine Art Notes" she covered a potpourri of art-related subjects, including, of course, the latest news from the Paris Salon. In one article she described the day of the awards at the Salon; it was the year when Klumpke received honorable mention for her 1885 portrait of Augusta. Perhaps this occasion represents Whiting's introduction to the name and fame of Anna Klumpke.[46]

Numerous articles focused upon Whiting's favorite topic, the "woman question." A lecture by Mrs. Henrietta Wolcott, "The Work of the World's Women," was touted as one of the most careful, comprehensive, and valuable résumés of the present status of woman's work that had yet been made. Quoting Wolcott extensively, the article noted:

The idea of working for a money compensation outside of the home is comparatively new and distasteful to many. . . . [But] money compensa-

tion has always a strong attractive force and it is not to be wondered that women desire to possess it for itself as a lever with which to move obstacles in limited spaces.[47]

Whiting specifically mentioned the women of the press, "their arduous duties and responsibilities as editors and sub-editors," as well as the "host of less gifted and less fortunate women who are laboring industriously and conscientiously to make their vocation an honored one." In another article, she gave voice to her belief in the "universality" of work, of "women working hand in hand with men."[48] Basic to her argument was the belief that "woman's work" was "either a component of the world's work or it [was] nothing."[49] Clearly, for Whiting, anything short of equality of opportunity was inadequate.

The subject of woman suffrage was a complex one for the *Boston Budget*'s editor. She supported Elizabeth Cady Stanton and Susan B. Anthony for their contributions to the woman's movement, especially applauding the gains that had been made as a result of their demands for educational reform.[50] She admitted that it would be hard in this enlightened age to offer any tenable reason why a woman should not vote if she wished to. But, Whiting wrote, she doubted woman suffrage would be wholly desirable for the body politic. She was not convinced that "the quality of womanly life would be ennobled and elevated by active participation in politics." She thought that the subject was "well-worn," arguing "that there [were] higher pursuits for women than party politics."[51] She admitted that there were still "unjust laws to be fought against, wrongs to be righted, help to be given, and prejudices to be worn away," but she insisted that "it would all have to be done by a calm and persistent appeal to a sense of right of the majority. Tears and scolding will have no effect whatever."[52] In other words, there were many ways to ameliorate women's positions outside the field of political activism.

Whiting's place as a journalist is complex and multifaceted.[53] As editor of a weekly society paper rather than the elitist, male-dominated *Boston Globe*, she was acting within the womanly sphere. Yet, as a member of the editorial and reporting forces in Boston, she had a place in the ranks of newspaper workers that gave her access to the public realm. Deservedly proud, she proclaimed, "I am a writer by profession." In contrast to the privileged women in Klumpke's circle, Whiting had a career with remunerative reward.

It is, then, not possible to see Klumpke's friends through the filter of sameness. The women came from different family backgrounds, which affected their lives and their work. Though there were many ways in which privileged women could extend their culturally circumscribed space, their heritage conditioned how they saw themselves and how society expected them to act. A single professional woman like Whiting, on the other hand, could appropriate what was basically a male space to serve her own purposes of independence, financial and otherwise. In brief, the concept of a Boston woman had many faces. For that reason generalization, as tentatively outlined by Ednah Cheney, was overly simple from the very beginning.

Having considered the diversity of these women's contributions, is it, nonetheless, still not possible to link their varied activities and argue for their unity of purpose? In viewing nonsalaried work by privileged women as an occupational career, Arlene Kaplan Daniels makes an important and original contribution to understanding the relationship between "visible" and "invisible" careers.[54] Although her focus is upon today's women, aiming to reveal the many forces that keep their work in volunteerism invisible, her interpretive approach also seems applicable to women of the past.

Obviously, each woman in Klumpke's circle of privileged friends had her own story and her own motive for working outside the home. Obviously, too, each woman's work would always remain in one sense marginal in a society governed by the cash nexus. One motive, however, seems common to them all: volunteerism, whether on behalf of educational reform or charity, was a way of crossing borders; it was a way to gain access to public roles. The pervasive cultural stereotype of Lady Bountiful tempts one to associate women's work with leisure.[55] By proclaiming the professional character of volunteer work, however, Daniels forces one to reconsider the absurd convention that defines "real" work as only that for which one is paid. Klumpke's women friends in Cambridge and Boston and Whitinsville were privileged, but they were not necessarily "leisured." In their determined pursuit of clear goals, they showed how they could apply their notions of work in career terms. Committed to their respective areas of expertise, they were in their way as professional as the woman who wielded a pen, or for that matter as the painter herself. Whether salaried or unsalaried, their activities were linked by a unity of purpose. Indeed, as a group of patrons around a

Parisian artist, they represented a microcosm of those women Cheney might have thought of as the most remarkable thing in Boston.

Along with influential patrons in Boston, the 1890s produced an array of patrons in other parts of the nation. My emphasis here is not so much upon their public commitments as on their personal connection with Anna Klumpke. Perhaps the most representative figure among them is Mary Copley Thaw (1842–1929). One of the grandes dames of Pittsburgh, she was as well known for her "will to win" as for her riches and largesse.[56] The daughter of Josiah Copley, a newspaperman and religious writer (of whom it was said that if his pen were ever paralyzed the pulpit was always waiting), she was raised a righteous Presbyterian subject to the rigors of Calvinism. Her girlhood was spent in Kittanning, a small rural town near Pittsburgh.

Mary Copley was twenty-five years old when she married William Thaw, one of the city's pioneers of industry and philanthropy.[57] A widower with five children, he was almost thirty years her senior. Described as the transportation wizard of his period, he was no less respected in Paris than in Pittsburgh.[58] A chronicler notes of their relationship, "If she was wilful as a child, headstrong, and insistent on having her own way, that quality did not abate with marriage, except that she permitted her husband to have his own way. Or rather," he adds, "she agreed not to work at cross purposes with him or in any way to abrogate his rights."[59] Indeed, although they sometimes worked hand-in-hand on philanthropic endeavors, they were more often engaged in separate projects. After the death of her husband in 1889, Mary Thaw took up his philanthropic commitments, expanded upon her own work in charitable organizations, and traveled.[60]

In 1895 Thaw and Klumpke met in Paris: Thaw wished to "make the rounds" of the artists' studios; Klumpke wanted to perfect her skills in the difficult medium of pastel drawing.[61] She had hoped to receive instruction from François Thévenot, not realizing that he did not take on students. Klumpke writes that on hearing about Thaw's interest, she arranged a meeting with Bonheur, a visit greatly appreciated by Thaw and her two daughters. At Thaw's suggestion they subsequently visited the Thévenot studio, where Thaw bought one of the artist's pastels. Klumpke did not miss the chance to remind him, tactfully, that she had come to Paris from Boston with the intention of becoming his student. Thévenot said noth-

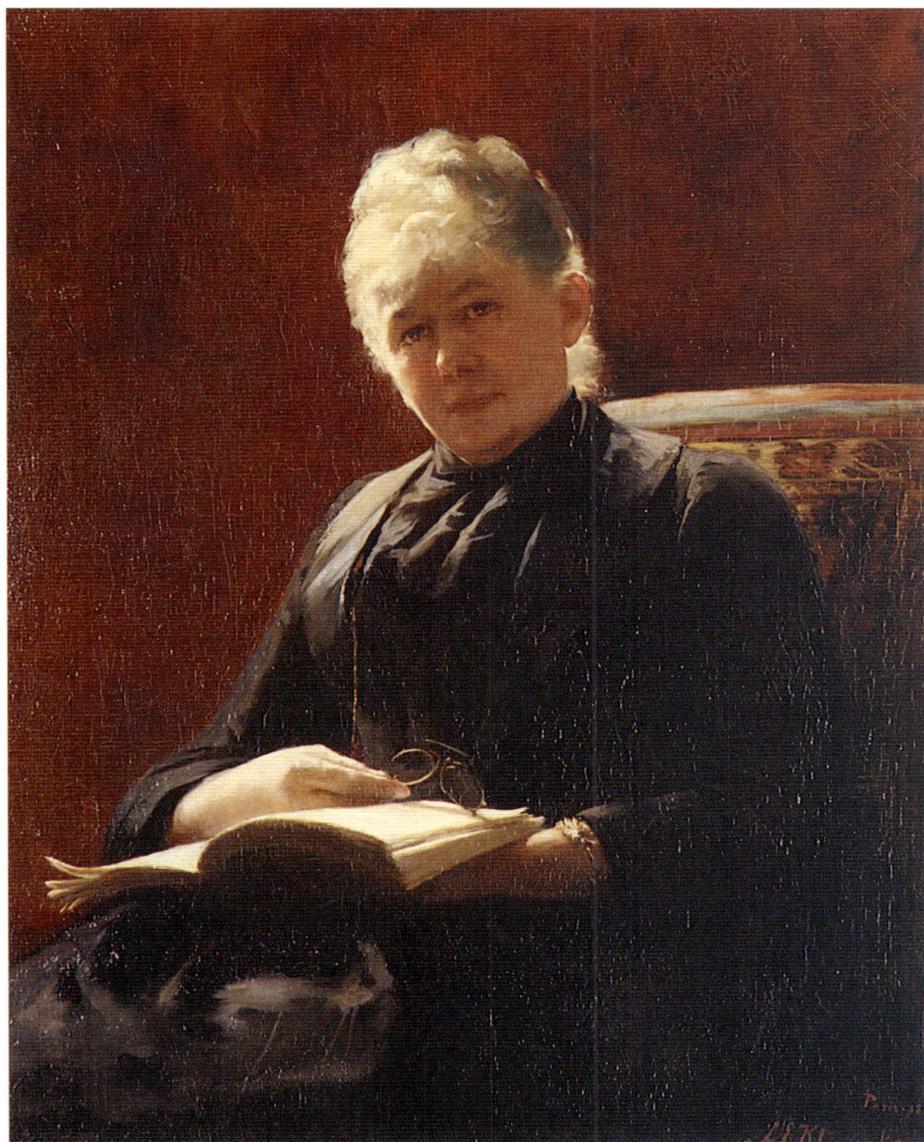

Anna E. Klumpke, Portrait of My Mother, *1889, oil on canvas, 35½ × 28 inches.*
Catherine A. Mueller Collection.

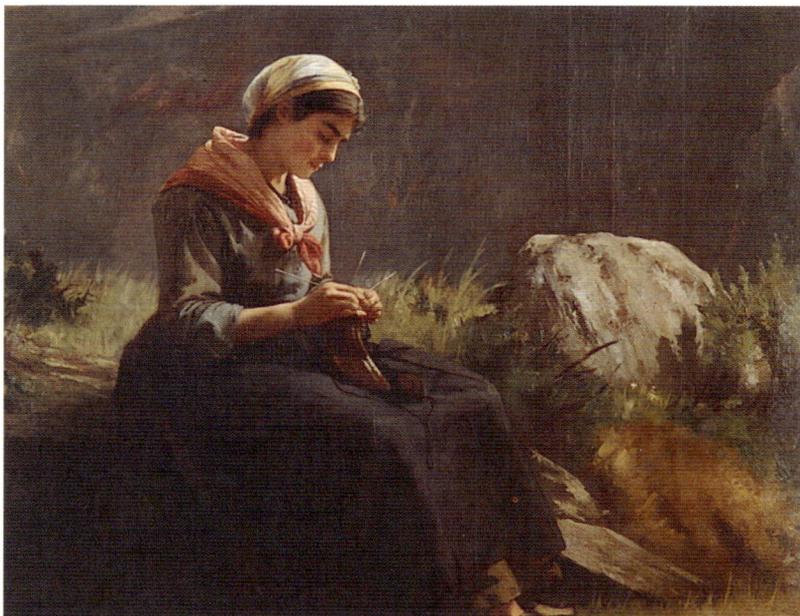

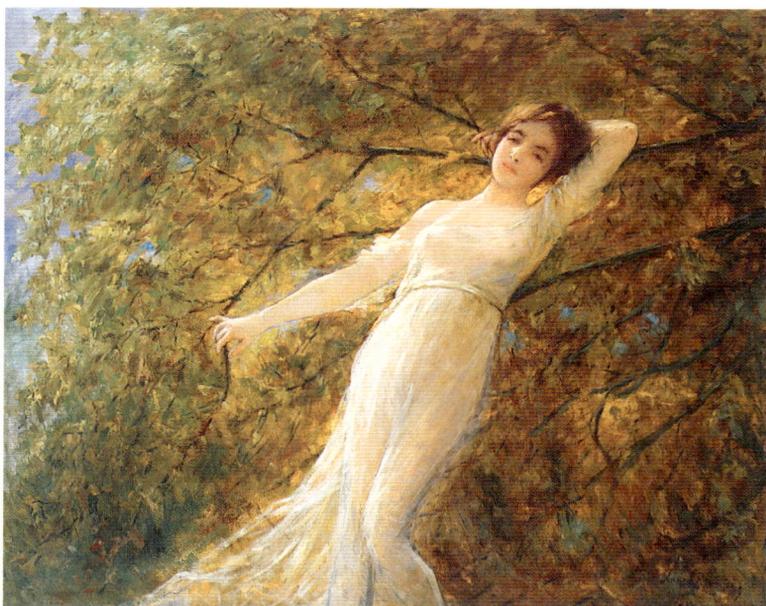

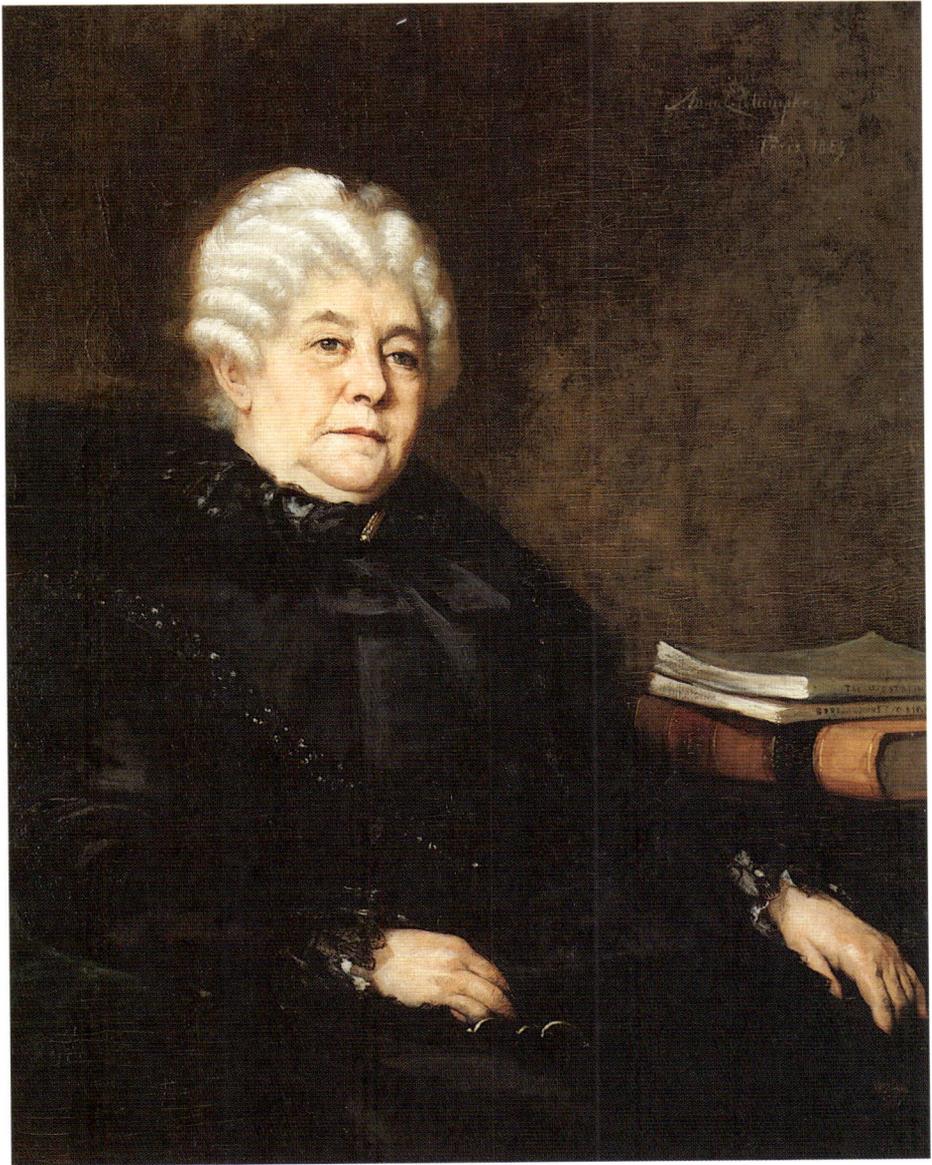

PLATE 4.
Anna E. Klumpke, Portrait of Elizabeth Cady Stanton, *1889, oil on canvas, 39¾ × 32½ inches.*
National Portrait Gallery, Smithsonian Institution, Washington, D.C. Transfer from the National Museum of
American History; gift of the National American Woman's Suffrage Association through Mrs. Harriot Stanton
Blatch, 1924.

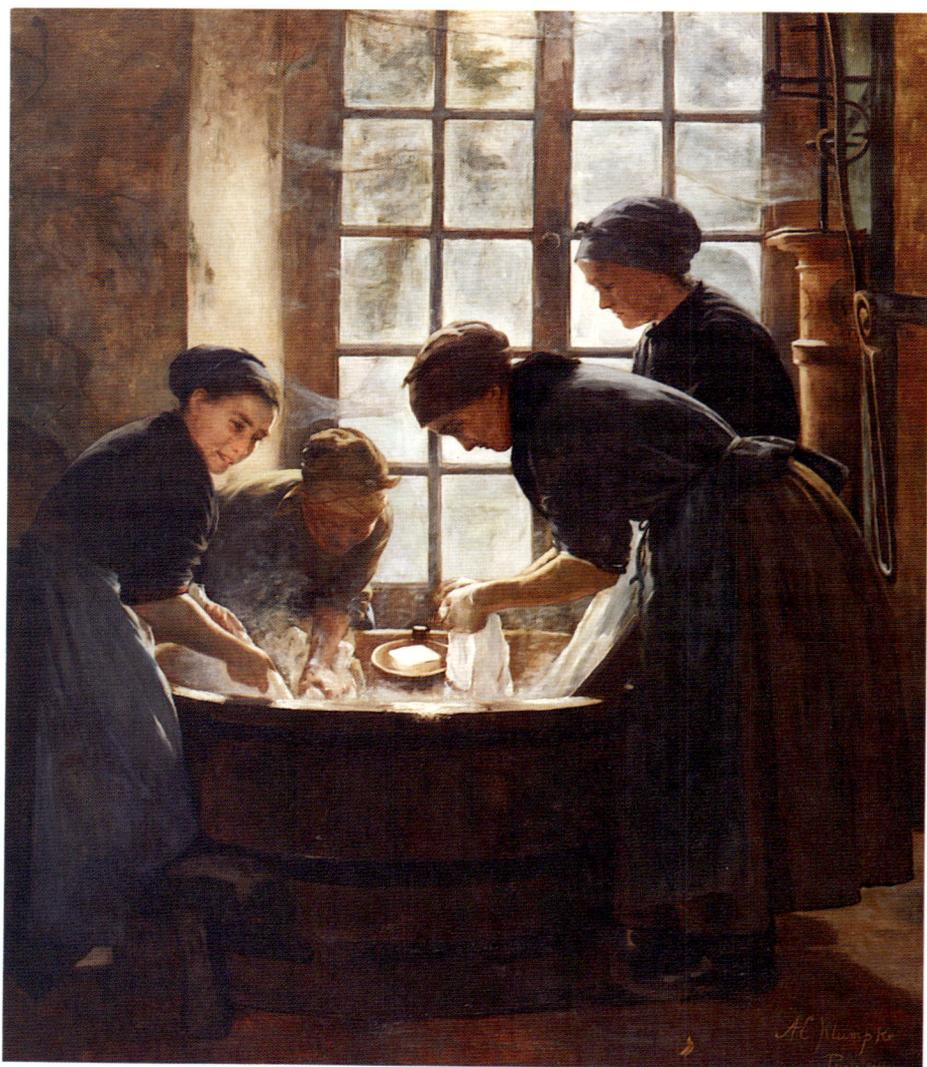

PLATE 5.
Anna E. Klumpke, In the Wash House, *1888, oil on canvas, 79 × 67 inches.*
Pennsylvania Academy of the Fine Arts, Philadelphia, Pennsylvania. Gift of the artist.

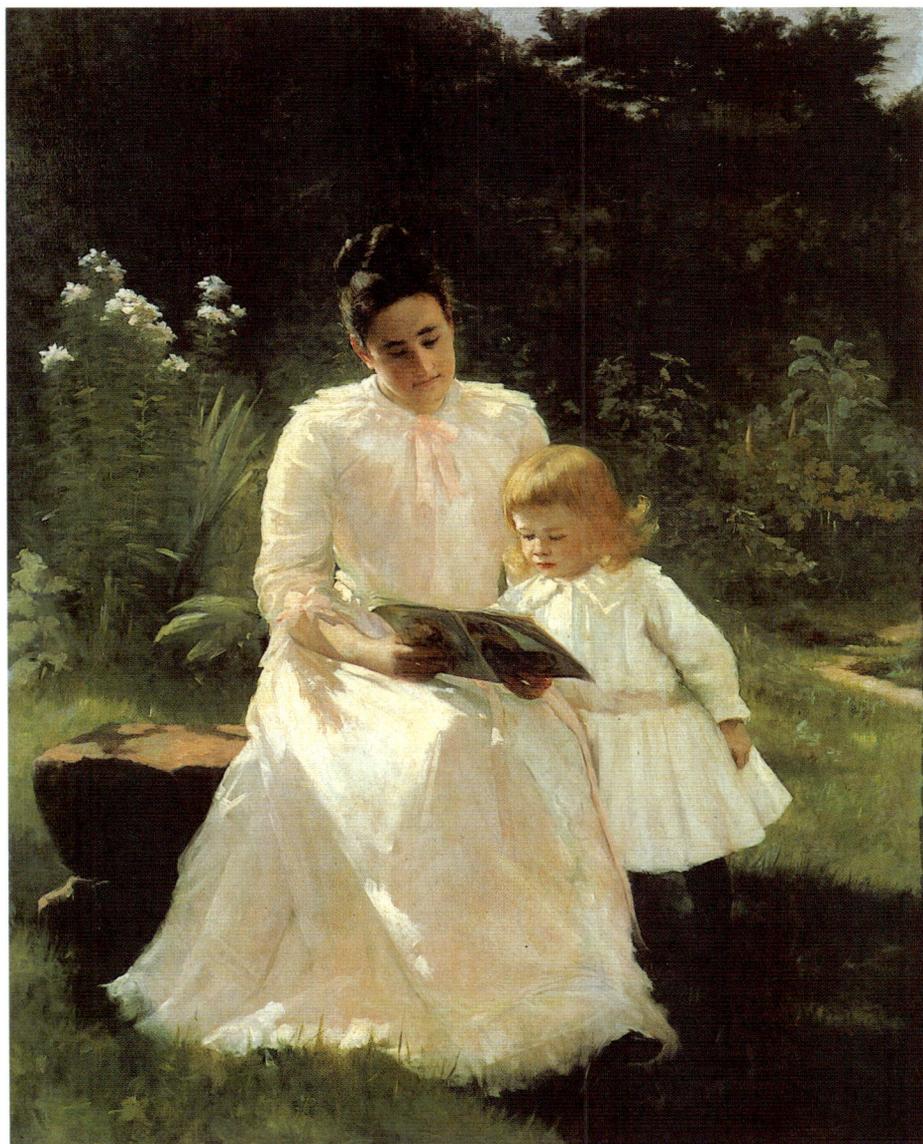

PLATE 7.

Anna E. Klumpke, The Dream (*Emile Zola*), *1891, oil on canvas, 51¾ × 33¾ inches.*
Geist Collection.

PLATE 9.
Anna E. Klumpke, The Artist's Father, *1912, oil on canvas, 38½ × 46 inches.*
Fine Arts Museums of San Francisco, San Francisco, California. Gift of Anna Klumpke, DY40039.

ing to give her any hope. A few days later, however, he informed her that he was able to take her on as a student for three months beginning in May. Klumpke attributes his change of mind to Thaw. How her Pittsburgh friend communicated with the Frenchman is not known. Thaw's educational background was limited; she was cultured but not learned. Knowing how to command, however, Thaw seems to have got her message across to Thévenot.

In addition to helping Klumpke in Paris with her professional aspirations, Thaw made an extraordinary effort to promote the painter in her native Pittsburgh. Inviting Klumpke to her home at Lyndhurst and commissioning her for a portrait (Private Collection), she was also instrumental in organizing a much publicized exhibition at the Gillespie Gallery in February 1897.[62] An article in the *Pittsburg Commercial Gazette* appropriately highlighted the patron. Headlined "Mrs. Thaw's Portrait," it discussed Klumpke's Parisian credentials and some of the works on view at the Wood Street gallery in downtown Pittsburgh.[63] One of several reports on Klumpke in the *Pittsburg Bulletin* introduced the artist to the public as "Pittsburg's Distinguished Visitor, Miss Anna E. Klumpke, at Work." A photograph showed the artist in her Paris studio with her painting *The Dream* (Emile Zola) on her easel. Underlining Thaw's patronage, a reporter added: "The picture on the wall at the left is now owned by Mrs. William Thaw—it is called *Old Recollections.* . . . The old model who stood for it is the one who was the model for Millet's famous picture of 'The Angelus.' "[64] Clearly, additional meaning was conferred on Klumpke's work by appropriating the name of a famous French artist.

The success of the Gillespie show was heralded in an article of May 1898, which credited Mrs. William Thaw for an "exhibition [that] was one of the events in last year's history of art in Pittsburg." Summarizing Klumpke's *tournée artistique*, which in addition to Pittsburgh included shows in Cincinnati, San Francisco, and Chicago, the writer appropriately acknowledged the Coolidges of Boston for introducing Klumpke to the American art public.[65]

Representing an extended circle of friends, Thaw resembled the Boston women in several ways. Like them she was Lady Bountiful, investing her time and energy in benevolent societies. Also like them, she accepted her marginalized position and role in society. Yet, her knack for ruling and getting her way made her quite different from the Boston women. Rather than waiting for the right moment, as Agassiz, Longfellow, and Horsford

proposed to do, Thaw argued her way through a problem. The Pittsburgh astronomer John Brashear once remarked, "Never enter into an argument with Mrs. Thaw! You have lost before you begin."[66] When Thaw espoused a cause (whether the founding of a country college or a religious mission) or aided an individual, she took on her responsibility absolutely and commanded respect. Not surprisingly, she gained Klumpke's recognition as the perfect fairy godmother ("une véritable fée bienfaisante").[67]

In promoting the painter, Thaw developed a relationship that was dedicated in equal measure to art production, social and professional interaction, and friendship. Yet, of all Klumpke's associates, it was Anna de Peyster Douw Miller who played the most dramatic role, in that she provided the artist with the courage to approach Bonheur to sit for a portrait. The rapport between patron and artist in the process of painting portraits helps to explain how Klumpke came to return to Paris.

A native of Albany, Anna de Peyster Douw Miller (d. 1921) was of proper Hudson Valley lineage, tracing her ancestry back to the earliest Dutch settlers of Rensselaerswyck, as the Albany area was then called.[68] Intelligent and well educated, she was the daughter of Volckert P. Douw, known as "the rich man of Albany." In 1877, she married George Douglas Miller (1847–1932), a native of Rochester, New York, who took over his wife's real estate business there, in New Haven, Connecticut, and elsewhere.[69] The couple settled in Albany.

Travels to Europe had kindled her cultural interests; it was only natural that Anna Miller would be drawn to the art center of Boston, where she may have met Klumpke. In 1897, the Millers asked the painter to come to Deer Island, a summer resort a mile down the St. Lawrence River from Alexandria Bay, New York, to visit them and to paint their portraits.

Klumpke was then in San Francisco to visit her father after not having seen him for twenty-five years; she was pleased to find him well. A successful exhibition of her work in the galleries of the Mark Hopkins Institute furthered buoyed her spirits. Gratified by her sojourn in her native city, she decided to accept the Millers' invitation and stop at their home on her way back to Boston.[70]

Of the two portraits Klumpke painted at Deer Island, only that of George Miller has been located.[71] It is a large picture, measuring 48 × 35³/₄", Miller is portrayed in a three-quarter pose with his beloved St. Bernard dog on his left. Wearing an olive-colored suit, a white shirt, and a light green tie, he stands slightly turned to the left in a casual pose; his

jacket is pushed back by his right arm and his left arm rests on the dog's back. A subdued golden light from the right of the picture highlights the top of his head and the left side of his face and shoulders.[72] The artist's fine wispy line defines Miller's pointed beard and his rather large drooping mustache. The dog's brownish coat with fluffy white patches is rendered in broad strokes, standing in sharp contrast to the smoother areas of the animal's large floppy ears and wet black nose. While the dog stares at the viewer with a direct and unflinching gaze, Miller's eyes look away from the viewer in a pensive, almost vacant manner. The light palette captures the characteristics of a portrait *en plein air*, a technique familiar to the artist. Yet, Klumpke felt less certain of her ability to do justice to the four-footed animal. In a letter addressed to Bonheur, she confided: "I am now at work on the portrait of a man, posed out of doors, with an effect of sunlight. There are trees for a background, I have a large dog posed near the sitter (the dog is so restless!), and I hope to succeed."[73]

Klumpke recalls that while working on the portrait of George Miller one day their conversation turned to Bonheur and her expertise in painting animals.[74] In awe of this "illustrious" artist, her host had said, "How proud you must be to have the friendship of such a woman," adding, "Oh, if only Rosa Bonheur would come to America and venture to Deer Island, what a reception we would give her! Let's invite her in our name. We could ask her to paint our Saint-Bernard, who would obligingly serve as a model. We would have a portrait painted by two artists." Amused at such an idea, Klumpke replied, "Just like the portrait of Rosa Bonheur by Dubufe."[75] "But yes," replied her hostess seriously, convinced that this image had greatly contributed to Bonheur's subsequent reputation simply because the bull standing next to her had been painted by her own brush. Turning to Klumpke, Anna Miller asked if she knew of more recent portraits of the artist. Replying in the affirmative, Klumpke noted, however, that nobody had been able to do justice to Bonheur's vivacious and energetic character.[76]

It is not hard to guess what followed. Her hostess asked, "Well, then, why do you not ask to paint her? If she were to agree, it would be a great honor to you." Klumpke admitted that she had often considered approaching Bonheur for a portrait, but, she reminded her hosts, "Remember that Bonheur is surrounded by the most famous portraitists: Bonnat, Dagnan-Bouveret, Jules Lefèbvre, and Benjamin Constant who [in addition] are friends of hers. How would I dare set myself up as a candidate?"

The response from Anna Miller was pointed and specific: "But are you not an American? You have to dare. . . . The woman who writes to you in such affectionate terms would not refuse you a favor which she should know would be advantageous for your reputation. . . . Besides, does she not wish to see you again . . . ? She says it . . . twice in the same letter." Klumpke admitted that she was tempted and promised to write to Bonheur. Yet, setting pen to paper was not easy. Describing her struggle, Klumpke recalls: "During my walks along the shores of the river, I thought of thousands of approaches, but invariably gave up, when [one day] a secret voice made itself heard and told me to dare. I began to write: it was September 14; the date has remained engraved in my memory." She began her letter by reminding "chère Mademoiselle" Bonheur of their first meeting, almost ten years ago in the fall of 1889. "I always have your photograph near me," she wrote, "and when discouraged in my work I look at you and you send me courage." She told Bonheur about her stay at Deer Island, and then came to the point:

> The great and ardent desire of my life is to paint a portrait of you. Would you grant me this great honor and give me a few sittings; I know I am asking a great favor. Let me try, Mademoiselle. I shall put into the work my deep gratitude. Our America would be happy to possess your portrait. Your work is on so high a pedestal. Please excuse my audacity. Do not refuse me this great honor. I may pass the winter in New York, where are your paintings of "The Horse Fair" and other works of yours. Could you not arrange to have an exhibition of your paintings in New York? I know you would be honored by every one. . . . Allow me to kiss your hand, and with deep affection, I am,
>
> Yours very devotedly,
> Anna E. Klumpke[77]

Having provided their guest and painter with moral support and having seen their portraits successfully completed, the Millers sent the works to an art exhibition at the new Albany Historical and Art Society the following spring.[78] Part of an ambitious program that included concerts, lectures, and no fewer than ten art exhibits, Klumpke's one-woman show was scheduled for April 25, 1898.[79] The exhibit comprised thirty-nine works,

including portraits and genre paintings that were either for sale or had been loaned to the exhibit. Several of the portraits depicted Bostonians and members of Klumpke's family; the portrait of Elizabeth Cady Stanton was also included.

To promote the marketing of the painter's work, a list of glowing press comments from across the country was distributed to visitors. Announcing the latest item of information, one journalist revealed:

> The best commendation of Miss Klumpke's skill is that she has received, since her arrival this week in Albany, a letter from Rosa Bonheur, unquestionably the greatest woman artist the world has ever known, commissioning her to paint a portrait of herself this summer. An artist could not receive a higher compliment than this, from the head of her craft.[80]

To what extent the Millers were involved in the advertising aspects of this show remains unknown. Perhaps it was they who passed along this sensational bit of news, crediting themselves in a way for having initially prompted the artist to approach Bonheur.

Finally receiving the letter for which she had been waiting impatiently, Klumpke wrote in her biography, "The match was won" ("La partie était gagnée"). Her memoirs include a more personal description of her feelings: "Tears of joy ran down my cheeks. I at once sent to the dear artist my grateful thanks and wrote her I would reach Paris about the middle of May."[81]

She bid farewell to her Bostonian friends, who congratulated her and wished well. Klumpke notes that once again Mrs. Thaw demonstrated her interest in her and all that concerned her. In a letter of good-bye, her Pittsburgh patron observed: "Since this famous woman has invited you to live with her during the course of your work together, make a summary of your conversations each night. These notes will be a valuable memory for you of this important episode in your artistic life."[82] Promising to follow the advice, Klumpke arranged to sail for France. Accompanied by her friend Lilian Whiting, she boarded a Cunard steamer for Liverpool. Moving on to London, they enjoyed the opera season before crossing the Channel for Paris. Klumpke expected to be away from her Boston friends and studio not more than three months.

Part Three

Matters of Choice

Chapter Seven

The Portrait as an Encounter:
A Record and an Interpretation

It was not easy to paint a picture of the most famous woman artist of the century in the hope that one's work would stand comparison with the great tradition of portrait painting. Yet, one should not think of Klumpke's difficulties here as simply practical ones. Nor were they merely the result of the particular audacity and risk involved in the project she had set herself. On the contrary, as Philip De Laszlo has remarked,

> Confidence and sympathy between the artist and sitter are essential,
> because the truly great portrait is the one in which this contact has been
> so close that it has spurred the artist to his highest achievement.[1]

Hence, the difficulties were as much psychological as artistic, arising out of personal experiences, expectations, and the very fond yet contentious bonds that drew the painter and her sitter ever closer.

The 1898 portrait of Bonheur marks the culmination of Klumpke's extensive list of women sitters (Plate 8). Aiming to present both the person and the professional, it belongs to the type of portrayal known as the *portrait d'apparat*. Bonheur is seated next to her easel, holding a study for a painting in her hand. Dominating the canvas, her figure stands out dramatically against the undefined, shadowed background. Her short hair is highlighted, drawing attention to her clearly articulated features. The

medal of the Legion of Honor is pinned prominently to her dark-blue jacket. A smooth brushstroke, a limited palette of earthy colors with fleshy highlights, and a careful modeling of forms reveal the formative influence of late-nineteenth-century realistic portrait painting. The composition, slightly off-centered, is balanced on the left by the partial view of an image of three horses. This painting within a painting probably refers to the subject of "wild horses" that had occasioned their first meeting in the fall of 1889.[2] The rhythmic movement of these animals leads the eye across an empty space to the image of Bonheur. A keen and serious gaze with a shadow of a smile gives her face an expression that hovers between the pensive and the provocative.

It would be hard to exaggerate how much Klumpke insisted that the person on the canvas be knowable, even familiar, to the kind of people likely to view the image, whether at the Salon or at other international exhibitions. The portrait still seems uncannily real and familiar; it seems so unproblematic, in fact, that viewers need to remind themselves that it is both a document and a work of art, with meanings that overlap in a complexity of discourses and professional practices.[3] Based as it is upon conflicting sets of norms—the referential and the aesthetic—a portrait has a dual nature. On the one hand, it represents a real person whose actuality it announces through its title and through its individualizing details; on the other hand, it is a work of art with symbolic values and ideological conventions. Yet, no matter the approach taken in interpreting the painted image, the question of verisimilitude remains at the center of the debate in the history of Western art portraiture.

But portraiture belongs to the category of experience as well as to the category of representation, and as a record of an encounter it needs to be analyzed and assessed on its own terms. From the outset, it is founded upon an agreement between two (or more) persons and depends for its making upon the interactions in this relationship; more to the point, it is created in the context of an ongoing, often extremely intimate and complex network of communicative acts. The sustained contact between artist and sitter should be viewed as a central fact of a portrait, John Gage argues, and a refusal to look at how the painter confronted, associated with, and related to the subject can only be an evasion.[4] Bearing these complex interpretive perspectives in mind, it is now time to analyze and assess Klumpke's portrait of Bonheur.

The narrative proper begins on June 16, 1898. After Klumpke's arrival at the Château de By, the two artists began discussing their work in the studio. In keeping with the rituals of portrait painting, Klumpke and Bonheur went over questions of pose, lighting, and dress, and established a general working schedule. To Klumpke's satisfaction Bonheur had made up her own mind about what clothes to wear, declaring that "this time" she wanted to be represented in a dress.[5] Opening her armoire, she proudly displayed her selection of women's dresses, including a black velvet ensemble consisting of a long jacket decorated with jet beads and a vest that buttoned up the front. Bonheur referred to this outfit as her ceremonial, or "official," dress, saying, "I believe that it will have a good effect in a portrait: this ornamentation of jet produces an iridescent light, and the black luster on the black matte [velvet] is very interesting to paint."[6] She also suggested another, simpler outfit of dark blue cloth with braid loops on the jacket. After deciding that Bonheur would wear the latter, they used the camera to try out a number of different poses. To dramatize the portrait, they agreed upon a *contre jour* light. With Bonheur seated on the platform so that her eyes were at the same level as the painter's, Klumpke took up her position, placing her easel close to her subject.

In the following two weeks Klumpke made preliminary sketches, established the colors, values, and tones of the portrait, and blocked in a suggestion of the accessories. Having established the placement and movement she wanted to achieve in the portrait, she watched for a characteristic expression that would capture her sitter's lively and spontaneous nature. As Bonheur conversed with the occasional visitor, Klumpke was able to focus upon her behavior and gestures. Most of the time, however, the two artists faced each other in the studio alone. Bonheur invariably chose the topic of conversation; listening, responding, and thus contributing to the dialogue that was developing between them, Klumpke worked at her easel (Fig. 5). She recalls: "We talked about art, of course: It was, considering the circumstances, the subject most frequently addressed. But, we entertained ourselves also with [Bonheur's account of] her long life, her friends, her travels . . . and [her views] on moral and religious matters" (60). Though Klumpke confesses that she found herself preoccupied at times with thoughts far removed from the observation of her sitter's physiognomy and distracted from the task at

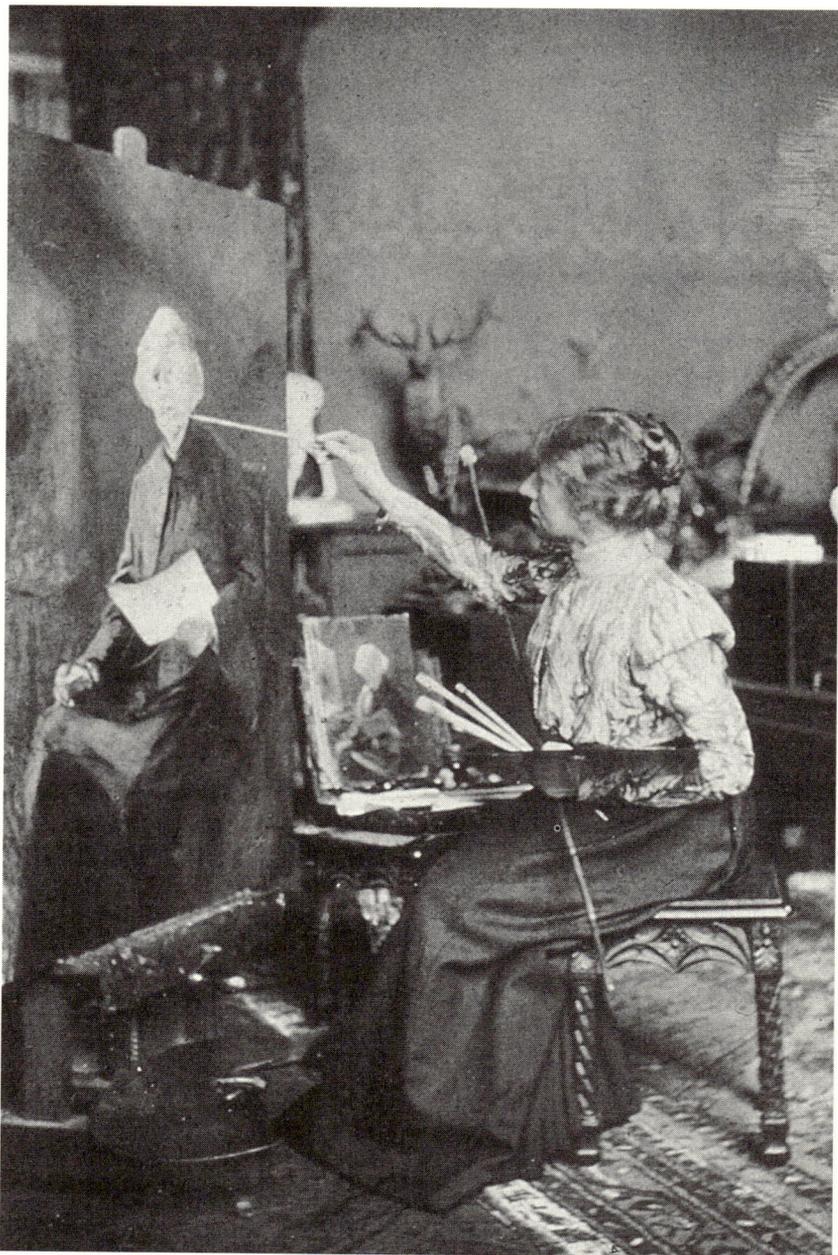

Figure 5. "Pendant une séance de portrait." Photograph from Anna E. Klumpke, Rosa Bonheur, sa vie, son oeuvre *(Paris: Ernest Flammarion, 1908).*

hand, she was delighted with the animated expressions that these conversations brought out from Bonheur.

As the overall shape of the portrait developed on the canvas, Klumpke tried to discover the uniqueness of her sitter's personality and interpret it. Striving for accuracy, the alpha and omega of an academic portraitist, Klumpke took close-up photographs of Bonheur's face. In translating the mechanical image onto her canvas, she softened and erased tangible lines around the eyes and mouth. Masking these and other traits of Bonheur's age (she was seventy-six), Klumpke recorded her sitter with a judicious emphasis on her best features. Having worked up a number of sketches that she felt were beginning to fuse the physiognomic likeness with a characteristic expression, Klumpke decided to show her work to her "masters" at the Académie Julian. Trusting their judgment, she sought to gain an objective view of her project, even guidance on how to proceed.

Known to take an active interest in students' careers after they had left the Académie, Tony Robert-Fleury and Jules Lefebvre had more than artistic advice to give to Klumpke. The former complimented her on the composition and the pose, praised her for the fine head, and suggested that she should begin working on the large canvas. He also advised the painter to seek out a studio in nearby Moret, where she would be more independent, adding that Bonheur could "be authoritarian and *séduisante* [seductive]" (56). Lefebvre was equally impressed with her early studies, exclaiming "What a superb head!" (58).

Klumpke noticed that, in addition to being genuinely interested in her work, they were also curious about the circumstances that had led her to paint Bonheur's portrait. "You are lucky," Lefebvre told her. Voicing regret that he was not in her place, he added that many an artist would be envious of the honor Bonheur had given her. Before she departed, both men wished her success and above all courage in her project.

Klumpke returned to By in good spirits to plan her work for the large painting. After priming the stretched canvas, she squared up her composition and started the *ébauche*, or painted sketch. By July 4, she had finished the head; while waiting for it to dry, she began working on the hands, dress, and accessories.

During these weeks, Bonheur kept a watchful eye on Klumpke's progress. In addition to inspecting the canvas regularly, she observed the younger painter's working methods, correcting her methods of scraping her palette and cleaning her brushes. Klumpke soon discovered that clean

brushes were an obsession of Bonheur's and that she was not satisfied with her tools until the last tiny soap bubble was removed. A confirmed draftsman, Bonheur reproached Klumpke for not making detailed drawings as a preliminary exercise. In addition to her firm belief in such preparatory studies, Bonheur had, as she herself would later admit, selfish reasons for insisting upon these time-consuming exercises.

As far as the progress of the image itself was concerned, Bonheur's praise was unmitigated. She told Klumpke early on in her work that she had a fine eye and an admirable sense of color. As the work proceeded and the portrait began to take shape, she said enthusiastically, "I tell you in all sincerity, it is delightful, quite artistic, full of life" (78). Presenting Klumpke with the ultimate seal of approval, she said with conviction, "It will be good."

If the practical progress on the canvas provided the artist with the confidence she needed to paint a good portrait, her close contact with the sitter influenced Klumpke in unexpected ways. Already during their first dinner together, she had come to realize how superficial her understanding of the older painter had been in spite of their ten years of association. Finding Bonheur in high spirits, she attributed her mood to the ease with which the practical questions had been settled in the studio earlier that day. However, "as if [Bonheur] expected to be compensated . . . for this favor she had given [Klumpke]" (51), Bonheur turned mischievous. Teasing Klumpke for having a nose like that of Cyrano de Bergerac, she asked her younger friend not to pout but to listen as she recited the passage in which Edmond Rostand portrays the nose as the index of a man's "affable, good, courteous, spiritual, liberal and courageous nature." As Klumpke grasped the double meaning of Bonheur's remarks, she felt more at ease (at least as far as her personal appearance was concerned). But, revealing her apprehension, she wrote in her notebook that night, "May God help me and inspire me in the task that I have undertaken, because I have to paint a good portrait" (53).

As Klumpke settled down to a regular schedule, working and living "under the same roof as Bonheur," she became better acquainted with her sitter. It was especially during their daily morning rides into the Fontainebleau forest in a horse-drawn carriage that she began to realize the richness of the older woman's character. Bonheur, who loved these moments in nature, was invariably lively and talkative. Leading Klumpke

to her favorite sites, she could wax poetic about the atmosphere of the morning mist, talk about her Barbizon contemporaries, and then shift suddenly to a discussion of the Old Masters, Goethe, or Molière. Bonheur's broad knowledge and intellectual interests never ceased to amaze Klumpke, who, listening and watching, was ushered more deeply into her sitter's thoughts.

The studio was naturally the place where they spent most of their time together, either working on the portrait, on separate projects, or just relaxing after a day's work while Bonheur smoked her favorite cigarettes. According to Klumpke's account of an incident in early July, when she photographed Bonheur adorned with a laurel crown and standing in front of her easel (Fig. 6), the mood there could become jovial, even intimate. The photograph, Klumpke notes, was taken during a discussion about Bonheur's awards and her disappointment that she had never received any honors from the United States or England, the nations where she had achieved her greatest success. Although Klumpke could not defend the oversight of the English, she explained that in the United States there were no equivalent honors, adding that George Washington "had refused to create such distinctions." To compensate for her country's "deficiency," she took it upon herself, as an American, to honor Bonheur with a crown of laurel that she wove together during one of their walks in the forest. Klumpke recalls that Bonheur had watched her with amusement. Yet, as she placed the wreath on the older woman's head, Bonheur suddenly turned serious. Embracing Klumpke, she said in a quiet voice, "My dear Anna, how I love you! . . . The crown that you have woven is for me the reward for a lifetime of struggle, success and honor" (70). To demonstrate her sincere appreciation, she asked Klumpke (and Céline the maid, who had been called to the studio) to promise that upon her death she would be buried wearing the crown. Klumpke, surprised at the unexpected turn of events, remembers being "deeply touched and unable to say anything" (70). The following day, Bonheur added her caption to Klumpke's photograph, entitling it "Old Europe crowned by young America."

The image of the artist standing at her easel in working clothes served as an important source for a later portrait of Bonheur. Actually, had Monsieur Tony, who saw the photograph and loved its composition, had his way, Klumpke might have taken on this far more ambitious

composition. Bonheur, however, had dismissed the idea; as a result, Klumpke continued to work on the traditional seated pose.

Still, getting to know her sitter well was not an unbroken succession of happy moments. There was something about Bonheur's mercurial temper, with rhapsodic exaltations suddenly changing to outbursts of anger or sadness, that began to affect Klumpke's work and to disturb her. Depending upon Bonheur's mood, or for that matter the weather (the summer of 1898 was unusually hot, with temperatures in the nineties), there were days when Klumpke received only a short sitting or found sessions abruptly cancelled with the words, "I cannot pose for you today . . . do what you want" (80). On these occasions, she was told by Bonheur to slow down, to become more of a *flâneur* (loafer) like herself.[7]

On July 19, Bonheur told Klumpke that she should "forget her work" in order to return to it later "with fresh eyes," adding resolutely that she would have to wait for Bonheur's permission to resume her painting (87). Klumpke had signed a contract to exhibit the portrait of Bonheur at the Annual Exhibition at the Carnegie Institute in Pittsburgh that fall. On July 21, she wrote in her notebook, "I ask myself with anxiety whether I shall manage to finish the portrait in time" (91).

The following day, as they were taking their usual ride in the forest, the discussion became strained and unusually confrontational. Questioning Klumpke's continuing need to seek the advice of her masters in Paris, Bonheur remarked, "I thought that your admiration for me was sincere; but it seems that you have only pity for your old friend" (92). Stung by the comment, Klumpke explained, "I have always had a fervent admiration for you, mademoiselle, and for your talent. Since I came here to paint your portrait, you have been so good, so affectionate toward me, that you have made me forget the genius painter [you are and] instead made me love only the woman. It is your fault if at times I forget the distance which separates me from the *grande artiste*" (92). Irritated and even impatient with Klumpke's deferential tone, Bonheur exclaimed, "Don't bother with your *grande artiste*, love me for myself" (92). Later that afternoon in the studio, as Bonheur continued to mock Klumpke for her admiration of Monsieur Tony, the tension between them came to a head. Klumpke, daring to confront Bonheur, asked, "So you are jealous of Monsieur Tony?" (94).

For the next few days, Klumpke worked on the accessories in the portrait, advancing haltingly, "little by little." In passing, she mentioned her

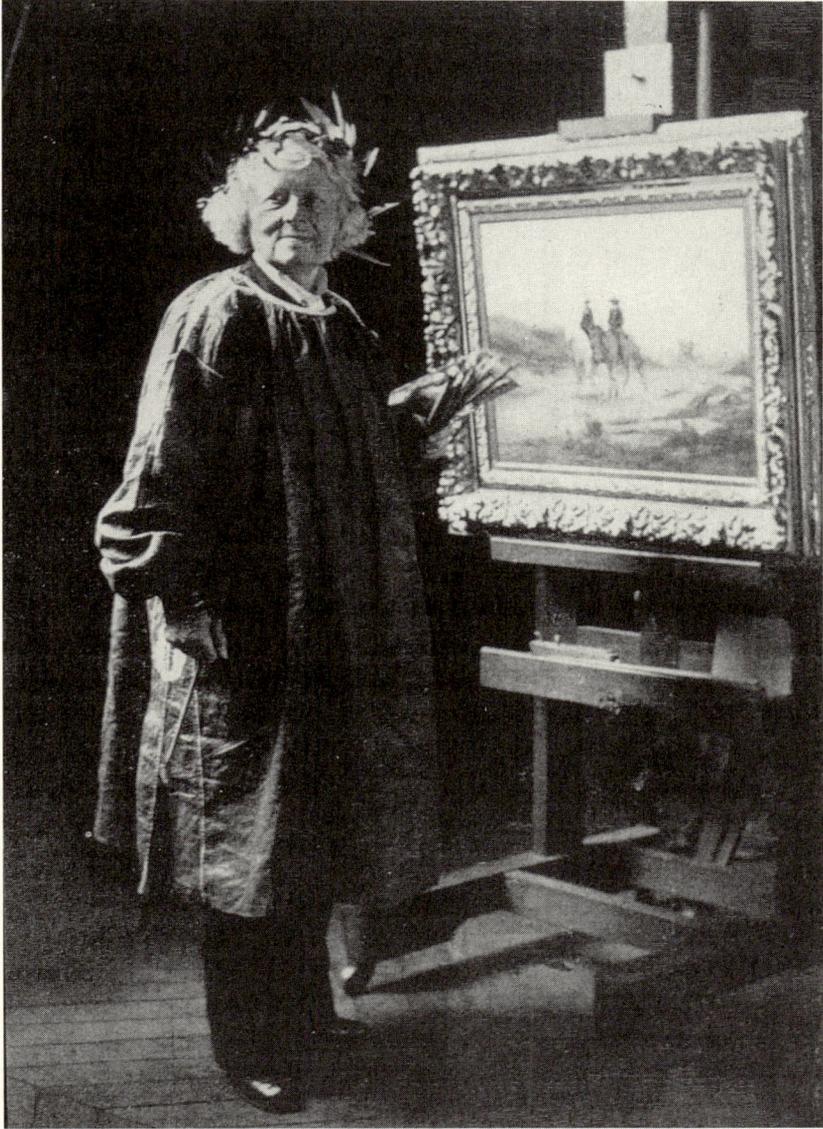

Figure 6. "La vieille Europe couronnée par la jeune Amérique." Photograph from Anna E. Klumpke, Rosa Bonheur, sa vie, son oeuvre *(Paris: Ernest Flammarion, 1908).*

upcoming return to Boston, which prompted Bonheur to ask again, "Do you really love me sincerely?" (100). As Klumpke answered "Yes, believe me" (100), Bonheur gave her a scrutinizing look. After this conversation, they worked separately, hardly speaking to one another for days.

Late in the afternoon on July 30, Bonheur entered the studio, where Klumpke was working. She examined the portrait in a distracted manner, giving the painter her customary words of praise. Then, turning toward Klumpke and clasping her shoulders, she said in a tender voice full of supplication, "Anna, would you like to stay with me and share my existence?" (101).

Klumpke, unable to find the right words, wanted to throw herself in Bonheur's arms, but did not dare to show her emotions. After what must have seemed a lifetime to the impatient Bonheur, waiting for an answer, the tearful Klumpke finally managed to reply, "This is too much happiness for me! All this is so unexpected, so unforeseen! Give me time to reflect!" (102).

Later that evening as the two women had dinner the conversation was subdued. They ate little and went up to the studio. Bonheur knew that Klumpke loved her; she saw "affection in her eyes," but she was not certain of her answer, and her wooing was not over. Unable to disguise her intense jealousy, she asked the younger woman, "Ah, maybe you have left a sweetheart on the other side of the Atlantic?" (102). When Klumpke replied that she would never marry, having decided long ago to marry Art, Bonheur promised to "guide her brush" and "inspire her work"; she also promised to love her like a daughter and a sister, adding that "if I love you it is because you remind me of my mother." She even wondered if it was not the soul of her mother who had sent Klumpke to her side to be her consolation and inspiration in work.

Sitting in the studio that evening, Klumpke gave Bonheur her answer. "Yes, I love you and I shall stay" (104). To convince Bonheur, she added, "[Y]ou can be assured that I shall keep my word religiously; neither my mother, nor sisters, nor anybody will have the power to influence my decision." "Like a pact," Bonheur said with a smile, and Klumpke responded, "Like that of Mephistopheles who asked Faust to give him his soul" (112).

What exactly Klumpke meant is not easy to say. Her German background and education had given her a solid foundation in the German classics; she was thus fully aware of the solemnity and consequences of the

Faustian pact. Did she seek knowledge and personal fulfillment at any cost? Maybe she attributed to herself the same kind of courage and determination with which Faust entered into his bargain.

Bonheur, satisfied that Klumpke had resolved never to leave her and reassured that no man would take her friend away from her, then asked her new companion also to become her biographer. They would work as a team, with Klumpke continuing to take notes of their conversation; then, they would edit the work together. Although Bonheur admitted that she already had a number of biographers—referring to Eugène de Mirecourt and his work of 1856, Lepelle de Bois-Galland's book of 1857, and most recently Venancio Deslandes—they were all men. She wished Klumpke to take on the task, to become her voice because only a woman could understand the chain of events in her life. Though Klumpke was hesitant, Bonheur's confidence in her professional and personal companion's ability remained unshaken. Believing that she would "render her portrait [with her pen] as well as she had done with her brush," she saw Klumpke's work with "brush and pen" as a way "to make known with sincerity the circumstances which had brought [them] together, and the development of [their] affection for one another" (124). It was the unique aspect of their professional relationship and their working circumstances that Bonheur seemed to want to make use of, hoping it would somehow "normalize" their relationship in the eyes of the world. In the end Klumpke consented, relying upon the help of her companion-artist.

Before they announced their decision in public, Klumpke wished to notify her mother, to talk to her in person. As she was about to leave for Paris, Bonheur handed her a letter addressed to Madame Klumpke in which she outlined her "offer."[8] She promised to "arrange before a lawyer a situation where [Anna would] be considered as in her own home," that she would be "as free as air," and that she had encouraged her "to keep her studio in Boston because of many of her acquaintances there." She declared, "I love your dear Anna for her own self, . . . Better than living alone, each one of us, would it not be better to unite our existence . . . cultivating art, and each having our own independence?" Bonheur asked Klumpke to read the letter carefully before delivering it, "in order to defend yourself and convince them" of the honorableness of her proposal. Nervous about the situation, she added, "[Y]our family does not know me as you do . . ." (Klumpke left this sentence unfinished in her book.) "Who knows if your family is not influenced by the bad reputation, *la mauvaise*

opinion, which the world has, in general, of women who live together" (117). Klumpke told Bonheur that she should not torment herself: she had committed herself never to leave her. Albeit mindful of the momentous decision she had made, she departed for Paris generally confident that living and working with a woman was an acceptable, alternative lifestyle. Her exposure to "Boston marriages," such as the one involving Lilian Whiting and Kate Field, may have helped attune her to the idea of a "union" of two women. (The next chapter examines the topic of female friendship in the context of Klumpke's own experiences in Boston.)

The family meeting took place at the Dejerine home on August 11, 1898. Although Klumpke was anticipating some resistance, she was disturbed at the amount of criticism expressed by her family. Central to the arguments, quoted in the biography, was a concern for her future career. Her brother-in-law Jules Dejerine, then professor at the Faculty of Medicine at the Sorbonne, and working also with Augusta at the Salpêtrière Hospital, spoke emphatically about the sacrifice Klumpke was making by not returning to her career in Boston. "What would happen," he wondered, "if Bonheur changed her mind, if they disagreed?" (116). Klumpke answered that if by misfortune they were to quarrel, she would return to Boston. She added: "Thanks to the experiences that I would have acquired from being associated with an artist so popular throughout America, it would not be difficult for me to find portraits [to paint]. I would, furthermore, have the resources to establish a course where I would teach young women what I would have learnt from being with the unequalled Rosa Bonheur" (116). Klumpke was fully aware of the advantages of painting the portrait of a famous figure. To gain access to the highest spheres of their profession, the fastest and most obvious route for young painters, sculptors, or photographers was to make a likeness of a celebrity. Even Rodin in his early years had made use of this same artifice.[9] Klumpke was thus endorsing here a strategy well known to her contemporaries.

Mrs. Klumpke had no doubt that her daughter could recover her position in America if she ever decided to return. She wondered, however, if Anna had thought about her position in relation to Rosa Bonheur, asking if she was not too proud to accept the functions of a lady companion. Anna explained that her role was far more "glorious," arguing, "I shall not only become the friend and pupil of the great artist but also the interpreter of her ideas" (117). When she offered assurances that she would continue her own career, keeping a studio in Paris to paint portraits, her

mother remained unconvinced. She told her daughter that her situation was more complicated than she realized and that she should not imagine that sitters would run after her to By. "Think it over carefully," she said; "there is still time" (117).

Ambivalence and conflict inevitably informed Mrs. Klumpke's thinking and words. If she, the mother, had been the person who set up Bonheur as an idol for her young daughter, then she was partly responsible for the problem at hand. Although the age difference affected how she felt about her daughter's decision, a more conscious and explicit source of tension involved the question of independence and autonomy. An ambitious single parent, Dorothea Klumpke had raised her daughters to become self-sufficient women with professional careers. The achievements of her oldest and favorite daughter, Anna, had surpassed all her expectations. Concerned about her social position vis-à-vis Bonheur, she feared that her daughter's hard-won career would now be subsumed by another person's "whims," that she would lose her freedom and independence. Of course, as a liberal and even "modern" mother it is also possible that she would have objected to any arrangement or relationship, be it with a woman or a man, that would jeopardize the successful career of her daughter.

Anna remained unshaken in her decision. Accordingly, her mother suggested that she should inform Bonheur of the family's reservations, concluding that if Bonheur "persists in keeping you with her, I pray God to assist you in your self-sacrifice, so that you may succeed in assuring her a happy old age" (117).

Upon her return to By, Klumpke gave Bonheur an account of her experiences in Paris and told her that her family's arguments had not altered her position. Embracing her companion, she promised that she would accompany her loyally until her last day on earth and never forget her. Filled with happiness, she confessed, "I love you with all my heart. Until now I did not dare show you my feelings. I may truly acknowledge them today" (117). On August 11, 1898, a formal announcement, signed by Bonheur, was written to Madame Klumpke: "[A]fter due consideration we [have] decided to associate our lives" (118). Happy and relieved, Bonheur could finally proclaim, "It will be the divine marriage of two souls" (112).

Their new lives began in August 1898, as they took on their roles as companion-artists. From the beginning they were contented together.

Bonheur, though forceful and opinionated, made a warm and affection-
ate friend, who felt rejuvenated by Klumpke's energy and put at ease by
her pliant and relaxed nature. Inspired by her presence, she exclaimed,
"You make my heart young: I have an insatiable desire to paint" (72).
Klumpke, for her part, felt motivated toward greater accomplishment
by Bonheur and enjoyed the intimacy and intense intellectual stimula-
tion that accompanied their union. Like most close associations, theirs
encompassed "bonds" as well as "binds." In this part of her biography,
Klumpke writes about the good moments in her life with Bonheur.

When the portrait that had caused her so much distress was finally fin-
ished, it was sent, together with Bonheur's painting *Cows and Oxen in
Auvergne*, to Pittsburgh for the fall opening of the Third Annual Exhibi-
tion.[10] On August 29, the first stone was laid for a separate studio for
Klumpke. Facing Bonheur's "sanctuary" across the courtyard, the build-
ing was to include a large studio with a glass roof and electric lights. They
intended to transport the huge, ten-foot painting *La Foulaison* to this
larger studio; there, with the collaboration of Klumpke, Bonheur hoped
to finish it for the Salon in 1900.

With the coming of fall, Klumpke began making plans to attend the
Pittsburgh show. She wanted to combine the trip with a visit to Boston to
close her studio and, above all, "to see her friends whom she had left for
just a few months and whom she did not know when she would meet
again" (120). Bonheur consented, but on hearing of the recent sinking of
La Bourgogne and the death of more than five hundred passengers she be-
gan imploring Klumpke not to expose herself to similar dangers. She
worried about what would happen to her if "Anna were to disappear in
the watery expanse." Realizing that Klumpke needed to settle her affairs
in Boston, Bonheur thought that these matters could be arranged with
the help of a power of attorney. In the end, Klumpke, unwilling to con-
tradict Bonheur, decided to cancel her plans.

The Third Annual Exposition opened on November 4, 1898, in Pitts-
burgh with a "grand display of art."[11] Although Klumpke was naturally
disappointed not to be there personally to find out where her portrait had
been hung and how it compared to the works surrounding it, she was
probably pleased with the reviews she received from the show. One re-
porter described her work as a "clever picture," praising the realistically
articulated features of the sitter.[12] Like the popular term "capital," the ad-
jective "clever" denoted quality work without reference to gender.

Because of the memories attached to it, the portrait had become so precious to Klumpke that she would not have parted with it under any circumstances had Bonheur not intervened. Encouraging Klumpke to allow her long-time dealer Ernest Gambart to purchase it, Bonheur promised to sit for another portrait. An inveterate dealer herself, Bonheur said that if the second one was even better and also pleased Gambart, Klumpke could simply exchange the portraits as long as he made an engraving of the first one (120). Though Klumpke may have agreed to this arrangement with some reluctance at first, she was well aware of Gambart's marketing skills and the professional benefit she would reap from collaborating with this prominent dealer. In the end she was delighted. She wrote to her father about her "very successful portrait at the Pittsburg exhibition," adding that "it was bought by Mr. Gambart [then] Spanish consul of Nice for $2,000. The portrait will be engraved by the best etcher in London and will greatly spread my reputation."[13]

As a result of this transaction and Bonheur's promise to sit for another painting, Klumpke started to make sketches for a large vertical portrait of the artist *debout en blouse* (standing in working clothes) at her easel, based on the photograph she had taken earlier that summer. Recalling Monsieur Tony's words of praise and encouragement, she decided to take on this more ambitious composition.

Klumpke may not have had any particular exhibition venue in mind as she began her next project. Bonheur, in contrast, was firmly focused upon the 1899 Salon, saying, "I do not want to appear in the Salon wearing working clothes; it is in my 'feminine' dress that I want my image to be transmitted to posterity" (121). She told Klumpke that this portrait would be different from the other two, explaining, "I will be holding in my lap my little Charley." She added, "You will have the courage to paint him yourself, won't you?" probably referring here to Edouard-Louis Dubufe's 1857 portrait of her with a bull, to which she had added her own "signature" by painting the animal herself.

Klumpke's discussion of the circumstances surrounding her next painting project seems to emphasize Bonheur's wishes, all the while underscoring the sitter's authoritarian manner. Still, the situation needs clarifying. Bonheur did not object to Klumpke's idea of painting her in work clothes; she was even willing to pose for such a portrait, adding that Klumpke could finish the work using her studies. The question that seems to have most concerned Bonheur related to her "re-appearance," albeit on canvas,

at the Salon. Sensitive after years of criticism, much of it based on her choice to dress in men's clothing, she hoped that her "new" life and work with Klumpke would somehow encourage the world "to judge [her] impartially" (114). A first step in this direction, Bonheur may have thought, was to please the public by being presented in formal and conservative dress. So, one should think about the decision-making process at the time as a compromise between the two women. As the Salon deadline loomed only a few months away, Klumpke's portrait of Bonheur with Charley took precedence over the vertical one, which they would work on later.

Klumpke does not discuss the making of her 1899 Salon portrait. Given that she could draw upon numerous studies and sketches from her earlier portrait, her work at the easel may have progressed relatively smoothly. As for painting Charley, Klumpke did not seize on Bonheur's oblique offer. She felt confident about undertaking this task herself, having recently and successfully completed the large vertical "double portrait" of her Albany patron George Douglas Miller and his St. Bernard.

In addition to her work in the studio, Klumpke continued to take daily notes of their conversation for the biography she had promised to write. She filled notebooks with information about Bonheur's childhood experiences, her training, travels, and triumphs in the world of art. Intending to correct the biographies that already existed, she listened carefully and with much interest to Bonheur's memories of her mother and her life with Nathalie Micas. While Bonheur acknowledged the supportive influence of her artist-father, she believed that it was her mother who was the deeper source of her art and that her mother's soul had continued to protect, guide, and inspire her throughout her life.[14]

As Bonheur spoke of her passionate allegiance to her mother and the "veritable cult" (168) she had created around her memory, Klumpke freely acknowledged her gratitude to her own mother. Thinking back to the source of her own professional ambitions, she explained to Bonheur that her mother had wanted her to pursue a career in art in memory of their German forebears, Ernest Riepenhausen and his two painter sons (111). Like Bonheur, she recognized that her inspiration, imagination, and achievements all sprang from her relationship with her mother.

It was only natural that Nathalie Micas featured in many of their conversations. With Micas, first in Paris and then for thirty years at By, Bonheur had found love and emotional fulfillment in addition to respect for her professional ambitions. Although Micas gave proof in several ways of

having a strong and independent spirit, the role that she apparently chose was auxiliary. "Her ambition," Bonheur explained, "was not to become my equal. The thing that she wanted, that satisfied this devoted heart, was to be useful to me" (178). Comparing her first and her second loves, Bonheur observed, "Nathalie was my childhood companion, she witnessed my trials and tribulations[;] as for you, my dear Anna, you have taken hold of my heart like the daughter that I would call my own in front of an assembly of the Muses" (360).[15]

The companionship that she shared with Klumpke, an American professional woman, gave their union important new meaning. Speaking of her enthusiasm for the people of the New World, Bonheur told Klumpke that "if the Americans were at the head of modern civilization it was because of the admirable and intelligent manner in which they educated their women and the respect they showed them" (312). Although Klumpke had not been brought up under typical American circumstances, Bonheur recognized the impact of her pioneering mother upon her daughter. Impressed by the pathbreaking careers of Klumpke's sisters in medicine and astronomy, Bonheur saw in Anna the quintessential "educated American woman." With sincerity, she declared: "It is not only a personal affection [that I have for you], but a sympathy for the country to which you belong. You are for me the symbolic alliance of old Europe with young America" (326).

Aware of the biases against women, their subordinate role in society, and the need for emancipation and equality between the sexes, Bonheur envisioned her association with Klumpke as an example that would encourage women to enter the field of art as professionals and promote their endeavors. Committed to a common cause, Bonheur "hoped to abolish at least some of the prejudice against women, . . . especially where their intelligence and their talent rendered them equal to men" (308). Speaking for them both, Bonheur said, "We'll work hard, we'll earn a living, each one independently" (101).

These shared interests and commitments epitomized the atmosphere in the studio, where they spent most of their time together. As the days grew short and the feeble winter light made work in the studio more difficult, they decided to take a break. Accepting an invitation from Ernest Gambart, they went for a short visit to Nice, in the south of France. They stayed in his elegant villa, Les Palmiers, enjoyed meeting the duchess d'Osenna, who invited them to Spain, and also arranged for formal

photographs to be taken of themselves, together and with their host and art dealer (Fig. 7).

Returning to By in February, Klumpke finished her second portrait and sent it, together with Bonheur's painting *Cows and Oxen in Auvergne*, which had just been returned from Pittsburgh, to the Salon. On the day of the *vernissage* they arrived at the Palais de l'Industrie. As usual the halls were packed with a mass of persons representing all that was famous, rich, or fashionable in Paris. Joining the herdlike movement of the crowds, with Bonheur leading the way, they maneuvered themselves through the suite of rooms like the characters in Emile Zola's *L'Oeuvre*, anxiously seeking out their paintings.[16] Whereas Zola's fictitious Claude Lantier was disappointed to find his work "clinging like a swallow" high up under the ceiling, Klumpke had every right to be satisfied. Hung "on the line" at eye level near a door leading into another large gallery, the position of her portrait proved that the hanging committee had found it of special merit.

Reviewed later by one reporter as a striking likeness and as one of the notable pictures at the Salon, the portrait depicts Bonheur seated in a large, comfortable armchair against an unidentified background (Fig. 8). One hand rests easily on the arm of the chair, and the other is placed on Charley, her favorite dog. Stretched out on her lap, with pointed ears and a pair of beaming eyes, he peers at the viewer through a curtain of golden hair. His fluffy and mottled fur is painted with exceptional skill, which caused Bonheur to say to Klumpke, "I see that you will become a good student, my dear Anna" (372). Though the remark seems amazingly reserved, Klumpke may not have minded; seeing herself as a perpetual student, she was willing to take advice from experts, whether its source was Bonheur or her masters in Paris. Open-minded about criticism, Klumpke had a confident sense of autonomy. She was, after all, a veteran Salon exhibitor with a remarkable exhibition history to boot.

Their next stop brought them to Bonheur's animal painting in the adjacent room. It was also hung in a good position, and Bonheur was excited to see how fine it looked.[17] Thinking about her reentry into the Salon circuit after an absence of almost four decades, she told her companion to consider her contribution as a *carte de visite*, a symbolic gesture to complement Klumpke's work. Next year, Bonheur said optimistically, she would show a painting that would create a sensation (*un éclat*) at the Salon similar to the one she had caused in 1853 with *The Horse Fair*.

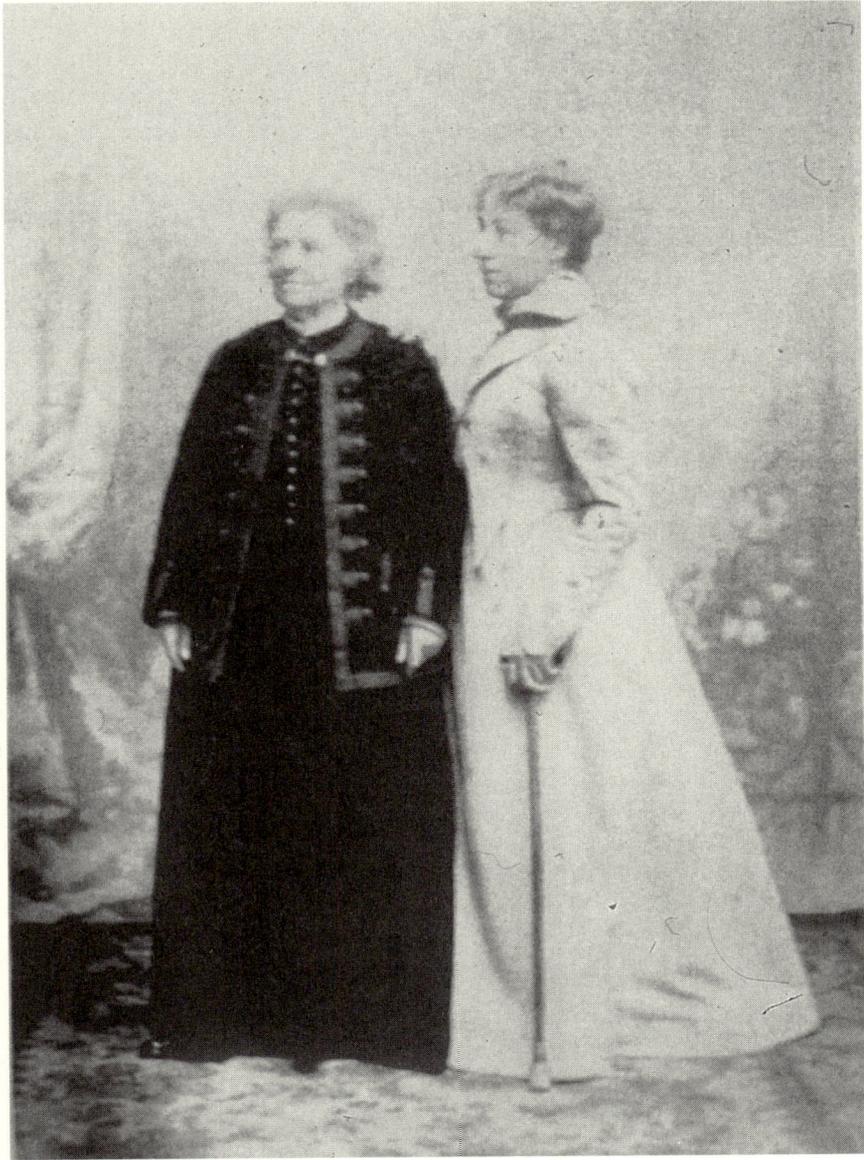

Figure 7. Photograph of Rosa Bonheur and Anna Klumpke, Nice, 1899. Thomery—Château de By—Musée de l'Atelier de Rosa Bonheur.

In May, Klumpke offered to take Bonheur to the Luxembourg Museum. The French artist, admitting with shame that she had never set foot in these galleries, was eager to see the works of her contemporaries gathered under one roof. As they moved through the galleries, Bonheur admired the academic figures of Puvis de Chavannes, waxed lyrical in front of the Barbizon landscapes, and marveled at the works of her friends Bastien-Lepage and Jules Breton. Deftly leading her through the rooms, Klumpke motioned her to stand in front of the painting *Ploughing at Nivernais*. Bonheur had not seen her work since its exhibition in 1849. Looking back at her life with nostalgia, she was pleased with the painting, saying, "[I]t has not changed ["Elle n'a pas bougé"]; it has stayed just as I painted it," meaning probably that the colors had not changed and also that it did not disappoint her (378). Klumpke, standing in front of the painting that had inspired and helped her own nascent efforts as an artist, would have liked to have lingered here, but Bonheur soon urged her on to the next canvas.

Before returning to By, Bonheur insisted upon seeing her lawyer. She had made Klumpke her sole legatee in November, but she wanted to add a codicil to her will, which would make Klumpke legally in possession of Bonheur's property.[18] The next morning Bonheur complained of not feeling well. Her condition deteriorated, and doctors were summoned from By and Paris. She failed rapidly, apparently from a congestion of the lungs. Bonheur died on May 25 in the arms of her companion, uttering the words "I shall be your guardian angel" (398). "The divine marriage of two souls" had lasted a mere nine months.

As historical description, the preceding biographical narrative has explained the circumstances involved in making the 1898 portrait and provided evidence of the romantic interaction between painter and sitter. Turning now to analysis, it is pertinent to try to interpret the psychological responses to the actual situation of painting, on the one hand, and the relationship that developed between two women, on the other. In addition to examining the operations of power and difference, it is especially useful to address some current theories about relationship dynamics that deal specifically with concepts of "connectedness," "continual accommodation," and "continuity" to see how they may apply to historical figures such as Klumpke and Bonheur.[19]

The conventional ritual preceding the making of the portrait is an appropriate place to begin. It seems clear from the narrative that the deci-

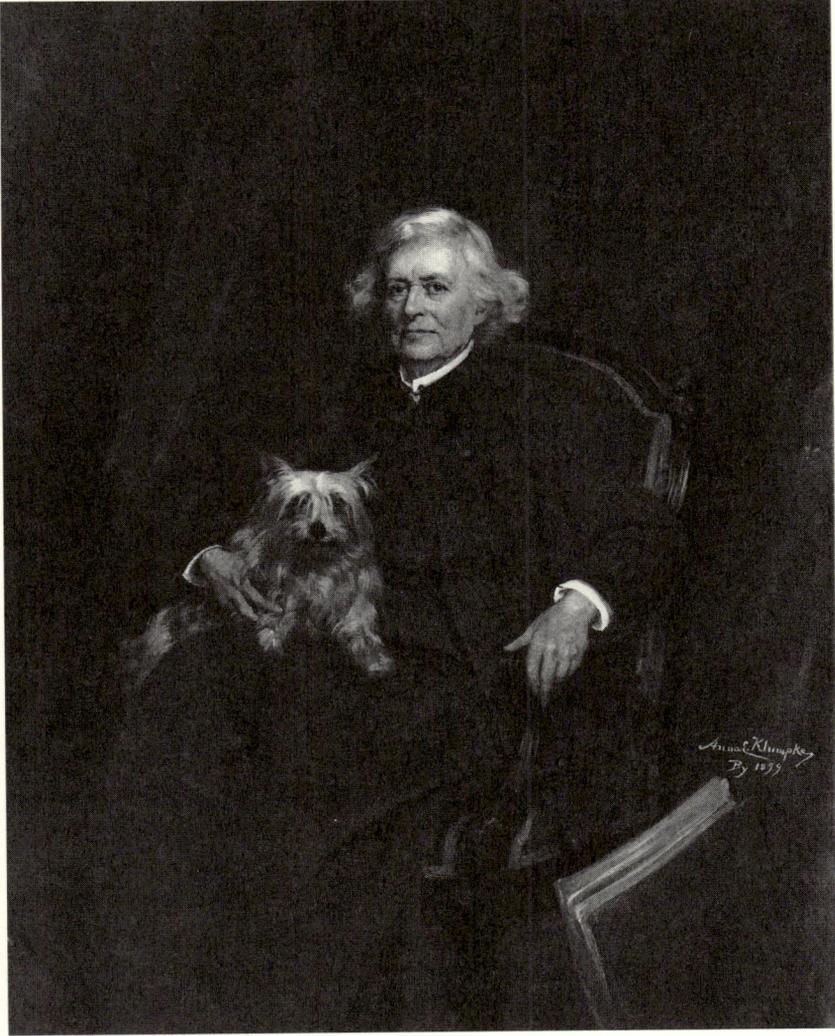

Figure 8.　Anna E. Klumpke, Portrait of Rosa Bonheur, *1899, oil on canvas, 58 × 45".*
Musée National du Château de Fontainebleau, Fontainebleau, France. © Photo RMN,
L'Hoir et Popovitch.

sion making in the studio on the first day was marked by general consen-
sus and accommodation. In trying to interpret each other's needs, the two
artists found solutions that served their individual purposes as far as pose,
lighting, composition, and dress were concerned. In terms of practical

progress on the canvas, it seems also right to say that the process, broadly speaking, acknowledged their technical parity: two painters each respecting the expertise of the other.

On a more philosophical level, the artwork may also be seen as coming into being in the actual meeting of two "kindred spirits." As Linda Nochlin has pointed out, "If the artist watches [and] judges the sitter, the sitter is privileged by the portrait relation to watch and judge back." As a result of this unique situation, "WHAT [Nochlin's emphasis] the artist is painting exists on the same plane of freedom and ontological equality as the artist herself."[20] While it is quite true that Klumpke was the agent, recording and interpreting for posterity, Bonheur was the other subject in this bipolar configuration, opening the avenue to recognition through her fame. Thinking about Klumpke and Bonheur as two subjectivities enables one to consider the progress on the canvas as a mediation between two artists.

If the apparent alliance in the studio is perceived as a form of "continual accommodation" and "connectedness," how is one to interpret Bonheur's messages of control and power? How might an account be written that would map the competing interests and claims in a relationship of unequal parties? Certainly by virtue of her reputation and age, Bonheur was the more powerful of the two women. She had status, money, even her own château—all determining factors in the distribution of power. Her seniority and self-proclaimed role as teacher further reinforced the pattern of a hierarchical relationship. But, as Marcia Pointon argues, the power may shift in the course of the sitting as a result of the dynamics of interpersonal relations.[21] The point needs to be emphasized in the discussion of this relationship: Bonheur, ostensibly the more powerful of the two, seemed to control the scene; however, the more she attached herself to the much younger Klumpke, the more vulnerable she became. For instance, Bonheur dreaded the day she would be left alone. Consequently, she devised an ingenious strategy: to prolong Klumpke's visit, she would postpone her sittings and insist upon time-consuming drawing exercises.

And, as Bonheur's strength evolved into weakness, her jealousy further helped subvert control and authority. Her many probing questions to Klumpke about marriage and men are understandable in light of Bonheur's growing dependence upon Klumpke, which led her to fear that she would lose her new companion to the charms of a man or to the pressures of social prejudice. In other words, as a woman falling in love with an-

other woman, Bonheur was doubly threatened—from without by the male world and its socially constructed attitudes about woman-woman relationships, and from within by uncertainty about Klumpke's attraction to her or to another woman.

Klumpke's place in the dynamics of this relationship is more complicated. Her indebtedness to Bonheur as a source of lifelong inspiration and now also as a provider of hospitality reinforced a submissive role. Also, in her self-proclaimed role as student, Klumpke created an image of herself that prescribed reverence and even obedience. Although Bonheur is inscribed as central and influential, the decision-making exchanges, however, exceeded the circumscribed bounds set up by the narrative. In this relationship of two seemingly unequal parties, Klumpke exists first and foremost as a painter with her own status and identity. As an interpreter of the famous French artist's life, she furthermore gained agency as an author and transmitter of Bonheur's legacy. Her relative youth was clearly another bonus. Yet, Klumpke's greatest strength lay in her single-minded determination to paint a good portrait and return to Boston. It was ultimately her independence and autonomy that caused the balance of power to shift, rendering Bonheur extremely vulnerable and Klumpke especially powerful.

Taking this theoretical analysis of power relations one step further, it is possible to think about their relationship in terms of continually shifting relational oppositions of strength and weakness—in Bonheur's case, hope and fear, in Klumpke's, trust and risk. Such a perspective may explain the ebb and flow of experiences that composed the history of their relationship and its interactional background in a unique context.

The question of power relations is, however, more complicated. While most scholarship in women's studies has adopted the feminist strategy of writing against the patriarchal account, the Klumpke-Bonheur situation is not determined by gender difference. For this reason an interdisciplinary foray into a realm of social psychology that participates in the ideology of power but is also shaped by notions of "sameness" and complementarity in interpersonal relationships is appropriate here. It is important to stress that such an examination needs to remain tentative. First, any relationship can be understood from different perspectives and is part of a complex process as well as a topic in its own right.[22] Second, an approach drawing upon scholarship that deals with relational conduct and conversation between "real human beings" becomes less successful when applied to

historical figures. With this caveat, how might the idea of mutuality in relationship processes operate?

In *The Dynamics of Relationships*, Steve Duck discusses the continual accommodations that are required in the relationship of two people.[23] He notes that for these transactions to be successful, certain essential dyadic skills are necessary, such as the management of conversation, the ability to listen to one another, and the awareness of the future as a shaper of the relationship. He adds that rather than focusing on the past events of a relationship as guides to explanation, it must be understood that "relationships are driven by a need to create meaning as a way to cope with the uncertainties of an unfolding future that places yesterday in a sequence of other days."[24] Duck concludes that it is this dynamic continuity that provides a context for partners to comprehend their connectedness to one another.[25]

Duck's idea of "continual accommodation" can certainly be applied to Klumpke and Bonheur as far as the work in the studio is concerned. His concepts of compliance and mutuality, however, are difficult to apply here, given Bonheur's messages of control. Perhaps, again drawing upon his writing, one may view the old and lonely Bonheur's conduct and conversation as being "driven by a need to create meaning as a way to cope with the uncertainties of an unfolding future." Perhaps the relational dynamics can be understood as more than mere sequences of behavior or the cumulation of individual acts—a first meeting, painting a portrait, viewing an exhibit—but rather in a context of "continuity built on a real past and extended future." If so, the idea of "ongoingness" and "connectedness" can be viewed as a process of "investment."[26] Let me try to explain. Though Klumpke was not young at forty-three, Bonheur, thirty-four years her senior, saw in her American companion the promise of a woman who would continue to foster and encourage women in the arts in a supportive context of production and promotion. Expressing her hopes, she told Klumpke, "I am convinced that to us belongs the future" (312). The younger woman concurred on her terms, believing that her own work as a painter and instructor would encourage other women artists. Although not feminist in the political sense of the term, Klumpke nevertheless effectively redefined a woman's rights to equality and saw herself as transmitting them to future generations of women. Perhaps the "uncertainties" each faced as a woman and as an artist were an important aspect of their "connectedness to one another."

Even though these perspectives of connectedness may indeed be largely interpreted as arising from their "sameness" as women, complementarity in interpersonal relationships is shaped by notions of difference: Klumpke was younger and Klumpke was an American reflecting the values of a liberal nation, the qualities Bonheur treasured most in her companion-artist.

To relate these psychological musings to a broader historical interpretation, it is helpful to examine how Klumpke was remembered by the townsfolk at By.[27] Generally accepting and tolerant of her relationship with Bonheur, the villagers did not seem interested in meddling in the private affairs of the two painters. Instead, they stressed the independent spirit of the American woman. The locals paid tribute to this characteristic, they claimed, by invariably addressing her as "Miss" rather than "Mademoiselle." The inhabitants were correct in their impression of Klumpke. It had required both independence and courage to come to By in the summer of 1898 to paint the portrait of the most famous woman artist of the century.

Before concluding this chapter, a few comments about Klumpke's three portraits are necessary. The 1898 portrait, which she had reluctantly sold to Ernest Gambart, returned to the painter's possession. The reasons for this remain unknown.[28] In 1922 Klumpke presented the portrait to the Metropolitan Museum of Art, dedicating it "in honor of Bonheur's Centennial and in memory of the great friendship in which she held me and all America in general."[29] That same year, Klumpke loaned the 1899 Salon portrait of Bonheur, seated with her Skye terrier nestled in her lap, to the Luxembourg Museum, then the French museum of contemporary art. Two years later, on the occasion of the twenty-fifth anniversary of Bonheur's death on May 25, 1899, Klumpke presented the portrait to the state.[30] The occasion was celebrated with the inauguration at the Palais de Fontainebleau of La Salle de Rosa Bonheur. Her painting of Bonheur *debout en blouse* appeared in the 1902 Salon, where it was favorably hung and received good reviews. It remains prominently displayed at the Musée de l'Atelier de Rosa Bonheur at By (Fig. 9).

The exhibition history of each portrait is difficult to explain, since catalogues invariably noted merely the sitter's name. A portrait of Bonheur is known to have made the exhibition circuit in Europe, including shows in Vienna (1902), Munich (1903), Berlin (n.d.), and Liverpool (n.d.). One portrait of Bonheur was also exhibited at the Institute of Art in

Figure 9. Museé de l'Atelier de Rosa Bonheur, By-Thomery. Photograph from Anna E. Klumpke, Rosa Bonheur, sa vie, son oeuvre (Paris: Ernest Flammarion, 1908).

Chicago (1901), the Pennsylvania Academy of the Fine Arts (1902), the "St. Louis Fair" of 1904 (where Klumpke received the bronze medal), and at the exhibition *Portraits of Famous Women* in Chicago (1905–6). In 1933, Klumpke arranged a joint exhibition of works by Bonheur and herself at the California Palace of the Legion of Honor in her hometown of San Francisco. Though the exhibition did not include a portrait of Bonheur, it marked her presence vicariously and appropriately with an image entitled *Charley, Rosa Bonheur's Favorite Dog* (unlocated) painted by Anna Klumpke. Honoring her companion, Klumpke perhaps was also thinking about the 1899 Salon portrait with Charley, when she as the perpetual student had risen to the challenge of her teacher.

Chapter Eight

A "Boston Marriage" in Sapphist Paris: A Cross-cultural Exploration of Female Friendship

The last decade of the nineteenth century—when Klumpke and Bonheur's relationship formed—has become commonly recognized as a crucial transitional period in the social experience of homosexuals.[1] It was in this decade that the homosexual as a separate and classifiable type began its emergence. That emergence was quite broad-based, arising on both sides of the Atlantic and fairly simultaneously in the arts, in social circles, and in the medical and legal professions. In this chapter we will look at some important points in the development of a public consciousness of "homosexuality," attempting, insofar as it is possible at a distance of a hundred years, to situate Klumpke and her partnership with Bonheur within this context. Since the 1890s was a liminal time in the development of the idea of homosexuality and since this idea arose in such diverse areas and varied contexts, we should expect complexity and ambiguity in general and conflicting experiences in particular.[2]

The first question that must be addressed is our present position. What for us constitutes a lesbian identity? In a similar vein, what is our definition of a same-sex relationship?

In her pioneering, narrative synthesis of the cultural, social, and political history of love between women, Lillian Faderman identifies the "original" form of twentieth-century "lesbianism" as "romantic friendship."[3] In the late 1800s, romantic, lifelong companionships between women were subjected to the scrutiny of sexologists. Linked with the idea of perversion and deviance, they emerged in medical literature and to some extent

in individual consciousness under the modern definition of lesbianism. Addressing the historical dilemma of labeling and identity, Faderman concludes that women who spent their lives primarily with other women and who gave to other women the bulk of their energy and affection would likely have used the word "lesbian" to characterize themselves.[4]

The relationship between Klumpke and Bonheur fits clearly and solidly into this definition. Indeed, as Gretchen van Slyke has pointed out, Klumpke's biographical account of her relationship with Bonheur was quite a "bold story of lesbian love," albeit one couched in reverential rhetoric.[5]

We should be cautious, however, in identifying Klumpke as a "lesbian." It is entirely unclear, first of all, whether Klumpke's relationship with Bonheur was sexual. Furthermore, Ann Ferguson argues that self-identity as a lesbian requires access to a "community of others who think of themselves as having the sexual identity in question."[6] According to Ferguson, then, a lesbian identity is possible only in the modern period, since there was no lesbian community in which to ground a sense of lesbian self before the twentieth century. In this respect Klumpke could not have used the word "lesbian" to describe herself.

In fact, the lesbian question, which is important for us critically and historically, may not have been uppermost in Klumpke's mind. The relationship between sexual identity and creative expression is, after all, only one inspirational force in an artist's life and work.[7] It is important to remember that Klumpke was a woman who went against the conventions of her time in many areas of her life: she chose not to become wife and mother; she chose instead to become an artist and to pursue that competitively in the male arena of the Salon. Even her disability would have set her apart from others in significant ways. Klumpke's "lesbianism," then, is but one strand in the varied skein of differences out of which Klumpke wove her life. It would perhaps be more correct to "identify" her, to view Klumpke first and foremost, as an individual who in a world of prejudice and strictures tried to prove that "woman" and "artist" did not represent mutually exclusive identities.

If this discussion of lesbianism and Klumpke's identity seems inconclusive, it is, again because public and private perceptions of sexuality, gender, and identity during her lifetime were undergoing considerable transformation. Largely because of the historical and critical complexities, I have chosen not to play the taxonomist pinning a label on Klumpke.

Instead, I offer a comparative exploration of attitudes toward same-sex love and "homosexuality," first in the United States and then in Europe, to try to understand the milieu of Klumpke and her companion, Bonheur.

Let us begin with a reflection on novels written by Henry Wadsworth Longfellow and Oliver Wendell Holmes, each of which captures something of this complex web of attitudes toward female friendship.[8] Longfellow in *Kavanagh* (1849) writes about one young woman's "affectionate, lover-like friend," and Holmes in *A Mortal Antipathy* (1885) presents the exchange of passionate letters of love between two women.[9] Simply put, both men understood such relationships to lie within the spectrum of acceptable behavior. According to Faderman, it seems that, given the homosocial environment prevalent in the nineteenth century, the fictional relationships depicted by Longfellow and Holmes reflected a casual acceptance of female friendships in real life.[10]

The quintessential American work treating the theme of women and the relations they set up among themselves remains Henry James's novel of 1886, *The Bostonians*.[11] Briefly, the story concerns the competition between the women's rights activist Olive Chancellor and an impoverished Southerner, Basil Ransom, for the possession of the young Verena Tarrant. It concludes with Verena succumbing to Ransom, albeit in tears that "were not the last she was destined to shed."[12]

There are few commentators who do not view the relationship between Olive and Verena as homosexual to some degree, either condemning it as perverse or condoning it as acceptable from a modern feminist perspective. Given the book's very puzzling conclusion, it is instructive to add a few words about the central female characters. James's biographer Fred Kaplan notes that to depict the relationship between Olive and Verena, James drew to some degree on the growing involvement of his sister, Alice, and Katherine Loring. In Kaplan's view, "As Alice desired and needed Katherine, Olive desires and needs Verena."[13] Jean Strouse, the biographer of Alice James, makes an important observation about Henry James's reaction to same-sex relationships. Referring to the partnership between the writer Sarah Orne Jewett and the widowed Annie Fields, James declared that "their reach together was of the firmest and easiest and I verily remember being struck with the stretch of wings that the spirit of Charles Street could bring off."[14] Yet, James did not view his sister's relationship with Loring in such idyllic terms. Something in its intensity troubled him, and he would express this unease in *The Bostonians*, Strouse

concludes.[15] Perhaps this unease reflected the author's own sense of self. Although James revealed little of his attitudes toward same-sex love, it is today well known that he had some sympathy for such relationships between men.[16] Addressing the issue in more detail, Kaplan points out that "James had a dim sense of his own homoeroticism, which his position, his personality, his background, and his culture all gave him every incentive to repress."[17] He adds that James had no desire to challenge his inhibitions, let alone society's. As a result, he left the interpretation of the relationship between Olive and Verena open-ended or, to put it more accurately, inscribed his own ambivalence and confusion in the text.

The work of young Willa Cather is telling in what it conceals and reveals. As was the case in *The Bostonians*, the subject—"the thing not named"—has to be circumscribed.[18] Indeed, the most prominent absence in her work is mention of the emotional bonds between women that were central to her own life. In analyzing Cather's work and identity, Sharon O'Brien points to the novelist's ambivalence in the early 1890s about love between women and adds that it may in part be understood as her way of trying to escape the woman writer's social and literary subordination.[19] O'Brien concludes that far from engaging in a struggle with her literary forefathers, during the 1890s Cather was trying to forge, not break, chains of inheritance and legitimacy.[20]

Like Cather, Klumpke may be understood as trying "to escape subordination" in the way she negotiated the Salon. In order to gain visibility and recognition, she too endorsed the male artists' conventional subjects and techniques. Similarly, Klumpke adopted traditional masculine values.

Records of attitudes held by the American medical community toward same-sex relationships in the last decade of the nineteenth century are sparse. Although American medical observers were aware of some of the work taking place in Europe, for the most part they did not do any major research on sexual topics until later.[21] This reluctance to study sexual activity in any serious way has been attributed to the prudishness of the American character. To put it bluntly, "There were certain things that the Americans did not want to think about."[22] Explaining the situation, Vern Bullough writes that physicians "strove to be as much a guardian of traditional morals . . . as medical practitioners."[23] Stressing respectability in their work and public discourse, they were influenced by what has been called "civilized morality," a powerful purity crusade to protect American society from "evil" and potentially destructive forces. Spearheaded by Anthony

Comstock, the moralists' campaign for respectability came to characterize official attitudes in late nineteenth-century America. Yet, even as social critics and educators insisted upon conformity and their ideas of social order, they rarely addressed the subject of female same-sex relationships. Perhaps, like physicians, they were uncomfortable about tackling a difficult issue; perhaps, too, their attitude sprang from a lack of knowledge.

In this context, it is only natural that any challenges to traditional gender and sex-role definitions would seem particularly threatening. As women's colleges proliferated in the last decades of the century, and as male colleges and universities hesitantly opened their doors to women, the response of men was far from enthusiastic. As Carroll Smith-Rosenberg has argued, "To place a career before marriage violated virtually every late-Victorian norm. It was literally to take [a woman] outside of conventional social arrangements."[24] By the very act of withdrawing from the world of domesticity, a woman rendered herself socially questionable. It is important to remember, then, that Klumpke, who not only chose a career but also eschewed traditional marriage entirely, was violating "every late-Victorian norm." From today's perspective it may seem that her relationship with Bonheur was the most daring aspect of her life. But in her own time, all her life choices were astonishingly nonconformist.

If some moralists approached the topic of same-sex relationships with a lack of interest, a sense of perplexity, or some combination of the two, the description of the companionship of Annie Fields and Sarah Orne Jewett by their contemporary Mark A. DeWolfe Howe seems surprisingly unproblematic. A young editor of the *Atlantic Monthly* and a regular visitor to their literary gatherings at 148 Charles Street in Boston, he called their relationship "a union—there is no truer word for it."[25] From what Howe could see, the two women were married in every sense on which he dared speculate. A shared household, joint sponsorship of social and literary gatherings, a kindred partnership as writers, planned travels and holidays together—all pointed to the same conclusion: a serious, intimate, and reciprocal relationship between two women, which came to be called a "Boston marriage."[26]

But while there was clearly at the time a kind of acceptance of "unions" between bourgeois women, it is important to remember that this does not imply an acceptance of a sexual relationship between them. Given the spiritualized way these women themselves wrote about their own relationships, it is most likely that Howe and others like him saw these unions

as entirely spiritual (rather than worldly) passions. Additionally, it may have been difficult for their male contemporaries to imagine sex between two women, simply because of the absence of a phallus.

To what extent any of these attitudes toward female friendships, ranging from tolerance to uncertainty, entered Klumpke's consciousness must remain conjectural. But we can look more closely at the women in her circle of friends who were involved in long-term relationships with other women.[27] Foremost among these friends is Lilian Whiting. Indeed, her relationship with the journalist and author Kate Field (1838–1896) bears a remarkable, almost uncanny similarity to Klumpke's experiences with Bonheur.

Describing her early admiration for Field, Whiting recalls:

> I was still a child, treading the quiet way of a country home, [when] her literary work touched the spring of enthusiasm, and I learned to watch for it and love it until it became the central interest in my life. . . . [From] my girlish fancy, as later to the perception of my womanhood, she seemed to impersonate the genius of nobleness . . . to be *her* friend became to me the dominant note in life.[28]

Field, Whiting's role model, began her career as a correspondent for the *Boston Courier*, writing letters from Italy during the U.S. Civil War. Branching out to become an actress, singer, playwright, author, and lecturer, Field became known in Europe and America as a woman of great intellect and versatility. Whiting had been in the public eye for more than a decade when she met Field in Boston, where Field was launching one of her latest ventures: the Cooperative Dress Association.[29]

Their meeting in Boston established a close and lifelong relationship. Separated because of their respective professional commitments, the two women corresponded almost daily and arranged to meet when they could. Describing their fifteen-year platonic relationship, Whiting recalls that while Field "was continuously flying about . . . [I was] living quietly in one place . . . so in touch with her plans that almost any day, if not hour, I could have reached her by telegram."[30] Their letters, which were later published in *Kate Field: A Record*, do not indicate great passion, but a steady, fruitful, and loving relationship that stressed the spiritual aspect of their union.[31] A note to Whiting dated "Xmas 1886" is typical of the tone

of their communication: "Ah, my dear friend, the Love that is true for which we all aspire in some form or other comes, perhaps, hereafter."[32] And of their shared belief in a spiritual union, she remarked:

> You must let me care for you in my way, which, had I the power would
> be very tangible. Unfortunately, I'm not able to carry out my desires.
> When we meet where gold is not the current coin, you'll know my real
> self better.[33]

After the death of Kate Field, Whiting, bereft and dispirited, memorialized her friend in two books: *After Her Death* and *Kate Field: A Record*.[34] She also sought a companion in Klumpke, and they traveled together to Europe. Perhaps Whiting helped Klumpke find the courage to paint the portrait of her own idol, Bonheur. Professionally and personally close to Whiting, Klumpke could not have had a better person to turn to after Bonheur's death in 1899.

Aside from this personal experience of female bonding, to use a modern term, it seems important also to consider Klumpke's continued contact with Ellen Day Hale.[35] This gained her knowledge of another female friendship: that of Hale and her colleague-companion, Gabrielle de Vaux Clements. After having left the Académie Julian, where Clements was also studying in 1885, Hale traveled with her partner in Europe and the United States. Inspiring each other in their work and committed to winning acknowledgment as professional painters and etchers, they participated in exhibitions together and separately. When their different commitments forced them to live apart, they corresponded in a matter-of-fact yet affectionate tone. Indicating an intimate, though not necessarily sexual relationship, Hale addressed her letter to Clements with "My dearest little girl" and concluded with "Yours, E."[36] Like the kindred partnership on Charles Street, the Hale-Clements relationship seems to have been another perfect "Boston marriage."

The acceptance, in certain circles of American society, of a "union" between two women stands in sharp contrast to the plethora of debates in Paris on the topic of *femmes damnées*.[37] Charles Baudelaire's sapphist theme in *Les Fleurs du mal* of 1857 had nothing to do with the real lives of women like Bonheur and Nathalie Micas. But his literary representation of "depraved" women mesmerized the artistic community and the rest of

sophisticated Paris; with time it affected how the larger public thought about women's sexuality. Before turning to those whose attitudes and views, according to Bonheur, "gave the world in general '*une mauvaise opinion*' of women who live together," the topic of woman-woman relationships needs to be considered against the background of some sociopolitical issues.[38]

Historically, the era after 1871 and France's humiliating defeat in the Franco-Prussian War was characterized by widespread fears of national decline. In the numerous arguments about how to combat social deterioration, the ideas of vice and sin became an important vehicle in a general struggle for reform. These fears reflected real social problems, although the sources of those problems were not always accurately identified.[39] Within this context, lesbianism as a social phenomenon became an important focus for male commentary on the moral and material situation of French culture. As an object of social approbation or condemnation and as the subject of legislative action or scientific inquiry, lesbianism was uniquely recorded in the discourse of the time. Memoirs, social commentaries, sociological surveys, fictional works, and, not least, medical tracts helped paint a picture of lesbianism in and around Paris that presented varying and perplexing perspectives on its meaning and impact on society.

The following discussion gives a vision of these shifting arguments, placing Baudelaire's poems about love between women in the context of two vociferous men, Emile Zola (1840–1902) and Auguste Rodin (1840–1917), who were, unlike Baudelaire, Klumpke's contemporaries in Paris. Focusing upon select material that deals with the subject of homosexuality, we begin the task by "peering into the spaces between words, into shadows, into what has been unspoken and not [mentioned]," and then suggest some attitudes that seem connected across culture and time.[40]

We start with Zola's novel *Nana*. Inspired by Baudelaire's charge to portray the modern world, Zola set out to provide a real picture of life as it was lived in the city by focusing on the low life of Paris. Convinced that nobody had yet had the courage or ability to paint a true-to-life portrait of modern prostitutes, courtesans, and lesbians, he set out to evoke the corrupt world of the Second Empire as an allegory for disintegration and collapse.[41] In 1880, when the heavily advertised work appeared in print, recognition of Zola's bold and daring concept came only from certain personal friends, foremost among them Gustave Flaubert.[42] Critics, on the other hand, launched a furious onslaught against the novel. Declaring

Nana a "literary orgy of obscenities," one reviewer wrote that it was "obviously just an attraction for libidinous old men and inquisitive women of all ages." Such comments missed the point, but they were the ones that the public heard and remembered as they read about "the crude and bestial life in Paris," now associating low life with lesbianism.[43]

Zola's own perspective on homosexuality is complex. Describing his central figure, the *cocotte* who triumphs in the demimonde, he noted that "she was good-natured, never does harm for harm's sake, she is vulgar and slovenly, I repeat she is a good-natured girl, [who] ends up regarding man as a material to exploit, but without meaning to."[44] Zola's treatment of the relationship between Nana and Satin suggests that Nana's passion for her companion is more loving and honest than any of her heterosexual involvements. Yet, the passion is one-sided. As Gretchen van Slyke points out, the novel portrays Nana's passion for Satin as sincere but totally abject, whereas Satin is an avid, insatiable, "fickle exploiter."[45] In the end, Zola depicted a love that is unilateral rather than reciprocal.

Zola's compassion for the male homosexual was more explicit and more problematic. A letter of June 25, 1895, to "Dr. Laupts" (actually, G. Saint-Paul) sums up the thorny questions he faced.[46] A text within a text, the published letter represents a private confession to the book's author. Zola began by gratefully acknowledging Dr. Laupts's decision to publish "Le Roman d'un inverti" (The story of an invert) which was based on a document Zola had given him. He added, "I am very pleased that you, as a man of science, can do that which a simple writer like myself would never dare to do."[47] Then Zola explained what he meant. He had received this fascinating and valuable document some time before from a young, well-born Italian homosexual, who had provided him with details of his own case history to help Zola to write about this difficult topic. Describing his feelings, Zola remarked, "He touches me by the absolute sincerity of the confession, because one feels the presence of a flame, I would say almost the eloquence of truth. The confession is absolute, naive and spontaneous, one that few men would dare to make."[48] He said that he had thought of using this material—"to give it to the public"—but that he finally abandoned the project. Explaining his "battle" as a writer, he said of his critics,

> First, they would have accused me of having invented the story; then of
> having written about a most repugnant speculative issue, and what if I

had allowed myself to say that no single subject exists that is more seri-
ous or sorrowful, [and] to suggest that to cure the wounds, which are so
much more pervasive than we think, [we have] to study them, to face
them, and to treat them![49]

Admitting that he saw no solution to the problem, he then summarized
his letter, saying, "The invert is a disorganization of the family, the na-
tion, and of humanity. Man and woman are certainly here below only to
beget children, and they destroy life the day when they no longer do what
must be done to perpetuate it."[50]

What emerges from this discussion of Zola's attitudes toward same-sex
relationships is a mélange of positions. On the one hand, we know of his
compassion for homosexuals—he was "touched, and deeply moved"—
and he wanted to educate the public; on the other hand, he spoke censo-
riously of "a cure" and wrote about same-sex relationships as an affliction.
Clearly, in the frenzied period just after Oscar Wilde was convicted of ho-
mosexual offenses (on May 25, 1895), conventional and safe views pre-
vailed. Zola's response, like that of Dr. Laupts, was conditioned by
popular opinion, which stigmatized same-sex relationships.

Like Zola, Auguste Rodin drew upon the low life of Paris when he en-
gaged prostitutes and lesbians as models for his work. Again like Zola, he
was carrying on the search to discover the "modern soul" in the manner
of Baudelaire. It is true that Rodin took delight in depicting the tumult of
bodies in ecstasy. Indeed, he treated physical love with such unusual free-
dom that he was sometimes described as being obsessed with sex. Yet,
many of the intertwined figures he sculpted can be seen as striking rendi-
tions of genuine abandon and love between two persons, perhaps trans-
figuring them from objects of the artist's desire to subjects of their own
desire.[51]

Though we do not know whether Klumpke saw any of Rodin's sculp-
tures of embracing women, she would have had access to view such works
in Paris, especially at the large 1889 Monet-Rodin exhibition at the Ga-
lerie Georges Petit.[52] She may also have seen Rodin's *Femmes enlacées* at
the 1890 (SNBA) Salon. In fin-de-siècle Paris, "sapphist" themes were
clearly part and parcel of a great master's repertoire.

As we attempt to decode the silences and gaps between text and con-
text, what emerges is an interpretation that points at certain similarities.

First, it is important to note that depictions of lesbian sex have always been a staple of pornography. The bordello, the harem, and the lesbian bed are all standard arenas for heterosexual male imaginings of sexualized female bodies. Zola, for instance, could have written about the demimonde of male homosexuals and prostitutes for the same social and moral purposes, but he chose not to do so. It was easier for him to imagine and, he clearly also felt, easier for the public to accept lesbian sexuality, as we infer from his reaction to the male homosexual's narrative that he ultimately gave to Dr. Laupts. Nor did Rodin depict male homosexual couplings. In these works the woman occupies the place of desire. She is looked at or acted upon. The women in the works of James, Baudelaire, Zola, and Rodin, then, find their origins in male-centered desire.[53]

However, while Baudelaire and his followers Zola and Rodin, as well as James, may not challenge perceptions about sex-role stereotypes, their portrayals of woman-woman relationships were nonetheless novel and modern. These men took what had been a private realm of sexual imagining and made it public in a grand way. In taking the private and making it public, they forever changed public notions of what was acceptable to represent.

An attempt to examine the phenomenon of lesbianism in a wider social context was not made until the end of the nineteenth century.[54] The root of the "problem" facing moralists lay in the legal system. For the French moral reformers, the main purpose in writing about female homosexuality was to exhort the establishment to take legal action—to introduce a law that would forbid women's same-sex relationships. But, since "Sapphism [was] not an offense foreseen by the Code Napoléon . . . if practices [were] done in a private dwelling out of the neighbors' view, and between majors, . . . the law [was] powerless [to] police."[55] As a result, the judiciary avoided tackling the problem of female homosexuality by acting as if there was no problem. Inadvertently, then, benign oversight left the women "free." From a comparative perspective, the French moral reformers' attempt to regulate what was viewed as obscenity seems somewhat similar to the campaign of Comstock and the American moralists. So long as a woman's activities did not constitute a criminal offense, she could choose an alternative lifestyle whether she lived in Boston or Paris.

Meanwhile, voices arose demanding that study of some same-sex relationships be detached from the moral rhetoric of the past. At the core of the debate lay the claim for scientific knowledge. Grounded in a wide

range of competing ideologies that involved the relationship between biology, genetic inheritance, and evolution, the belief took hold that if science could throw light on what was wrong in society, the problems could be eliminated.[56] In the process of debate, a medical controversy emerged that would provide literature with scientific models of explanation. A central issue in the medical inquiry was whether homosexuality was an innate or an acquired condition. The congenital case could be cured, or so the doctors hoped; the second case called for prevention as well as punishment. Both law and medicine, it should be emphasized, were to collaborate in this task of finding scientific truth.[57]

Although collaboration between the two professions was complicated by the fact that each country had its own penal codes, an approach that used the law to codify "types" had advantages for a gender that has historically remained outside jurisdiction.[58] In other words, the actual nonexistence or neglect of female homosexuality in legal tracts freed lesbians from severe forms of public censure.

This ambiguous situation might be clarified by some anecdotal information. In his novel *A Madman's Manifesto*, the Swedish writer August Strindberg (1849–1912) addressed the subject of law and lesbianism.[59] He may seem a person poorly qualified to discuss this topic realistically and objectively: first, because he had only recently arrived from Sweden and thus had but scant knowledge of the intricacies of French social life; second, because he was consumed with jealous anger over the lesbian infidelities of his wife, Siri von Essen.[60] Nonetheless, he expressed a perhaps distinctly European matter-of-factness in his acknowledgment of the sexual nature of female relationships as well as a sort of qualified tolerance shown by many toward female homosexuals in the last decade of the century: "What frolics these girls get up to is of no interest to me as long as it does not affect my family! But as soon as this peculiarity, if one can put it that way, causes trouble, it becomes a prejudicial act. As a philosopher I do not believe in vices, . . . except in cases where a citizen's rights are seriously affected."[61] Strindberg did admit that there could be a discrepancy between theory and practice (especially in his wife's case). But the philosophical distinction remained, and in Paris in the early 1890s lesbianism was generally regarded a peculiarity rather than a vice so long as it did not upset the even tenor of everyday life.

Even if these comments provide a view of women's position as different and separate from that of men in the world of law, it remains a truism that

a female homosexual was *like* a male homosexual in that both occupied a problematic place in society. Because of their shared position as outsiders, some contemporary attitudes in the debate over same-sex relationships have to be considered in detail.

There is a vast literature on the development of this discourse in Europe.[62] There can be no certainty as to how much of this discourse filtered down to Klumpke's social circle. But it is safe to say that with Klumpke's familial connections to the medical community, she had more exposure to such ideas than many. Focusing, then, on two men who dominated the field of psychopathology in the last decades of the century, the following discussion traces the influence of their theories on the French medical community.

Carl Westphal (1833–1890) is usually given credit for putting the study of stigmatized sexual expression on a "scientific" basis with an 1869 article in the *Archiv für Psychiatrie und Nervenkrankenheiten*. He coined the phrase *Konträre Sexualempfindung*, usually translated as "contrary sexual feeling," and believed that such an abnormality was congenital. Emphasizing the pathological nature of his patients, he argued that they should be exempt from the sections of the Prussian legal code condemning homosexuality. Westphal's work marks the beginning of the medicalization of homosexuality in a legal context.

The most significant medical writer of the last part of the nineteenth century was Richard von Krafft-Ebing (1840–1902). Combining several prevailing theories on disease, hereditary defects, and the concept of degeneracy, he used clinical case studies to illustrate his ideas about deviant behavior. In contrast to Westphal, he distinguished between innate and acquired perversion; he also believed that homosexuality was just one of four broad categories of sexual variation. (The names he gave to the other three are still used: fetishism, sadism, and masochism.)

By the mid-1880s, he had begun to include lesbianism in his discussion of sexual perversion. True to his taxonomical approach, he divided the "phenomenon" into four distinct categories, each describing a different social behavior and physical appearance. Nonetheless, he had to admit that "most of the questions [still] need to be addressed and demand elucidation."[63] Like Westphal's, Krafft-Ebing's expressed intentions were to help his fellow physicians cope better with the sexual problems of their patients and to aid the courts in dealing with various forms of sexual behavior. Once these two men established the importance of the medical study of sexuality, other physicians turned to it as well, replacing moralizing with "serious" research "studied by the doctor and by the jurist."[64]

The first medical interpretation of homosexuality in France was presented in an 1882 article by Jean-Martin Charcot (1825–1893) and Valentin Magnan (1835–1916).[65] Although the question of sexual inversion did not occupy a prominent place in Charcot's investigations, his status helped to legitimize the inclusion of German ideas on homosexuality (not a minor accomplishment during an era of intense hostility between the two nations) and to set the tone for further investigation.

In the early 1880s, Charcot was at the height of his fame as a scientist and a physician.[66] By virtue of his innovative work in pathologic anatomy at the faculty of medicine at the Sorbonne and in clinical neurology at the Salpêtrière in Paris, he was well known outside France and was credited with having made his country a leader in neuropathology.[67] His lectures on hysteria, the major source of his renown, attracted an international audience from the medical community and the public at large. As a medical student Augusta Klumpke naturally went to hear the master speak, but Anna also attended these lectures. Charcot's more elegant Tuesday soirées included *le tout Paris* as well as royalty and other foreign dignitaries. Those who knew him well described Charcot as the omnipotent and uncontested *maître*, whose "purpose was to teach and to convince."[68] In addressing the subject of homosexuality, Charcot and Magnan, his collaborator, drew upon Westphal's theories on "contrary sexual feelings."[69] Like their predecessors in this new field of sexology, Charcot and Magnan saw their work as rooted in the nineteenth-century tradition of experimental science and positivist medicine.

Studies by Charcot and Magnan and the medico-legalists at the Lyon School brought French research abreast of the "scientific" modes of analysis practiced in Germany and Austria. Still, as a source of information on lesbianism, the work was dangerously limited. Addressing the lack of information about women and their relationships, the noted medico-legalist Julien Chevalier remarked that "in general novelists preferred studying homosexual love among women rather than among men, because it seemed less repulsive."[70] Again we see that heterosexual male imaginings of lesbianism—because they are based on male-centered desire for women's bodies—are more acceptable than imaginings of male homosexuality. Thus Zola was able to examine women's passion, but when his own sex was involved he turned censorious to convey society's disgust.

The medico-legalist Chevalier's views were as vague as they were typical of the scientific discourse at the time. He thought that "observations

relative to women [were] rarer . . . probably because of the greater facility with which they were able to hide their troubled instincts."[71] More important, he argued, "in science, in contrast to what we have seen in literature, most of the data correspond to men. . . . It is evident that the scientists have not had the same concern [*préoccupation*] as the novelists."[72]

Summing up the confusion that prevailed in the medical community about female homosexuality, Albert Moll in 1893 suggested that in order to form an opinion it would be necessary to investigate the matter from different perspectives, since the facts seemed to indicate that there were numerous variations.[73] With unusual insight he added that his research in Berlin had revealed that a large number of the women he studied had no sexual relations whatsoever, finding contentment in platonic relationships. Though his interpretation seems close to what we have called a perfect "union," a "Boston marriage," his professional perspective won out. In the end he believed in the necessity for a cure, however difficult, for this condition.

An example of real-life figures and a discussion of female friendship may serve as a parallel to the histories of these larger-than-life investigators and their findings. The analysis here focuses upon Jules Dejerine, the husband of Augusta Klumpke, eminent neurologist at the Salpêtrière hospital in Paris, and successor to Charcot's professorial chair at the faculty of medicine at the Sorbonne.[74] Taking the family meeting of August 11, 1898, as a point of reference, I shall try to understand Dejerine's position regarding Klumpke's decision to live and work with Bonheur.

The discussion in the biography about the family meeting is brief, a mere page in length.[75] It includes the comments of Anna, Mrs. Klumpke, and Jules Dejerine. Dorothea's sentiments remain locked in secrecy; she left the room after having made her views known to her sister. The issues that were raised all addressed Klumpke's career as an artist. Klumpke remarks that she had not expected this unanimous "*blâme*" and that the situation affected her painfully.[76] The text does not include any reference to the "delicate" question of a same-sex relationship. Second, and relatedly, we have no documents to validate our account of Dejerine's opinion. To be more precise, he published an extensive list of articles, but none about "sexual perversion, innate or acquired." Although this lacuna makes it more difficult for us to reconstruct the situation and his stance, we can assume that as a member of a certain culture he knew and understood medical discourse.[77] An examination of Dejerine as a teacher and clinician can

give us, perhaps, some insight into how he might have viewed Klumpke's momentous decision to join with Bonheur.

In his extensive career as a teacher, Dejerine was said to have advocated no particular theory. In contrast to Charcot, whose clinico-anatomic teachings had earned him the title of "sharp-eyed master classifier," Dejerine lectured but did not label.[78] Recognized as both the *maître* and the *ami* of those he taught, he was reasonable and frank. Indeed, if he had a fault, it was his frankness. A colleague recalled:

> [Dejerine] was known to speak openly about what was on his mind. He never knew how to disguise his thought. To beat about the bush, to say neither yes nor no, all these devious manoeuvres dear to the judges and members of the *concours* were alien to him and stood in sharp contrast to his character. His honesty was absolute.[79]

As a clinician, Dejerine was a firm believer in *"la confession libératrice."*[80] Describing his own views on this matter, he called himself a physician who in his practice had the right and the power to engage in the same charitable act as a priest or a close friend.[81] Though *la médecine sacerdoce*— the priesthood of medicine—certainly was no new concept, in the privacy of Dejerine's consulting room at the Salpêtrière the term took on a new psychological meaning. There the patient's physical condition was not classified, but observed from a humanitarian perspective. Whereas for Charcot objectivity and distance were the unspoken rule in diagnosis, for Dejerine the guiding principle was empathy. It is difficult to imagine, then, that he would have veered significantly from that empathic and nonjudgmental stance when it came to his own sister-in-law.

Finally, in hoping to understand his attitude toward women in general and his sister-in-law in particular, we must look at his partnership with his wife, Augusta. Impressed from the start by her American spirit of independence and her intelligence, he came to see her as "a true partner."[82] The medical students commented upon this unusual arrangement, saying that they worked for *le patron* but also for *la patronne*. They also said of Dejerine that his firsthand experience of Augusta's professional battles had made him "a convinced feminist [who] campaigned vigorously in favor of women's educational rights."[83] Admittedly, he did not proclaim his feminism publicly; nor did his wife. Yet he was well known as a supporter

of women's rights; as such, he believed in a woman's right to make choices. Indeed, just as his contribution to the medical community stood alone, his personal commitment to a professional woman was also unique.

Choice and criticism of choice bring us back to where we began: the meeting at the Dejerine home in Saint Germain-des-Près on August 11, 1898. Though the real scenario cannot be known, let us draw upon our earlier discussion of those who, according to Bonheur, gave the world in general "a bad opinion about women who lived and worked together" and posit some questions. Did Dejerine consider Bonheur a *femme damnée*? Did he, like Magnan and Krafft-Ebing, see same-sex relationships as pathological? Did he, like Moll, view them as something abnormal that nonetheless ought to be accepted and tolerated? We do not know. Still, given what has been presented about his personality and career, it seems possible that the criticism he leveled at Klumpke was simply an expression of his concern for her professional endeavors. Klumpke was a successful woman with a brilliant future. But Bonheur was an artist of great international stature, one of the most famous painters in the Western world. Dejerine may well have been concerned that Klumpke, in giving up her Boston career, would become entirely eclipsed, Bonheur's acolyte rather than her partner. It was, however, as we know, not in Dejerine's nature to be judgmental, but to leave the final choice to the individual.

Dejerine's concern needs to be viewed in the context of Klumpke's own deliberations, bearing directly as it does upon her own mind-set. In her lonely hours thinking about Bonheur's offer, Klumpke had been torn between the stark realities of staying in France and leaving for America. Of course, she wished to unite her life with Bonheur's, and, of course, she was not sure how such a decision would affect her professionally. Although Dejerine, from an objective standpoint, was able to anticipate problems where her future career was concerned, Klumpke denied that a partnership with Bonheur would curtail her professional activities. In making the choice to join Bonheur, she imported an American "Boston marriage" to sapphist Paris.

To what extent this union compares with such a companionship as it might exist a century later cannot be entirely understood. As has been pointed out, when discussing the idea of "understanding" other cultures and actors in them, we need to realize the distinction between the participants' understanding and the observers' understanding.[84] In other words, however rich our source material may be in giving proof to a developing

relationship of love and affection between two women, in the end it is limited in its ability to give us full access to a situation. We have ventured to explore, but cannot explain. Yet, even though barred from the participants' space and stance, we have had the privilege of perspective, enabling us to make particular points across time and connections across cultures. Perhaps the essence of an ahistorical language of commonality and constancy lies in the words of Klumpke and Bonheur themselves. Expressing their love, they said to each other,

> My dear Anna, I love you so much. . . . if only I would have been a man I would have married you and all would have been all right; but because we are two women people do not want to believe in a union of souls. It is my happiness (*bonheur*) to know that you love me Anna as I love you, the body is old but my heart is young, I love you more and more, in Heaven we shall never be separated.

And Klumpke responded:

> *Ma chère amie*, if you say that I make your life happy, let us think of the happiness (*bonheur*) that we enjoy (*jouissons*) and that nothing can trouble this happiness. I love you, I adore you so much, *ma noble amie* and God will permit that we live still a long time together.[85]

A Retrospective

What is a retrospective? Traditionally, it is a comprehensive exhibition of the work created by a single artist over a span of years. Often it adds new information and insight to provide a better understanding of the artist and her or his life, work, and time. Although this Klumpke retrospective shares these elements, it is also different in a number of ways. First, it is, rather than a visual experience, a textual and conceptual one. Second, the narrative is not strictly chronological. It begins with the reader asking some important questions: What happened to Klumpke's promise to write a book on Bonheur? What happened to Klumpke's circle of American friends? More specifically, how did the events of the Great War bring the painter and her former patrons into a relationship of philanthropic solidarity? Having paused to answer these questions, the retrospective takes on a more traditional structure, re-viewing some of Klumpke's later work in the context of her life as a woman and her career as a painter.

The first "stop" in this retrospective is entitled "The Book." It addresses the difficult and demanding task Klumpke faced of doing justice to her *bien-aimée* in a biography. Explaining her predicament, the author-to-be observes: "To paint the portrait of her friend was quite within the day's work; to write a book about her, this was quite another matter—a painter and a writer are not interchangeable terms."[1] Referring to the mound of documents she had to sift through, Klumpke recalls, "It was a half century of accumulation that confronted me . . . [and the] task was arduous in the extreme."[2]

Aside from this daunting task, there remained the problem of executing Bonheur's will. The French painter had made Klumpke sole legatee of the estate. She had also entrusted her "with the mission of handing over to her brother Isidore Bonheur what she, according to the circumstances, would have given him."[3] The house was to remain in Klumpke's possession. How to distribute the more than one million francs' worth of studies placed Klumpke in a very difficult situation, especially as Bonheur had not wanted her work to be scattered. Klumpke remembered her saying, "If the whole lot gets sold, not a single trace of them will remain behind."[4] With no easy solution Klumpke nonetheless decided to have an auction and to give half the proceeds to Isidore Bonheur. Her generous offer had been virtually accepted when she suddenly received a subpoena from the Bonheur family, who contested the will that had left everything to Klumpke. In a letter written to her close friend in Boston, Klumpke explains her position:

> My dear Lilian,
>
> I have offered a large and generous proposition to the family . . . [but] I don't know what will come out of it all[;] . . . a most scandalous letter was sent to me accusing me of hypnotizing Bonheur, that she was feeble minded and took to drink!!! My whole conduct has been . . . most misunderstood, misinterpreted. I can defend myself, but I can never forget the slander on my darling's name.[5]

Finally, four months after Bonheur's death, she wrote to Whiting,

> [A]ll is satisfactorily ended between my Rosa Bonheur's family and myself. Of course I was not obliged to give anything, but it was a mission of honor & confidence which my darling friend had given me to fulfill & especially to keep her studio with all its memories & associations. Her pictures, studies, drawings, etchings & bronzes will be sold & I shall try & buy some pictures back so as to form a museum.[6]

Among those who gave her moral support at this time were Tony Robert-Fleury and Jules Lefebvre—in her words, "mes chers maîtres"; there were also "numerous other friends in the Old and the New World."

Acknowledging their support, Klumpke remarks: "[They] helped me to persevere and maintain until the end [a] serenity of mind."[7]

On May 25, 1900, a public sale of Bonheur's works took place at the galleries of Georges Petit in Paris. (A two-volume catalogue was produced for the event by the gallery publishers.) The troubles were settled. "But," Klumpke wrote in her biography, "how can I describe the life I led during a whole year that these hostilities and tribulations lasted."[8]

In the years that followed, words of encouragement were important in helping Klumpke pursue the promise she had made to Bonheur. A letter from Monsieur Deslandes, the head of the National Publishing House in Lisbon and a friend of Bonheur's, in whose judgment the French artist had always placed great confidence, arrived in 1904, saying: "There is no one as qualified as you who can give a faithful portrait of Rosa Bonheur's life; you, who have filled her closing years, her beautiful old age, with the joy of your affection. So do not tarry too long."[9]

On October 28, 1908, Klumpke saw the completion of her mission: the publication of the deluxe volume *Rosa Bonheur, sa vie, son oeuvre.*[10] Expressing "her admiration and wonder at the taste and industry which produced such a souvenir of [Bonheur]," Mary Thaw went on to ask, "[W]ho else could have better accomplished what you have in such a great and handsome memorial book?"[11]

The work was a commemoration of Bonheur, but it was also necessarily a testimony to their union. It is only natural that Klumpke would have wished to circulate their story among her friends in the English-speaking world. Indeed, she had hardly finished writing the biography when she began to prepare notes for an English version. On June 26, 1906, with encouraging news from an American publisher, she wrote in her journal, "Good news for my book."[12]

In the meantime, following the 1908 Flammarion publication, Klumpke began to promote the biography, presenting signed copies to friends, colleagues, and business acquaintances.[13] In 1912, before leaving for a visit to Boston, New York, and Chicago to see her friends again, she wrote to Alice Longfellow, "I trust that I shall get many orders for the sale of my book. If you would and could speak about it to your friends I would much appreciate your kindness. . . . I would let them have a copy at $6 and my autograph instead of $7 (31.50Ffr) which is the real price of the book if they get it from the editor." Excited about returning to her native country and "her second home in Boston" after an absence of fourteen years,

Klumpke noted, "I am anticipating great pleasure in seeing my devoted Boston friends and those in Chicago and in NY."[14] As she sailed from Boulogne on June 22, she also carried with her several copies of the biography that she hoped to sell or give away during a return visit to her hometown of San Francisco. Mary Thaw's purchase of seven books undoubtedly pleased Klumpke; information on other sales has not been found.

Sales of the book probably were affected by the fact that it was written in French, a language that the majority of Klumpke's friends did not know. Perhaps an English version would have interested the distant members of Bonheur's generation, the American admirers of whom still so little is known. Whereas demand for such a publication may indeed have existed, a supplier seems to have been difficult to find. As a result a book that covertly sought to "normalize" the collaborative relationship of two women never reached its potential audience.[15] Klumpke undoubtedly felt some measure of disappointment. On the other hand, Bonheur's charge to Klumpke in 1898 to purge her reputation and their union from prejudice was from the start unnaturally demanding.

If Klumpke had not expected to write a book, neither had she anticipated becoming the founder and director of a convalescent hospital during the Great War. This second "stop" in the retrospective draws upon a collection of letters written to friends in America to describe some of her activities and responsibilities in war-relief work. More important, it points to the unusual interplay between painter, patron, and philanthropy in her wartime enterprise at By.

In August 1914, when hostilities broke out between Germany and France and foreigners were urged to leave the country, Klumpke decided to remain at By.[16] She wrote that they hoisted an American flag and decided to help to the best of their ability those who were fighting for liberty and justice.[17] When the French government appealed to civilians to take in and care for convalescent French soldiers, Klumpke offered her support.[18] She was joined in her relief work by her mother, *la bonne maman*, and her sisters Dorothea and Augusta.[19] Describing the conversion of her home, which became a working hospital for the next four years, she wrote to a friend in New England, "[I am] moving all my artist's materials, easels etc, into different parts of the house, transforming my large studio into a hospital for wounded French soldiers."[20] The enterprise, referred to as l'Hôpital de Rosa Bonheur, opened on October 29, 1914,

with seventeen beds; by December of the following year, 109 soldiers had been cared for. To defray the cost of housing and treating these soldiers, many of whom stayed for two or three months, Klumpke decided to appeal for assistance from her circle of American friends. Explaining the situation as well as she could, she wrote asking for "anything [they] could spare," including money, knitted underwear, and Woodbine cigarettes. To justify her request, she invariably added, "[T]he expense for each soldier per month is 122 francs and we are grateful for small and large contributions."[21]

Over time, her letters came to be directed at a wide range of persons. She wrote to Mrs. Sharp, the wife of the American ambassador in Paris, asking her to "send iodine in powder";[22] a more ambitious request for funds was addressed to her New York dealer, M. Knoedler. Providing him with information about the circumstances at By and photographs of her poilus (the popular term for the haggard soldiers), she pointed out: "[A] few families in the village helped us in our work but now we are almost alone to continue the relief work. . . . Do you think it would be possible to sell one or two of the Rosa Bonheur pictures that I left in your safe-keeping . . . ? Do try and see what you can do."[23] No reply from Knoedler has been found.

Klumpke's numerous letters thanking her generous and benevolent friends demonstrate the successful results of her fund-raising. As she put it: "Gifts from our friends . . . enable us to care for a larger number of these brave soldiers! There is so much to be done and it is comforting to know former friends are helping us in our relief work."[24]

Several letters were addressed to her former art agent in Chicago, Sara Hallowell, who since 1910 had been living nearby in Moret, France. Like Klumpke, she was active in the war-relief effort. Visiting whenever possible, Klumpke acknowledged gifts of clothing, wishing her compatriot the strength and good health necessary to carry out her mission among the brave wounded soldiers in Moret.[25]

In correspondence with her banks (in San Francisco and in Paris), Klumpke often mentioned being short of money; in many letters to her American friends she mentioned being "very tired," saying, "I am busy and writing to my friends." She expressed her hatred of the "Prussian Huns"; she wrote about the thin and haggard soldiers arriving with the experience of trench warfare still vivid in their minds; and she often mentioned her mother, who was "knitting all day long."[26] Yet, Klumpke never

expressed any fear about living so close to the front. What was it like to know that the dreaded cannon "Big Bertha" was heaving its shells a mere forty-five miles away, or to hear firsthand about the slaughter at Verdun and the Somme? Perhaps the words a young French lieutenant entered in his Verdun diary on May 23 capture the prevailing exasperation: "Humanity . . . must be mad to do what it is doing. . . . What scenes of horror and carnage! . . . Hell cannot be so terrible."[27] Klumpke often closed her letters with the words "When will it all end?" After the first two years it was indeed difficult to believe that the war would ever be over. But by 1918 the end was at last in sight, and so too was Klumpke's fearful exposure to the Great War. In appreciation of their work over four long years, Anna and her mother were later honored by the French government with a medal, La Reconaissance Française.

Exactly how an artist like Klumpke carried out her task as administrator of a hospital needs to be looked at more closely. Other American women, also committed to aiding the Allied cause, drew upon their private funds to defray the cost of their relief work.[28] As money ran out or was blocked in a bank because of the war, fund-raising became part of these women's administrative responsibilities.

Philanthropy during the war certainly was synonymous with women. Yet the largesse upon which Klumpke depended was indissolubly linked to her professional career. The volumes of letters to her former patrons make this abundantly clear. Of the artist's transactional processes—commissioning a portrait, purchasing a painting—there had developed a circular mutuality that created the conditions for philanthropic activity. In brief, the subtle interplay of painter, patron, and philanthropist brought forth a reciprocal sphere of sponsorship, a women's realm of solidarity and unreserved cooperation that epitomized the funding and execution of the relief work at the hospital at By.

It is appropriate now to weave the experiences of this long "preamble" into the individual artist's "work and time." The last word should be emphasized: "time" cannot be confined to a single meaning with an integral status of its own. It may serve as a way of talking about what happened or of establishing difference and similarity, but to think of individuals in terms of their existence in the past involves very precise consideration of a person's particular circumstances in society. Bearing this point in mind, one final, important question should be addressed. What happened to Klumpke's life-sustaining commitment to art?

As one might expect, in spite of her demanding commitments she never left the studio; even during the war, she made sketches of her "brave soldiers." Finding solace as well as sadness, she returned to the unfinished portrait of her companion, standing at the easel in working clothes. Portraiture was the center of Klumpke's life, and other paintings of famous and fascinating people followed. (See Appendix.) After having entered the Salon, many of these portraits were exhibited in shows in Berlin, Munich, Chicago, and Pittsburgh. As is true of portraits of notable persons in general, these works served a dual function: they spread the fame of the sitter and enhanced the artist's international recognition. Although the art of photography loomed as a challenge, in the early 1900s realistic portraits still constituted an important section at the Paris Salon and were popular with artists, critics, and the public.

A true Salon artist, Klumpke continued to schedule her life around the calendar of these annual exhibits. For example, on February 10, 1910, she wrote: "My very dear Friend, I am trying to finish three pictures for the Salon. . . . I am exceedingly busy working from 9 to 6pm." With what seems a sense of panic she added, "the last day of acceptance is March 13."[29] The painting she was working on at the time was probably *The Breeze*, the ambitious image of a quasi-nude figure in nature discussed earlier.

A return visit to her native San Francisco in 1912 proved highly successful. She received the handsome sum of $2,300 for a portrait of Mathilde Unserud de Bretteville, the mother of "Big Alma" Spreckels and matriarch of the family.[30] On this trip she also painted the portrait of her father (Plate 9). It shows the aging pioneer, frequently compared in looks to Walt Whitman because of his flowing white hair and beard, slouched in a chair, his hand nonchalantly placed on the edge of a table. John Gerald Klumpke faces the viewer with the solemn eyes reminiscent of an "old Rembrandt" self-portrait. The bold execution is matched by a sensitive interpretation of the sitter. A testament to personal reconciliation, the portrait, which subsequently went on display at several American exhibits, was entitled *The Artist's Father*.[31]

It was probably upon her return to France that Klumpke sought to improve the fortunes of women painters by founding an art school, the Rosa Bonheur Memorial Art School for Women Painters and Sculptors at By/Thomery. Aside from a printed application form and a letterhead with the school's name, very little is known about the establishment, which un-

doubtedly faced difficult competition from the larger and more progressive American School at nearby Fontainebleau.[32]

With the reopening of the Salon after the war, Klumpke's successes continued. A large pastel, *Vive la France et l'Amérique (Alliance)* (Fine Arts Museum of San Francisco, San Francisco, Calif.) depicts a mother with her young child, waving the flags of France and the United States. In subject and style, this work set the stage for the type of paintings Klumpke would continue to present to the public in the coming years. Maintaining the armature she had acquired in her academic training, she painted *en plein air* genre subjects in an Impressionistic vein using muted tones. The purchase of one of her paintings by the French government in 1927 has already been mentioned. Four years later, she was awarded a bronze medal for her Salon painting *La Joie du foyer* (*The Joy of Home*) (unlocated).[33] Klumpke was then in her mid-seventies, and according to one American reporter "the passing years [had] not dimmed [her] dynamic energy and forceful personality."[34] Then, as in 1889 when she had won international acclaim and had decided "to marry Art," she did not attempt to be original and startling; her works were never meant to *épater le bourgeois*. Rather, in her view—and in that of a vast number of her contemporaries—the painter's professional goal was specific and clear: to carry on a tradition, as every good painter had always done.[35] Indeed, this was precisely what she had set out to do. In this sense, Klumpke demonstrated that "woman" and "career" were compatible terms.

If one tries to say that Klumpke was a woman of her time, the phrase brings with it great vexation. Her "time" was an extraordinary one. She was born before the Civil War, in the same year as Sigmund Freud, and died during World War II, in 1942. Her training began when Impressionism was considered shocking, and she was still active at her easel (in San Francisco) as Paris was losing its cultural hegemony to an "American school" based in New York. She formed a "union" with a companion-artist when such a choice was almost tolerated in France and wrote her memoirs during the 1930s during a period of intense homophobia in America. If defining her "time" seems to raise difficult questions, they are relatively easy compared with the ones concerning the importance of her sex. It is still not possible to ignore the first word in the phrase "woman artist." Obviously, there has been progress. Social and ideological changes certainly enabled many hundreds of women to take up the paintbrush and the pen. But progress has been neither constant nor consistent. A

woman's life and the opportunities that are afforded her are still influ-
enced by her sex. We still base our studies on a definition of "art" that
makes women's modes of visual creativity at best marginal, more often in-
visible.[36] Although historians have been theorizing historical processes of
change, we need, in Joan Scott's formulation, to ask more questions about
how things happened in order to find out why they happened.[37] Wisely,
she adds: "History is not an alibi. It defines life's terms in certain ways, but
it does not explain the events in a person's life."[38]

Klumpke may have wished to shed some light on the events in her life
when she wrote to her friend and editor, Lilian Whiting: "Perhaps [I
should] leave these reminiscences *until* I have passed away into the great
beyond. No one may feel interested NOW in what Anna Klumpke has
done but perhaps after she is gone . . . !"[39] (The last sentence of her let-
ter was left unfinished.) As a historical inquiry, this book has tried to ex-
plain some of the contradictions and conflicts that were part and parcel
of Anna Klumpke's time. It also serves to honor her prophetic wish for
remembrance.

Appendix: Select Portraits by Anna E. Klumpke

Unless otherwise stated, all portraits are unlocated.
The text includes select Sources and general Comments with brief information from archival material that documents the painter-patron relationship.

Hill-Coolidge Portraits

Hamilton Hill, father of Mary Coolidge.
Mary Eliza (Robbins) Hill, mother of Mary Coolidge.
Alonzo Hill, grandmother of Mary Coolidge.
Marian Appleton Sargent, daughter of T. Jefferson Coolidge.

Sources
[Neill, Helen S.?], Biographical Notes: "Descendants of Julia (Gardner) and Joseph Randolph Coolidge, 1860–1901," manuscript, n.d., Private Collection; Mary H. Lincoln, "A Remembrance of Mary Hamilton Coolidge," manuscript, 1984, Private Collection; Frances A. Hill, "Reminiscences of My Father and Mother," manuscript, n.d., Roger Sherman Coolidge Collection; MdARB; Correspondence in "Letters, Volumes One to Six"; Private Communication: Roger Sherman Coolidge, Mary Lincoln, Joseph Randolph Coolidge IV.

Longfellow Family Portraits

Richard Henry Dana III, husband of Edith Longfellow, Alice's sister.

Joseph G. Thorp, Jr., husband of Annie Longfellow, Alice's sister.
Amelia Chapman Thorp, mother of Joseph and Sara (Thorp) Bull.

Sources

Bernice Brown Cronkite, "Grave Alice," *Radcliffe Quarterly* (November 1965): 11–14; J. Almus Russell, "Grave Alice of 'The Children's Hour,'" *Healthways*, September–October 1977, 8–9; Howells, *A Century to Celebrate Radcliffe College, 1879–1979* (Cambridge, Mass.: Radcliffe College, 1978); Janice Killackey, "Photographs and Memories of the Longfellow Family Selected from the Collection at Longfellow National Historic Site," manuscript, Cambridge, Mass., n.d.; Elizabeth Ellery Dana, *The Dana Family in America* (Cambridge, Mass.: n.p., 1956); Sara C. Bull, *Ole Bull: A Memoir* (Boston: Riverside Press, 1886); Mortimer Brewster Smith, *The Life of Ole Bull* (Princeton: Princeton University Press, 1947); LNHS; Correspondence between Mrs. Thorp and Klumpke; MdARB; Correspondence in "Letters, Volumes One to Six."

Comments

After the death in 1880 of her internationally famous Norwegian son-in-law, the violinist Ole Bull, Mrs. Thorp lived with her daughter Sara at 168 Brattle Street, Cambridge, Massachusetts, where Klumpke was a frequent visitor.

Morison Family Portraits

John Hopkins Morison, 1894
Emily Hurd Rogers, 1890s?
Robert Swain Morison, 1913
Anne Theresa Abbot, 1913
Mary Morison, 1913
All portraits are located at the Morison homestead, Peterborough, New Hampshire.

Sources

George Abbot Morison, *Nathaniel Morison and His Descendants* (Peterborough, N.H.: Peterborough Historical Society, 1951), and *History of Peterborough, New Hampshire* (Peterborough, N.H.: Richard R. Smith, 1954); Jeffrey R. Brackett, *Memorial: Mary Morison* (Peterborough, N.H.: Peterborough Historical Society, 1917); MdARB; Correspondence in "Letters, Volumes One to Six."

Comments

Typical in many ways of the Boston women whose portraits Klumpke had painted in the 1890s, Mary Morison was a dynamic and intelligent person, whose activities included teaching, leading the Boston Public Library Committee, where she

worked "hard for the wise choice of books," supervising the management of her farm, and representing New Hampshire on the American Commission to study agricultural cooperation in Europe. To quote her eulogist, "She enjoyed leadership, . . . as the good runner in the race enjoys the power of speed." The portrait, which Klumpke painted while staying with Mary Morison in Peterborough, was exhibited in the 1914 Salon.

Foster Family Portraits

Nancy Smith Foster
George Adams, son-in-law of Nancy Smith Foster.

Sources
Private communication with John A. Bross, Jr., great-great-grandson of Nancy S. Foster; Jean F. Block, *The Uses of Gothic: Planning and Building the Campus of the University of Chicago, 1892–1932* (Chicago: University of Chicago Library, 1983); Mary Jo Aagerstoun, "Gender, Nationality, and Agency and the Art of the *fin de siècle* Woman Artist: The Example of Anna Elizabeth Klumpke (1856–1942)" (M.A. thesis, George Washington University, 1994), 140.

Comments
Nancy Smith, originally from New England, was the daughter of Deacon John Smith, a Unitarian, whose family had for several generations occupied a homestead near Peterborough, New Hampshire. She arrived in Chicago in 1840 as the wife of John H. Foster, a practicing physician. After his death, she turned to philanthropic work. She was a firm believer in women's higher education, and her most conspicuous gift is the hall that bears her name in the Women's Quadrangle of the University of Chicago. Her donation of 1892 was significant as being the first gift to signify approval of a liberal policy toward women on the part of the university. Klumpke's portrait hangs in the Nancy Foster Hall.

Adolph Meyer, M.D.

Sources
The Alan Mason Chesney Medical Archives of The Johns Hopkins Medical Institutions, Baltimore; Alfred Lief, ed., *Adolph Meyer* (New York: McGraw-Hill, 1948); Eunice E. Winters, ed., *Adolph Meyer, 1866–1950* (Baltimore: Johns Hopkins University Press, 1950–52); Edward Shorter, *A History of Psychiatry: From the Era of the Asylum to the Age of Prozac* (New York: John Wiley and Sons, 1997).

Comments

Born in Zurich and trained under Jean-Martin Charcot in Paris, Meyer arrived in Worcester, Massachusetts, in 1895. He became clinical director of Worcester State Hospital, then known as the State Lunatic Hospital. He was married to Mary Potter Brooks, who became a pioneer in many fields of psychiatry, working with her husband in hospitals and in home visits. Letters (at the Alan Mason Chesney Medical Archives) indicate that Klumpke and Meyer knew each other well from their days in Paris and were interested in each other's work. He visited her exhibitions in Boston, and she asked him to show her some of the hospital work he was engaged in during December 1896. The portrait of Meyer was painted in the spring of 1898, shortly before Klumpke's departure for Paris.

Mary Sophia Walker

Sources

Klumpke, *Rosa Bonheur*, 27; Bowdoin College Museum of Art, Walker Art Building, Brunswick, Maine; 1901.6 Correspondence in object file; Lillian B. Miller, "The Legacy: The Walker Gift, 1894."

Comments

In 1895 Walker was the donor, together with her sister Harriet Sarah Walker, of the Walker Art Building, Bowdoin College, Brunswick, Maine. Klumpke introduced Sophia Walker to Rosa Bonheur. Her American friend had expressed a wish to acquire a "tableau" for the newly founded museum. The portrait, which was painted sometime before Walker's visit to France, hangs in the college's Sophia Walker Gallery.

Mrs. Hugh Reid Griffin

Sources

MdARB; Correspondence in "Letters, Volumes One to Six"; and an unpublished speech written for the "unveiling of the portrait"; Mildred White Wells, ed., *Unity in Diversity: The History of the General Federation of Women's Clubs* (Washington, D.C.: General Federation of Women's Clubs, 1953).

Comments

Griffin was founder and first president in, 1898–99, of the Society of American Women in London, a forerunner of many American women's clubs in Europe; in 1916 the organization was renamed the American Woman's Club. Klumpke

painted two portraits of Griffin. The 1925 oil portrait, which was painted at the Château de By, France, is unlocated; the pastel, also of 1925, belongs to the General Federation of Women's Clubs, Washington, D.C.

Lucetta M. de Ver Warner

Sources
Fairfield Historical Society, AAA Inventory; accession number 1979.39.1; D. Hamilton Hurd, *History of Fairfield County, Connecticut* (Philadelphia: J. W. Lewis, 1881), 145–46; John W. Field, *Fig Leaves and Fortunes: A Fashion Company Named WARNACO* (West Kennebunk, Maine: Phoenix, n.d.).

Comments
Born Lucetta Greenman in McGrawville, New York, she married Dr. Ira de Ver Warner, a physician who, in addition to practicing medicine, built up what was then the largest corset-manufacturing company in the world. Her 1891 portrait hangs today at the Warnaco Corporation, Bridgeport, Connecticut.

Dr. Ephraim Weiss

Source
The Bancroft Library, University of California, Berkeley.

Comments
A graduate of the University of Vienna, Weiss continued his studies in philosophy in California. He and his wife, Amalia, were benefactors of the University of California and Stanford University.

Wilfrid de Fonvielle

Sources
Dictionnaire universel des contemporains, ed. G. Vaporeau (Paris: Librairie Hachette, 1893), 598; Victor Silberer, *Wiener Luftschiffer-Zeitung* (Vienna: Verlag der "Allgemeinen Sport-Zeitung," 1905), 239–40.

Comments
Fonvielle was born in Paris in 1824. He began his career by teaching mathematics. In the 1850s he experimented successfully with balloon flight. A pioneer aero-

naut, he was the author of some thirty works of popular science. His portrait was exhibited in the 1905 Salon.

Madame Mathilde Marchesi

Source
Nothing found

Comments
Marchesi was a preeminent mezzo-soprano. Her portrait was exhibited in the 1904 Salon.

Madame Camille Flammarion

Source
Dictionnaire de Biographie Française, ed. Roman d'Amat (Paris: Librairie Letouzey et Ané, 1975), 3:1463.

Comments
Mme Gabrielle Flammarion was born Gabrielle Renaudot; her father was a sculptor, her mother a painter. She studied literature at the university level and pursued a career in science journalism. During World War I she worked as a nurse and was decorated for her service. After the war she married Camille Flammarion, the great French astrologer. Following his death in 1925, she became the secretary-general of the Astronomical Society of France and editor in chief of *L'Astronomie*. She was a founding president of the Association for Peace and Disarmament by Women. Her portrait was exhibited in the 1905 Salon.

Walter Wellman

Source
Webster's American Biographies, ed. Charles Van Doren (Springfield, Mass.: Merriam-Webster, ca. 1974), 1113–14.

Comments
Born in Ohio in 1858, Wellman was a journalist, explorer, and airman. Founder of the *Cincinnati Post*, he worked as a Washington correspondent for the *Chicago*

Herald and the *Chicago Record-Herald*. In the early 1890s he became interested in travel and exploration, activities that he carried on intermittently for the rest of his life. In 1907 he embarked on an expedition in a motor-powered airship in an attempt to locate the North Pole. His portrait was exhibited that year at the Carnegie International show in Pittsburgh. It is now in a private collection.

Notes

[Introduction]

1. See *Webster's New International Dictionary*, 3d ed., s.vv. "patronage" and "matronage."

2. Although Klumpke's book *Memoirs of an Artist*, ed. Lilian Whiting (Boston: Wright and Potter Printing, 1940), is also consulted, the primary source here remains the biography of Bonheur.

3. For this interpretation, see Richard D. Altick, *Lives and Letters: A History of Literary Biography in England and America* (New York: Alfred A. Knopf, 1969), xiii.

4. For a feminist methodology of biographical writing, see Sara Alpern, ed., *The Challenge of Feminist Biography: Writing the Lives of Modern American Women* (Urbana: University of Illinois Press, 1992); Teresa Iles, *All Sides of the Subject: Women and Biography* (New York: Teachers College Press, 1992); Sidonie Smith, *Subjectivity, Identity, and the Body: Women's Autobiographical Practices in the Twentieth Century* (Bloomington: Indiana University Press, 1993); and Linda Wagner-Martin, *Telling Women's Lives: The New Biography* (New Brunswick, N.J.: Rutgers University Press, 1994).

[Chapter One]

1. MdARB; letter to John G. Klumpke, March 4, 1881.
2. MdARB; Dorothea Klumpke Roberts, "Short Biographical Sketch of the Klumpke Family," written for the Association of Pioneer Women of California, San Francisco, March 5, 1925; this unpublished document notes that John G. Klumpke's first stop, in about 1844, was New Orleans, where "he remained in his trade as boot and shoe maker, until the time of the Gold Fever of California." He arrived in Santa Barbara on August 20, 1850, and shortly thereafter moved on to San Francisco with his friend John Pfeiffer, whom he had met in New Orleans. In 1854 he was listed in the San Francisco city directory under "KLUMPKE and PFEIFFER, boots and shoes; office: 154 Montgomery."
3. The ceremony took place on October 28, 1855, in a new home on Sutter Street; presiding was the Reverend W. A. Scott, a Protestant minister from the Calvary Church in San Francisco.
4. At midcentury San Francisco's population had reached two thousand, most of whom were men and boys of Spanish, Chinese, French, Italian, Irish, or Chilean descent.
5. Klumpke, *Memoirs*, 12.
6. Ibid., 13.
7. For an extended discussion of her international fame, see Gabriel Weisberg, "La fortune des oeuvres de Rosa Bonheur en Angleterre et en Amérique," in the exhibition catalogue *Rosa Bonheur, 1822–1899* (Bordeaux: Musée des Beaux-Arts de Bordeaux, 1997), 55–76.
8. For Bonheur's popularity not only in San Francisco but throughout America, see Klumpke, *Memoirs*, 12.
9. MdARB; typewritten document to Treasury Department, Washington, D.C., February 1, 1923, signed by Dorothea Klumpke Roberts, executrix of the last will and testament of Dorothea Mathilda Tolle Klumpke, deceased.
10. MdARB; for her fond memories of the San Francisco school years, see Klumpke Roberts, "Short Biographical Sketch."

11. Dorothea Tolle had learned the craft of "stitchery" as a youngster in New York from her two sisters Augusta and Mathilda, who at the time ran their own millinery business.

12. Klumpke, *Memoirs*, 13. The difficult subject of religion arose again when Anna, later in life, was trying to reach an understanding of her own religious background. Wanting to know if she had been rebaptized because of her stepaunt's Catholic views, she wrote to her father, "What I want to know [is] the truth, and if you say you know that we were baptized Catholic I shall have to believe it" (MdARB; letter to John G. Klumpke, March 4, 1898). No letter of response has been found.

13. Quoted in Bessie van Vorst, "The Klumpke Sisters," *Critic* 37 (September 1900): 225.

14. This interpretation draws upon Margaret S. Mahler, Fred Pine, and Ani Bergman, *The Psychological Birth of the Human Infant: Symbiosis and Individuation* (New York: Basic Books, 1975); Nancy Chodorow, *The Reproduction of Mothering: Psychoanalysis and the Sociology of Gender* (Berkeley and Los Angeles: University of California Press, 1978), *Feminism and Psychoanalytic Theory* (New Haven: Yale University Press, 1989), and *Femininities, Masculinities, Sexualities: Freud and Beyond* (Lexington: University Press of Kentucky, 1994); Marcia Westkott, *The Feminist Legacy of Karen Horney* (New Haven: Yale University Press, 1986); and Janet Sayers, *Mothers of Psychoanalysis: Helene Deutsch, Karen Horney, Anna Freud, Melanie Klein* (New York: Norton, 1992). Part of a branch of psychology called "object relations," in which the mother represents the first "object" in an individual's life, their theories focus upon the dynamic nature of early mother-infant interaction and the later developmental process of separation-individuation.

15. Nancy Chodorow does not claim a universal, idealized, constructed mother-daughter relationship, but rather an intense attachment, which might include hatred and ambivalence. She adds that the attachment to a mother is not *all* that matters to a daughter, but that it does matter enormously.

16. Klumpke's leg continued to cause her much pain later in life. Writing to her father in 1902, she mentioned being in bed "with atrocious pains in my lame knee. A week ago I slipped and injured [it] very badly and shall have to lay [*sic*] perfectly quiet in bed for six weeks." MdARB; letter to John Gerald Klumpke, November 27, 1902.

17. Another source of income is referred to in Klumpke's *Memoirs*, 15. She identifies the buyer as "a stranger" who offered to buy the copy for $200.

18. The salary of a seamstress was approximately $60 a month; a tourist, according to the 1898 Baedeker guide to Paris, needed $4 a day pocket money, or $120 per month. On comparative wages, see Paul Hayes Tucker,

"The Revolution in the Garden: Monet in the Twentieth Century," in *Monet in the Twentieth Century* (New Haven: Yale University Press, 1998), 14–85, esp. 17 and n.7. In Emile Zola's *La Bête humaine* (1890), a working-class family of four lived on six thousand francs a year. I am indebted to Tucker for this information.

[Chapter Two]

1. Edith B. Gelles, *Portia: The World of Abigail Adams* (Bloomington: Indiana University Press, 1992), 105.

2. MdARB; Klumpke's words come from a letter she wrote to her friend Lilian Whiting on July 27, 1899, in which she reminisces about her sisters' triumphs.

3. The documents consulted in connection with Augusta Klumpke's medical career include Gustave Roussy, *Eloge de Madame Dejerine-Klumpke, 1859–1927* (Paris: Imprimerie Lahure, 1928); André-Thomas, ed., *Madame Dejerine, 1859–1927* (Chartres: Imprimerie Durand, 1929); and Mme [Jacqueline] Sorrel-Dejerine, *Madame Dejerine-Klumpke*, "Extrait d'un Bulletin de l'Association Française de Femmes Médecins" (Paris: Imprimerie Polygraphique, 1959); E. Gauckler, *Le Professeur J. Dejerine, 1849–1917* (Paris: Masson, 1922). I am grateful to Jean-Claude Dejerine for sharing this important material with me.

4. Sorrel-Dejerine, *Madame Dejerine-Klumpke*, 4.

5. Ibid. Vulpian noted that there were ten other women registered at the faculty of medicine at the Sorbonne, but most of them were between thirty and forty-five years of age; he added with concern, "And you, you are so young." The women Vulpian mentioned were probably working toward their medical degree. Although this degree would allow them to practice medicine in private clinics, it would not entitle them to serve as house officers in one of the great hospitals in Paris, a goal the eighteen-year-old Augusta had set for herself.

6. Françoise Leguay and Claude Barbizet, *Blanche Edwards-Pilliet: Femme et médecin, 1858–1941* (Le Mans: Editions Cénomane, 1988), is a welcome publication by two French scholars. Albeit brief, it should set a precedent for further scholarship on professional women in nineteenth-century France.

7. See the discussion "The Fight for the Internship in France," in Thomas Neville Bonner, *To the Ends of the Earth: Women's Search for Education in Medicine* (Cambridge: Harvard University Press, 1992), esp. 70–75.

8. Ibid., 72 n. 73.

9. Ibid., 70 n. 74; for a historical study of women in medicine from a French perspective, see Constance Joël, *Les filles d'Esculapes: Les femmes à la conquête du pouvoir médical* (Paris: Robert Laffont, 1988).

10. Leguay and Barbizet, *Blanche Edwards-Pilliet*, 47; according to the authors, Augusta's colleague was nominated "provisional" intern, probably because she had been "somewhat forceful" in her educational demands.

11. For information on the feminist debate in general in France, see Karen Offen's articles "Depopulation, Nationalism, and Feminism in Fin-de-Siècle France," *American Historical Review* 89 (June 1984): 648–76, "Defining Feminism: A Comparative Approach," *Signs: Journal of Women in Culture and Society* 14, nos. 1–2 (Autumn 1988): 119–57, and "On the French Origin of the Words *Feminism* and *Feminist*," *Feminist Issues* 8, no. 2 (1988): 45–51; also, see Claire Goldberg Moses, *French Feminism in the Nineteenth Century* (Albany: State University of New York Press, 1984).

12. Richard Satran, "Augusta Dejerine-Klumpke, First Woman Intern in Paris Hospitals," *Annals of Internal Medicine* 80 (February 1974): 263.

13. Ibid., 263 and n. 12.

14. MdARB; letter from Augusta Klumpke to John Gerald Klumpke, June 28, 1887.

15. William G. Spiller, untitled essay in André-Thomas, *Madame Dejerine*, 98; in 1886 her paper was awarded the prize of the Academy of Medicine.

16. André-Thomas, in *Madame Dejerine*, 11, merely mentions that with her marriage "the internship was suspended." The exact circumstances of this decision remain unknown.

17. Bonner, *Ends of the Earth*, 73 and n. 80; the author notes that, in spite of the success of Klumpke and Edwards, between 1886 and 1908 only seven other women were named as interns in the hospitals of Paris, and a mere six were designated as alternates.

18. MdARB; for mention of her early interest in astronomy, see Klumpke Roberts, "Short Biographical Sketch"; see also van Vorst, "The Klumpke Sisters," 229.

19. Kenneth Weitzenhoffer, "The Triumph of Dorothea Klumpke," *Sky and Telescope* 71 (August 1986): 109–10. Women played a major role in the great survey programs that were developed in the nineteenth century, though their appointed tasks usually involved routine data collection. Dorothea was named assistant to the pioneer astrophotographers Paul and Prosper Henry.

20. See Margaret W. Rossiter, *Women Scientists in America: Struggles and Strategies to 1940* (Baltimore: Johns Hopkins University Press, 1982), especially the chapter "The Manly Profession," for the "antifeminist practices" in the sciences of natural history, astronomy, botany, and marine biology; see also Londa Schiebinger, *The Mind Has No Sex? Women in the Origins of Modern Science* (Cambridge: Harvard University Press, 1989), for a rich and comprehensive history of women's contributions to the development of early modern science.

21. Weitzenhoffer, "The Triumph of Dorothea Klumpke," 109.

22. To observe the mid-November 1899 Leonid meteor shower, scientists in Russia, Germany, and France made plans to launch balloons. Having applied to be one of the candidates, Dorothea learned with surprise that the French Society of Aerial Navigation had chosen her for the astronomical expedition.

23. In 1902, Dorothea married the English astronomer Isaac Roberts. She lived in England until his death two years later. She continued her work in astronomy until the end of her own life.

24. Theodore Stanton, ed., *The Woman Question in Europe* (1881; reprint, New York: MSS Information, 1974), 73–74.

25. How Mathilda would have pursued her promising career in music must remain unanswered. She died at the age of thirty, after a short marriage to Harry Dalton, a lawyer whom she had met at the American colony in Paris. After their wedding in 1887 at the American Church on rue de Berri, Mathilda and her husband settled in Cincinnati. The Daltons had three children. Mathilda and her oldest child died of diphtheria, shortly before Pasteur discovered the serum that led to a vaccine against it. She was survived by her husband and her children, Cortland and Dorothy.

26. For a selection of her compositions, see José Rodriguez, ed., *Dictionary of Music and Dance in California* (Hollywood: Bureau of Musical Research, 1940), 378.

27. "New England Conservatory, Annual Meeting and Reports of the President and Director," *Boston Evening Transcript*, January 19, 1894.

28. Julia gained her diploma in June 1895, when she may have returned to Paris. For information on Ysaÿe and Boulanger, see Boris Schwartz, *The Great Masters of the Violin* (New York: Simon and Schuster, 1983), 279–94 and 348, respectively.

29. New England Conservatory, Spaulding Library, Archives, File: "Testimonial and Press Notices, Julia Klumpke."

30. MdARB; letter from Wilhelm Klumpke to "Dear Father," August 31, 1887.

31. For a general history of this institution, see Catherine Fehrer, *The Julian Academy, Paris, 1868–1939* (New York: Shepherd Gallery, 1989). A detailed study of this most popular establishment in the context of fin-de-siècle culture is urgently needed.

32. See *L'Académie Julian*, Bagnols (Gard) (Paris: Alban Broche, 1890). This publication, which describes the work at the Académie, includes a detailed account of its curriculum and instructors. For a wealth of information about studio practices at the academic ateliers, see Albert Boime, *The Academy and French Painting in the Nineteenth Century* (New Haven: Yale University Press, 1986).

33. See Germaine Greer, "'A tout prix devenir quelqu'un': The Women of the

Académie Julian," in *Artistic Relations: Literature and the Visual Arts in Nine-teenth-Century France*, ed. Peter Collier and Robert Lethbridge (New Haven: Yale University Press, 1994); for details concerning tuition fees, see the 1890 publication *L'Académie Julian*; for more general information on this topic, see Lois Marie Fink, *American Art at the Nineteenth-Century Paris Salons* (Cambridge: Cambridge University Press, 1990), 136. For the comment of a student, see Ida Smith, "At the Académie Julian," *Bulletin*, January 26, 1893: female "[p]upils pay twelve dollars [about one hundred francs] a month for morning only; twenty dollars [for the whole day]."

34. Smith, "At the Académie Julian."

35. MdARB; handwritten, undated notes by Anna Klumpke.

36. Smith, "At the Académie Julian."

37. Klumpke, *Memoirs*, 20.

38. Smith, "At the Académie Julian."

39. Véronique Wiesenger, *Paris Bound: Americans in Art Schools, 1868–1918* (Paris: Dossiers du Musée de Blérancourt, no. 1, 1990), 23–24 and n. 34; see also other essays in this richly illustrated bilingual publication on American students in Paris.

40. Ibid., 24 and n. 36.

41. Fehrer, *The Julian Academy*, 15.

42. SSC; Ellen Day Hale, Box 45b, File 1073; letter dated Paris, March 16, 1882.

43. *L'Académie Julian*, 9–10.

44. Klumpke, *Memoirs*, 18, mentions a group portrait of the Marquis de Raige-count's children and a portrait of Madame de Gayon. Neither has been found.

45. Fink, *American Art*, 237, notes that of oil paintings shown by Americans at the Champs-Elysées and the Champ-de-Mars Salons, at the end of the century portraits accounted for 20 percent of the canvases.

46. Klumpke, *Memoirs*, 17.

47. Ibid., 20; the other two women honored on this day were Mlle Burgan, who also gained an honorable mention, and Mlle Baurey-Sorrel, who was awarded a bronze medal; see Fink, *American Art*, 135–36, for a brief discussion of female artists and Salon awards, and also 310–12 for a list of awards to American Salon exhibitors between 1800 and 1899.

48. "The End of the Salon," *Boston Evening Traveller*, July 17, 1885.

49. See Debora L. Silverman, *Art Nouveau in Fin-de-Siècle France: Politics, Psychology, and Style* (Berkeley and Los Angeles: University of California Press, 1989), 69, but especially chapter 4, "Amazone, Femme Nouvelle, and the Threat to the Bourgeois Family," with its excellent discussion of the differ

ent factors contributing to the public preoccupation with the menace of the *femme nouvelle.*

50. MdARB; unpublished document. The words are from an address by the Reverend Chauncey W. Goodrich at the funeral of Dorothea Mathilda Tolle Klumpke at the American Church, 21, rue de Berri, May 15, 1922.

51. For an insightful and inspirational interpretation, see Gelles, *Portia,* "Mother and Citizen," 133–49.

52. For a development of this idea, see Philip J. Greven, *The Protestant Temperament: Patterns in Child Rearing, Religious Experience, and the Self in Early America* (New York: Alfred A. Knopf, 1977), 178–79. According to Greven, the concept of duty was the significant motif, the dominant theme, of the moderate temperament and religious experience.

53. For a mention of this mother, whose exacting strictness, tempered by sympathy, urged the children on to do their best, see van Vorst, "The Klumpke Sisters," 224–25.

54. Klumpke, *Memoirs,* 14.

55. For a discussion of Dorothea's ascent of November 16, 1899, a significant event in the history of women and aircraft, see Weitzenhoffer, "The Triumph of Dorothea Klumpke," 109–10.

56. For the quote, see André-Thomas, *Madame Dejerine,* 12.

57. MdARB; letter from her mother to Anna Klumpke, Paris, December 31, 1897.

58. MdARB; letter from Wilhelm Klumpke to "Dear Father," Paris, August 31, 1887.

59. Véronique Wiesenger, *Les Américains et la Légion d'Honneur, 1853–1947* (Paris: Musée national de la Coopération franco-américaine, Château de Blérencourt, 1993), esp. 66–67. Of the four Legion of Honor designations, Grand Officier and Commandeur were restricted to men.

60. Highlighting the area around the head was a baroque device, later favored especially by Sir Joshua Reynolds in his portrayal of wigged sitters. Klumpke adopted this technique in several of her other portraits.

61. MMA; Artist File. The quote of March 5, 1891, belongs to a list of press comments published for the 1897 opening of the Albany Historical and Art Society.

62. See George William Sheldon, *Recent Ideals of American Art* (ca. 1888; reprint, New York: Garland Publishers, 1977), 159. An illustration of her *Portrait of My Mother* appears on 160.

63. For essays that address this topic, see Annette Blaugrund, *Paris, 1889: American Artists at the Universal Exposition* (New York: Harry N. Abrams, 1989).

64. Anna E. Klumpke, *Rosa Bonheur, sa vie, son oeuvre* (Paris: Flammarion, 1908), 111.

[Chapter Three]

1. See John Milner, *The Studios of Paris: The Capital of Art in the Late Nineteenth Century* (New Haven: Yale University Press, 1988), 48 and n. 10.

2. Ibid., 48 n. 9.

3. See Fink, *American Art*, 116–24; it was an enormous change in a culture where, for more than two centuries, the state had supported and manipulated the production of art. As Fink points out, though some artists and critics were apprehensive about having artists, with all of their factions, in charge of the Salons, others welcomed this radical step, including the editor of *L'Art français*, who believed future Salons would be brilliant.

4. For a discussion, see Tamar Garb, *Sisters of the Brush: Women's Artistic Culture in Late-Nineteenth-Century Paris* (New Haven: Yale University Press, 1994), 26–27. The number of women accepted at the Salon had increased throughout the 1870s. From 286 in 1874, the number had grown to 648 by 1877 and to as many as 1,081 by 1880. With the introduction of an altogether stricter admissions policy, the number of women admitted to the 1881 Salon was reduced to 658. From then on, women made up about 20 percent of the total number of Salon artists. Also, judging by the information in Fink, *American Art*, "List of American Exhibitors," it seems that it was especially painters of porcelain and miniatures who were eliminated from showing at the Salon.

5. See Fink, *American Art*, 135 and especially 136 for a useful comparative graph.

6. Fehrer, *The Julian Academy*, 13.

7. Milner, *The Studios of Paris*, 49 n. 20; Fehrer, *The Julian Academy*, 13. On June 15, 1879, Bashkirtseff wrote in her journal: "You urge me on because of the money I bring in and the honor that I may bring to the atelier." Later that year Julian suggested that she should paint the subject of a woman's atelier. Since it would bring him publicity, he would do everything in his power to promote her and her work. Bashkirtseff's painting *L'atélier Julian* (1882) is today in the permanent collection of the Dnepropetrovsk Art Museum, Ukraine.

8. Smith, "At the Académie Julian," April 8, 1893.

9. SSC: Ellen Day Hale, Box 45b, File 1074.

10. Fink, *American Art*, 121; she notes that the number of paintings presented to Salon juries often exceeded five thousand.

11. See Madeleine Fidell-Beaufort, "Elizabeth Jane Gardner Bouguereau: A Parisian Artist from New Hampshire," *Archives of American Art Journal* 24, no. 2 (1984): 2–9; see also Charlotte Streifer Rubinstein, *American Women Artists* (Boston: G. K. Hall, 1982), 110–12.

12. Fidell-Beaufort, "Elizabeth Jane Gardner Bouguereau," 8 and n. 38.
13. Nancy Mowll Mathews, *Mary Cassatt: A Life* (New York: Villard Books, 1994), 117 and 131 n. 41; her brother Robert wrote in 1878, "We do not go to either the [American] chapels or in any way court the *Colony*."
14. The dates of their Salon debuts are 1885 for Hale, 1887 for Beaux and Lee-Robbins, 1888 for Nourse, and 1889 for Perry.
15. See Mary Alice Heekin Burke and Lois Marie Fink, *Elizabeth Nourse, 1859–1938: A Salon Career* (Washington, D.C.: National Museum of American Art/Smithsonian Institution Press, 1983), for a biographical study of the painter.
16. See Fink, *American Art*, which lists addresses of American Salon exhibitors. When Klumpke moved to a larger studio on 90, rue d'Assas in 1888, Nourse took over her apartment on 6, rue de la Grand Chaumière and remained there until 1891.
17. For some information on this artist's studio, see H. Barbara Weinberg, "Carolus Duran," in *The Lure of Paris: Nineteenth-Century American Painters and Their French Teachers* (New York: Abbeville Press, 1991), 189–219.
18. For two related articles, see Constance Cain Hungerford, "Meissonier and the Founding of the Société Nationale des Beaux-Arts," and Marie Jeannine Aquilino, "The Decorating Campaigns at the Salon du Champ-de-Mars and the Salon des Champs-Elysées in the 1890s," both in *Art Journal* 48 (Spring 1989): 71–77 and 78–84, respectively. Aquilino notes that in order to distinguish themselves from their competition, the founders of the Nationale suppressed the traditional distribution of medals and honorary mentions that followed the exhibition in favor of a certificate of membership for artists considered to be of exceptional merit by an elected delegation of twenty-six members. In essence, the "new" Salon eliminated privileges, making it appear as though favoritism and entitlement would be abolished.
19. An outstanding difference between the two exhibitions was their size. Approximately fourteen hundred works appeared in 1890 at the smaller Champ-de-Mars Salon, compared to the more than five thousand at the Champs-Elysées.
20. Fink, *American Art*, 123.
21. For a discussion of Klumpke and the Salon, see Britta C. Dwyer, "Anna Elizabeth Klumpke: A Salon Artist *Par Excellence*," *Revue française d'études américaines* 59 (February 1994): 11–23.
22. For further explanation of the division into sections and levels of membership, see Lois Marie Fink, "Elizabeth Nourse: Painting the Motif of Humanity," in Burke and Fink, *Elizabeth Nourse*, 97 and n. 29.
23. Burke and Fink, *Elizabeth Nourse*, 70 and n. 175.

24. "Buoyed by this success," Burke and Fink observe, Nourse continued to experiment with similar images as well as painting watercolor landscapes. Ibid., 70–72.

25. The *New York Times*, September 15, 1927, showcased the news in an article entitled "France Buys Painting by American." The reporter explained that the director of the Beaux-Arts had bought Klumpke's painting after seeing it at the first salon of American artists held at the Jacques Seligmann Galleries in Paris.

26. Burke and Fink, *Elizabeth Nourse*, 34 n. 62.

27. MdARB; Letters, Volume Five, 1928–June 1930; to Miss Katherine Gavan, January 13, 1930. Miss Gavan was the secretary to Klumpke's patron Mary Thaw, of Pittsburgh.

28. Fink, *American Art*, 204, writes that the painting was acquired by a Frenchman for the French national collection and that the price had been pushed up to this astronomical figure through competition with American buyers. See also Milner, *The Studios of Paris*, 103, for a discussion of Millet's reputation in the 1880s and 1890s.

29. A smaller version of this painting, measuring 55 × 69", is in the Louise and Alan Sellars Collection of Art by American Women, Marietta, Ga.

30. For an analysis of works by women artists in the context of the dominant representations of femininity, see Griselda Pollock, "Modernity and the Spaces of Femininity," in *Vision & Difference: Femininity, Feminism, and the Histories of Art* (London: Routledge, 1988), 50–90; the quote is from p. 81.

31. For an insightful development of this approach, see Elaine Showalter, "Women's Writing and Women's Culture," in *The New Feminist Criticism: Essays on Women, Literature, and Theory* (New York: Pantheon Books, 1985), 259–67, esp. 264.

32. Brandon Brame-Fortune, "Not above Reproach: The Career of Lucy Lee-Robbins," *American Art* (Spring 1988): 40–65.

33. For this interpretation, I am indebted to Brame-Fortune, "Not above Reproach."

34. The full French title is *La brise se balance dans les arbres de la forêt* (Ed. Romilly). The young writer Edouard Romilly had visited Klumpke at By. In appreciation of her hospitality he sent her a copy of his latest romantic poem, *Mayâni, Colombine et Colombin: Un moment de la pensée indienne* (1910). Klumpke used his allegorical figure *La Brise* as a source for her painting. See Aagerstoun, "Gender, Nationality, Agency and the Art of the *fin de siècle* Woman Artist: The Example of Anna Elizabeth Klumpke (1856–1942)" (M.A. thesis, George Washington University, 1994), 132–50, for interpretations of Klumpke's 1896 female figure *Scheherazade*, the Middle Eastern woman in the classic folk tales

Arabian Nights, and of the 1921 image of a standing, flimsily draped woman, *L'âme de la forêt*. Both are in a private collection.

35. MdARB; Letters, Volume One, 1906–10; to "Mon cher et bon Professeur," March 15, 1910.

36. Georges Normandy, *Le Nu aux Salons* (Paris: Albert Méricant, 1912), v–xxxi.

37. Ibid., xxvi.

38. See Tamar Garb, "Gender and Representation," in Francis Franscina et al., *Modernity and Modernism: French Painting in the Nineteenth Century* (New Haven: Yale University Press, 1993), 256–77, esp. 262.

39. See Carol Ockman, *Ingres's Eroticized Bodies: Retracing the Serpentine Line* (New Haven: Yale University Press, 1995).

40. This area of visual culture is still underresearched; Ockman's learned and sophisticated book provides the encouragement needed to activate further explorations.

41. See Fink, *American Art*, 362, for a record of Klumpke's exhibits, included in the author's invaluable list of nineteenth-century American exhibitors and their works.

42. MdARB; a handwritten list of postcards of her paintings spanning two decades includes Salon works as well as the portrait of Elizabeth Cady Stanton.

[Chapter Four]

1. For this interpretation, see Nancy Mowll Mathews, "American Women Artists at the Turn of the Century: Opportunities and Choices," in *Lilla Cabot Perry: An American Impressionist*, ed. Meredith Martindale (Washington, D.C.: National Museum of Women in the Arts, 1990), 105–14, especially 106.

2. Theodore Stanton, ed., *Selections from "The Woman Question in Europe"* (1884; reprint, New York: Hacker, 1910).

3. The word *Review*, which is inscribed on both journals, is perhaps a shortening of the *North American Review*, in which her article "Has Christianity Benefitted Women?" appeared in 1885.

4. See Lois W. Banner, *Elizabeth Cady Stanton: A Radical for Woman's Rights* (Boston: Little, Brown, 1980), 47, who notes that the event marked a most important moment in the history of woman suffrage: the founding of the International Council of Women and the National Council of Women for the United States.

5. Although Bonnat attracted American patronage from prominent, wealthy businessmen, he was less popular with American women sitters. Whether it was Bonnat's mannered approach, his focus upon delicacy and color, or his display of costume details and textures that accounts for his relative lack of popularity among women is a question for future Bonnat scholars to address.

6. Elizabeth Cady Stanton, in *Eighty Years and More (1815–1897): Reminiscences of Elizabeth Cady Stanton* (1898; reprint, Boston: Northeastern University Press, 1993), 404–5, recalled that she was in the hands of two artists, Anna Klumpke, who painted her portrait, and Paul Bartlett, who sculpted her bust. To shorten the operation, she sometimes sat for both at the same time.

7. Allocating a work a good or a bad place in the display was a succinct indication of the jury members' opinion. To have a work placed close to eye level, "on the line," represented the ultimate approval.

8. For more observations on her visit, which lasted from April to October 1886, see Theodore Stanton and Harriot Stanton Blatch, eds., *Elizabeth Cady Stanton as Revealed in Her Letters, Diary, and Reminiscences*, 2 vols. (1922; reprint, New York: Arno and the New York Times, 1969), 1: 307–17; the prime minister is quoted on 310.

9. MdARB; Letters, Volume Four, 1916; the date is not legible.

10. MdARB; Letters, Volume Five, 1929–33; letter to Harriot Stanton Blatch, October 7, 1929.

11. See Fidell-Beaufort, "Elizabeth Jane Gardner Bouguereau," 4. The artists whose works were collected by the Americans included Camille Corot and popular Salon painters such as Jean-Léon Gérôme, Hughes Merlem, and Bouguereau.

12. Klumpke, *Memoirs*, 26; for brief information on Breton and de Vuillefroy, see E. Bénézit, *Dictionnaire critique et documentaire des peintres, sculpteurs, dessinateurs et graveurs*, vol. 2 (Paris: Librairie Gründ, 1976), 302 and 589–90, respectively. An animal painter and engraver, Emile-Adélard Breton benefitted greatly from the reputation of his older brother Jules. His Salon debut occurred in 1861 with three peasant scenes, and his success was confirmed with medals in following exhibits. He lived throughout his life in his native village of Pas-de-Calais in northern France. He was especially admired by Vincent van Gogh for his sensitive approach and artistic quality. Félix Dominique de Vuillefroy was a painter and lithographer with a well-established Salon record. In 1880, he was named Chevalier of the Legion of Honor. A member of the Société des Artistes Français, he painted pasture scenes with bovine subjects. A picture like *Harvest Gathering* sold in Paris in 1884 at 1,950 francs. The price of his lithographs is not known. For Klumpke's selection of a work by "Monsieur Tony," see MdARB; Letters, Volume Five, 1928–29; to Monsieur Gelhay (unknown), June 5, 1929. Klumpke was to show her allegiance to her *maître* throughout her life. Decades later, she tried to contribute to the memory of "her dear professor Tony Robert-Fleury," seeking to find the whereabouts of his large painting *Départ de Washington* in the hope that, once found, an American museum would purchase it.

13. Klumpke, *Memoirs*, 26.

14. Ibid.

15. For a discussion, see Gabriel P. Weisberg, "P. A. J. Dagnan-Bouveret and the Illusion of Photographic Naturalism," *Arts Magazine* 56 (March 1982): 101–5, esp. 102–3.

16. For an extended study, see Gabriel P. Weisberg, *Beyond Impressionism: The Naturalist Impulse* (New York: Harry N. Abrams, 1992).

17. See Jeanne Madeleine Weimann, *The Fair Women: The Story of the Woman's Building, World's Columbian Exposition* (Chicago: Academy Chicago, 1981), 181–214. As secretary of the art department of the Interstate Industrial Exposition of Chicago, Hallowell had become a well-known American agent in the yearly Paris Salons. By keeping her standards high, she had gained a reputation as a fine judge with remarkable executive ability.

18. PAFA Archives; Artist File; letter to George Corliss, July 2, 1890. In appreciation of the award, Klumpke presented the picture to the Pennsylvania Academy.

19. MdARB; unidentified newspaper clipping, October 14, 1899. An explanation of how Arbuckle came to meet Klumpke is provided by the reporter, who noted that the American visitor and his family had lived at Mrs. Klumpke's house. For a discussion of the encounter with Bonheur, see Klumpke, *Memoirs*, 28–29, and Klumpke, *Rosa Bonheur*, 7–8.

20. For a specific discussion that explains Bonheur's oversight, see Britta C. Dwyer, "Rosa Bonheur and Her Companion-Artist: What Made Anna Klumpke Special?" in *Rosa Bonheur: All Nature's Children* (New York: exhibition catalogue, Dahesh Museum, 1998), 63–78.

21. Klumpke, *Memoirs*, 29.

22. Klumpke, *Rosa Bonheur*, 6.

23. For a discussion of Bonheur's encounter with Buffalo Bill Cody, see Dore Ashton, *Rosa Bonheur: A Life and Legend* (New York: Viking Press, 1981), 148–57; see also Gabriel P. Weisberg, "Rosa Bonheur's Reception in England and America: The Popularization of a Legend and the Celebration of a Myth," in *Rosa Bonheur: All Nature's Children*, 1–22.

24. Klumpke, *Rosa Bonheur*, 10.

25. For some rare information on Americans studying architecture at the Ecole des Beaux-Arts, see "Biographical Notes: Descendants of Julia (Gardner) and Joseph Randolph Coolidge, 1860–1901," compiled (possibly) by Helen S. Neill (private collection), n.d. In March 1891, he tried for the Beaux-Arts examination but failed. This was apparently the second time when only thirty candidates of two hundred or more were admitted. He passed the exam that June, the thirtieth of thirty admitted. The entrance exams were infamously difficult, especially for foreigners, who had to master the history and theory in French. Having completed his studies at the EBA in 1894, he, Mary, and

their three children (Elsa was born in Paris on December 10, 1890) returned to Boston.

26. His sister Julia was born on September 6, 1889.

27. The varnish that gave added lustre to the paintings also gave the day its name, *vernissage*.

28. Klumpke, *Memoirs*, 31; later exhibition venues for her painting included the St. Botolph Club, Boston (1892), Boston Museum of Fine Arts (1893), and Gillespie Gallery, Pittsburgh (1897). The exhibition catalogues for the last two shows listed the painting as *Mother and Child*.

29. MdARB; typed manuscript by Klumpke for an English translation of her biography.

30. Klumpke, *Memoirs*, 32.

31. Ibid.

[Chapter Five]

1. For the following description and interpretation, see William L. Vance, "Redefining 'Bostonians,'" in *The Bostonians: Painters of an Elegant Age, 1870–1930*, ed. Trevor J. Fairbrother (Boston: Museum of Fine Arts, 1986), 9–30.

2. Music rose to prominence under the leadership of Henry Lee Higginson, founder of the Boston Symphony Orchestra. Julia Klumpke, who was about to further her studies at the New England Conservatory, could not have wished for a more inspirational setting in America as far as her professional interests were concerned.

3. Vance, "Redefining 'Bostonians,'" 16. For a summary of the high regard in which Hunt was held in Boston, see also Sally Webster, *William Morris Hunt, 1824–1879* (New York: Cambridge University Press, 1991), esp. 194.

4. S. C. de Soissons, *Boston Artists: A Parisian Critic's Notes* (Boston: n.p., 1894), esp. 40.

5. For a development of these ideas, but in a different, more recent context, see Carol Duncan's now classic article, "When Greatness Is a Box of Wheaties," in *The Aesthetics of Power: Essays in Critical Art History* (Cambridge: Cambridge University Press, 1993), 121–32.

6. Ibid., 130.

7. The following year Klumpke moved to 82 Beacon Street. She later also lived at 56 Chestnut Street, and in 1898 at 480 Boylston Street.

8. For a discussion with useful information related to the art community, see Doris A. Birmingham, "Boston's St. Botolph Club: Home of the Impressionists," *Archives of American Art Journal* 31, no. 3 (1991): 26–34.

9. Archives of St. Botolph Club, Boston, Mass.; "List of Exhibitions, 1882–1991, Prepared for the Massachusetts Historical Society, 1991." The records

are incomplete. For a brief discussion of Whitman, see Martha Hoppin, "Women Artists in Boston, 1870–1900: The Pupils of William Morris Hunt," *American Art Journal* 13 (Winter 1981): 28–31. For an article lauding her former art instructor, see Sarah W. Whitman, "William Morris Hunt," *International Review* 8 (1880): 389–401.

10. Strong was a professional painter of apparently solid achievement. She was born either in the United States (possibly in San Francisco) or in Paris. Listed as a pupil of M. Van Marcke and G. Dupré, she entered the Salon in 1883 and exhibited there through 1888. She seems to have lived most of these years in Cernay-la-Ville, residing in Paris only in 1886, when she rented accommodation *chez* M. Tripp at 34, rue de Provence.

11. For information about this work, see Alan Schom, *Emile Zola: A Bourgeois Rebel* (London: Queen Anne Press, 1997), 121–22 and 220. As its title suggests, the 1888 novel is a fantasy. Dismayed by the intensity of the criticism leveled at his previous work, *La Terre*, part of the *Rougon-Macquart* series, Zola wanted to show the world that not every product of his pen was necessarily crude and decadent. On June 18, 1891, barely two months after the opening of the Salon, where Klumpke had exhibited her version of Zola's work, the novel was produced as a play at the Opéra-Comique in Paris. The stage production subsequently toured the capitals of Europe with resounding success. Klumpke was then in Boston.

12. For the significance of this book, see Emile Zola, *Le Rêve* (*The Dream*), trans. Eliza E. Chase (London: Chatto and Windus, 1893), 25. Zola writes that Angelique cherished the book's mysticism, in which she reveled until it seemed real.

13. *Boston Evening Transcript*, January 16, 1892.

14. See Gary A. Reynolds, *John Singer Sargent* (New York: Whitney Museum of American Art, 1987), 147–81, esp. 155 n. 25, for a discussion of his work in the late 1880s and the difficulties Sargent had with the conservative Boston critics, who were disappointed with his hasty execution and often eccentric compositions.

15. De Soissons, *Boston Artists*, 23–41.

16. For more information, see Erica Hirshler, "Artists' Biographies," in Fairbrother, *The Bostonians*, 204. Twelve years younger than Klumpke, Chase played an important role in the Boston art community during a later period.

17. Both had returned from art training in Paris to take up teaching positions at the School of the Boston Museum of Fine Arts in 1889.

18. De Soissons, *Boston Artists*, 40.

19. Although the record of achievement for women artists in Boston seems impressive, there are only a few monographs about any of the city's female painters. Except for Erica Hirshler's "Lilian Westcott Hale (1880–1963): A

Woman Painter of the Boston School," 2 vols. (Ph.D. diss., Boston University, 1992), there is no scholarly survey of their accomplishments.

20. See Hoppin, "Women Artists in Boston," 17–46.

21. For this interpretation, see Hirshler, "Lilian Westcott Hale," 1: 17.

22. Hoppin, "Women Artists in Boston," 19. Devoting himself full-time to painting, he kept on making daily visits and continued to guide the students until about 1875. Webster's discussion of Hunt's "school" and female students in *William Morris Hunt, 1824–1879* is limited and cursory.

23. See artists with Boston addresses in "List of American Exhibitors and Their Works, 1800–1899," Fink, *American Art*, 313–409.

24. More than half of the women, including Sarah Whitman, Elizabeth Boott, Emily Norcross, and Annete Rogers, resorted to painting and exhibiting still lifes, a category that was not taught by Hunt.

25. See Kathleen D. McCarthy, *Women's Culture: American Philanthropy and Art, 1830–1930* (Chicago: University of Chicago Press, 1991), "Artists and Mentors," 83–109.

26. William Morris Downes, "Boston Art and Artists," in *Essays on Art and Artists*, ed. F. Hopkinson Smith et al. (Boston: American Art League, 1896), 280.

27. Hoppin, "Women Artists in Boston," 45.

28. See the excellent article by Sarah Burns, "The 'Earnest, Untiring Worker' and the Magician of the Brush: Gender Politics in the Criticism of Cecilia Beaux and John Singer Sargent," *Oxford Art Journal* 15, no. 1 (1992): 36–54. See also Sarah Burns, "Outselling the Feminine," chap. 5 in *Inventing the Modern Artist: Art and Culture in Gilded Age America* (New Haven: Yale University Press, 1996).

29. Burns, *Inventing the Modern Artist*, 181 and n. 26.

30. Greta [pseud.], "Art in Boston," *Art Amateur* 16 (January 1887): 28; see other citations to Greta in Fairbrother, *The Bostonians*, 88–89.

31. MdARB; newspaper clipping; *Boston Evening Transcript*, January 26, 1892.

32. MdARB; newspaper clipping; *Boston Sunday Herald*, January 14, 1894.

33. MdARB; newspaper clipping; *Boston Evening Transcript*, January 11, 1894. See Douglass Shand-Tucci, *Boston Bohemia, 1881–1900*, vol. 1 of *Ralph Adams Cram: Life and Architecture* (Amherst: University of Massachusetts Press, 1995), for mention of Cram as art critic of this paper in the mid-1880s. Whether he was the author of this column remains uncertain.

34. MdARB; newspaper clipping; unidentified, no date.

35. MdARB; newspaper clipping, *Boston Daily Advertiser*, February 7, 1893.

36. Klumpke told the interviewer at the time that she had brought nearly everything from Paris, saying, "One can pick up things there for comparatively little, while here they would cost fabulous sums." See Abigail May Niereker,

Studying Art Abroad and How to Do It Cheaply (Boston: Roberts, 1879), esp. 43–44 and 70–71, for some information on how to furnish an American studio with ornamental *meubles* at surprisingly little cost. The author recommended a visit to the Hôtel Druot, the great auction rooms of Paris, noting that "household articles after a year's use, together with bric-à-brac which belongs in the category of 'artist's tools of trade,' could enter the United States free of heavy customs duties."

37. See Burns, *Inventing the Modern Artist*, 49–58, esp. 50 n. 6, for her excellent discussion "Marketing Ambience: Studios and the Culture of Display."

38. MdARB; letter to John G. Klumpke, Boston, June 3, 1892.

[Chapter Six]

1. Th. Bentzon, "Condition de la femme aux Etats-Unis, Notes de voyage II," *Revues des deux mondes* 125 (1894): 94–131, esp. 98.

2. For this essay, see Ednah D. Cheney, "The Women of Boston," in *The Memorial History of Boston*, ed. Justin Winsor (Boston: James R. Osgood, 1880–81), 4: 331–56. I am grateful to William L. Vance for his inspirational essay "Redefining 'Bostonians,'" in Fairbrother, *The Bostonians*, 9–30.

3. Quoted in Vance, "Redefining 'Bostonians,'" 25.

4. Ibid., 26.

5. MdARB; newspaper clipping, unidentified, March 14, 1897.

6. Frances A. Hill, "Reminiscences of My Father and Mother," unpublished manuscript, Roger Sherman Coolidge Collection.

7. Klumpke, *Rosa Bonheur*, 22.

8. Little is known about her mother, Frances Appleton, who was accidentally burned to death in 1861 when a match set fire to her dress.

9. LNHS Archives; Papers of Alice Mary Longfellow (1850–1928), Catalogue # LONG 16173, Location: LONG Basement Vault, Box 23.

10. In addition to her love of travel, Longfellow's public life was characterized by her interest in numerous charitable and volunteer activities, including preservation efforts at Mount Vernon and relief work during World War I.

11. For a detailed discussion of the history of the Society to Encourage Studies at Home, see Sally Schwager, "'Harvard Women': A History of the Founding of Radcliffe College" (Ph.D. diss., Harvard University, 1982), 30–79.

12. Dorothy Eliza Howells, "An Experiment in Faith," chap. 1 in *A Century to Celebrate: Radcliffe College, 1879–1979* (Cambridge: Radcliffe College, 1978), 5. Lilian's mother, Mary L'Hommedieu, was a poet and contributor to the popular *Knickerbocker Magazine* of New York; she died in 1885. Her father, Eben Norton Horsford, was well known for his special local interests in the history of American Indians, geography, and archeology. A notable chapter

in his career was his connection with Wellesley College as a donor of funds and equipment. In 1887, Lilian also became a trustee of the college. In 1900, she married William Gilson Farlow, a professor of biology at Harvard, and lived at 24 Quincy Street in Cambridge. Her friend Longfellow remained single, which she stressed was "from her own choice."

13. See Schwager, "'Harvard Women,'" 188–209, for discussions of Elizabeth Cary Agassiz and Charles William Eliot, whose stance the author describes as one of "benign opposition" to women's higher education.

14. Ibid., 357 and n. 38.

15. Ibid., 368–85; Schwager discusses some of the ongoing problems that riddled Radcliffe and its relationship with Harvard.

16. Ibid., 375 and n. 56.

17. Ibid., 193.

18. LNHS Archives; these two paintings were added to an already substantial collection of art. It has recently been documented and is awaiting analysis and interpretation.

19. The hospital, which opened in June 1892, adopted a corporate structure drawn up along the lines of Children's Hospital in Boston, where their husbands, Robert C. Winthrop and Oliver W. Peabody, were trustees. Starting with beds for about thirty youngsters, the hospital grew to several hundred beds in the following decades. Most of the patients were convalescing from bone or glandular tuberculosis and typhoid; children suffering from malnourishment were also cared for. The institution was an extremely useful adjunct to Children's Hospital through the 1930s. As antibiotics became common, its usefulness declined.

20. For some information on the Convalescent Home for Children at Wellesley Hills, see Clement Smith, *The Children's Hospital of Boston* (Boston: Little, Brown, 1983). The story of how these women "steadily kept shouldering" various responsibilities needs to be more widely known.

21. Peabody, for instance, loaned the painting to the exhibition at the Chase Gallery in 1894, where it received good reviews as "a head of a peasant woman." Winthrop lent her portrait to Klumpke's 1897 show at the Mark Hopkins Institute of Art, San Francisco. For a reference to authors who explore the ways in which female patrons and artists served each other's needs, see Cynthia Lawrence, ed., *Women and Art in Early Modern Europe: Patrons, Collectors, and Connoisseurs* (University Park: Pennsylvania State University Press, 1997).

22. Klumpke, *Memoirs*, 37.

23. LNHS Archives; letter from Anna E. Klumpke to Amelia Chapman Thorp, By/Thomery, June 1, 1909.

24. Klumpke, *Memoirs*, 37.

25. For the background of the Whitin family, see Thomas R. Navin, *The Whitin Machine Works since 1831: A Textile Machinery Company in an Industrial Village* (Cambridge: Harvard University Press, 1950), 172–79. Sarah married John Crane Whitin (1807–82), almost thirty years her senior, in 1875. He died seven years later, when she was forty-six years old.

26. See "The Buildings," in *Wellesley College, 1875–1975: A Century of Women*, ed. Jean Glasscock (Wellesley, Mass.: Wellesley College, 1975), 305–7; and WC Archives, 2 BI Whitin, Sarah E. (Mrs. John C.) 1836–1917 Trustee, and 1K Buildings, Whitin Observatory, which holds a collection of newspaper clippings (many of them, however, unidentified and undated).

27. "The Buildings," in *Wellesley*, ed. Glasscock, 305.

28. For details on the Whitin Observatory, see WC Archives, Folder 11, 1K Buildings, Survey of Buildings and Grounds, 1989.

29. "The Buildings," in *Wellesley*, ed. Glasscock, 306.

30. WC Archives; 3L Department of Astronomy, Correspondence: Mrs. John C. Whitin to Sarah Frances Whiting (1898–99). Letters include information on some of the issues Whitin addressed in the construction of the building.

31. Ibid., letter from Sarah Whitin to Sarah Whiting, October 11, 1898.

32. "The Buildings," in *Wellesley*, ed. Glasscock, 307.

33. Ibid., 306.

34. WC Archives; Folder 1K Buildings, Whitin Observatory; newspaper clipping, unidentified and undated.

35. Ibid.

36. Rossiter, *Women Scientists in America*, includes important information on the activities of women astronomers.

37. Ibid., 56.

38. Ibid., 57.

39. Ibid., 77.

40. For this interpretation, see Sally Gregory Kohlstedt, "In from the Periphery: American Women in Science, 1830–1880," *Signs: Journal of Women in Culture and Society* 4, no. 1 (Autumn 1978): 81–96.

41. For information on Whiting, see *The National Cyclopædia of American Biography, Being the History of the United States* (Ann Arbor, Mich.: University Microfilms, 1967), 9: 261, and *Notable American Women, 1607–1950: A Biographical Dictionary*, 3 vols., ed. Edward T. James (Cambridge: Harvard University Press, 1971), 3: 592–93.

42. *National Cyclopædia*, 261.

43. For information on this paper, see Fairlee Hersey, "'Changing with the Times': A Study of the *Boston Traveller* from 1825 to 1940," M.A. thesis, Boston University, 1953 (Cambridge, Mass.: Microfilm Graphic of New England, 1953), microfilm PN4899.B6T7.

44. The *Boston Budget*, appearing each Sunday, was one of the major society papers, with a circulation of twenty thousand. Working under Whiting's supervision was the managing editor, William G. James, and a large number of other personnel, including reporters, proofreaders, and apprentices. Since articles were generally published without bylines, it is not possible to tell how many women were employed at the paper. However, some comparisons with other local publications reveal the scope and range of Whiting's responsibilities. The *Home Journal*, a weekly sixteen-page society paper, had a circulation of eighty-five hundred; the eight-page suffragist paper *Woman's Journal*, edited by Lucy Stone and her daughter Alice, published about five thousand copies. See also Sherilyn Cox Bennion, *Equal to the Occasion: Women Editors of the Nineteenth-Century West* (Reno: University of Nevada Press, 1990), for information on women editors outside Boston.

45. *Boston Budget*, January 10, 1892.

46. "The End of the Salon"; Whiting's Parisian contact was Ellen Day Hale, who was then attending the Académie Julian. In a letter to her parents in Boston, she writes about trying to defray her living expenses by writing articles for a home journal.

47. *Boston Evening Traveller*, "Le Beau Monde," November 7, 1885; Wolcott had presented the paper earlier that year at the Woman's Congress in Des Moines, Iowa.

48. *Boston Budget*, "An Unanswered Question," January 3, 1892.

49. *Boston Evening Traveller*, "Le Beau Monde," November 28, 1885.

50. *Boston Budget*, January 24, 1892.

51. Ibid., June 1, 1890.

52. *Boston Evening Traveller*, December 26, 1885.

53. In 1894 Whiting turned to writing her own books; her first three volumes of essays, *The World Beautiful* (1894–96), ran through fourteen printings. In 1895 she published a book of poems, *From Dreamland*.

54. I am indebted for my interpretation of this topic to an insightful study by Arlene Kaplan Daniels, *Invisible Careers: Women Civic Leaders from the Volunteer World* (Chicago: University of Chicago Press, 1988).

55. See Kathleen D. McCarthy, ed., *Lady Bountiful Revisited: Women, Philanthropy, and Power* (New Brunswick, N.J.: Rutgers University Press, 1990), esp. "Parallel Power Structures: Women and the Voluntary Sphere," 1–31; see also in the same book Anne Firor Scott, "Women's Voluntary Associations: From Charity to Reform," for a discussion of the invisible careers women have carved out for themselves in voluntary associations. For more information, see McCarthy, *Women's Culture*, which highlights the dynamics of power and the ways in which middle- and upper-class women

have historically used philanthropy and volunteerism to shape their public lives.

56. The following information is drawn from a series of five articles by Harvey Gaul, "The Untold Life of Mary Copley Thaw." The installments appeared in the *Pittsburg Bulletin* on December 7, 21, and 28, 1929, and January 4 and 11, 1930. (The city's name had not yet acquired an "h.") Mary Thaw was the mother of Harry Kendall Thaw, who killed the architect Stanford White in 1906 in a brawl at Madison Square Roof Garden. He suspected that White was the lover of his wife, Florence Evelyn Nesbit Thaw.

57. *Bulletin*, December 28, 1929. The account of her romantic meeting with Thaw was well known in Pittsburgh. When an appeal was made to raise funds for the soldiers of the Civil War at the Pittsburgh Sanitary Fair, Mary, a patriot and an indefatigable worker, contributed a ring, which she gave because she had nothing else to offer. Thaw, widowed and rich, saw the gift and asked permission to redeem it and return the ring personally to the giver.

58. Ibid., December 21, 1929.

59. Ibid., December 28, 1929.

60. He died in Paris of peritonitis. It is said that she revered his memory and always spoke of him as "Mr. Thaw."

61. The circumstances of Klumpke's meeting with Thaw remain uncertain. Klumpke, *Rosa Bonheur*, 32, recalls writing from Paris in the winter of 1895 that "I received one day the visit from Mrs. Thaw, of Pittsburgh, whose patronage had been valuable during my last sojourn in America." There is no record of Thaw's American patronage prior to 1897. The *Pittsburg Bulletin*, June 4, 1898, reporting on Klumpke's stay as a guest of Mrs. William Thaw at Lyndhurst, suggests a more likely first encounter. The reporter notes that "Mrs. Thaw [had] met the artist during one of her trips abroad." For Klumpke's interest in Thévenot, see Klumpke, *Rosa Bonheur*, 27–38.

62. CMA Archives; minutes of the Fine Arts Committee, February 1, 1897. The minutes note: "A request by Klumpke to use one of the Galleries (of the museum) for a private exhibition of her works was presented to the committee. It was moved and seconded that the request be not granted." The show at the Gillespie Gallery opened on February 25. For a brief discussion of the city's oldest and finest showroom of art, see Britta C. Dwyer, "Nineteenth-Century Regional Women Artists: The Pittsburgh School of Design for Women, 1865–1904" (Ph.D. diss., University of Pittsburgh, 1989).

63. MdARB; Exhibition Brochure. The show consisted of thirty oils and ten pastels; in addition to portraits and genre paintings, there were several entries marked "Study." Handwritten prices in the margin ranged from $50 for the studies to $800 for the 1896 Salon painting *Scheherazade* (Private Collec-

tion); the portrait of Mrs. Thaw (Private Collection) was later exhibited at the 1903 Salon.

64. *Pittsburg Bulletin*, February 27, 1897. For some information on Mary Thaw as patron, see Alison McQueen, "Private Art Collections in Pittsburgh: Displays of Culture, Wealth, and Connoisseurship," in *Collecting in the Gilded Age: Art Patronage in Pittsburgh, 1890–1910*, ed. Gabriel P. Weisberg, DeCourcy E. McIntosh, and Alison McQueen (Hanover, N.H.: University Press of New England, 1997), 53–106, esp. 87–89.

65. *Pittsburg Bulletin*, June 4, 1898.

66. Ibid., December 7, 1929.

67. Klumpke, *Rosa Bonheur*, 36.

68. For a history of the family and its numerous contributions, see Morris Douw Ferris and Dorothy van Breestede Douw McNeilly, *The Douws of Albany* (Albany, N.Y.: Albany Institute of History and Art, 1973).

69. Charles L. Miller, "The Life of George Douglas Miller and the First 75 Years of the Deer 'Iland' [*sic*] Club Corporation" (manuscript in the collection of the Russell Trust Association, New Haven, Conn.).

70. Klumpke, *Memoirs*, 36.

71. The portrait hangs today in the Russell Trust Association Building, New Haven, Connecticut, the home of the Skull and Bones society.

72. A photograph found at Deer Island of the artist with palette and brush, clutching her cane with her right hand, shares the background of moss-covered boulders and trees that appears in Miller's portrait. It was taken from the ten-foot circumferential veranda of the Ledges, a frame house with a commanding view of the surrounding islands in the St. Lawrence River. The first of several buildings on the premises, the Ledges was completed in 1897. The Millers loved Deer Island, where Klumpke may have been one of the first of many guests.

73. Klumpke, *Memoirs*, 37.

74. Klumpke, *Rosa Bonheur*, 44–48.

75. The large portrait, measuring 51 × 36", by Edouard-Louis Dubufe (1820–83) shows Bonheur standing three-quarter length with her favorite bull, which she herself had painted.

76. Klumpke may have been thinking specifically about the portrait by George Achille-Fould (Musée des Beaux-Arts, Bordeaux) or that by Consuelo Fould (unlocated). For an illustration of the former, see "Rosa Bonheur, 1822–1899" (Musée des Beaux-Arts, Bordeaux, exhib. cat., in association with William Blake and Co., 1997); for the latter, see L. Roger-Milèt, *Rosa Bonheur: Sa vie, son oeuvre* (Paris: Imprimierie Georges Petit, 1900).

77. Klumpke, *Memoirs*, 37.

78. See the annual report—*Register of the Albany Historical and Art Society*, March 3, 1899—for information on George Miller's involvement as president of the society's building committee, especially his interest in remodeling the interior to include a large fireproof art gallery. AIHA; Box B 7.1.1, Folder A15, Miller File; letter of June 3, 1896. In addition to stressing the importance of a museum in educating the public, Miller was sensitive to the painter's perspective, writing in one of his letters of solicitation that "artists always and everywhere are glad to send their pictures to a loan exhibition. It makes a market for them."

79. MdARB; exhibition brochure.

80. MMA Archives; Artist File; the document is entitled "Press Comments on Miss Klumpke's work now on Free Exhibition at the Historical Society."

81. Klumpke, *Memoirs*, 38–39.

82. Klumpke, *Rosa Bonheur*, 47–48.

[Chapter Seven]

1. The quotation is from Philip De Laszlo, *Painting a Portrait, Recorded by A. L. Baldry* (London, 1934); it appears in Andrew Wilton, *The Swagger Portrait* (London: Tate Gallery, 1992), 61.

2. Klumpke, *Rosa Bonheur*, 392; a reference by Bonheur affirms this symbolic reading of the sketch of "wild horses." Shortly before her death, Bonheur told Klumpke that she planned to make a bas-relief for their new studio depicting *des chevaux sauvages*, adding that her work would be in memory of the wild horses that had providentially brought them together.

3. For an excellent review article concerning four publications offering new approaches to the topic of portrait painting in England, see John Gage, "Saving Faces," *Art History* 16, no. 4 (1993): 663–67; see also Richard Brilliant, *Portraiture* (London: Reaktion Books, 1991), who provides a theoretical and speculative study of the definition of portraiture, including works such as propaganda images of noted politicians, passport photos, and tribal masks. This book and others are reviewed by Clark Hulse, *Art Bulletin* 75, no. 2 (1993): 327–28.

4. I am grateful to John Gage for his persuasive reasoning in "Saving Faces."

5. She may have been referring to the 1893 Salon portrait by George Achille-Fould (Musée des Beaux-Arts, Bordeaux), where Bonheur is seated at her easel wearing a smock and velvet trousers.

6. Klumpke, *Rosa Bonheur*, 53. (Further page references to dialogue from this work will be included parenthetically in the text of Chapter 7.) For related discussions, see Shane Adler Davis, "Rosa Bonheur's 'Feminine Costume,'"

Antiques West Newspaper, July 1986, 12–15; see also Gretchen van Slyke, "Does Genius Have a Sex? Rosa Bonheur's Reply," *French American Review* 63, no. 2 (Winter 1992): 12–23. Klumpke donated Bonheur's velvet dress to the Textile Collection of the Fine Arts Museum of San Francisco.

7. For a description of the *flâneur* and his place in Baudelaire's oft-quoted discussion of the heroism of modern life, see Franscina et al., *Modernity and Modernism*, 53–54 and 273.

8 For the complete contents of the letter, see Klumpke, *Memoirs*, 46–47.

9. See Hélène Pinet, "Rodin et les photographes américains," in *Le Salon de Photographie* (Paris: Musée Rodin, 1993), 13.

10. See Kenneth Neal, "A Wise Extravagance: The Founding of the Carnegie International Exhibitions, 1895–1901" (Ph.D. diss., University of Pittsburgh, 1993), 82–84, for a general discussion of the jury procedure of the Foreign Advisory Committee in Paris.

11. The *Pittsburg Times*, November 3, 1898, included a front-page article, "Third Annual Exhibition at the Carnegie Galleries."

12. Ibid.

13. MdARB; in her letter to her father dated January 1, 1899, she wrote that the price included the copyright to have it engraved.

14. Klumpke, *Rosa Bonheur*, 134–35. Bonheur attributed the inspiration for her first animal drawings to her mother; in order to teach her daughter the alphabet, she had asked her to draw an animal next to each letter. "This intelligent object-lesson was a revelation for the mind of the child that I was then," Bonheur claimed.

15. For a discussion of the maternal-sororal relations that Bonheur realized anew with Anna Klumpke, see Gretchen van Slyke, "Reinventing Matrimony," *Women's Studies Quarterly* 19, nos. 3–4 (Fall–Winter 1991): 59–77. I am grateful to the author for her insightful interpretation of this subject.

16. For a vivid description of this scene, see Emile Zola, *L'Oeuvre* (*The Masterpiece*), trans. Thomas Walton (Oxford: Oxford University Press, 1993), 326–41.

17. Klumpke, *Rosa Bonheur*, 372–73, notes in her biography that the Société des Artistes Français had considered awarding Bonheur an honorary medal. Bonheur, however, had refused to be nominated as a candidate because she considered her work an insignificant contribution.

18. Klumpke, *Memoirs*, 66; explaining the changes, Bonheur said: "You are a foreigner and the inheritance tax you will have to pay is about twelve per cent of the value of the property. If I deed it to you, this inheritance tax will be less."

19. These concepts are from Steve Duck, ed., *The Dynamics of Relationships*, Un-

derstanding Relationship Processes Series, vol. 4 (London: Sage Publications, 1994).

20. Linda Nochlin, *Women, Art, and Power and Other Essays* (New York: Harper and Row, 1988), 99.

21. See Marcia Pointon, *Hanging the Head: Portraiture and Social Formation in Eighteenth-Century England* (New Haven: Yale University Press, 1993), 184.

22. See Beverley Burch, *On Intimate Terms: The Psychology of Difference in Lesbian Relationships* (Urbana: University of Illinois Press, 1993), for a provocative exploration of gender relations and feminist psychoanalysis.

23. See Duck, ed., *Dynamics of Relationships;* the book is a coherent and progressive review of current thinking in the field of relationship processes.

24. Ibid., xii.

25. Ibid., xiii.

26. Ibid., xii, xiii.

27. Private communication with Mlle Suzanne Delorne and Mlle Germaine Auclair, By/Thomery, December 12, 1991. I am grateful to Mme Jeanine Curie, a local resident, for putting me in touch with these women and for providing general information about the village and its history.

28. The auction catalogue listing the pictures and property of Ernest Gambart, consul-general of Spain, at the auction at Christie's on May 2 and 4, 1903, did not include Klumpke's 1898 portrait of Bonheur.

29. Metropolitan Museum of Art Archives; a letter, June 18, 1922, discussed giving the portrait to the museum.

30. Joining Bonheur's portrait were a number of paintings and studies by Bonheur that Klumpke donated to the French government, including *Ploughing at Nivernais.*

[Chapter Eight]

1. For this interpretation, see George Chauncey, Jr., "From Sexual Inversion to Homosexuality: Medicine and the Changing Conceptualization of Female Deviance," *Salmagundi* 58–59 (Fall 1982–Winter 1983): 114.

2. For an inspiring article, encouraging historians to "recuperate" a past however "unattractive, messy, and confusing," see Martha Vicinus, "'They Wonder to Which Sex I Belong': The Historical Roots of the Modern Lesbian Identity," in *The Lesbian and Gay Studies Reader*, ed. Henry Abelove, Michele Aina Barale, and David M. Halperin (New York: Routledge, 1993), 432–52, esp. 433, 447.

3. Lillian Faderman, *Surpassing the Love of Men: Romantic Friendship and Love between Women from the Renaissance to the Present* (New York: William Morrow, 1981).

4. Since the early 1980s, major debates have developed in lesbian historiography; these involve a variety of conceptual approaches, including social construction- ism, essentialism, and more recently "queer theory." For an overview of this scholarship, see the introduction to *Hidden from History: Reclaiming the Gay and Lesbian Past*, ed. Martin Duberman, Martha Vicinus, and George Chauncey, Jr. (New York: Meridian Books, 1990), 1–13, as well as review articles by Susan K. Cahn, "Sexual Histories, Sexual Politics," *Feminist Studies* 18, no. 3 (Fall 1992): 629–47, and Peter Laipson, "From Boudoir to Bookstore: Writing the History of Sexuality," *Comparative Studies in Society and History* 34, no. 3 (1992): 636–44. For more recent publications, see *The Lesbian and Gay Studies Reader*, ed. Abelove et al.; Donna Penn, "Queer: Theorizing Politics and History," *Radical History Review* 62 (Spring 1995): 24–57; see also Chodorow, *Femininities, Mas- culinities, Sexualities*. Addressing the question of "defining, describing and cate- gorizing" sexuality from a different angle, Chodorow brings into question the polarization of normal and abnormal sexualities. Drawing upon her clinical ex- perience as a psychoanalyst, she contends that theorists and practitioners con- sider a plurality of femininities and masculinities and a variety of sexualities in their analysis of clinical and cultural observations.

5. See van Slyke's introduction to *The Artist's (Auto)Biography: Rosa Bonheur by Anna Klumpke* (Ann Arbor: University of Michigan Press, 1997), xv.

6. Ann Ferguson, "Patriarchy, Sexual Identity, and the Sexual Revolution," *Signs: Journal of Women in Culture and Society* 7, no. 1 (Autumn 1981): 159–72, esp. 165.

7. For a development of this idea, see Sharon O'Brien, *Willa Cather: The Emerging Voice* (New York: Oxford University Press, 1987), "Divine Femi- ninity and Unnatural Love," 117–46.

8. See Lillian Faderman, "Female Same-Sex Relationships in Novels by Longfellow, Holmes, and James," *New England Quarterly* 51, no. 3 (Septem- ber 1978), 309–32.

9. Ibid., 317; Faderman agrees that Longfellow was probably not depicting a les- bian relationship through knowledge of what such relationships entail, but that he was nonetheless mirroring the sort of female-female relationships that later writers observed to be common in nineteenth-century New England.

10. For related discussion, see Carroll Smith-Rosenberg's now classic article, "The Female World of Love and Ritual: Relations between Women in Nine- teenth-Century America," *Signs: Journal of Women in Culture and Society* 1, no. 1 (Autumn 1975): 1–29, and Nancy F. Cott, *The Bonds of Womanhood: "Woman's Sphere" in New England, 1780–1835* (New Haven: Yale University Press, 1977), 160–96.

11. See Leon Edel, *Henry James: A Life* (New York: Harper & Row, 1985), 310, who writes that when visiting Boston in the early 1880s, James decided to

write a book on "the relation of . . . two girls . . . , one of those friendships between women which are so common in New England."

12. Henry James, *The Bostonians* (1886; New York: Signet Classic, 1979), 370.

13. Fred Kaplan, *Henry James: The Imagination of Genius* (New York: William Morrow, 1992), 280–81.

14. Jean Strouse, *Alice James: The Life of the Brilliant but Neglected Younger Sister of William and Henry* (Boston, Houghton Mifflin, 1980), 200.

15. Ibid.

16. See Faderman, "Female Same-Sex Relationships," 331 n. 39, for other writers who discuss James's sexual orientation, including Edel's remarks of 1972.

17. Kaplan, *Henry James*, 300.

18. O'Brien, *Willa Cather*, 126.

19. Ibid., 126–27.

20. In other words, rather than approaching the subject of female friendship candidly, as Longfellow and Holmes and to a certain degree James did, Cather's text resorts to silence.

21. For a brief discussion of medical research in America, see Vern L. Bullough, *Science in the Bedroom: A History of Sex Research* (New York: Basic Books, 1994), 92–96; see also John d'Emilio and Estelle B. Freedman, *Intimate Matters: A History of Sexuality in America* (New York: Harper and Row, 1988), 222–29. The first major influence on the American readership was a work by Havelock Ellis, *Studies in the Psychology of Sex*, the first volume of which appeared in 1897. A breakthrough came with Sigmund Freud's visit to America in 1909, when his ideas about sexuality started to take root in the culture.

22. Bullough, *Science in the Bedroom*, 96.

23. Ibid., 93.

24. For an interpretation of the situation, see Carroll Smith-Rosenberg, *Disorderly Conduct: Visions of Gender in Victorian America* (New York, Oxford University Press, 1985), 245–96, esp. 252.

25. For a discussion of the Fields-Jewett relationship, see Judith A. Roman, *Annie Adams Fields: The Spirit of Charles Street* (Bloomington: Indiana University Press, 1990), 105–18, esp. 107; for an interpretive discussion, see also Lillian Faderman, "Nineteenth-Century Boston Marriage as a Possible Lesson for Today," in *Boston Marriages: Romantic but Asexual Relationships among Contemporary Lesbians*, ed. Esther D. Rothblum and Kathleen A. Brehony (Amherst: University of Massachusetts Press, 1993), 29–42, esp. 29.

26. Faderman, "Nineteenth-Century Boston Marriage," 33; the late nineteenth-century version of the earlier romantic friendship, modified by women's new

economic independence, the "Boston marriage," Faderman writes, would develop and flourish for a period without stigmatization.

27. For a study of Boston's male homosexual subculture, see Shand-Tucci, *Boston Bohemia*.

28. Lilian Whiting, *After Her Death: The Story of a Summer* (Boston: Roberts Brothers, 1897), 18–19. For biographical information on Kate Field, see *Notable American Women 1607–1950*, 1: 612–13; Francis E. Willard and Mary A. Livermore, *American Women: 1500 Biographies* (New York: Mast, Crowell and Kirkpatrick, 1897), 288; also, *The Bold Women* (New York: Farrar, Straus and Young, 1953), 201–14.

29. Whiting took advantage of the situation, using her new position at the *Boston Traveller* to interview Field. Whiting continued to promote Field, her ideas about dress reform, and many of her other pursuits in the press.

30. Whiting, *After Her Death*, 58.

31. Whiting, *Kate Field: A Record* (Boston: Little, Brown, 1899); most of Field's private papers have not survived. Whiting's book, accurate and rich in detail, albeit slanted in its evaluations, is the most important primary source.

32. Ibid., 457.

33. Ibid., 565.

34. Kate Field died on May 19, 1896. She was buried at Mount Auburn Cemetery, Cambridge, Massachusetts, where her ashes were later joined by those of Lilian Whiting.

35. SSC; Ellen Day Hale, Box 44, File 1050; an address book with information on Klumpke's living quarters, first at 82 Beacon Street and in 1898 at 480 Boylston Street, as well as a note on her weekly Wednesday social hours, suggests that Hale kept in touch with Klumpke.

36. In 1893 they settled at Folly Cove, in Rockport, Massachusetts, where they worked together developing careers that were almost indistinguishable.

37. While *femme damnée* was a generic term in fiction and art criticism, the words "tribade," "transvestite," "hermaphrodite," and "sapphist" were others frequently used to describe the women in same-sex relationships. Occasionally, the term "lesbian" was used to refer to the classical prototype of Sappho; Charles Baudelaire's censured poem "Lesbos" is such a case.

38. For Bonheur's reference, see Klumpke, *Rosa Bonheur*, 114.

39. For an instructive and engaging study, see Eugen Weber, *France: Fin-de-Siècle* (Cambridge: Harvard University Press, 1986).

40. For this quotation (and admonition to today's literary critics), see Bonnie Zimmerman, "What Has Never Been: An Overview of Lesbian Feminist Literary Criticism," in *The New Feminist Criticism*, ed. Showalter, 208.

41. The book was part of a series of twenty novels, published between 1871 and 1893, that was to study "scientifically" the effects of heredity and environment on one family, Les Rougon-Macquart.

42. The newspapers launched the biggest campaign yet mounted to advertise a novel; on February 15, 1880, the first printing of 55,000 copies sold out in one day.

43. George Holden, introduction to Emile Zola's *Nana* (New York: Penguin Books, 1979), 15.

44. Ibid.

45. I am indebted to Gretchen van Slyke for her valuable comments on Zola and his novel *Nana*.

46. Zola's letter appeared in the preface to *L'homosexualité et les types homosexuels* by "Le Docteur Laupts (G. Saint-Paul)" (1896; Paris: Vigot Frères, 1910).

47. Ibid., 1.

48. Ibid.

49. Ibid., 2, 4; Zola added that he was pleased that the document, which had for so long been "sleeping in one of [his] drawers," would be published by a knowledgeable man of science.

50. Ibid., 3–4.

51. See Ruth Butler, *Rodin: The Shape of Genius* (New Haven: Yale University Press, 1983), 436–54, esp. 441 n. 19; in assessing Rodin's vast and important output, Butler argues that a line must be drawn between the exploitation of female models and the celebration of the erotic as a life force. This point, she claims, is succinctly articulated by Catherine Lambert, a scholar and herself an artist's model. Even though Lambert sees Rodin as using his charismatic power over women, as well as his money (which pays for the models), she nevertheless considers him "the first sculptor to want to make women's sexuality important." This, Lambert suggests, is why this part of Rodin's oeuvre is more than simply the work of a celebrated old man demonstrating his power over women. Rodin gives equal attention to the passions of both sexes, and his women are like men, "awake and filled with longing."

52. Some of the many sculptures of embracing women in Rodin's oeuvre of the 1880s are *Femmes damnées, Metamorphoses d'Ovide, Daphnis et Lycenion*, and *L'Idylle*.

53. For a different and challenging interpretation, see Annette Shaw, "Baudelaire's 'Femmes Damnées'": The Androgynous Space," *Centerpoint* 3, no. 3–4 (Fall–Spring 1980): 57–64. Challenging perceptions of sex-role stereotyping in general, and of the writer's misogyny in particular, the author argues against Baudelaire's depictions of love between women as pathological aberrations. Drawing upon the poet's view that the fusion of gender characteristics was to be at the core of all artistic creation, she interprets Baudelaire's attitude in the

light of this androgynous vision. As the archetypal symbolic element in his psyche, woman occupies the place of desires and fears within himself. As such, the portrayal of woman is metamorphosed; she no longer exists just to please him; on the contrary, she is depicted as having an authentic life of her own, which she freely chooses to share with the androgynous poet.

54. See Catherine van Casselaer, *Lot's Wife: Lesbian Paris, 1890–1914* (Liverpool: Janus Press, 1986), 10–22 and valuable information in the bibliography; she mentions *La Prostitution dans la ville de Paris* (1836) by Alexandre Parent-Duchalet as one of the first works on this topic, adding that a full-scale study of all the vices in the city appeared in Ali Coffignon's book *Paris vivant: La corruption à Paris* (1889). Trying to determine the etiology of lesbianism, Coffignon wrote that it may have been caused by women riding astride horses and by working at sewing machines. His study was followed in 1891 by Léo Taxil's *La Corruption de fin-de-siècle*.

55. Casselaer, *Lot's Wife*, 13; see also Robert Nye, "The History of Sexuality in Context: National Sexological Traditions," *Science in Context* 4, no. 2 (1991): 387–406.

56. Vicinus, in "They Wonder to Which Sex I Belong," 443, notes that the most prominent late nineteenth-century sociobiological ideologies included social Darwinism, eugenics, criminology, positivism, anthropology, and determinism; women's sexual relations could hardly remain unaffected by them.

57. For extensive studies, see Jack D. Ellis, *The Physician-Legislators of France: Medicine and Politics in the Early Third Republic, 1870–1914* (Cambridge: Cambridge University Press, 1990), and Antony Copley, *Sexual Moralities in France, 1780–1980* (New York: Routledge, 1989).

58. Modern codification of laws followed different patterns; in the German-speaking countries (i.e., in Bismarck's unified Germany and in the Austro-Hungarian Empire) new laws were enacted making male homosexuality a criminal offense. The English Criminal Law Amendment Bill was introduced in 1885. By contrast and certainly by nineteenth-century European standards, the Code Napoléon of 1811 took a more liberal view when it made social harmfulness of an act the criterion for its status in law. Copley, *Sexual Moralities in France*, 25, focusing upon male homosexuals, points out that the legal situation in France did not mean that a large number of male homosexuals were not brought to the attention of the police.

59. August Strindberg, *A Madman's Manifesto*, trans. Anthony Smerling (Tuscaloosa: University of Alabama Press, 1971), 204 (originally published in German in 1893, in French in 1895). I am indebted to Catherine van Casselaer for drawing my attention to this book.

60. For a discussion of Strindberg's novel and his anxieties about his wife, see Faderman, *Surpassing the Love of Men*, 285–88.

61. van Casselaer, *Lot's Wife*, 22.

62. For a detailed discussion with extensive notes, see David M. Halperin, *One Hundred Years of Homosexuality: And Other Essays on Greek Love* (New York: Routledge, 1990), 15–41, 154–68; see also Jane Caplan, "Sexuality and Homosexuality," in *Women in Society: Interdisciplinary Essays*, ed. Cambridge Women's Studies Group (London: Virago Press, 1981), 149–67.

63. R. von Krafft-Ebing, preface to Albert Moll, *Les Perversions de l'instinct génital* (Paris: Georges Carré, 1893), ii.

64. Bullough, *Science in the Bedroom*, 43 and n. 25.

65. J. M. Charcot and Valentin Magnan, "Inversion du sens génital," *Archives de neurologie* 3 (January–June 1882): 53–60.

66. For a study by one of Charcot's students, see Georges Guillain, *J.-M. Charcot, 1825–1893: His Life, His Work*, trans. Pearce Bailey (New York: Harper & Brothers, 1959); for a detailed analysis and interpretation, see Christopher Goetz, *Charcot: Constructing Neurology* (New York: Oxford University Press, 1995).

67. See Guillain, *J.-M. Charcot*, chap. 5, "Charcot at the Salpêtrière," 51–65; in 1892 Charcot accepted the chair for the study of nervous disorders at the Salpêtrière. This appointment represented the first official acknowledgment of neurology as a specialty in its own right.

68. Sigmund Freud, who went to study under Charcot in 1885–86, absorbed his master's lessons and ultimately incorporated his conclusions into a radically new theory of sexuality and the unconscious. Before he himself became a classifier, albeit of a different kind, Freud recognized in Charcot his "flair for classification" and his obsession with cataloguing his patients into groups. A product of his time, Charcot had a powerful effect on all those who came under his spell, whether colleagues, students, or readers of his articles.

69. Presenting the case of "a cultivated, very erudite 31-year-old man," they diagnosed him as suffering from hereditary degeneration and prescribed a cure of hydrotherapy and potassium bromide. Subscribing to the contemporary interest in anatomic and cerebral pathology, they emphasized the external and visually observable aspects of their patient's condition.

70. For a reference to Chevalier, see Moll, *Perversions de l'instinct*, chapter 12, "Inversion sexuelle chez la femme," 307.

71. Julien Chevalier, *De l'inversion de l'instinct sexuel au point de vue médico-légal* (Paris: Octave Doin, 1885), 87.

72. Ibid. Also see Jan Goldstein, "The Uses of Male Hysteria: Medical and Literary Discourse in Nineteenth-Century France," in *French Medical Culture in the Nineteenth Century*, ed. Ann La Berge and Mordechai Feingold (Amsterdam: Rodopi, 1994), 210–47. The author points out that for the majority of nineteenth-century alienists (i.e., sexologists), the "serious stamp of science"

ruled supreme. Their work demanded objectivity and distance; it stood in sharp contrast to the subjective probings of artists such as Zola and Rodin. In an insightful discussion on this complex topic, Goldstein adds that at no time was the alienist supposed to recognize the "diseased" aspects of the patient in his own psyche. Recognition of the value of subjectivity as an appropriate instrument of medical-scientific investigation had to wait for the advent of psychoanalysis.

73. Moll, *Perversions de l'instinct génital*, 318.

74. For a Festschrift with biographical information, see E. Gauckler, *Le Professeur J. Dejerine, 1849–1917* (Paris: Masson, 1922); Dejerine was thirty years old when he left his hometown, Geneva, to study medicine in Paris. Like his wife, he trained under Dr. Vulpian. In 1886 Dejerine was appointed professor of neurology at the faculty of medicine; he held the Charcot Chair from 1910 until his death in 1917.

75. Klumpke, *Rosa Bonheur*, 116–17.

76. Ibid., 116.

77. Indeed, as a member of the medical community, he had a particularly good sense of the complexities involved. He had students who pursued this area of research; moreover, he interacted with such professional colleagues as Magnan, Moll, Cesare Lombroso, and even the pioneering Westphal, who had sought him out because of his innovative work in experimental pathology.

78. Ibid., 110; Dejerine was said to "abhor" a diagnostic neologism, a word more or less empty of meaning that catalogued a patient on scant knowledge of appearances barely understood.

79. Gauckler, *Dejerine*, 106.

80. For a discussion of Dejerine, see entries in Goetz, *Charcot*; see also those in Elisabeth Roudinesco, *Histoire de la psychanalyse en France*, vol. 1, *1885–1939* (Paris: Fayard, 1994), and Edward Shorter, *A History of Psychiatry: From the Era of the Asylum to the Age of Prozac* (New York: John Wiley & Sons, 1997).

81. Gauckler, *Dejerine*, 98; in addition to his regular Wednesday outpatient practice at the Salpêtrière, where he worked in consultation with this students, he had a practice in which he saw patients individually. Situated next to his two large laboratories, his consulting room was painted bottle green and furnished with a table covered with a green carpet, "un bon fauteuil, et quelques chaises." (The Freudian couch of psychoanalysis was yet to be introduced.) A colleague, referring to the unusual practice, noted: "For these sessions, he was left alone with the patients, who 'in secret and in silence' could lighten their heart burdened with too much suffering." For a historical analysis of nineteenth-century French psychiatry, its professionalization, bureaucratization, and secularization, see Jan Goldstein, *Console and Classify* (Cambridge: Cambridge University Press, 1987).

82. Gauckler, *Dejerine*, 71; the interesting reference to Augusta's national background comes from a letter he wrote to his parents in the early 1880s, in which he told them about the young woman he had met. Describing Augusta, he wrote, "[She] is the epitome of a 'miss américaine' who runs her own life. Her frank and healthy cheerfulness, typically American, makes her attractive." The success of their later joint research in neurology was demonstrated in the 1894 publication of *Anatomy of the Nervous System*, a monumental work that established a totally new neural topography.

83. Gauckler, *Dejerine*, 84. Unlike many of his male colleagues, Dejerine had lacked important personal contacts to help him along in his studies toward a career in medicine. "A self-made man" (the English words are Gauckler's), Dejerine knew the difficulties he—a man—had had to overcome as an outsider from Geneva.

84. I am indebted to Michael Baxandall for his inspiring ideas and explorations in *Patterns of Intention: On the Historical Explanation of Pictures* (New Haven: Yale University Press, 1992).

85. MdARB; handwritten documents.

[A Retrospective]

1. Klumpke, *Memoirs*, 73–74; in addition to compiling and editing her own notes, Klumpke had masses of engravings and lithographs, as well as a whole variety of pictures and reproductions, that had to be examined.

2. Ibid., 74.

3. Klumpke, *Rosa Bonheur*, 405–12, esp. 406.

4. Ibid., 407.

5. MdARB; letter to Lilian Whiting, July 27, 1899.

6. MdARB; letter to Lilian Whiting, September 11, 1899.

7. Klumpke, *Rosa Bonheur*, 410.

8. Ibid.

9. Klumpke, *Memoirs*, 74.

10. An edition of 2,000 copies was published by Ernest Flammarion with prints by Georges Petit, Paris; 1,900 copies were for sale by the publisher. Petit and the author each received fifty complimentary copies; additional copies (at least seventy) were purchased by Klumpke at 18 francs.

11. Klumpke, *Memoirs*, 74.

12. MdARB; journal entry of June 26, 1906. Klumpke also jotted down for that day the following note: "Miss Ripley received letter from Little, Brown and Co. Boston who are willing to publish RB English version if she finds an English Publisher in London."

13. MdARB; unpublished document. Klumpke kept an account of the number of books she sold and those she gave away as gifts, calculating her expenses and making note of her dedicatory messages. The last entry mentions the presentation of a copy to Mr. and Mrs. Theodore Roosevelt. Dated April 21, 1910, it reads, "With respectful greetings and a hearty welcome to Paris from the author, Anna Klumpke."

14. MdARB; letter to Longfellow, June 14, 1912.

15. See van Slyke's translation, *Artist's (Auto)Biography*.

16. Her brother also decided to stay in Paris to work in the ambulance service. John Wilhelm died on February 4, 1917, of pneumonia.

17. Klumpke, *Memoirs*, 76; since Klumpke had no large flag, she describes the makeshift one she made of red-and-white striped awning cloth and a blue blouse formerly worn by Bonheur, onto which she painted the forty-eight stars.

18. MdARB; unpublished document; cooperating with the medical authorities, they established a staff of nurses and had physicians visit and inspect the hospital three times a week.

19. Julia spent the war years at Converse College, Spartanburg, South Carolina, as professor of music. Her fund-raising efforts were an important source of income for her sister's work at By.

20. MdARB; Letters, Volume Two, 1911–15; letter to Mary Morison, November 26, 1914.

21. Ibid.; Volume Three, 1915–16; letter to Mary Thaw, December 18, 1915.

22. Ibid.; letter to Mrs. Sharp, January 19, 1916.

23. Ibid.; letter to M. Knoedler, February 12, 1915.

24. Ibid.; letter to Mrs. Whitin (?), n.d.

25. Ibid.; letter to Sara Hallowell, December 23, 1915. Also, see in Historical Society of Pennsylvania collection, Perot Malting Company Papers, 1818–1956, letter to T. Morris Perot, Jr., March 7, 1917, from Sara Hallowell, in which she expresses her appreciation of living close to the Klumpkes, a family that had taken her and her niece Harriet under their wing. I thank Carolyn Carr for this information.

26. MdARB; diaries written by the soldiers during their stay at the hospital give detailed descriptions of their campaigns. They also provide a touching testimony of their gratitude to the Klumpke family.

27. S. L. A. Marshall, *History of World War I* (New York: American Heritage Publishing, 1964), 185.

28. Of the many American women who, like Klumpke, did relief work in France at that time, the most familiar are Edith Wharton (1862–1937) and the legendary couple Gertrude Stein (1874–1946) and Alice B. Toklas (1877–1967).

For information on Wharton's activities, see Edith Wharton, "The War," in *Autobiography: A Backward Glance* (1934; reprint, New York: Charles Scribner, 1964), 336–60, and R. W. B. Lewis, "The Refugees" and "Within the Tide," in *Edith Wharton: A Biography* (New York: Fromm International, 1985), 363–403. Also, for Wharton's firsthand impressions of the war, see *Voyages au front de Dunkerque à Belfort* (Paris: Plon-Nourrit, 1916). For a summary discussion, drawn from the above sources, of Wharton's experiences, see William Wiser, *The Great Good Place: American Expatriate Women in Paris* (New York: W. W. Norton, 1991), 136–41. For the relief work by Stein and Toklas, see Linda Wagner-Martin, *"Favored Strangers": Gertrude Stein and Her Family* (New Brunswick, N.J.: Rutgers University Press, 1995), 122–25, 132–41, and Diana Souhami, "The First War," in *Gertrude and Alice* (London: Pandora Press, 1991), 125–41. Whereas these names might easily dominate this period, the full story of others clamors to be told in detail, especially that of the rehabilitation work by Anne Morgan (1873–1952), the daughter of the financier J. P. Morgan, and her companion Anne Murray Dike. For a short study of Morgan, see Evelyne Diebolt and Jean-Pierre Laurant, *Anne Morgan: Une Américaine en Soissonnais (1917–1952) de l'Aisne dévastée à l'action sociale* (Troesnes, France: Editeur Amsam, 1990).

29. MdARB; Letters, Volume One, 1906–10; letter to Lilian Whiting, February 10, 1910.

30. See Bernice Scharlach, *Big Alma: San Francisco's Alma Spreckels* (San Francisco: Scottswall Associates, 1990), for a biography of Mathilde's daughter, the future founder of the California Palace of the Legion of Honor Museum and donor of the Auguste Rodin collection. How exactly Klumpke availed herself of the commission from de Bretteville is not known. MdARB; letter addressed to "My Dear Dear Anna," September 5, 1912, from her mother at By noted, "Yes, I am more than happy of your success . . . it is a great satisfaction to me that you got this portrait without anybody's help." The portrait is unlocated; an illustration of it appears in the 1929 Salon exhibition catalogue.

31. John G. Klumpke died four years later, aged ninety-two.

32. For a discussion, see Elizabeth Hutton Turner, *American Artists in Paris, 1919–1929* (Ann Arbor, Mich.: UMI Research Press, 1988), 31 and n. 47. For a brief account of the history of the school, see Polly Damrosch Howard, "1918: An Idea Is Born," *Fontainebleau Alumni Bulletin* (November 29, 1961): 1.

33. The painting was illustrated in the 1931 Salon exhibition catalogue.

34. MMA Archives, Artist File; a photograph in an unidentified newspaper clipping shows Klumpke standing in front of her large painting of a mother holding her young child in her arms.

35. Fink, *American Art*, 285 n. 39; the full quotation from the American painter Childe Hassam reads, "The business of a good painter is to carry on a tradition as everyone [*sic*] of the good painters have done always." See also Dwyer, "Anna Elizabeth Klumpke," which suggests a corrective interpretation of the twentieth-century Salons as a barometer of artistic success.

36. For a related study, see Anne Higonnet, *Berthe Morisot's Images of Women* (Cambridge: Harvard University Press, 1992), esp. 256.

37. Joan W. Scott, "Gender: A Useful Category of Historical Analysis," *American Historical Review* 91, no. 5 (1986): 1053–75.

38. Ibid.

39. MdARB; Letters, Volume Six, 1930–33; letter to Lilian Whiting, (?) July 1933.

Bibliography

Books and articles are arranged alphabetically by author. Archival sources are arranged alphabetically by the city in which the material is deposited, beginning with sources in the United States and followed by those in Europe. Periodicals and newspapers are listed separately, by city. Interviews are listed chronologically.

[Books]

Aagerstoun, Mary Jo. "Gender, Nationality, and Agency and the Art of the *fin de siècle* Woman Artist: The Example of Anna Elizabeth Klumpke (1856–1942)." M.A. thesis, George Washington University, 1994.

Abelove, Henry, Michele Aina Barale, and David M. Halperin, eds. *The Lesbian and Gay Studies Reader*. New York: Routledge, 1993.

L'Académie Julian. Bagnols (Gard). Paris: Alban Broche, 1890.

Alpern, Sara, ed. *The Challenge of Feminist Biography: Writing the Lives of Modern American Women*. Urbana: University of Illinois Press, 1992.

Altick, Richard D. *Lives and Letters: A History of Literary Biography in England and America*. New York: Alfred A. Knopf, 1969.

Amory, Cleveland. *The Proper Bostonians*. Orleans, Mass.: Parnassus Imprints, 1947.

André-Thomas, ed. *Madame Dejerine, 1859–1927*. Chartres: Imprimerie Durand, 1929.

Aquilino, Marie Jeannine. "The Decorating Campaigns at the Salon du Champ-de-Mars and the Salon des Champs-Elysées in the 1890s." *Art Journal* 48 (Spring 1989).

Art by American Women: Selections from the Collections of Louise and Alan Sellars. Gainesville, Ga.: Brenau College, 1991.

The Art Student in Paris. Boston: Boston Art Students' Association, 1887.

Ascher, Carol, Louise DeSalvo, and Sara Ruddick, eds. *Between Women: Biographers, Novelists, Critics, Teachers, and Artists Write about Their Work on Women.* Boston: Beacon Press, 1984.

Ashton, Dore. *Rosa Bonheur: A Life and a Legend.* New York: Viking Press, 1981.

Bacon, Edwin M. *Boston: A Guide Book.* Boston: Ginn and Co., 1903.

Bailey, William G. *Americans in Paris, 1900–1930: A Selected, Annotated Bibliography.* New York: Greenwood Press, 1989.

Banner, Lois W. *Elizabeth Cady Stanton: A Radical for Woman's Rights.* Boston: Little, Brown, 1980.

Bashkirtseff, Marie. *Journal of Marie Bashkirtseff.* London: Virago Press, 1985.

Bates, Mrs. D. B. *Incidents on Land and Water.* 1858. Reprint. New York: Arno Press, 1974.

Battersby, Christine. *Gender and Genius: Towards a Feminist Aesthetics.* Bloomington: Indiana University Press, 1989.

Baxandall, Michael. *Patterns of Intention: On the Historical Explanation of Pictures.* New Haven: Yale University Press, 1992.

Beaux, Cecilia. *Background with Figures.* Boston: Houghton Mifflin, 1930.

Benstock, Shari. *Women of the Left Bank: Paris, 1900–1940.* Austin: University of Texas Press, 1988.

Bentzon, T. "Condition de la femme aux Etats-Unis, Notes de voyage II." *Revues des deux mondes* 125 (1894).

Berger, Milton M., ed. *Women beyond Freud: New Concepts of Feminine Psychology.* New York: Brunner/Mazel, 1993.

Betterton, Rosemary, ed. *Looking On: Images of Femininity in the Visual Arts and Media.* London: Pandora, 1987.

Birmingham, Doris A. "Boston's St. Botolph Club: Home of the Impressionists." *Archives of American Art Journal* 31, no. 3 (1991).

Blair, Karen J. *The Torchbearers: Women and Their Amateur Arts Associations in America, 1890–1930.* Bloomington: Indiana University Press, 1994.

Blatch, Harriot Stanton, and Alma Lutz. *Challenging Years.* New York: G. P. Putnam's Sons, 1940.

Blaugrund, Annette. *Paris, 1889: American Artists at the Universal Exposition.* New York: Harry N. Abrams, 1989.

Block, Jean F. *The Uses of Gothic: Planning and Building the Campus of the University of Chicago, 1892–1932.* Chicago: University of Chicago Library, 1983.

Blumenthal, Henry. *American and French Culture, 1800–1900: Interchange in Art, Science, Literature, and Society.* Baton Rouge: Louisiana State University Press, 1975.

Boime, Albert. "The Case of Rosa Bonheur." *Art History* 4 (December 1981).

———. *The Academy and French Painting in the Nineteenth Century*. New Haven: Yale University Press, 1986.

Bonner, Thomas Neville. *To the Ends of the Earth: Women's Search for Education in Medicine*. Cambridge: Harvard University Press, 1992.

———. *Becoming a Physician: Medical Education in Britain, France, Germany, and the United States, 1750–1945*. New York: Oxford University Press, 1995.

Bonnet, Marie-Jo. *Un choix sans équivoque*. Paris: Denoël, 1981.

Borthwick, Nancy. *Three Years in California*. London: William Blackwood and Sons, 1857.

Brackett, Jeffrey R. *Memorial: Mary Morison*. Peterborough, N. H.: Peterborough Historical Society, 1917.

Brame-Fortune, Brandon. "'Not above Reproach': The Career of Lucy Lee-Robbins." *American Art* (Spring 1998).

Brilliant, Richard. *Portraiture*. London: Reaktion Books, 1991.

Broude, Norma, and Mary G. Garrard, eds. *Feminism and Art History: Questioning the Litany*. New York: Harper and Row, 1982.

———. *The Expanding Discourse: Feminism and Art History*. New York: Harper-Collins, 1992.

Bull, Sara C. *Ole Bull: A Memoir*. Boston: Riverside Press, 1886.

Bullough, Vern L. *Science in the Bedroom: A History of Sex Research*. New York: Basic Books, 1994.

Burch, Beverley. *On Intimate Terms: The Psychology of Difference in Lesbian Relationships*. Urbana: University of Illinois Press, 1993.

Burke, Mary Alice Heekin, and Lois Marie Fink. *Elizabeth Nourse, 1859–1938: A Salon Career*. Washington, D.C.: National Museum of American Art, Smithsonian Institution Press, 1983.

Burns, Sarah. "The 'Earnest, Untiring Worker' and the Magician of the Brush: Gender Politics in the Criticism of Cecilia Beaux and John Singer Sargent." *Oxford Art Journal* 15, no. 1 (1992).

———. *Inventing the Modern Artist: Art and Culture in Gilded Age America*. New Haven: Yale University Press, 1996.

Butler, Ruth. *Rodin: The Shape of Genius*. New Haven: Yale University Press, 1983.

Cahn, Susan K. "Sexual Histories, Sexual Politics." *Feminist Studies* 18, no. 3 (Fall 1992).

Campbell, Margaret. *The Great Violinists*. New York: Doubleday, 1981.

Caplan, Jane. "Sexuality and Homosexuality." In *Women in Society: Interdisciplinary Essays*, edited by the Cambridge Women's Studies Group. London: Virago Press, 1981.

Chadwick, Whitney. *Women, Art, and Society*. New York: Thames and Hudson, 1990.

———. "The Fine Art of Gentling: Horses, Women, and Rosa Bonheur in Victorian England." In *The Body Imaged: The Human Form and Visual Culture since the Renaissance*, edited by Kathleen Adler and Marcia Pointon, 89–197. Cambridge: Cambridge University Press, 1993.

Charcot, J. M., and Valentin Magnan. "Inversion du sens génital." *Archives de neurologie* 3 (January–June 1882).

Chauncey, George, Jr. "From Sexual Inversion to Homosexuality: Medicine and the Changing Conceptualization of Female Deviance." *Salmagundi* 58–59 (Fall 1982–Winter 1983).

Cheney, Ednah D. "The Women of Boston." In *The Memorial History of Boston*, edited by Justin Winsor, 4:331–56. Boston: James R. Osgood, 1880–81.

Cherry, Deborah. *Painting Women: Victorian Women Artists*. New York: Routledge, 1993.

Chevalier, Julien. *De l'inversion de l'instinct sexuel au point de vue médico-légal*. Paris: Octave Doin, 1885.

Chodorow, Nancy J. *The Reproduction of Mothering: Psychoanalysis and the Sociology of Gender*. Berkeley: University of California Press, 1978.

———. *Feminism and Psychoanalytic Theory*. New Haven: Yale University Press, 1989.

———. *Femininities, Masculinities, Sexualities: Freud and Beyond*. Lexington: University Press of Kentucky, 1994.

Clark, Vicky, et al. *International Encounters: The Carnegie International and Contemporary Art, 1896–1996*. Pittsburgh: Carnegie Museum of Art, 1996.

Collier, Peter, and Robert Lethbridge, eds. *Artistic Relations: Literature and the Visual Arts in Nineteenth-Century France*. New Haven: Yale University Press, 1994.

Cooper, Emmanuel. *The Sexual Perspective: Homosexuality and Art in the Last 100 Years in the West*. London: Routledge and Kegan Paul, 1986.

Copley, Antony. *Sexual Moralities in France, 1780–1980*. New York: Routledge, 1989.

Cott, Nancy F. *The Bonds of Womanhood: "Woman's Sphere" in New England, 1780–1835*. New Haven: Yale University Press, 1977.

———. *The Grounding of Modern Feminism*. New Haven: Yale University Press, 1987.

———, ed. *A Woman Making History: Mary Ritter Beard through Her Letters*. New Haven: Yale University Press, 1991.

Croly, Jennie C. *The History of the Women's Club Movement*. New York: Allen, 1989.

Cronkite, Bernice Brown. "Grave Alice." *Radcliffe Quarterly* (November 1965).

Dana, Elizabeth Ellery. *The Dana Family in America*. Cambridge, Mass.: n.p., 1956.

Daniels, Arlene Kaplan. *Invisible Careers: Women Civic Leaders from the Volunteer World*. Chicago: University of Chicago Press, 1988.

de Bois-Gallais, Mons. F. Lepelle. *Memoir of Mademoiselle Rosa Bonheur*. Translated by James Parry. New York: Stevens, Williams, 1857.

de Lauretis, Teresa. *The Practice of Love*. Bloomington: Indiana University Press, 1994.

de Soissons, S. C. *Boston Artists: A Parisian Critic's Notes*. Boston: n.p., 1894.

d'Emilio, John, and Estelle B. Freedman. *Intimate Matters: A History of Sexuality in America*. New York: Harper and Row, 1988.

Diebolt, Evelyne, and Jean-Pierre Laurant. *Anne Morgan: Une Américaine en Soissonnais (1917–1952) de l'Aisne dévastée à l'action sociale*. Troesnes, France: Editeur Amsam, 1990.

Digne, Danielle. *Rosa Bonheur—ou l'insolence: L'histoire d'une vie, 1822–1899*. Paris: Denoël/Gonthier, 1980.

Dodge, Grace H., et al. *What Women Can Earn: Occupations of Women and Their Compensation*. New York: Frederick A. Stokes, 1899.

Donovan, Josephine. "The Unpublished Love Poems of Sarah Orne Jewett." *Frontiers* 4 (Fall 1978).

———. *Feminist Theory: The Intellectual Traditions of American Feminism*. Rev. ed. New York: Continuum, 1990.

Dorléac, Laurence Bertrand, ed. *Le commerce de l'art de la Renaissance à nos jours*. Besançon, France: Editions La Manufacture, 1992.

Downes, William Morris. "Boston Art and Artists." In *Essays on Art and Artists*, edited by F. Hopkinson Smith et al. Boston: American Art League, 1896.

Duberman, Martin, Martha Vicinus, and George Chauncey, Jr., eds. *Hidden from History: Reclaiming the Gay and Lesbian Past*. New York: Meridian Books, 1990.

Duck, Steve, ed. *The Dynamics of Relationships*. Understanding Relationship Processes Series, vol. 4. London: Sage Publications, 1994.

Duffus, R. L. *The American Renaissance*. New York: Alfred A. Knopf, 1982.

Duncan, Carol. *The Aesthetics of Power: Essays in Critical Art History*. Cambridge: Cambridge University Press, 1993.

Dwyer, Britta C. "Nineteenth-Century Regional Women Artists: The Pittsburgh School of Design for Women, 1865–1904." Ph.D. diss., University of Pittsburgh, 1989.

———. "Anna Elizabeth Klumpke: A Salon Artist *Par Excellence*." *Revue française d'études américaines* 59 (February 1994).

———. "Rosa Bonheur and Her Companion-Artist: What Made Anna Klumpke Special?" In *Rosa Bonheur: All Nature's Children*, 63–78. New York: Dahesh Museum, 1998.

Dynes, Wayne R. *Homosexuality: A Research Guide*. New York: Garland Publications, 1987.

————, ed. *Encyclopedia of Homosexuality*. 2 vols. New York: Garland Publications, 1990.

Edel, Leon. *Henry James: A Life*. New York: Harper and Row, 1985.

Edelstein, T. J., ed. *Perspectives on Morisot*. New York: Hudson Hills Press, 1990.

Eitner, Lorenz. *An Outline of Nineteenth-Century European Painting, from David through Cézanne*. New York: Harper and Row, 1987.

Ellen Day Hale, 1855–1940. New York: Richard York Gallery, 1981.

Ellington, George. *Women of New York*. New York: New York Books, 1869.

Ellis, Havelock. *Man and Woman: A Study of Human Secondary Sexual Characters*. London: Walter Scott Publishing, 1904.

Ellis, Jack D. *The Physician-Legislators of France: Medicine and Politics in the Early Third Republic, 1870–1914*. Cambridge: Cambridge University Press, 1990.

Epstein, Cynthia Fuch. *Deceptive Distinctions: Sex, Gender, and the Social Order*. New Haven: Yale University Press, 1988.

Faderman, Lillian. "Female Same-Sex Relationships in Novels by Longfellow, Holmes, and James." *New England Quarterly* 51, no. 3 (September 1978).

————. *Surpassing the Love of Men: Romantic Friendship and Love between Women from the Renaissance to the Present*. New York: William Morrow, 1981.

————. *Odd Girls and Twilight Lovers: A History of Lesbian Life in Twentieth-Century America*. New York: Penguin Books, 1992.

————. "Nineteenth-Century Boston Marriage as a Possible Lesson for Today." In *Boston Marriages: Romantic but Asexual Relationships among Contemporary Lesbians*, edited by Esther D. Rothblum and Kathleen A. Brehony, 29–42. Amherst: University of Massachusetts Press, 1993.

Faderman, Lillian, and Brigitte Eriksson. *Lesbians in Germany: 1890's–1920's*. Tallahassee, Fla: Naiad Press, 1990.

Fairbrother, Trevor J. "Notes on John Singer Sargent in New York, 1888–1890." *Archives of American Art Journal* 22, no. 4 (1982).

————, ed. *The Bostonians: Painters of an Elegant Age, 1870–1930*. Boston: Museum of Fine Arts, 1986.

Fairlee, Hersey. "Changing with the Times: A Study of the 'Boston Traveler' from 1825–1940." M.A. thesis, Boston University, 1953.

Fauré, Christine. *Democracy without Women: Feminism and the Rise of Liberal Individualism in France*. Translated by Claudia Gorbman and John Berks. Bloomington: Indiana University Press, 1985.

Fehrer, Catherine. "New Light on the Académie Julian and Its Founder." *Gazette des Beaux-Arts* 102 (May–June 1984).

————. *The Julian Academy, Paris, 1868–1939*. New York: Shepherd Gallery, 1989.

Ferguson, Ann. "Patriarchy, Sexual Identity, and the Sexual Revolution." *Signs: Journal of Women in Culture and Society* 7, no. 1 (Autumn 1981).

Ferris, Morris Douw, and Dorothy van Breestede Douw McNeilly. *The Douws of Albany*. Albany, N.Y.: Albany Institute of History and Art, 1973.

Fidell-Beaufort, Madeleine. "Elizabeth Jane Gardner Bouguereau: A Parisian Artist from New Hamsphire." *Archives of American Art Journal* 24, no. 2 (1984).

Field, John W. *Fig Leaves and Fortunes: A Fashion Company Named WARNACO*. West Kennebunk, Maine: Phoenix, n.d.

Fink, Lois Marie. *American Art at the Nineteenth-Century Paris Salons*. Cambridge: Cambridge University Press, 1990.

Flanner, Janet. *Paris Was Yesterday, 1925–1939*. Edited by Irving Drutman. New York: Viking Press, 1972.

Flax, Jane. "The Conflict between Nurturance and Autonomy in Mother-Daughter Relationships and within Feminism." *Feminist Studies* 4 (June 1978).

Fox-Genovese, Elizabeth. *Feminism without Illusions: A Critique of Individualism*. Chapel Hill: University of North Carolina Press, 1991.

Franscina, Francis, et al. *Modernity and Modernism: French Painting in the Nineteenth Century*. New Haven: Yale University Press, 1993.

Fraser, Nancy, and Sandra Lee Bartky, eds. *Revaluing French Feminism: Critical Essays on Difference, Agency, and Culture*. Bloomington: Indiana University Press, 1991.

Gage, John. "Saving Faces." *Art History* 16, no. 4 (December 1993).

Gammell, R. H. Ives, ed. *The Boston Painter, 1890–1930*. Orleans, Mass.: Parnassus Imprints, 1986.

Garb, Tamar. "'L'art feminin': The Formation of a Critical Category in Late Nineteenth-Century France." *Art History* 12 (March 1989).

———. *Sisters of the Brush: Women's Artistic Culture in Late-Nineteenth-Century Paris*. New Haven: Yale University Press, 1994.

Gauckler, E. *Le Professeur J. Dejerine, 1849–1917*. Paris: Masson, 1922.

Gay, Peter. *The Bourgeois Experience: Victoria to Freud*, vol. 5, *Pleasure Wars*. New York: W. W. Norton, 1997.

Gelles, Edith B. *Portia: The World of Abigail Adams*. Bloomington: Indiana University Press, 1992.

Gilligan, Carol. *In a Different Voice: Psychological Theory and Women's Development*. Cambridge: Harvard University Press, 1982.

Gilligan, Carol, Annie G. Rogers, and Deborah L. Tolman. *Women, Girls, and Psychotherapy: Reframing Resistance*. New York: Harrington Park Press, 1991.

Gilman, Sander L. *Difference and Pathology: Stereotypes of Sexuality, Race, and Madness*. Ithaca, N.Y.: Cornell University Press, 1985.

Glasscock, Jean, ed. *Wellesley College, 1875–1975: A Century of Women*. Wellesley, Mass.: Wellesley College, 1975.

Goetz, Christopher. *Charcot: Constructing Neurology*. New York: Oxford University Press, 1995.

Goldsmith, Barbara. *Other Powers: The Age of Suffrage, Spiritualism, and the Scandalous Victoria Woodhull*. New York: Alfred A. Knopf, 1998.

Goldstein, Jan. *Console and Classify*. Cambridge: Cambridge University Press, 1987.

———. "The Uses of Male Hysteria: Medical and Literary Discourse in Nineteenth-Century France." In *French Medical Culture in the Nineteenth Century*, edited by Ann La Berge and Mordechai Feingold, 210–47. Amsterdam: Rodopi, 1994.

Graham, Julie. "American Women Artists' Groups: 1867–1930." *Woman's Art Journal* 1 (Spring–Summer 1980).

Gresky, Wolfgang. "Der Göttinger Aufruhr von 1831." *Göttinger Jahrbuch, 1968*.

Grosskurth, Phyllis. *Havelock Ellis: A Biography*. London: Allen Lane, 1980.

Grunfeld, Frederic V. *Rodin: A Biography*. New York: Henry Holt, 1987.

Guillain, Georges. *J.-M. Charcot, 1825–1893: His Life—His Work*. Translated by Pearce Bailey. New York: Harper and Brothers, 1959.

Hale, Nancy. *Mary Cassatt*. Reading, Mass.: Addison-Wesley, 1987.

Halperin, David M. *One Hundred Years of Homosexuality: And Other Essays on Greek Love*. New York: Routledge, 1990.

Halttunen, Karen. *Confidence Men and Painted Women: A Study of Middle-Class Culture in America, 1830–1870*. New Haven: Yale University Press, 1982.

Hare-Mustin, Rachel L., and Jeanne Marececk, eds. *Making a Difference: Psychology and the Construction of Gender*. New Haven: Yale University Press, 1990.

Harris, Barbara J. *Beyond Her Sphere: Women and the Professions in American History*. Westport, Conn.: Greenwood Press, 1978.

Havice, Christine. "The Artist in Her Own Words." *Woman's Art Journal* 2 (Fall 1981–Winter 1982).

Herbert, Robert L. "City vs. Country: The Rural Image in French Painting from Millet to Gauguin." *Artforum* 8 (February 1970).

Hess, Thomas B., and Elizabeth C. Baker, eds. *Art and Sexual Politics: Why Have There Been No Great Women Artists?* New York: Collier Books, 1973.

Higonnet, Anne. *Berthe Morisot*. New York: Harper and Row, 1990.

———. *Berthe Morisot's Images of Women*. Cambridge: Harvard University Press, 1992.

Hirshler, Erica. "Lilian Westcott Hale (1880–1963): A Woman Painter of the Boston School." 2 vols. Ph.D. diss., Boston University, 1992.

Hoppin, Martha. "Women Artists in Boston, 1870–1900: The Pupils of William Morris Hunt." *American Art Journal* 13 (Winter 1981).

Howard, Polly Damrosch. "1918: An Idea Is Born." *Fontainebleau Alumni Bulletin* (November 29, 1961).

Howe, Mark A. DeWolfe. *Memories of a Hostess: A Chronicle of Eminent Friendships Drawn Chiefly from the Diaries of Mrs. James T. Fields.* Boston: Atlantic Monthly Press, 1922.

Howells, Dorothy Eliza. *A Century to Celebrate: Radcliffe College, 1879–1979.* Cambridge, Mass.: Radcliffe College, 1978.

Huddleston, Sisley. *Paris Salons, Cafés, Studios: Being Social, Artistic, and Literary Memories.* Philadelphia: J. B. Lippincott, 1928.

Hungerford, Constance Cain. "Meissonier and the Founding of the Société Nationale des Beaux-Arts." *Art Journal* 48 (Spring 1989).

Hurd, D. Hamilton. *History of Fairfield County, Connecticut.* Philadelphia: J. W. Lewis, 1881.

Hustin, Arthur. *Salon de 1891: Société des artistes français et Société Nationale des Beaux-Arts.* Paris: L. Baschet, 1891.

———. *Salon de 1892: Société des artistes français et Société Nationale des Beaux-Arts.* Paris: L. Baschet, 1892.

Husung, Hans-Gerhard. *Norddeutschland zwischen Restauration und Revolution.* Göttingen: n.p., 1983.

Iles, Teresa. *All Sides of the Subject: Women and Biography.* New York: Teachers College Press, 1992.

International Council of Women. *Women in a Changing World: The Dynamic Story of the International Council of Women since 1888.* London: Routledge and Kegan Paul, 1966.

James, Henry. *The Bostonians.* 1886. New York: Signet Classics, 1979.

Joël, Constance. *Les filles d'Esculapes: Les femmes à la conquête du pouvoir médical.* Paris: Robert Laffont, 1988.

Johnson, Douglas W. J. *The Age of Illusion: Art and Politics in France, 1918–1940.* London: Thames and Hudson, 1987.

Jones, Howard Mumford, and Bessie Zaban Jones. *The Many Voices of Boston: A Historical Anthology, 1630–1975.* Boston: Little, Brown, 1930.

Kaplan, Fred. *Dickens: A Biography.* New York: William Morrow, 1988.

———. *Henry James: The Imagination of Genius.* New York: William Morrow, 1992.

Keller, Evelyn Fox. *Reflections on Gender and Science.* New Haven: Yale University Press, 1985.

Kemble, John Haskell. *The Panama Route, 1848–1869.* Columbia: University of South Carolina Press, 1990.

Kerber, Linda. *Toward an Intellectual History of Women.* Chapel Hill: University of North Carolina Press, 1997.

Kibler, Lilian Adele. *The History of Converse College, 1889–1971.* Spartanburg, S.C.: Converse College, 1971.

Killackey, Janice. "Photographs and Memories of the Longfellow Family Selected from the Collection at Longfellow National Historic Site." Manuscript, Cambridge, Mass., n.d.

Kling, Jean L. *Alice Pike Barney: Her Life and Art*. Washington, D.C.: National Museum of American Art, 1994.

Klumpke, Anna E. *Rosa Bonheur, sa vie, son oeuvre*. Paris: Flammarion, 1908.

———. *Memoirs of an Artist*. Edited by Lilian Whiting. Boston: Wright and Potter Printing, 1940.

Kohlstedt, Sally Gregory. "In from the Periphery: American Women in Science, 1830–1880." *Signs: Journal of Women in Culture and Society* 4, no. 1 (Autumn 1978).

Kysela, John D. "Sara Hallowell Brings 'Modern Art' to the Midwest." *Art Quarterly* 27, no. 2 (1964).

———. "Mary Cassatt's Mystery Mural and the World's Fair of 1893." *Art Quarterly* 29, no. 2 (1966).

Laipson, Peter. "From Boudoir to Bookstore: Writing the History of Sexuality." *Comparative Studies in Society and History* 34, no. 3 (1992).

Lawrence, Cynthia, ed. *Women and Art in Early Modern Europe: Patrons, Collectors, and Connoisseurs*. University Park: Pennsylvania State University Press, 1997.

Leach, William. *True Love and Perfect Union: The Feminist Reform of Sex and Society*. Middletown, Conn.: Wesleyan University Press, 1989.

Leguay, Françoise, and Claude Barbizet. *Blanche Edwards-Pilliet: Femme et médecin, 1858–1941*. Le Mans: Editions Cénomane, 1988.

Leonard, John William, ed. *Woman's Who's Who of America: Contemporary Women of the United States and Canada, 1914–1915*. New York: American Commonwealth, 1914.

Lesbian History Group. *Not a Passing Phase: Reclaiming Lesbians in History, 1840–1985*. Rev. ed. London: Women's Press, 1993.

Lewis, R. W. B. *Edith Wharton: A Biography*. New York: Fromm International, 1985.

Lief, Alfred, ed. *Adolph Meyer*. New York: McGraw-Hill, 1948.

Lodge, Oliver, F. R. S. *Pioneers of Science*. London: Macmillan, 1893.

Loewenthal, Anne W., ed. *The Object as Subject: Studies in the Interpretation of Still Life*. Princeton: Princeton University Press, 1996.

Looney, Mary Beth. *Hidden Treasures: Selections from the Permanent Collection of Brenau University*. Athens: Georgia Museum of Art, 1995.

Maas, Jeremy. *Gambart, Prince of the Victorian Art World*. London: Communica, Europa, Barrie and Jenkins, 1954.

Mahler, Margaret S., Fred Pine, and Ani Bergman. *The Psychological Birth of the Human Infant: Symbiosis and Individuation*. New York: Basic Books, 1975.

Mantz, Paul. *Salon de 1889*. Paris: L. Baschet, 1889.

Marchalons, Shirley, ed. *Friendship and Writing in Nineteenth-Century America.* New Brunswick, N.J.: Rutgers University Press, 1988.

Marlais, Michael, and Marianne Doezema. *Americans and Paris.* Waterville, Maine: Colby College Museum of Art, 1990.

——. *Conservative Echoes in Fin-de-Siècle Parisian Art Criticism.* University Park: Pennsylvania State University Press, 1992.

Marshall, S. L. A. *History of World War I.* New York: American Heritage Publishing, 1964.

Marson, Olivier. *Salon de 1893: Société des artistes français et Société Nationale des Beaux-Arts.* Paris: L. Baschet, 1893.

Martindale, Meredith, ed. *Lilla Cabot Perry: An American Impressionist.* Washington, D.C.: National Museum of Women in the Arts, 1990.

Mathews, Nancy Mowll. *Mary Cassatt: A Life.* 1989. New York: Villard Books, 1994.

Mathews, Nancy Mowll, and Barbara Stern Shapiro. *Mary Cassatt: The Color Prints.* New York: Abrams, 1989.

Mauclair, Camille. *De L'Amour Physique.* Paris: Librairie Ollendorff, n.d.

——. "La femme devant les peintres modernes." *La Nouvelle Revue,* Ser. I (1899): 190–213.

McCarthy, Kathleen D. *Women's Culture: American Philanthropy and Art, 1830–1930.* Chicago: University of Chicago Press, 1991.

——, ed. *Lady Bountiful Revisited: Women, Philanthropy, and Power.* New Brunswick, N.J.: Rutgers University Press, 1990.

McCauley, Elizabeth Anne. *A. A. E. Disderi and the Carte de Visite Portrait Photograph.* New Haven: Yale University Press, 1985.

McQueen, Alison. "Private Art Collections in Pittsburgh: Displays of Culture, Wealth, and Connoisseurship." In *Collecting in the Gilded Age: Art Patronage in Pittsburgh, 1890–1910,* edited by Gabriel P. Weisberg, DeCourcy E. McIntosh, and Alison McQueen, 53–106. Hanover, N.H.: University Press of New England, 1997.

Meyer, Adolph. *The Collected Papers of Adolph Meyer.* 4 vols. Edited by Eunice Winters. Baltimore: Johns Hopkins University Press, 1950–52.

Miles, Ellen, ed. *Portrait Painting in America: The Nineteenth Century.* New York: Universe Books, 1977.

Miller, Lillian B. "The Legacy: The Walker Gift, 1894." In *The Legacy of James Bowdoin III,* edited by Kenneth E. Carpenter et al., 187–212. Brunswick, Maine: Bowdoin College, 1994.

Milner, John. *The Studios of Paris: The Capital of Art in the Late Nineteenth Century.* New Haven: Yale University Press, 1988.

Mitchell, Juliet. *Psychoanalysis and Feminism.* New York: Vintage, 1975.

Moll, Albert. *Les perversions de l'instinct génital.* Paris: Georges Carré, 1893.

Montrosier, Eugène. *Salon de 1888*. Paris: L. Baschet, 1888.

Morantz, Regina Markell. *In Her Own Words: Oral Histories of Women Physicians*. New Haven: Yale University Press, 1982.

Morison, George Abbot. *Nathaniel Morison and His Descendants*. Peterborough, N.H.: Peterborough Historical Society, 1951.

——. *History of Peterborough, New Hampshire*. Peterborough, N.H.: Richard R. Smith, 1954.

Morton, Brian N. *Americans in Paris*. New York: Quill, 1986.

Moses, Claire Goldberg. *French Feminism in the Nineteenth Century*. Albany: State University of New York Press, 1984.

Naginski, Isabelle Hoog. *George Sand: Writing for Her Life*. New Brunswick, N.J.: Rutgers University Press, 1991.

The National Cyclopædia of American Biography, Being a History of the United States. Vol. 9. 1899. Reprint. Ann Arbor, Mich.: University Microfilms, 1967.

Navin, Thomas R. *The Whitin Machine Works since 1831: A Textile Machinery Company in an Industrial Village*. Cambridge: Harvard University Press, 1950.

Naylor, Maria, ed. *The National Academy of Design Exhibition Record, 1861–1900*. New York: Kennedy Galleries, 1973.

Neal, Kenneth. "A Wise Extravagance: The Founding of the Carnegie International Exhibitions, 1895–1901." Ph.D. diss., University of Pittsburgh, 1993.

——. *A Wise Extravagance: The Founding of the Carnegie International Exhibitions, 1895–1901*. Pittsburgh: University of Pittsburgh Press, 1996.

Niereker, Abigail May. *Studying Art Abroad and How to Do It Cheaply*. Boston: Roberts, 1879.

Nochlin, Linda. *Women, Art, and Power and Other Essays*. New York: Harper and Row, 1988.

Notable American Women, 1607–1950: A Biographical Dictionary. 3 vols. Edited by Edward T. James. Cambridge: Belknap Press of Harvard University Press, 1971.

O'Brien, Sharon. *Willa Cather: The Emerging Voice*. New York: Oxford University Press, 1987.

——. *Willa Cather*. Lives of Notable Gay Men and Lesbians Series. New York: Chelsea House Publishers, 1994.

Ockman, Carol. *Ingres's Eroticized Bodies: Retracing the Serpentine Line*. New Haven: Yale University Press, 1995.

Offen, Karen. "Depopulation, Nationalism, and Feminism in Fin-de-Siècle France." *American Historical Review* 89 (June 1984).

——. "Defining Feminism: A Comparative Approach." *Signs: Journal of Women in Culture and Society* 14, nos. 1–2 (Autumn 1988).

——. "On the French Origin of the Words *Feminism* and *Feminist*." *Feminist Issues* 8, no. 2 (1988).

Offen, Karen, Ruth Roach Pierson, and Jane Rendall, eds. *Writing Women's History: International Perspectives*. Bloomington: Indiana University Press, 1991.

Olney, Susan Faxon. *Two American Impressionists: Frank W. Benson and Edmund C. Tarbell, Sources, Influences, and Developments in Their Work*. Durham, N.C.: University Art Galleries, 1979.

Opfell, Olga S. *Special Visions: Profiles of Fifteen Women Artists from the Renaissance to the Present Day*. Jefferson, N.C.: McFarland, 1991.

Orr, Clarissa Scott, ed. *Women in the Victorian Art World*. New York: St. Martin's Press, 1995.

Orwicz, Michael R., ed. *Art Criticism and Its Institutions in Nineteenth-Century France*. New York: St. Martin's Press, 1994.

Peet, Phyllis. *American Women of the Etching Revival*. Atlanta: High Museum of Art, 1988.

Penn, Donna. "Queer: Theorizing Politics and History." *Radical History Review* 62 (Spring 1995).

Pennsylvania Academy of the Fine Arts. *The Paintings and Drawings of Cecilia Beaux*. Philadelphia: Pennsylvania Academy of the Fine Arts, 1955.

———. *Cecilia Beaux: Portrait of an Artist*. Philadelphia: Pennsylvania Academy of the Fine Arts, 1974.

Perrot, Michelle, ed. *Writing Women's History*. Translated by Felicia Pheasant. Oxford: Blackwell, 1992.

Personal Narrative Group. *Interpreting Women's Lives: Feminist Theory and Personal Narratives*. Bloomington: Indiana University Press, 1989.

Pichois, Claude. *Baudelaire*. Translated by Graham Robb. London: Hamish Hamilton, 1989.

Pierce, Patricia Jobe. *Edmund C. Tarbell and the Boston School of Painting (1889–1980)*. Hingham, Mass.: Pierce Galleries, 1980.

Pinet, Hélène. "Le Salon de Photographie: Les écoles pictorialistes en Europe et aux Etats-Unis vers 1900." Paris: Musée Rodin, 1993.

Pointon, Marcia. *Hanging the Head: Portraiture and Social Formation in Eighteenth-Century England*. New Haven: Yale University Press, 1993.

Pollock, Griselda. "Underground Women." *Spare Rib* 21 (March 1974).

———. *Mary Cassatt*. New York: Harper and Row, 1980.

———. *Vision & Difference: Femininity, Feminism, and the Histories of Art*. London: Routledge, 1988.

Price, Olive. *Rosa Bonheur: Painter of Animals*. Champaign, Ill.: Garrard Publishing, 1972.

Quick, Michael, Marvin Sadik, and William H. Gerdts. *American Portraiture in the Grand Manner: 1720–1920*. Los Angeles: Los Angeles County Museum of Art, 1981.

Raven, Arlene, Cassandra Langer, and Johanna Frueh, eds. *Feminist Art Criticism: An Anthology*. Ann Arbor, Mich.: UMI Research Press, 1988.

Reiss, Sheryl, and David Wilkins, eds. *Beyond Isabella: Secular Women Patrons of Art in the Italian Renaissance*. Forthcoming.

Reynolds, Gary A. *Giovanni Boldini and Society Portraiture, 1880–1920*. New York: Grey Art Gallery and Study Center of New York University, 1984.

———. *John Singer Sargent*. New York: Whitney Museum of American Art, 1987.

Rhode, Deborah L., ed. *Theoretical Perspectives on Sexual Difference*. New Haven: Yale University Press, 1990.

Ribemont, Francis. *Rosa Bonheur (1822–1899)*. Bordeaux: Musée des Beaux-Arts de Bordeaux with William Blake and Co., 1997.

Rodriguez, José, ed. *Dictionary of Music and Dance in California*. Hollywood: Bureau of Musical Research, 1940.

Roger-Milès, L. *Rosa Boneur: Sa vie, son oeuvre*. Paris: Imprimerie Georges Petit, 1900.

Roman, Judith A. *Annie Adams Fields: The Spirit of Charles Street*. Bloomington: Indiana University Press, 1990.

"Rosa Bonheur." *Masters in Art: A Series of Illustrated Monographs* 4, pt. 44 (August 1903): 1–42.

Rose, Hilary. *Love, Power, and Knowledge: Towards a Feminist Transformation of the Sciences*. Cambridge, England: Polity Press, 1994.

Ross, Ishbel. *Ladies of the Press: The Story of Women in Journalism by an Insider*. New York: Harper and Brothers, 1936.

Rossiter, Margaret W. *Women Scientists in America: Struggles and Strategies to 1940*. Baltimore: Johns Hopkins University Press, 1989.

Rothblum, Esther D., and Kathleen A. Brehony. *Boston Marriages: Romantic but Asexual Relationships among Contemporary Lesbians*. Amherst: University of Massachusetts Press, 1993.

Roudinesco, Elisabeth. *Histoire de la psychanalyse en France*. Vol. 1, *1885–1939*. Paris: Fayard, 1994.

Roussy, Gustave. *Eloge de Madame Dejerine-Klumpke, 1859–1927*. Paris: Imprimerie Lahure, 1928.

Rubinstein, Charlotte Streifer. *American Women Artists*. Boston: G. K. Hall, 1982.

Saint-Paul, G. [Docteur Laupts, pseud.]. *L'homosexualité et les types homosexuels*. 1896. Reprint. Paris: Vigot Frères, 1910.

Saslow, James M. "'Disagreeably Hidden': Construction and Constriction of the Lesbian Body in Rosa Boneur's *Horse Fair*." In *The Expanding Discourse: Feminism and Art History*, edited by Norma Broude and Mary D. Garrard, 187–205. New York: HarperCollins, 1992.

Satran, Richard. "Augusta Dejerine-Klumpke, First Woman Intern in Paris Hospitals." *Annals of Internal Medicine* 80 (February 1974).

Sauer, Marina. *L'entré des femmes à l'Ecole des Beaux-Arts, 1880–1923.* Paris: Ecole National Supérieure des Beaux-Arts, 1990.

Savigneau, Josyane. *Marguerite Yourcenar.* Paris: Gallimard, 1990.

Sayers, Janet. *Mothers of Psychoanalysis: Helene Deutsch, Karen Horney, Anna Freud, Melanie Klein.* New York: Norton, 1992.

Scharlach, Bernice. *Big Alma: San Francisco's Alma Spreckels.* San Francisco: Scottswall Associates, 1990.

Schiebinger, Londa. *The Mind Has No Sex? Women in the Origins of Modern Science.* Cambridge: Harvard University Press, 1989.

Schirmacher, Kathe. *The Modern Woman's Rights Movement: A Historical Survey.* New York: Kraus Reprint, 1971.

Schom, Alan. *Emile Zola: A Bourgeois Rebel.* London: Queen Anne Press, 1997.

Schor, Naomi. *Breaking the Chain: Women, Theory, and French Realist Fiction.* New York: Columbia University Press, 1985.

Schwager, Sally. "'Harvard Women': A History of the Founding of Radcliffe College." Ph.D. diss., Harvard University, 1982.

Schwartz, Boris. *The Great Masters of the Violin.* New York: Simon and Schuster, 1983.

Scott, Anne Firor. *Making the Invisible Woman Visible.* Urbana: University of Illinois Press, 1984.

———. *Natural Allies: Women's Associations in American History.* Urbana: University of Illinois Press, 1991.

Scott, Joan W. "Gender: A Useful Category of Historical Analysis." *American Historical Review* 91, no. 5 (1986).

Sergeant, Elizabeth Shepley. *French Perspectives.* Boston: Houghton Mifflin, 1916.

Shand-Tucci, Douglass. *Boston Bohemia, 1881–1900,* vol. 1 of *Ralph Adams Cram: Life and Architecture.* Amherst: University of Massachusetts Press, 1995.

———. *The Art of Scandal: The Life and Times of Isabella Stewart Gardner.* New York: HarperCollins, 1998.

Shaw, Annette. "Baudelaire's 'Femmes Damnées': The Androgynous Space." *Centerpoint* 3, no. 3–4 (Fall–Spring 1980).

Shawe-Taylor, Desmond. *The Georgians: Eighteenth-Century Portraiture and Society.* London: Barrie and Jenkins, 1990.

Sheldon, George William. *Recent Ideals of American Art.* ca. 1888. Reprint. New York: Garland Publishers, 1977.

Sherwood, Dolly. *Harriet Hosmer: American Sculptor, 1830–1908.* Columbia: University of Missouri Press, 1991.

Shirley-Fox, John. *An American Student's Reminiscences of Paris in the Eighties.* London: Mills and Boon, 1909.

Shorter, Edward. *A History of Psychiatry: From the Era of the Asylum to the Age of Prozac*. New York: John Wiley and Sons, 1997.

Showalter, Elaine, ed. *The New Feminist Criticism: Essays on Women, Literature, and Theory*. New York: Pantheon Books, 1985.

Shriver, Rosalie. *Rosa Bonheur: With a Checklist of Works in American Collections*. Philadelphia: Art Alliance Press, 1982.

Silver, Kenneth E., and Romy Golan. *The Circle of Montparnasse: Jewish Artists in Paris, 1905–1945*. New York: Universe Books, 1985.

Silverman, Debora L. *Art Nouveau in Fin-de-Siècle France: Politics, Psychology, and Style*. Berkeley: University of California Press, 1989.

Silverman, Willa Z. *The Notorious Life of Gyp, Right-Wing Anarchist in Fin-de-Siècle France*. New York: Oxford University Press, 1995.

Simon, Robin. *The Portrait in Britain and America*. Oxford: Phaidon, 1987.

Slater, Michael. *Dickens and Women*. Stanford: Stanford University Press, 1983.

Slatkin, Wendy. *Women Artists in History: From Antiquity to the Twentieth Century*. Englewood Cliffs, N.J.: Prentice-Hall, 1990.

Smith, Clement. *The Children's Hospital of Boston*. Boston: Little, Brown, 1983.

Smith, Matthew Hale. *Sunshine and Shadow in New York*. Hartford, Conn.: J. B. Burr, 1868.

Smith, Mortimer Brewster. *The Life of Ole Bull*. Princeton: Princeton University Press, 1947.

Smith, Sidonie. *Subjectivity, Identity, and the Body: Women's Autobiographical Practices in the Twentieth Century*. Bloomington: Indiana University Press, 1993.

Smith-Rosenberg, Carroll. "The Female World of Love and Ritual: Relations between Women in Nineteenth-Century America." *Signs: Journal of Women in Culture and Society* 1, no. 1 (Autumn 1975).

———. *Disorderly Conduct: Visions of Gender in Victorian America*. New York: Oxford University Press, 1985.

Solomon, Barbara Miller. *In the Company of Educated Women: A History of Women and Higher Education in America*. New Haven: Yale University Press, 1985.

Sorrel-Dejerine, Jacqueline. *Madame Dejerine-Klumpke*. Extrait d'un Bulletin de l'Association Française de Femmes Médecins. Paris: Imprimerie Polygraphique, 1959.

Souhami, Diana. *Gertrude and Alice*. London: Pandora Press, 1991.

Spiller, William G. Untitled essay. In *Madame Dejerine, 1859–1927*, edited by André-Thomas, 95–99. Chartres: Imprimerie Durand, 1929.

Stanford University Museum of Art. *Museum Builders in the West: The Stanfords as Collectors and Patrons of Art, 1870–1906*. Stanford: Stanford University Museum of Art, 1986.

Stanton, Elizabeth Cady. *Eighty Years and More (1815–1897): Reminiscences of Elizabeth Cady Stanton*. 1898. Reprint. Boston: Northeastern University Press, 1993.

Stanton, Theodore, ed. *The Woman Question in Europe*. 1881. Reprint. New York: MSS Information, 1974.

————. *Reminiscences of Rosa Bonheur*. 1910. Reprint. New York: Hacker Art Books, 1976.

Stanton, Theodore, and Harriot Stanton Blatch, eds. *Elizabeth Cady Stanton as Revealed in Her Letters, Diary, and Reminiscences*. 2 vols. 1922. Reprint. New York: Arno and the New York Times, 1969.

Strindberg, August. *A Madman's Manifesto*. Translated by Anthony Smerling. Tuscaloosa: University of Alabama Press, 1971.

Strouse, Jean. *Alice James: The Life of the Brilliant but Neglected Younger Sister of William and Henry*. Boston: Houghton Mifflin, 1980.

Tappert, Tara L. "Choices—The Life and Career of Cecilia Beaux: A Professional Biography." Ph.D. diss., George Washington University, 1990.

————. *The Emmets: A Generation of Gifted Women*. York: Borghi and Co., 1993.

————. "Cecilia Beaux and the Art of Portraiture." Washington, D.C.: Smithsonian Institution, National Portrait Gallery, 1995.

Taylor, P. A. M., ed. *More than Common Powers of Perception: The Diary of Elizabeth Rogers Mason Cabot*. Boston: Beacon Press, 1991.

Thompson, James. *The Peasant in French Nineteenth-Century Art*. Dublin: Douglas Hyde Gallery, Trinity College, 1980.

Ticknor, Caroline. *May Alcott, a Memoir*. Boston: Little, Brown, 1928.

Troyat, Henri. *Zola*. Paris: Flammarion, 1992.

Troyen, Carol, and Pamela Tabbaa. *The Great Boston Collectors: Paintings from the Museum of Fine Arts*. Boston: Museum of Fine Arts, 1984.

Tucker, Paul Hayes. "The Revolution in the Garden: Monet in the Twentieth Century." In *Monet in the Twentieth Century*, 14–85. New Haven: Yale University Press, 1998.

Turner, Elizabeth Hutton. *American Artists in Paris, 1919–1929*. Ann Arbor, Mich.: UMI Research Press, 1988.

Turner, Herbert Hall, F.R.S. *Modern Astronomy, Being Some Account of the Revolution of the Last Quarter of a Century*. London: Archibald Constable, 1901.

van Casselaer, Catherine. *Lot's Wife: Lesbian Paris, 1890–1914*. Liverpool: Janus Press, 1986.

van Hook, Bailey. *Angels of Art: Women and Art in American Society, 1876–1914*. University Park: Pennsylvania State University Press, 1996.

Van Nostrand, Jeanne. *The First Hundred Years of Painting in California, 1775–1875: With Biographical Information and References Relating to the Artists*. San Francisco: John Howell Books, 1980.

van Slyke, Gretchen. "Reinventing Matrimony." *Women's Studies Quarterly* 19 (Fall–Winter 1991).

————. "Does Genius Have a Sex? Rosa Bonheur's Reply." *French American Review* 63, no. 2 (Winter 1992).

————, trans. *The Artist's (Auto)Biography: Rosa Bonheur by Anna Klumpke*. Ann Arbor: University of Michigan Press, 1997.

van Vorst, Bessie. "The Klumpke Sisters." *Critic* 37 (September 1900).

Vance, William L. "Redefining 'Bostonians.'" In *The Bostonians: Painters of an Elegant Age, 1870–1930*, edited by Trevor J. Fairbrother, 9–30. Boston: Museum of Fine Arts, 1986.

Vicinus, Martha. *Independent Women: Work and Community for Single Women, 1850–1920*. Chicago: University of Chicago Press, 1988.

————. "'They Wonder to Which Sex I Belong': The Historical Roots of the Modern Lesbian Identity." In *The Lesbian and Gay Studies Reader*, edited by Henry Abelove, Michele Aina Barale, and David M. Halperin, 432–52. New York: Routledge, 1993.

————, ed. *Lesbian Subjects: A Feminist Studies Reader*. Bloomington: Indiana University Press, 1997.

Le voyage de Paris: Les américains dans les écoles d'art, 1868–1918. Les Dossiers du Musée de Blérancourt, no. 1. Paris: Réunion des musées nationaux, 1990.

Wagner-Martin, Linda. *Telling Women's Lives: The New Biography*. New Brunswick, N.J.: Rutgers University Press, 1994.

————. *"Favored Strangers": Gertrude Stein and Her Family*. New Brunswick, N.J.: Rutgers University Press, 1995.

Walker, John. *Portraits, 5000 Years*. New York: Harry N. Abrams, 1983.

Walsh, Mary Roth. *Doctors Wanted, No Women Need Apply: Sexual Barriers in the Medical Profession, 1835–1975*. New Haven: Yale University Press, 1977.

Ward, Martha. "Impressionist Installations and Private Exhibitions." *Art Bulletin* 50 (December 1991).

Weber, Eugen Joseph. *France, Fin-de-Siècle*. Cambridge: Harvard University Press, 1986.

Webster, Sally. *William Morris Hunt, 1824–1879*. New York: Cambridge University Press, 1991.

Weimann, Jeanne Madeleine. *The Fair Women: The Story of the Woman's Building, World's Columbian Exposition*. Chicago: Academy Chicago, 1981.

Weinberg, H. Barbara. *The Lure of Paris: Nineteenth-Century American Painters and Their French Teachers*. New York: Abbeville Press, 1991.

Weir, Irene. "Rosa Bonheur." *Perry Magazine* 3 (October 1900): 51–56.

Weisberg, Gabriel P. "P. A. J. Dagnan-Bouveret and the Illusion of Photographic Naturalism." *Arts Magazine* 56 (March 1982).

————. *Beyond Impressionism: The Naturalist Impulse*. New York: Harry N. Abrams, 1992.

————. *Redefining Genre: French and American Painting, 1850–1900*. Washington, D.C.: Trust for Museum Exhibitions; Seattle: University of Washington Press, 1995.

————. "Rosa Bonheur's Reception in England and America: The Popularization of a Legend and the Celebration of a Myth." In *Rosa Bonheur: All Nature's Children*. New York: Dahesh Museum, 1998.

Weitzenhoffer, Kenneth. "The Triumph of Dorothea Klumpke." *Sky and Telescope* 71 (August 1986).

Wells, Mildred White, ed. *Unity in Diversity: The History of the General Federation of Women's Clubs*. Washington, D.C.: General Federation of Women's Clubs, 1953.

Wendell, Barrett. *The France of Today*. New York: Charles Scribner's Sons, 1907.

Wendorf, Richard. *The Elements of Life: Biography and Portrait-Painting in Stuart and Georgian England*. Oxford: Clarendon Press, 1990.

Westkott, Marcia. *The Feminist Legacy of Karen Horney*. New Haven: Yale University Press, 1986.

Wharton, Edith. *The Marne*. New York: D. Appleton, 1918.

————. *Autobiography: A Backward Glance*. 1934. Reprint. New York: Charles Scribner, 1964.

Whiting, Lilian. *After Her Death: The Story of a Summer*. Boston: Roberts Brothers, 1897.

————. *Kate Field: A Record*. Boston: Little, Brown, 1899.

————. *Women Who Have Ennobled Life*. Philadelphia: Union Press, 1915.

Wiesen-Cook, Blanche. "'Women Alone Stir My Imagination': Lesbianism and the Cultural Tradition." *Signs: Journal of Women in Culture and Society* 4 (Summer 1979): 718–39.

Wiesenger, Véronique. *Paris Bound: Americans in Art Schools, 1868–1918*. Paris: Dossiers du Musée de Blérancourt, no. 1, 1990.

————. *Les Américains et la Légion d'Honneur, 1853–1947*. Paris: Musée national de la Coopération franco-américaine, Château de Blérancourt, 1993.

Wilton, Andrew. *The Swagger Portrait*. London: Tate Gallery, 1992.

Wiser, William. *The Great Good Place: American Expatriate Women in Paris*. New York: W. W. Norton, 1991.

Wolff, Janet. *Resident Alien: Feminist Cultural Criticism*. New Haven: Yale University Press, 1995.

Woloch, Nancy. *Women and the American Experience*. New York: Alfred A. Knopf, 1984.

Zeldin, Theodore. *The French*. New York: Pantheon Books, 1982.

Zimmerman, Bonnie. "What Has Never Been: An Overview of Lesbian Feminist Literary Criticism." In *The New Feminist Criticism: Essays on Women, Litera-*

ture, and Theory. Edited by Elaine Showalter. New York: Pantheon Books, 1985.

Zimmermann, Bonnie, and A. H. McNaron, eds. *The New Lesbian Studies: Into the Twenty-First Century*. New York: Feminist Press, 1996.

Zola, Emile. *Nana*. 1880. Translated by George Holden. New York: Penguin Books, 1979.

———. *L'Oeuvre (The Masterpiece)*. 1886. Translated by Thomas Walton. Oxford: Oxford University Press, 1993.

———. *Le Rêve (The Dream)*. Translated by Eliza E. Chase. London: Chatto and Windus, 1893.

[Archival Sources]

Albany, N.Y.
Albany Institute of History and Art, Archives.

Baltimore, Md.
The Alan Mason Chesney Medical Archives of The Johns Hopkins Medical Institutions.

Boston, Mass.
Archives of American Art, Manuscript Collection.
Archives of the St. Botolph Club.
Boston Public Library, Fine Arts Department, Vertical Files.
Massachusetts Historical Society, Manuscript Collection.
Museum of Fine Arts, Paintings Department, Curatorial Files.
Museum of Fine Arts, Registrar's Records.
New England Conservatory, Spaulding Library, Archives.
New England Historic Genealogical Society, Library.
Suffolk Probate Office, Wills and Inventories.

Cambridge, Mass.
Archives of the Henry Wadsworth Longfellow National Historic Site, Papers of Alice Mary Longfellow (1850–1928).
The Arthur and Elizabeth Schlesinger Library, Radcliffe College, Manuscript Collection.
Radcliffe College, Archives.

New Haven, Conn.
Archives of RTA Incorporated: Russell Trust Association Archives: George Douglas Miller.

New York, N.Y.
Archives of the Metropolitan Museum of Art, Artist File: Anna E. Klumpke.

Northampton, Mass.
Hale Papers, Sophia Smith Collection, Smith College.

Philadelphia, Pa.
Pennsylvania Academy of the Fine Arts, Curatorial Files.

Pittsburgh, Pa.
Archives of the Historical Society of Western Pennsylvania: Thaw Papers.
Carnegie Library, Oakland: Biographical File for Thaw Family and Newspaper
 and Manuscript Collection in the Pennsylvania Room.
Museum of Art, Carnegie Institute, Department of Fine Arts.

Sacramento, Calif.
California State Library, Sacramento, Biographical File: Clark, Klumpke.

San Francisco, Calif.
Alice Phelan Sullivan Library and Archives at the Society of California Pio-
 neers, Special Collection.
The Bancroft Library, University of California, Berkeley, Newspaper Collec-
 tion.
San Francisco Public Library, Special Collection.

Sandwich, N.H.
Sandwich Historical Society, Documents.

Washington, D.C.
Archives of American Art.
National Gallery of Art, Archives (Exhibition Catalogues).
National Museum of American Art, Registrar's File; Artist File: Anna E.
 Klumpke.
National Museum of Women in the Arts, Artist File: Rosa
 Bonheur.
National Portrait Gallery: Anna E. Klumpke.

Wellesley, Mass.
Wellesley College, Archives, 3L Department of Astronomy, Correspon-
 dence: Mrs. John C. Whitin to Sarah Frances Whiting (undated,
 1898–1899).

Worcester, Mass.
American Antiquarian Society.
Worcester Art Museum, Klumpke Archive Records.
Worcester Historical Museum, Library, Archives.

France
Archives nationales, Paris: document F/21/4227.
Centre Georges Pompidou, Paris, *Documentation*.
Musée de l'Atelier de Rosa Bonheur, By/Thomery.
Musée national du château de Fontainebleau, Fontainebleau.
Musée d'Orsay, Paris, Librarie, *Documentation*.
Musée Rodin, Hôtel Biron, Paris, Archives.

Germany
Stadt Göttingen, Göttingen Archiv.

[Selected Newspapers and Periodicals]

Boston, Mass. (all at BPL)
Boston Budget.
Boston Evening Transcript.
Boston Traveller/Boston Evening Traveller.

Pittsburgh, Pa. (all at CL)
Pittsburg Bulletin; the *Bulletin* (founded in 1876) merged with the *Index* (founded
 in 1895) to form the *Bulletin-Index* in 1930.
Pittsburg Chronicle.
Pittsburg Daily Dispatch.
Pittsburg Evening Chronicle.

[Interviews]

France
Eric and Olivier Sorrel Dejerine, Paris, June 7–15, 1991.
Jean-Claude Dejerine, Paris, June 15, 1991.
Germaine Auclair, By/Thomery, December 12, 1991.
Suzanne Delorne, By/Thomery, December 12, 1991.

U.S.A.
John A. Bross, Jr., August 1991.
Elting Morison, July 15, 1992.

Catherine and Harold Mueller, February 1993.
Joseph Randolph Coolidge IV, July 1993.
Roger Sherman Coolidge, July 1993.
Mary Lincoln, July 1993.

Index